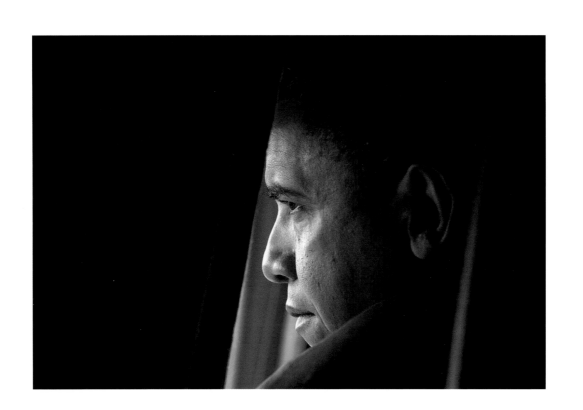

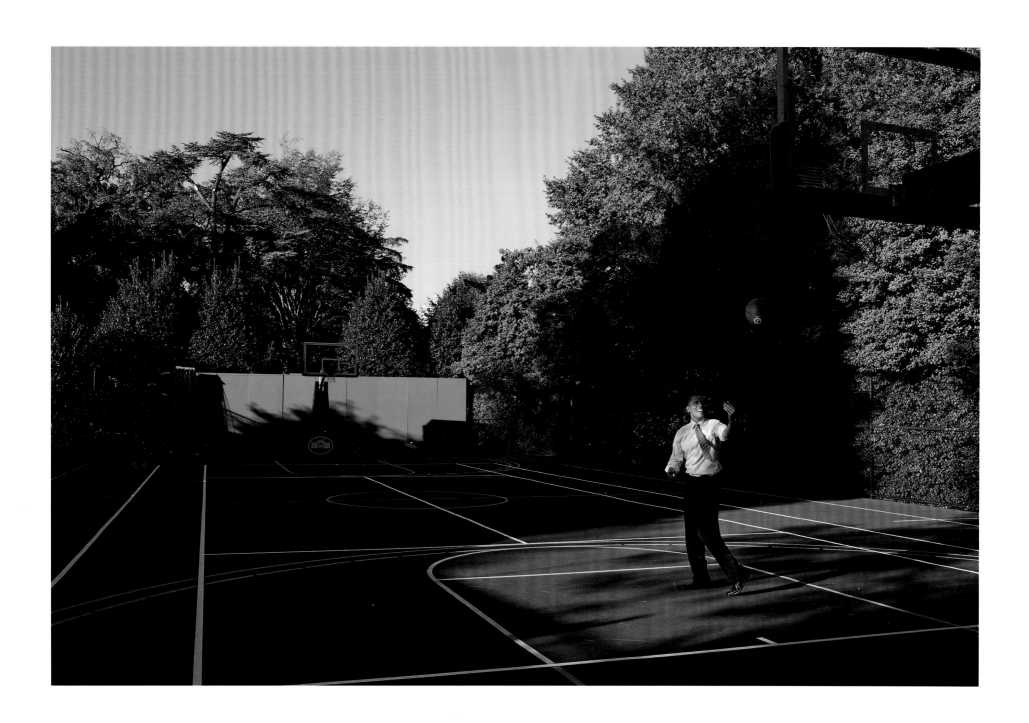

OBAMA

AN INTIMATE PORTRAIT

—

PETE SOUZA

FOREWORD BY BARACK OBAMA

LITTLE, BROWN AND COMPANY
NEW YORK BOSTON LONDON

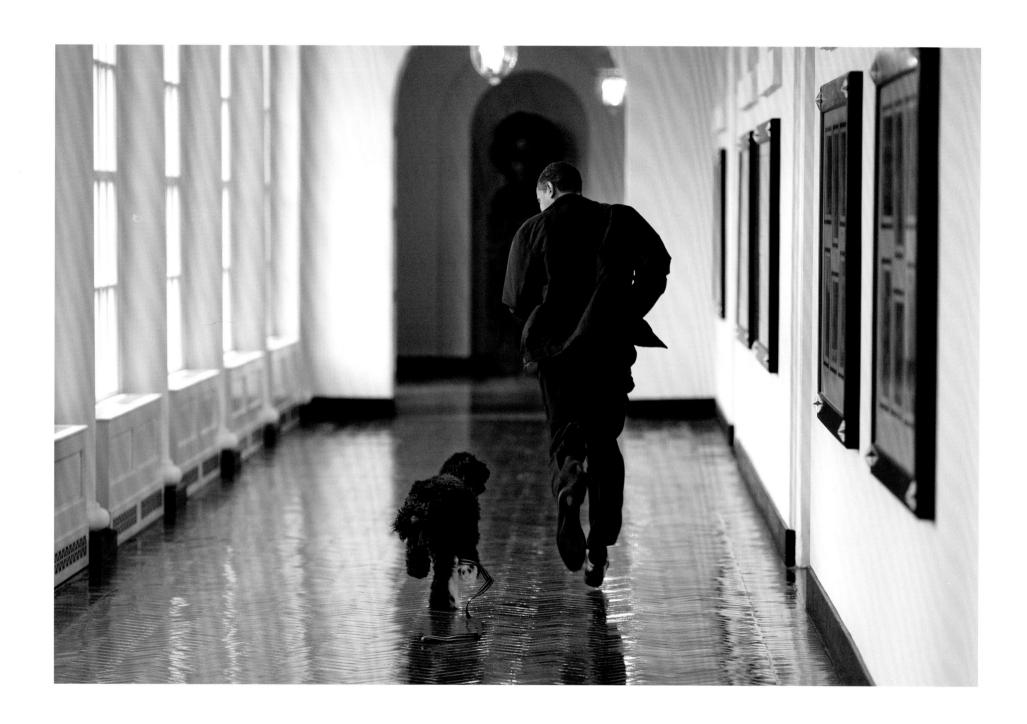

FOREWORD

BY BARACK OBAMA

Over the course of eight years in the White House, I probably spent more time with Pete Souza than with anybody other than my family.

From moments of America's triumph to times of our deepest tragedy, from high-stakes meetings with world leaders to quiet mornings of study in a sun-splashed Oval Office, Pete was always present, dutifully documenting every moment, large and small, for history. And here's the thing: I wouldn't always know it. In addition to his exceptional eye, Pete has a remarkable talent for making himself invisible. In fact, what makes Pete such an extraordinary photographer, I think, is something more than his ability to frame an interesting moment. It's his capacity to capture the mood, the atmosphere, and the meaning of that moment. And for all the unique and often historic images he captured, he never made himself a part of the story those images told.

Pete Souza chronicled eight years of American history. His work, and his team's work, is a gift to future generations, scholars, and everyday citizens alike—artifacts worthy of our appreciation and our gratitude.

But I'll always be grateful to Pete for something more than that. Over those eight years, Pete became more than my photographer—he became a friend, a confidant, and a brother. We broke up long days with stories and laughs. We broke up long overnight flights with fiercely competitive card games. I consider him and Patti part of our family—which is why we held their wedding in the Rose Garden.

Having Pete around made my life better. And if there's one gift for which I'm even more grateful to Pete than his friendship, it's the many photos he captured of my family. Frozen moments of Malia and Sasha, who grew up so fast. Exquisite images of Michelle, in her spectacular service as First Lady. Snapshots of Bo and Sunny frolicking on the South Lawn, or discovering snow for the first time. And, above all, the millions of faces that make up the proud, diverse, optimistic, bighearted character of America—faces in the crowd that I'll always cherish seeing, thankful that Pete's talented eyes saw them first.

I hope you and your family enjoy experiencing Pete's photos as much as I do.

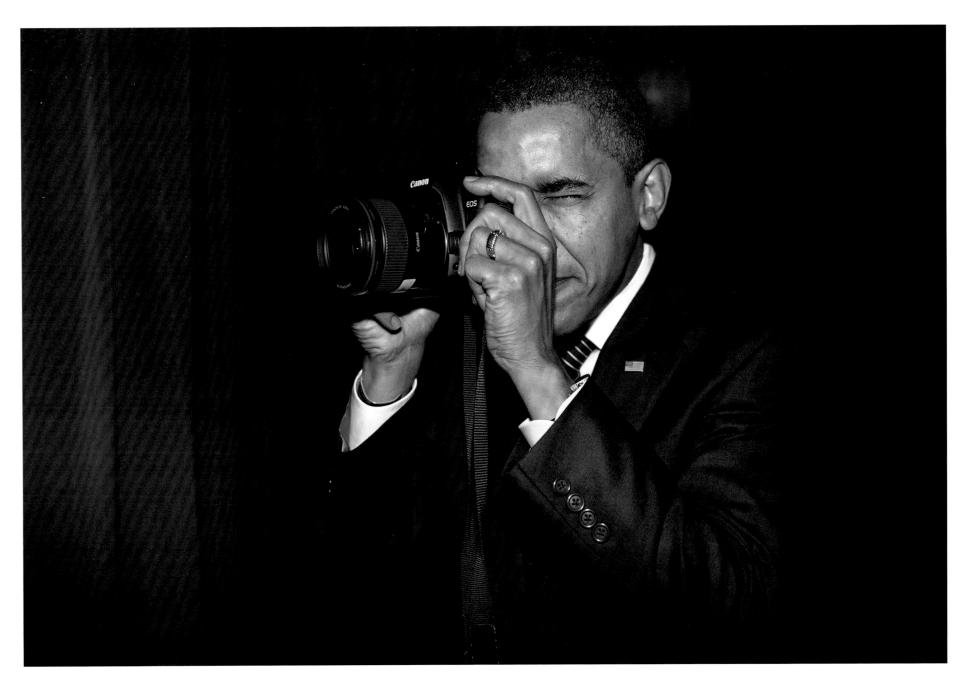

February 18, 2009

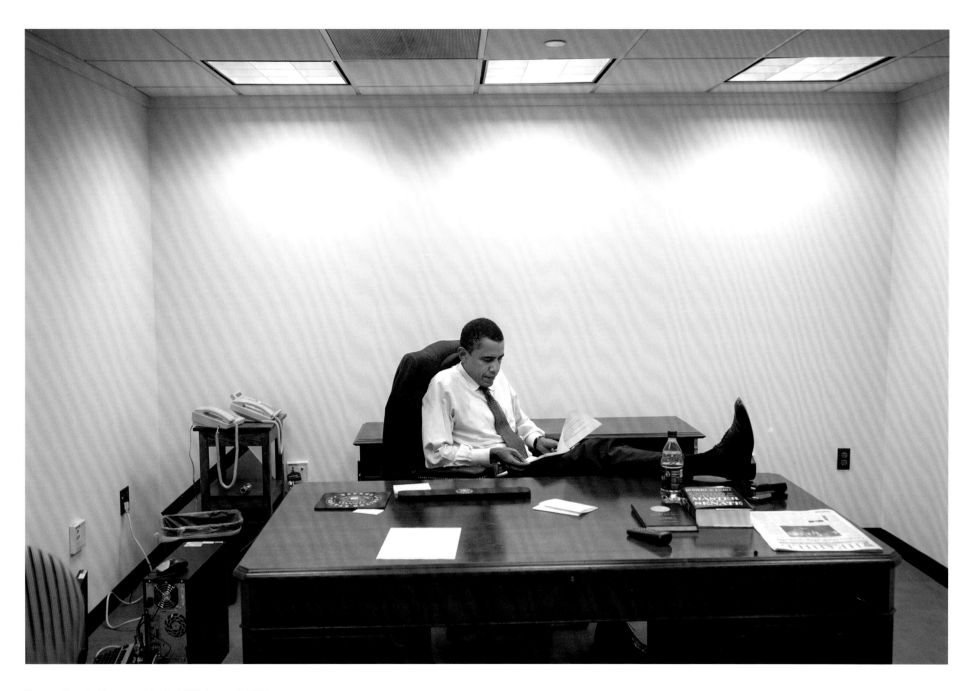

Senator Barack Obama on Capitol Hill. *January 5, 2005*

INTRODUCTION

The man was seated at a desk in a windowless basement office. Two aides had just left the room. I was now alone with the new U.S. Senator from Illinois. It was January 5, 2005.

One of his feet was propped up on the desk. A government computer had been dumped on the floor, cables strewn. Fluorescent lights flickered overhead. The desk held only a few objects, including a notepad, a book (Robert Caro's *Master of the Senate: The Years of Lyndon Johnson*), and a mouse pad. The Senator was reading a document, paying me no mind.

Click. I made a nice candid frame of this scene, as any photojournalist would do. I was using a quiet camera. I didn't want to disturb him. *Click.* I paused. *Click* again. I waited for a gesture, something, anything. He never once looked up at me—just went about his business. So I went about my business too. I captured a few more frames and walked out. I had what I needed.

I had just met Barack Obama the day before, when he had been sworn in as a 43-year-old Senator. It was a day of pomp and circumstance. He had his family in tow: a stylish wife and two young daughters.

I saw right away how much those girls meant to him. He doted on them throughout the day. Making sure they were comfortable. Bending down outside the Capitol after Malia, then six, had twirled a little dance just for him. Later, inside the Capitol, getting kisses from Sasha, then three, and Malia in the middle of chewing a sandwich. All the while, it was as if he didn't even notice there was this photographer with him, capturing those moments throughout the day.

How lucky for me that I happened to be the Washington photographer for the *Chicago Tribune*, the young Senator's adoptive hometown newspaper. That day was the first day documenting his first year in the Senate. Jeff Zeleny, the political reporter for the paper, and I were preparing a series of major stories throughout the year, tracking how the new Senator adjusted to life in Washington and what he'd done while he was there. The plan was for me to spend as much time as I could with him between other assignments.

After only 24 hours, I had already begun thinking a crazy thought. The Senator was not from a famous or political family. His father was from Kenya, his mother from Kansas. His name was Barack Hussein Obama. But he had a gift.

What if? I thought to myself. *Could I be observing the future President of the United States?* I imagined how that photograph of him seated at his stale bureaucratic desk in his drab government office might compare with a future photograph of him sitting at the Resolute Desk in the Oval Office.

Thus began my professional relationship with Barack Obama. I shadowed him extensively during his first year in the Senate. We got to know each other and understand how we each worked.

In 2005, I accompanied him on a Congressional delegation trip to Russia, Ukraine, and Azerbaijan. I remember trying to make a telling photograph of him walking around Red Square unrecognized, just in case that scene could never be repeated as he became better known. In 2006, I also documented him on a family trip to Kenya, the country where his father was born. I was amazed to see the thousands of people who gathered to try and catch a glimpse of someone who at the time was still a lowly freshman Senator.

I covered the start of his Presidential campaign in 2007. During that summer, however, I resigned from the *Tribune* to start a new life as a photojournalism professor at Ohio University. But I did continue to photograph Senator Obama and eventually published a book, *The Rise of Barack Obama.*

His incoming press secretary, Robert Gibbs, called me on a Sunday night in early January 2009 to offer me the job as Chief Official White House Photographer.

I remember telling Gibbs that in order to do the job, I needed to have access. Access to *everything*. All the important stuff, the moments when decisions are made. Even if it was classified. He said, "Of course, the President-elect gets it." That was all I needed to hear.

On paper, the job of Chief Official White House Photographer is to visually document the President for history. But *what,* and *how much,* you photograph depends on each individual photographer.

I knew what I was in for—or at least I thought I did. I had worked at the White House in my 20s as a "junior" official photographer during the Reagan administration. The person I wanted to emulate was Yoichi Okamoto, President Lyndon Johnson's chief photographer. Previous Presidential photographers had made a lot of ceremonial pictures and a few candid pictures here and there. Okamoto pushed the bar and photographed seemingly everything Johnson did.

Starting on Day One—January 20, 2009—I was determined to take Okamoto's approach. It sounds simple. But everything can change the moment a President sets foot in the Oval Office.

I had a plan for how to make it work for both of us. I'd explain to him and everyone around him why I needed to be in every meeting, every day: It was my job to capture real moments for history. The highs and lows, the texture of each day, the things we didn't even know would be important later on. But, to paraphrase a line from Lin-Manuel Miranda's *Hamilton*, "You gotta be in the room where it happens." If you're not there, you're not going to capture *any* moment, let alone a historic one.

My job was to be the observer, not the participant. Easy, right? But it was damn hard. Physically. Mentally. Spiritually. It is a job meant for someone with some experience, and a lot of youth and energy. Ideally someone in their mid-30s, maybe early 40s, tops. I started the job when I was 54.

Someone—I think it was Andy Card, he of the Reagan and Bush administrations—once described working at the White House as trying to take a sip of water from a fire hose that never shuts off. That's a pretty good analogy. Just when you think you have a break, *boom*, you realize that documenting the President for history

is an all-consuming, 24/7, always-on-call, no-vacation, no-sick-days, BlackBerry-always-vibrating kind of job.

President Obama and I shared a lot of time in each other's presence. It was 10 to 12 hours a day, five days a week (and sometimes six or seven). I photographed every meeting, every day, every place he went to. The Oval Office, the Situation Room, the Roosevelt Room. Nearly 1.5 million miles on *Air Force One*. All 50 states; more than 60 countries. Just shy of 2 million photographs over eight years.

Along the way, I became his friend. And he became my friend. How could you not when you share so much of life together? We played countless games of Spades together on our long flights overseas. He called me Pete or later the Azorean when he found out my ancestry, and I called him Mr. President or, more often, POTUS. He poked fun at my age, my bald spot, or at the reptiles I kept at home. And I saw what delighted him, what wore on him, what made him mad and what brought him peace. Amid all that togetherness, did I ever get on his nerves? Certainly. Did he get on my nerves? One learns to always say no.

Now, I think back to that scene from January 2005 in the basement office on his second day as a U.S. Senator. So much has changed since then. But in the 12 years I've known him, the character of this man has not changed. Deep down, his core is the same. He tells his daughters, "Be kind and be useful." And that tells you a lot about him. As a man. A father. A husband. And yes, as a President of the United States.

This book represents the moments I captured of President Obama throughout his Presidency. The big moments and the small moments. Fun moments. Moments of crisis. Moments of laughter. Moments when I had to hide my own tears behind the viewfinder. Intimate family moments. Symbolic moments and historic moments.

I have had the extraordinary privilege of being the man in the room for eight years, visually documenting President Obama for history. This book is the result of that effort; I gave it my all. I hope that the photographs that follow, accompanied by my words, will show you the true character of this man and the essence of his Presidency, as seen through my eyes and felt through my heart.

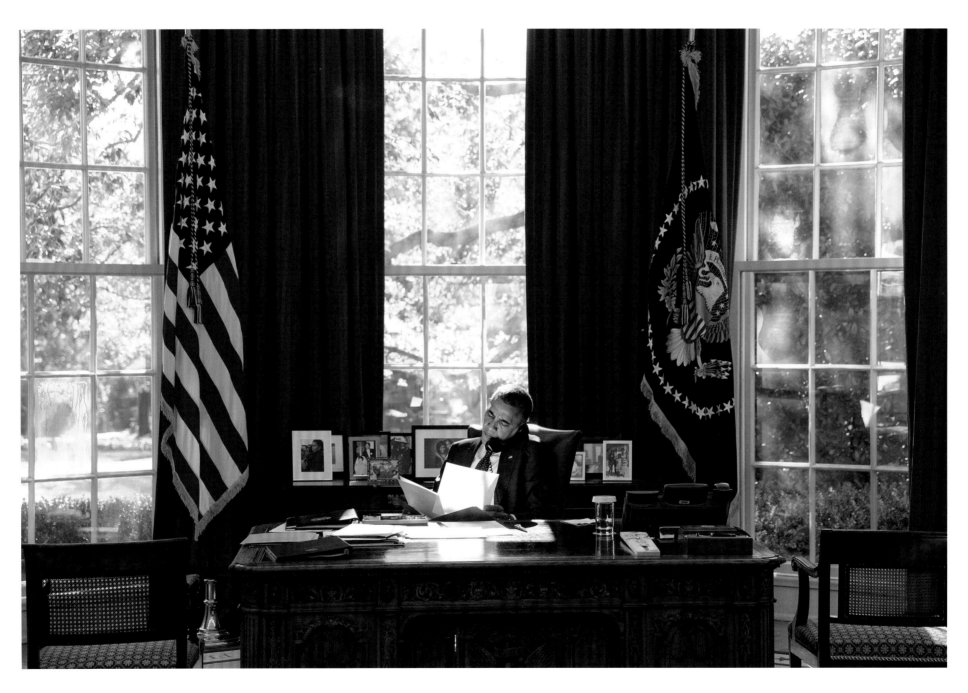

President Barack Obama in the Oval Office. *November 9, 2012*

FIRST TERM

I

INAUGURATION DAY

SETTLING IN AT THE WHITE HOUSE

TOUGH DECISIONS ON THE ECONOMIC CRISIS

DANCING TO EARTH, WIND & FIRE

BAILING OUT THE AUTOMOBILE INDUSTRY

A VISIT TO PRAGUE AND IRAQ

HAIR LIKE MINE

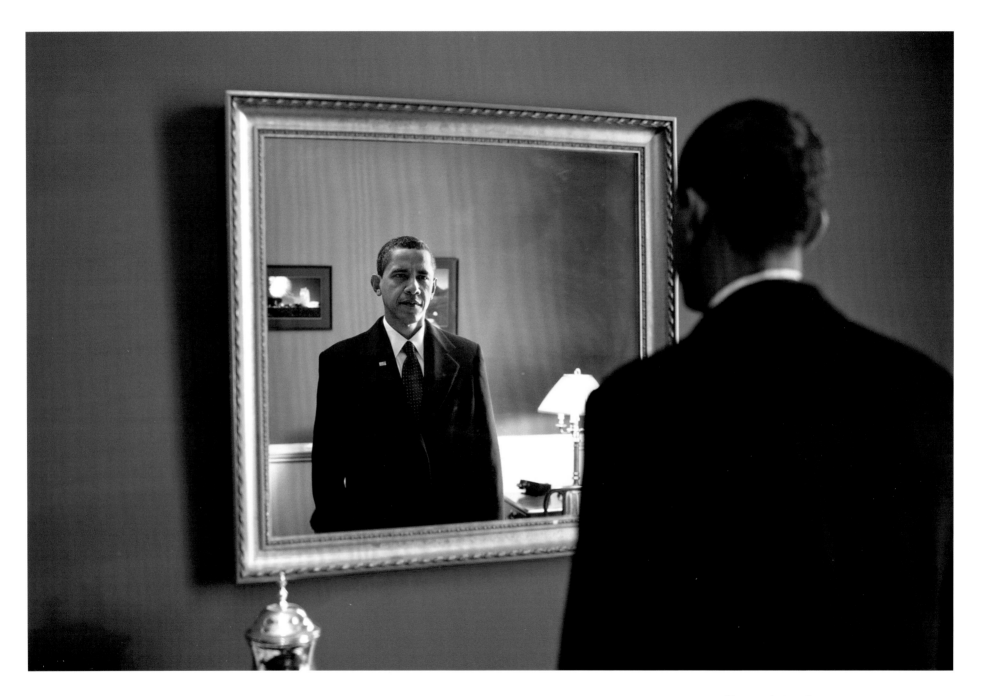

Moments before the inauguration. *January 20, 2009*

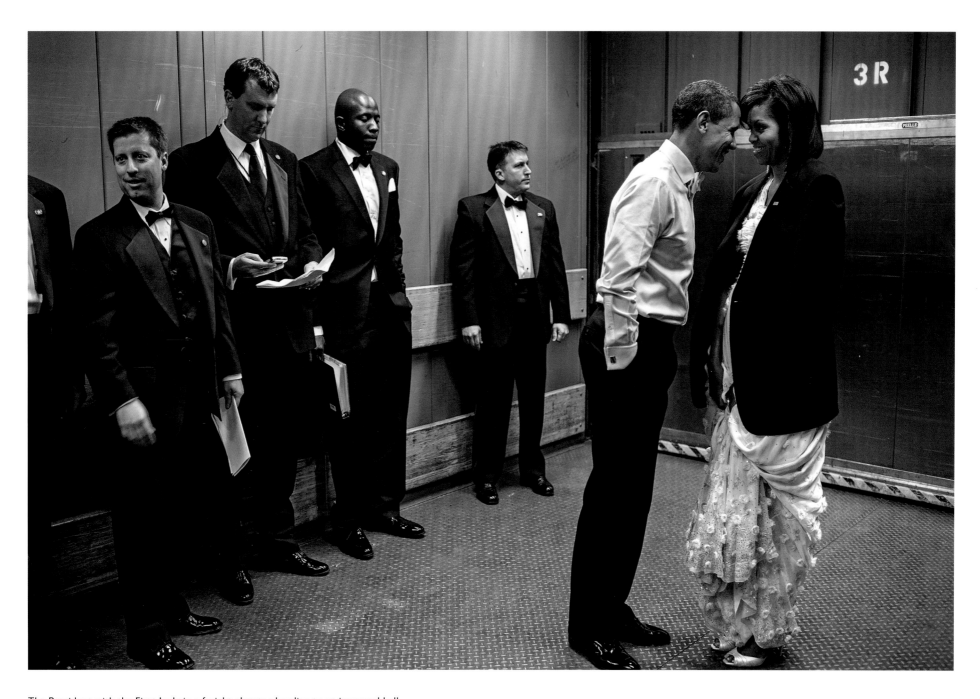

The President with the First Lady in a freight elevator heading to an inaugural ball.
It was chilly, so he draped his jacket over her shoulders. *11:00 p.m., January 20, 2009*

On the elevator to the private residence after the inaugural
party at the White House. *2:00 a.m., January 21, 2009*

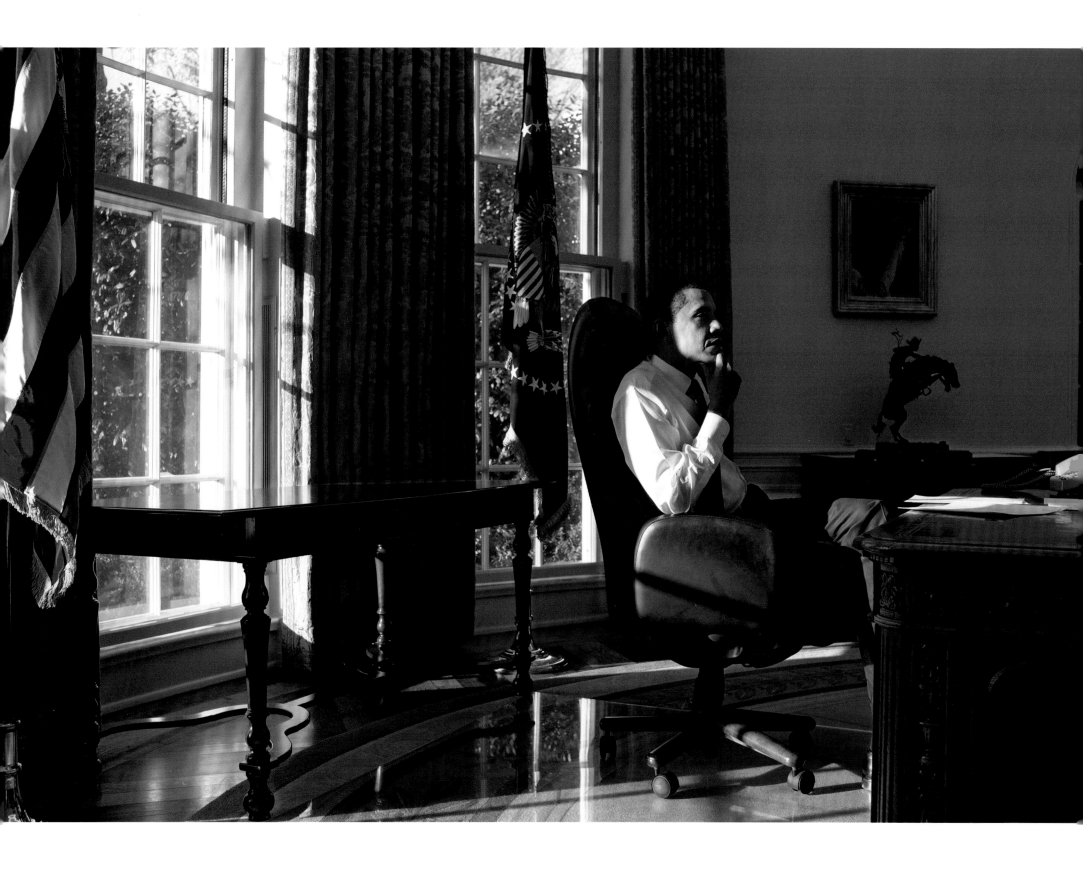

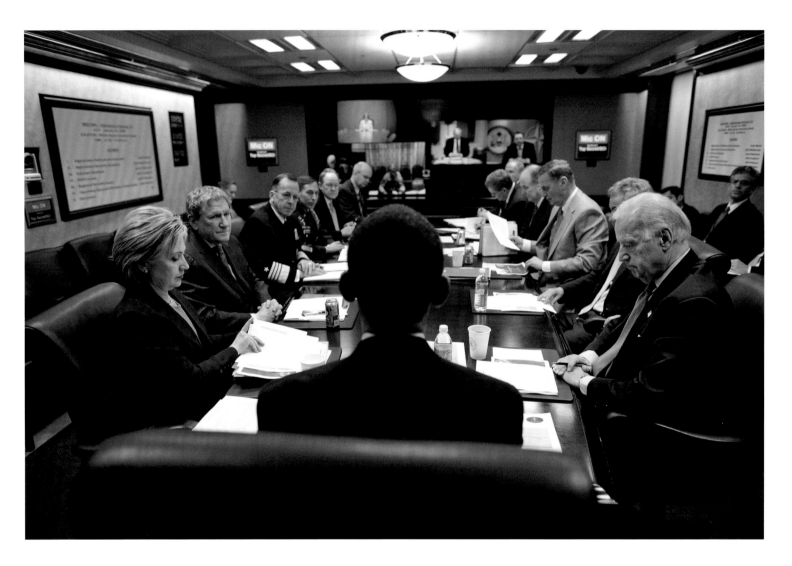

OPPOSITE: Seven hours after calling it a night, Barack Obama sat at the Resolute Desk in the Oval Office as President of the United States for the first time. *9:02 a.m., January 21, 2009*

ABOVE: Meeting in the Situation Room with his National Security team for the second time in the first three days. *January 23, 2009*

The economic crisis was the biggest challenge of the first year of his Presidency. Many of the meetings about it took place in the Roosevelt Room, just across the hall from the Oval Office. I tried to capture the President's emotion as he dealt with the issue, which was the worst financial disruption since the Great Depression. *January 29, 2009*

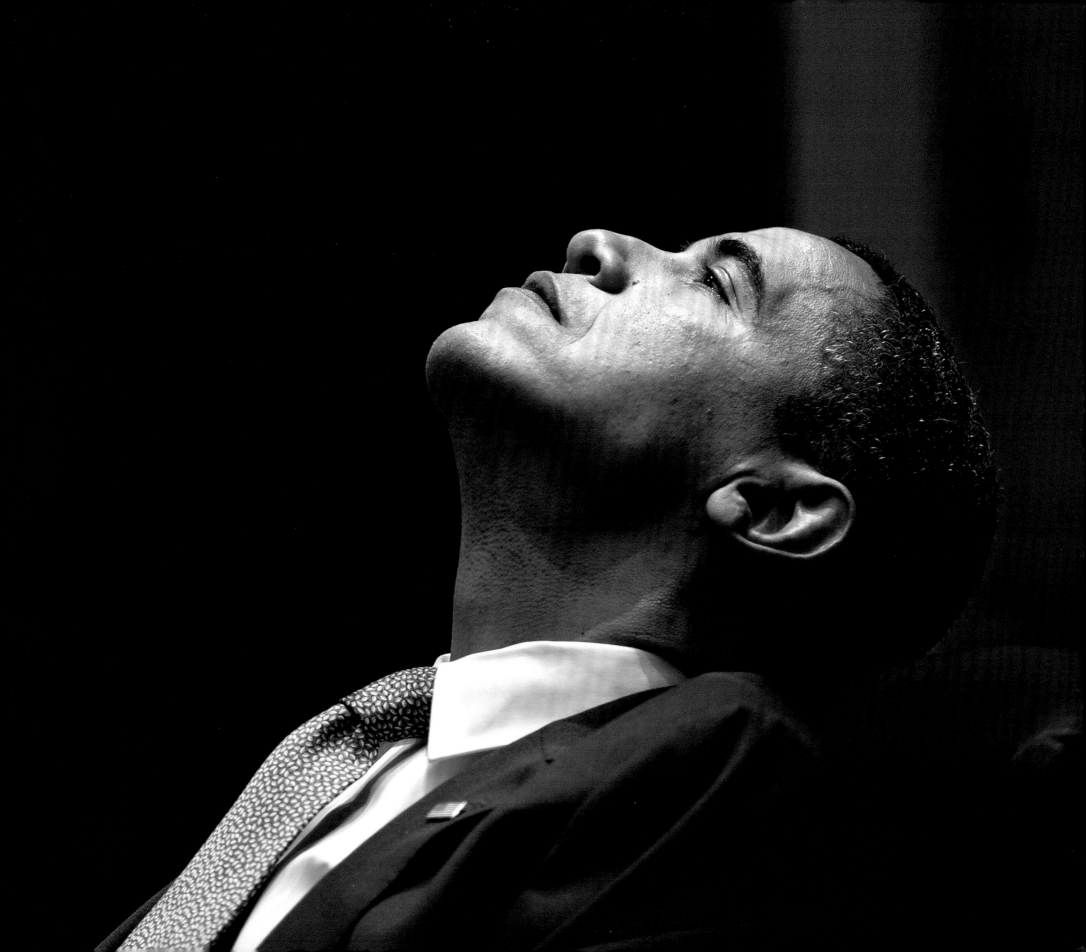

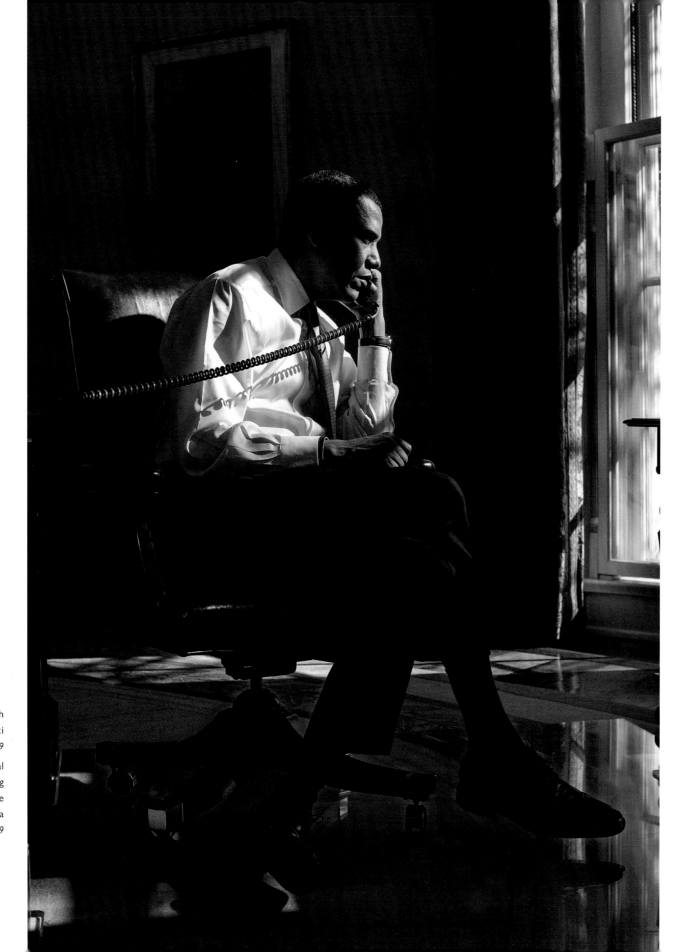

Talking on the phone with
Prime Minister Nouri al-Malaki
of Iraq. *February 2, 2009*

OPPOSITE: Watching a 3D commercial
in the family theater during
Super Bowl XLIII, between the
Pittsburgh Steelers and Arizona
Cardinals. *February 1, 2009*

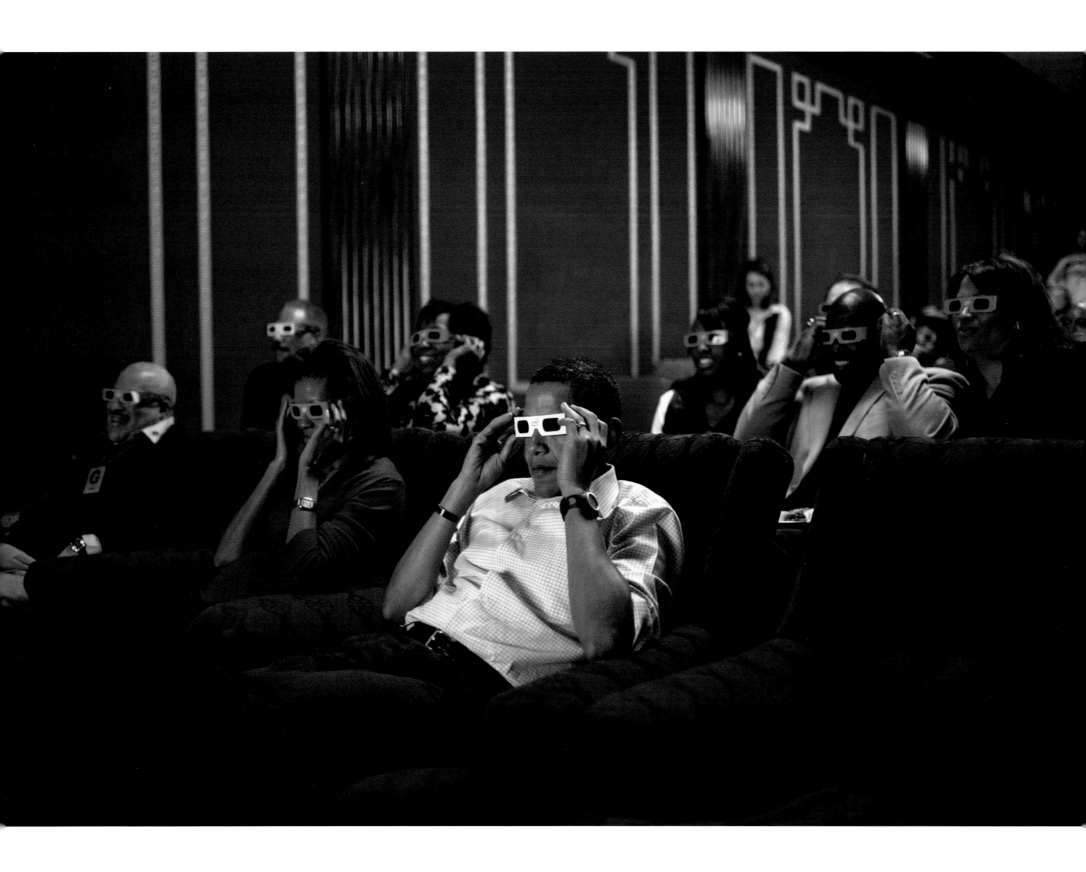

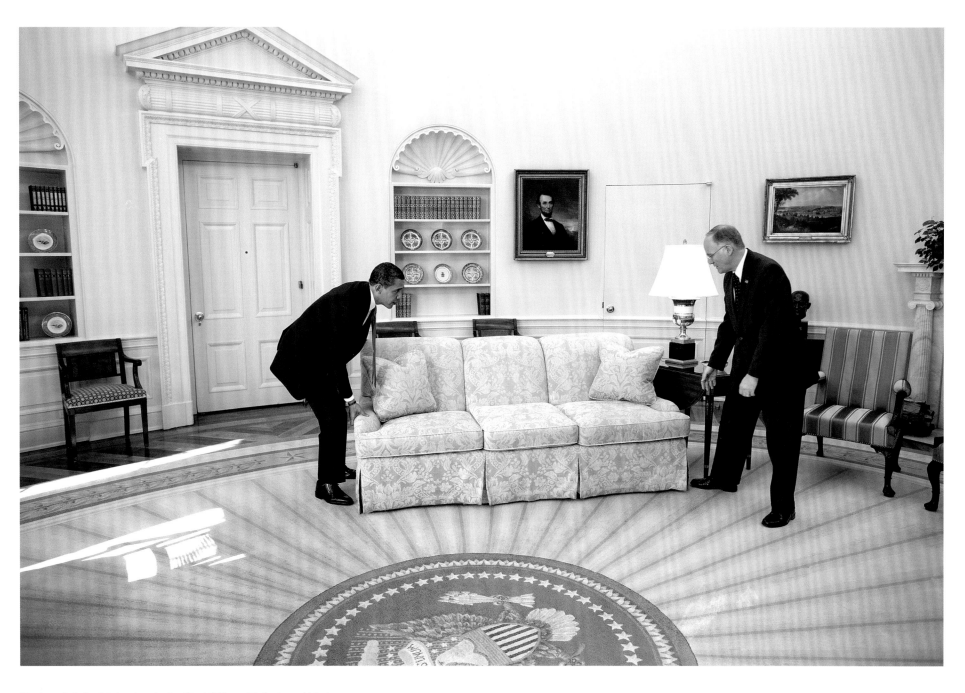

Moving a sofa back into place in the Oval Office with (not much) help
from Governor Jim Douglas of Vermont. *February 2, 2009*

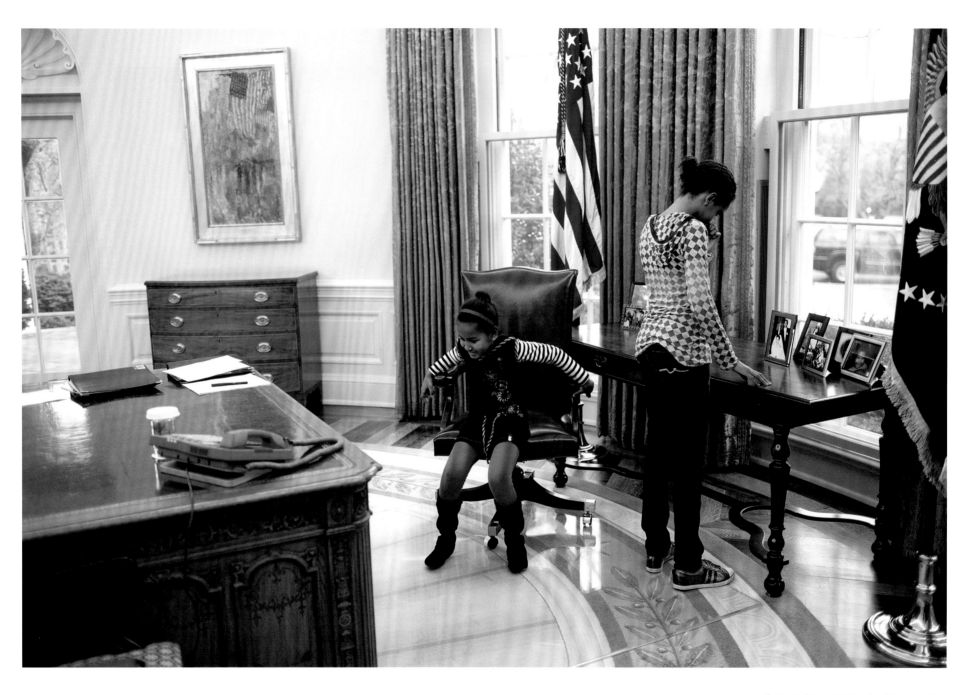

Sasha (left) and Malia checking out their
dad's new office. *February 2, 2009*

The American Recovery and Reinvestment Act, also known as
the stimulus package. I composed this shot on *Air Force One*, as we
returned from its signing in Denver. *February 17, 2009*

OPPOSITE: Dancing with the First Lady at the Governors Ball in the
East Room and singing along with the legendary band Earth, Wind &
Fire—who were performing directly behind me. *February 22, 2009*

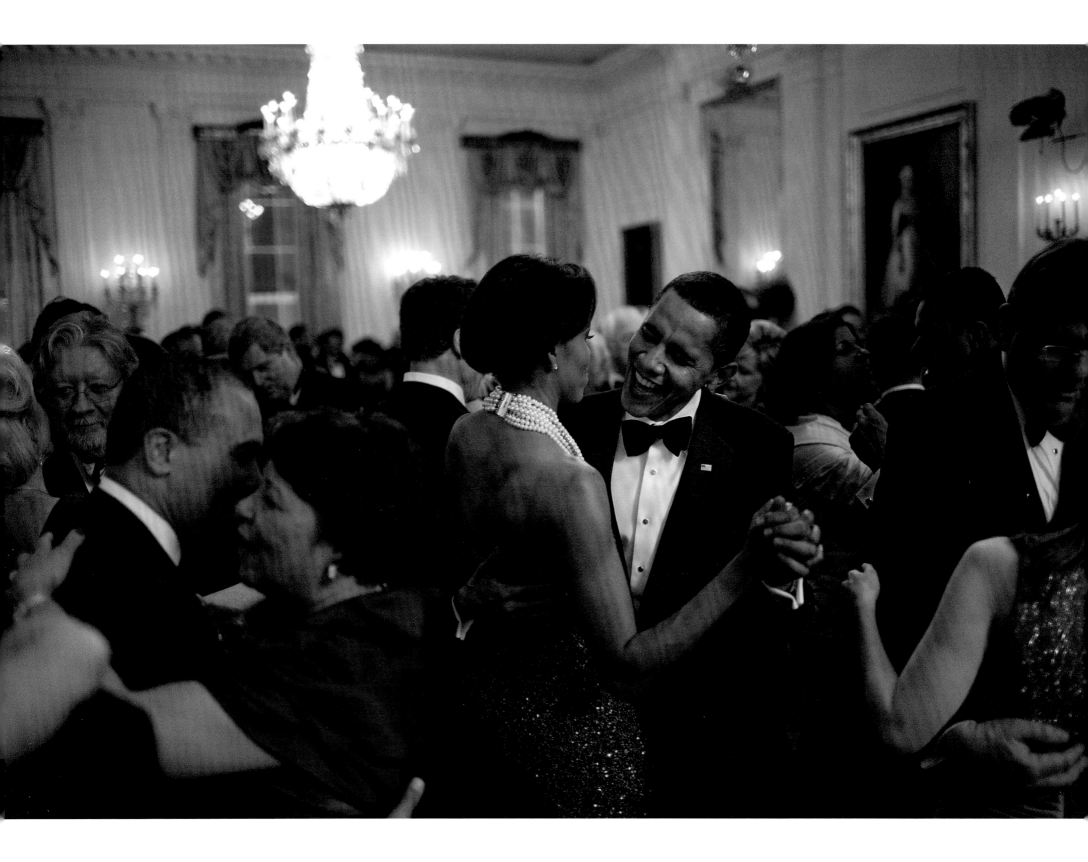

First speech to a joint session of Congress. *February 24, 2009*

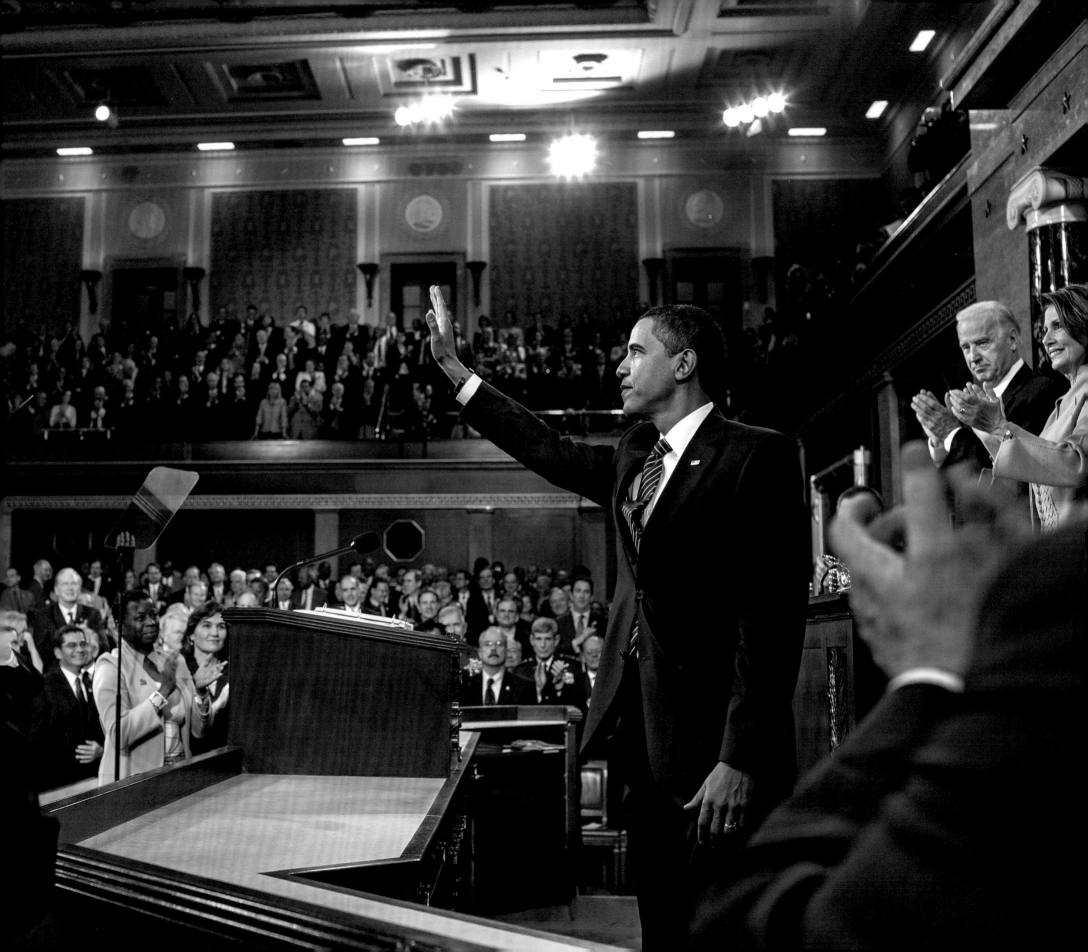

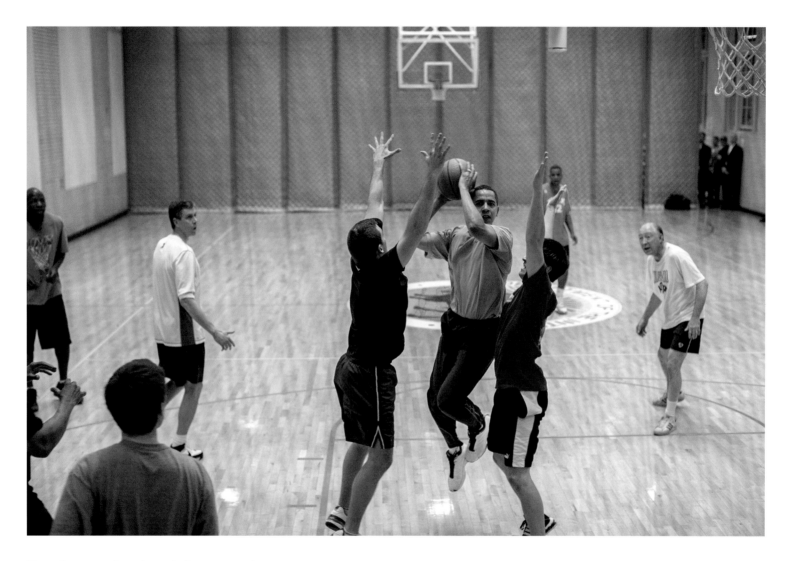

Playing hoops on a Saturday at the Department of
Interior gymnasium. *February 28, 2009*

OPPOSITE: The President once told me that he got
a lot of thinking done on the Colonnade connecting the
residence to the West Wing. *February 26, 2009*

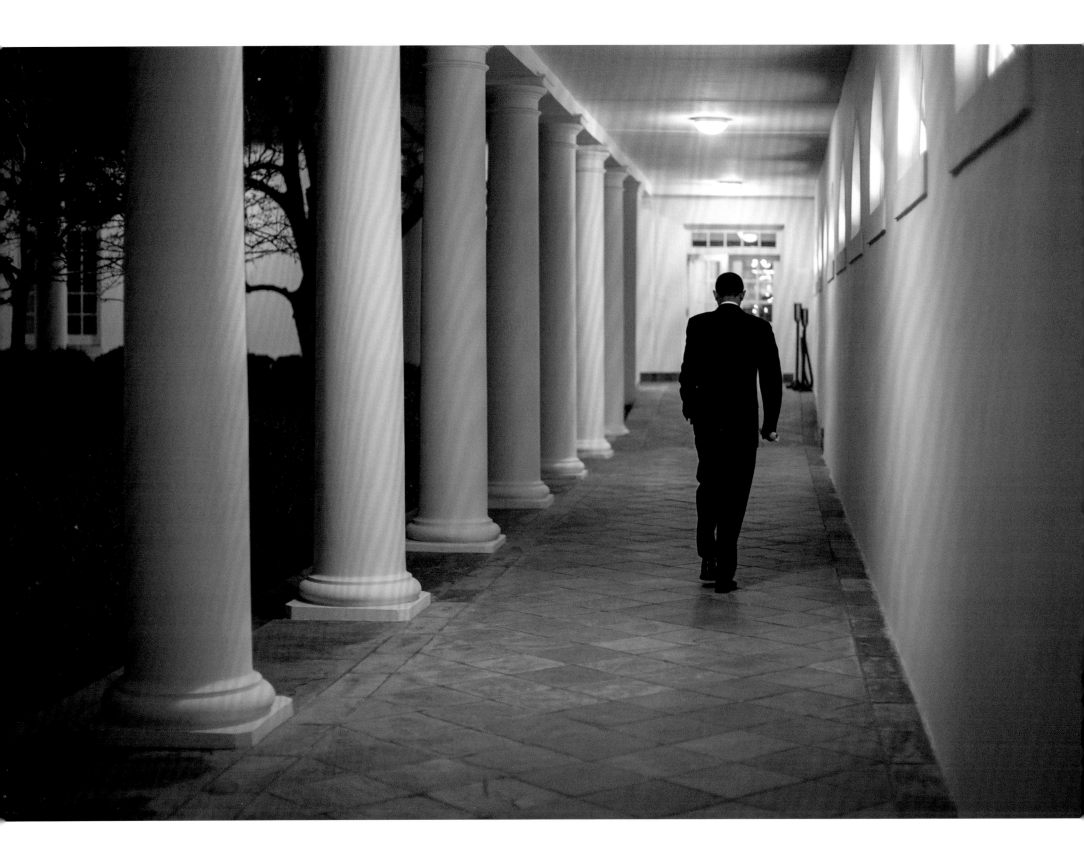

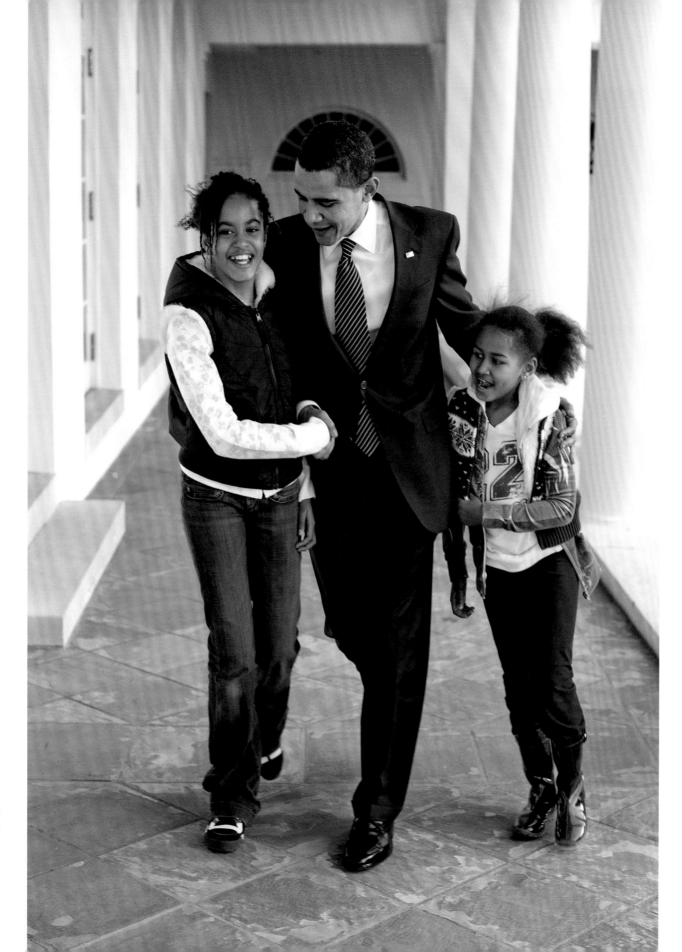

Running into the girls on the Colonnade after school. *March 5, 2009*

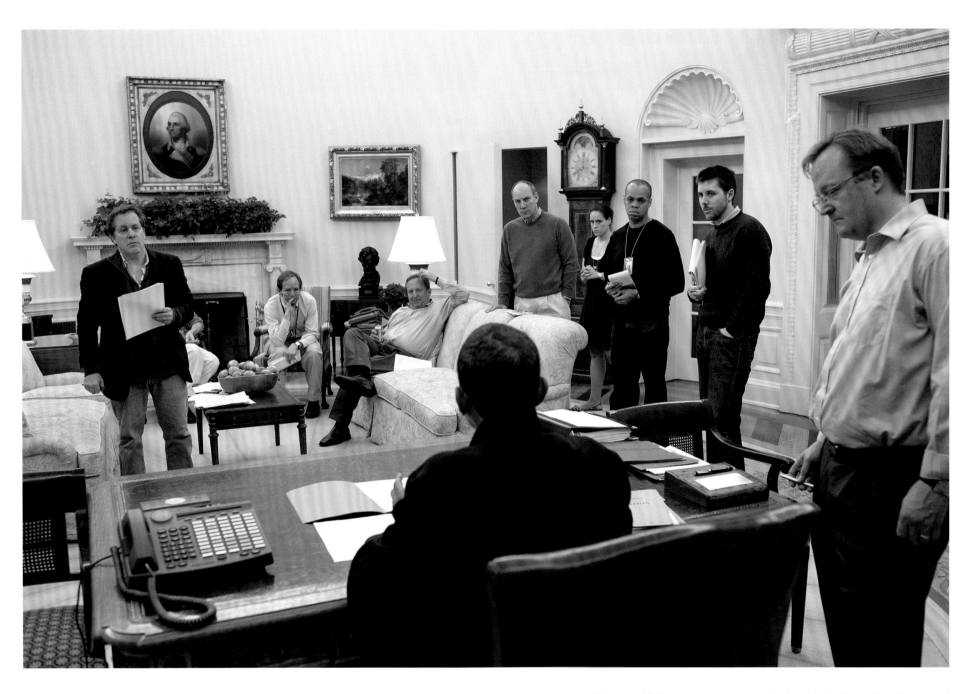

Meeting with his economic team on a Sunday night, before calling the heads of General Motors and Chrysler to tell them the government was effectively taking over their companies. Though the decision was unpopular at the time, the bailout saved the auto industry. *March 29, 2009*

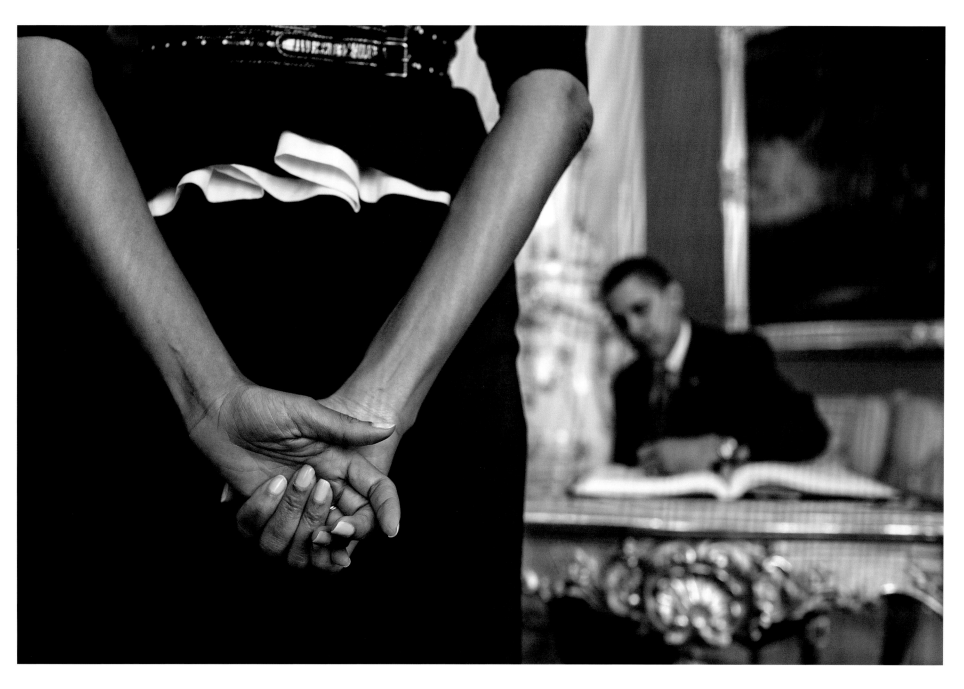

With the First Lady at Prague Castle, in the Czech Republic. *April 5, 2009*

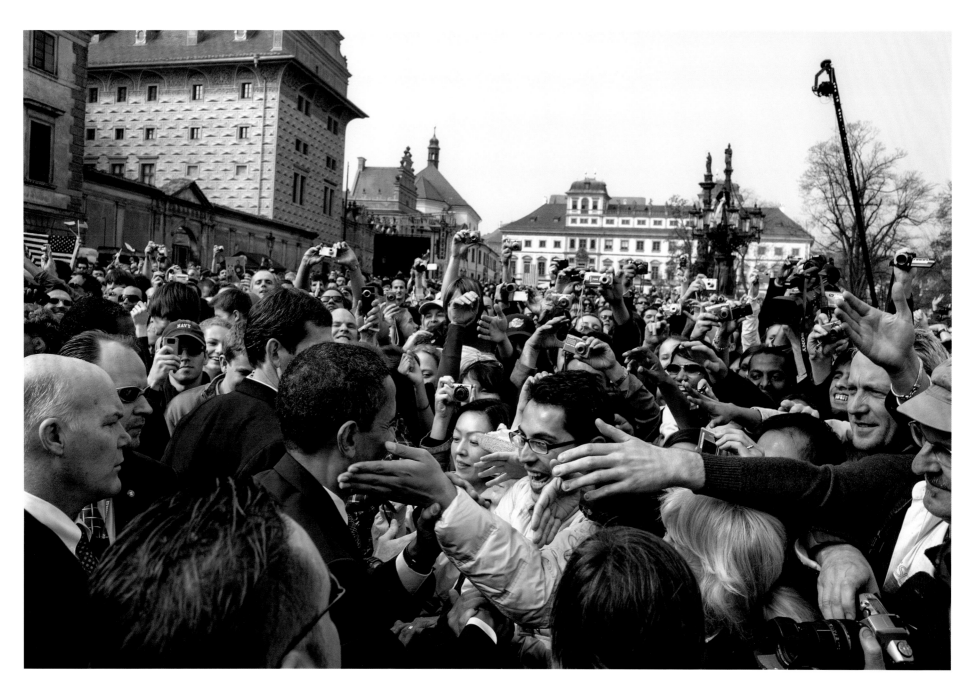

Embraced by the crowd following his speech in
Prague's Hradčany Square. *April 5, 2009*

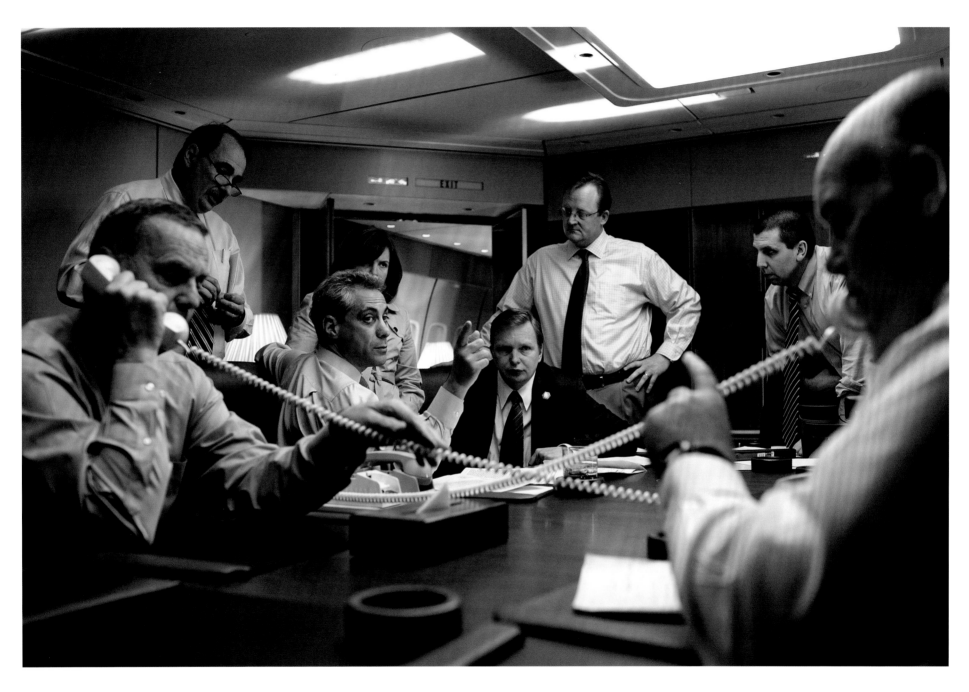

Aboard *Air Force One*, senior staff and Secret Service agent Joe Clancy, far right, coordinating the security details for an unscheduled visit to Iraq. *April 7, 2009*

OPPOSITE: Speaking to U.S. troops at Camp Victory, in Baghdad. *April 7, 2009*

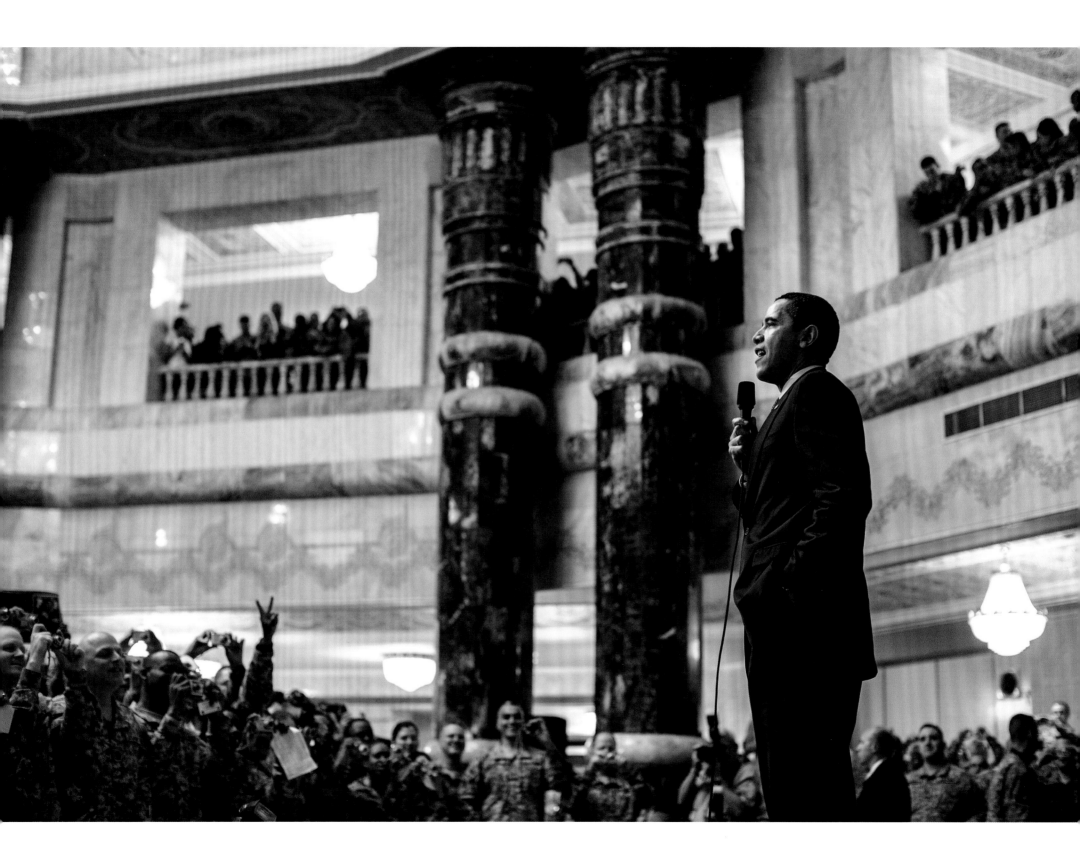

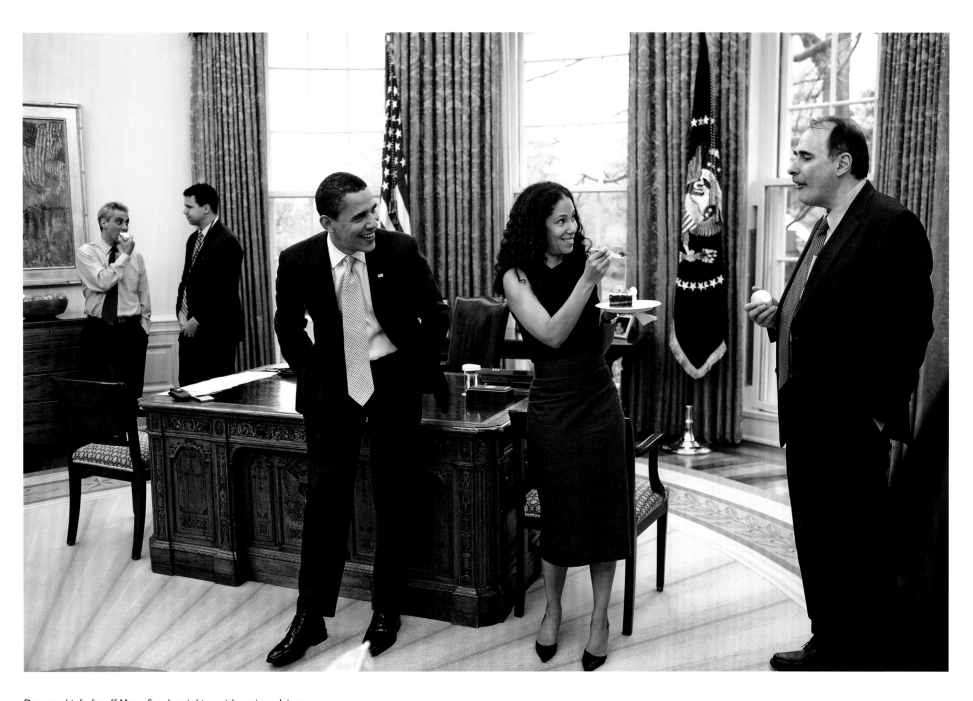

Deputy chief of staff Mona Sutphen joking with senior advisor
David Axelrod; staff had gathered to celebrate
senior advisor Pete Rouse's birthday. *April 15, 2009*

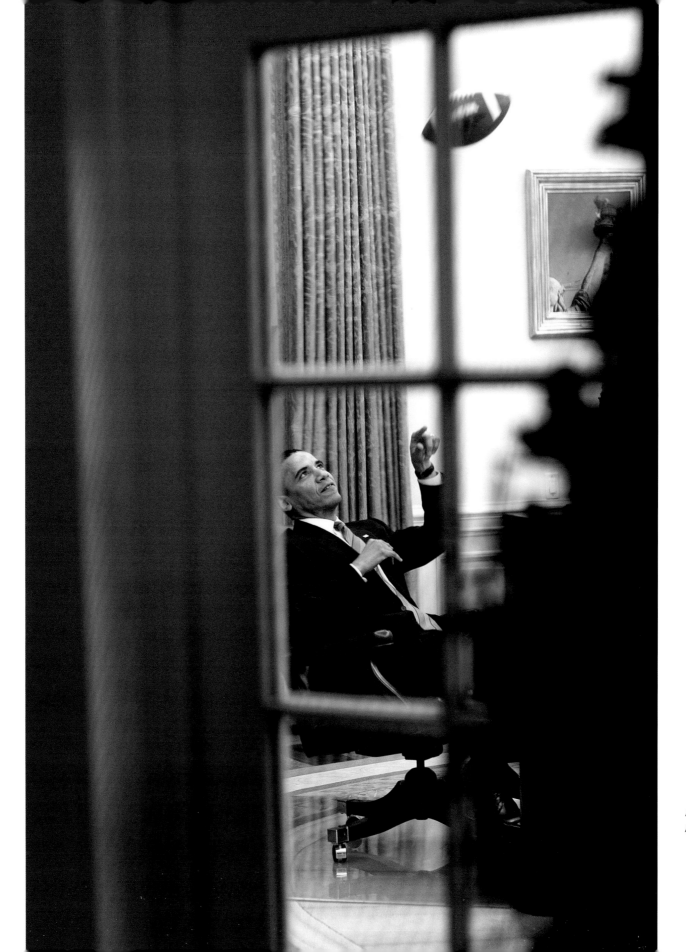

A late night in the Oval.
April 23, 2009

HAIR LIKE MINE

Part of my job as White House photographer was taking the obligatory family photograph, usually when a staff person was leaving the White House. We referred to them as departure photos. The President would invite the staff member and his or her family into the Oval Office, and I would snap a posed photograph in front of the Resolute Desk. I called it brainless photography. But while these shots did not mean much to me as a photographer, I knew they meant everything to the family. The President often would chat with family members after the formal picture was taken. Such was the case when Carlton Philadelphia, a career nonpolitical member of the National Security staff, was leaving the White House to move on to his next post. After posing with the President, each of Carlton's sons said they had a question. Jacob, five, had a simple one. He wanted to know if the President's hair felt just like his. "Why don't you see for yourself," the President replied. He bent over and Jacob felt the President's head. It happened so fast, I clicked just one picture. Compositionally, the photograph is not ideal. But I did manage to freeze the moment at just the precise second. Later, when I saw the picture blown up, I knew it was special. But until we hung it on the walls of the West Wing, I didn't realize the reaction it would receive. The White House staff loved it. Although we rotated out pictures every few weeks, we kept this one hanging in the same spot for three years, which eventually caught the attention of *New York Times* reporter Jackie Calmes in 2012. She tracked down the Philadelphia family, wrote a poignant story, and brought renewed attention to the photograph. Sometime in the beginning of the second term, I finally took it down from the West Wing. But that week, several members of the White House staff independently approached me and asked me to consider hanging it back up. When they gave friends and family a West Wing tour, they said, the photograph and the story behind it had become the most important stop. So back up it went and remained in the West Wing until the final days of the Obama administration. *May 8, 2009*

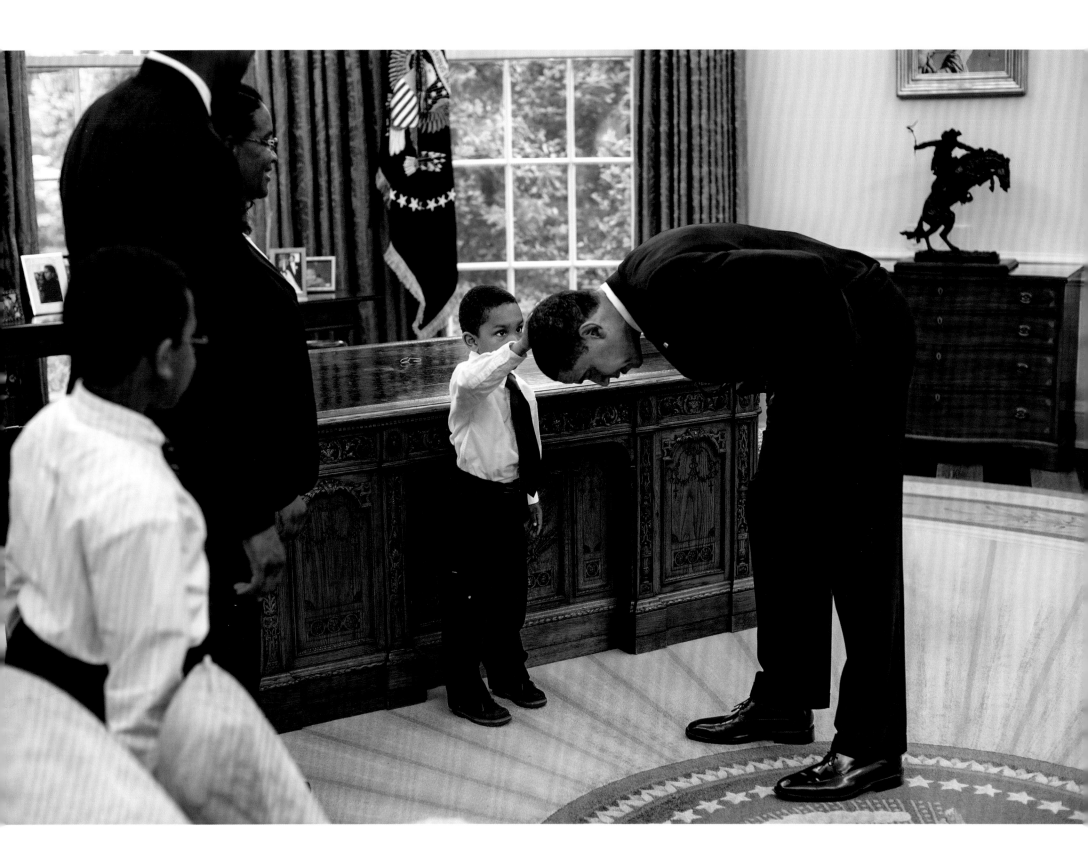

2

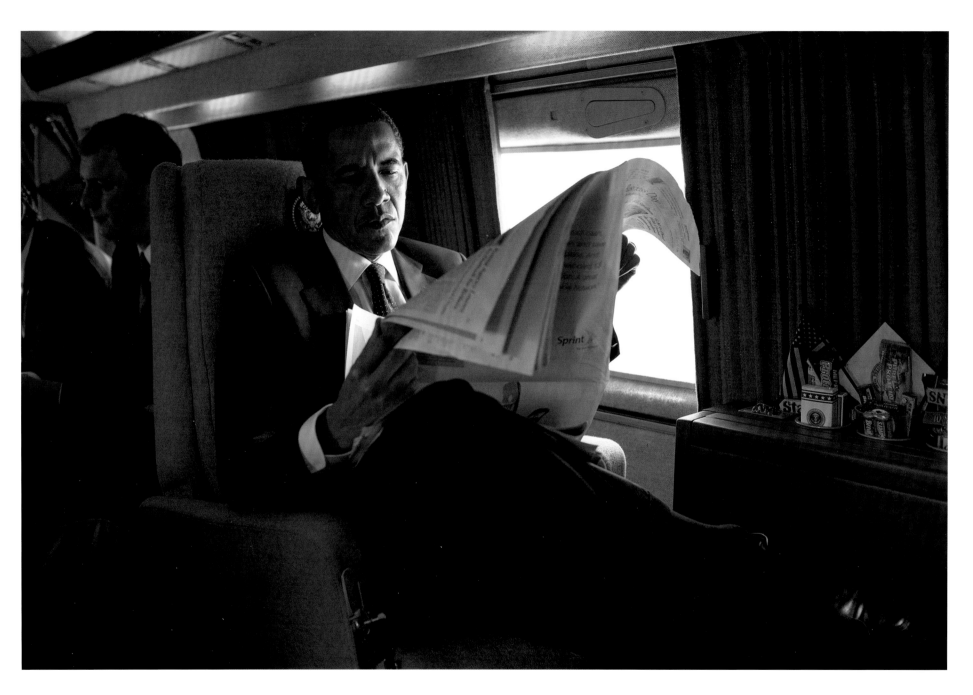

En route to the Naval Academy commencement aboard
the *Marine One* helicopter. *May 22, 2009*

With senior advisors after moving a meeting from the Oval Office
to the Rose Garden on a warm spring day. *May 20, 2009*

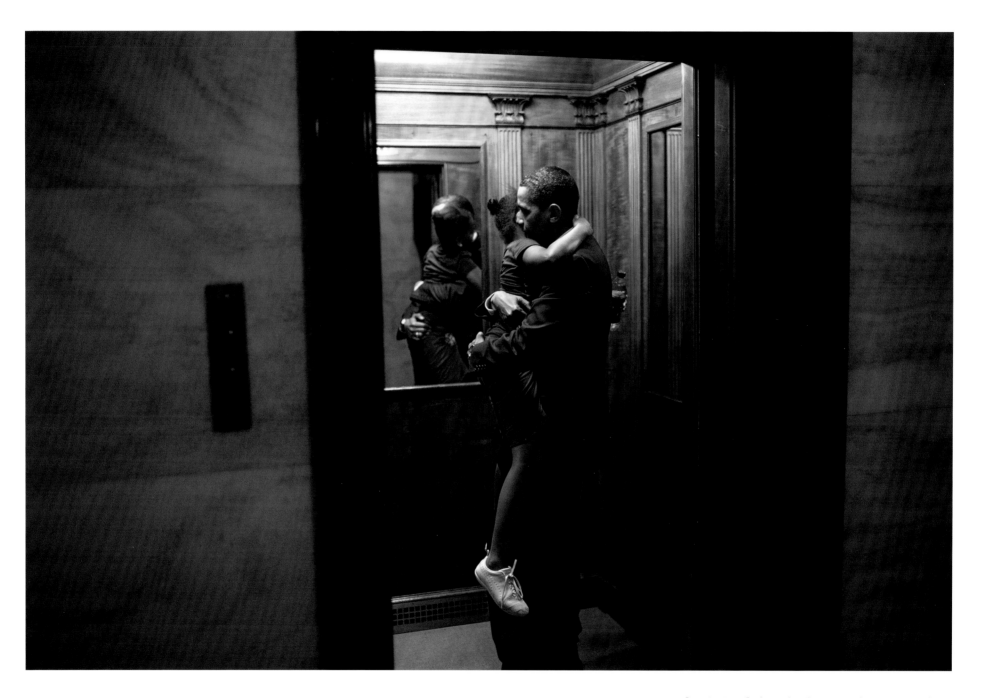

Running into Sasha in the elevator to the private residence
as she returned home from school. *May 19, 2009*

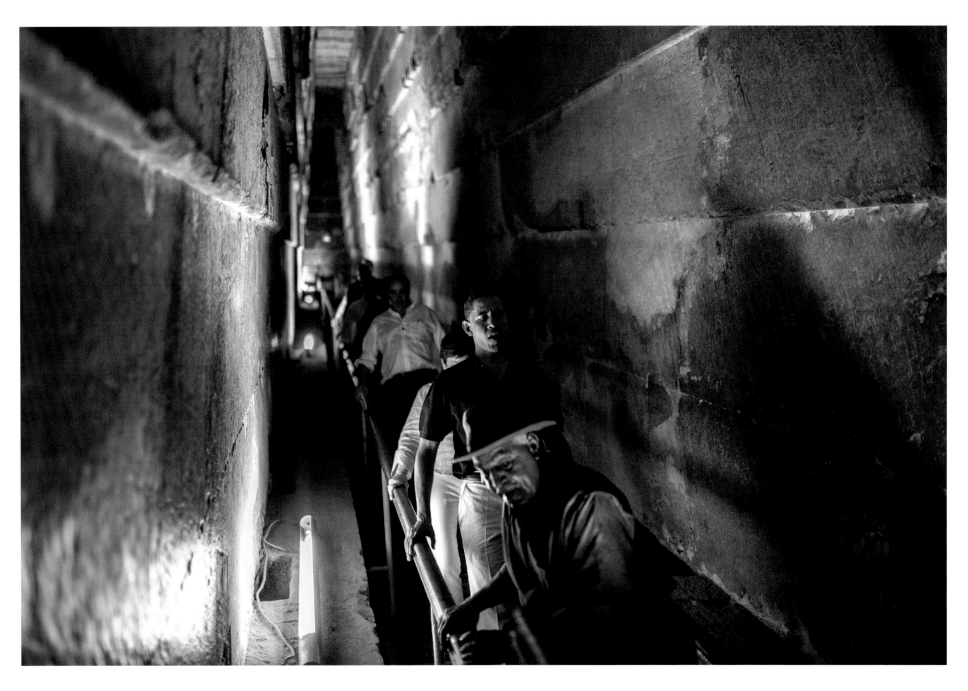

Inside the Great Pyramid of Giza, near Cairo, Egypt. *June 4, 2009*

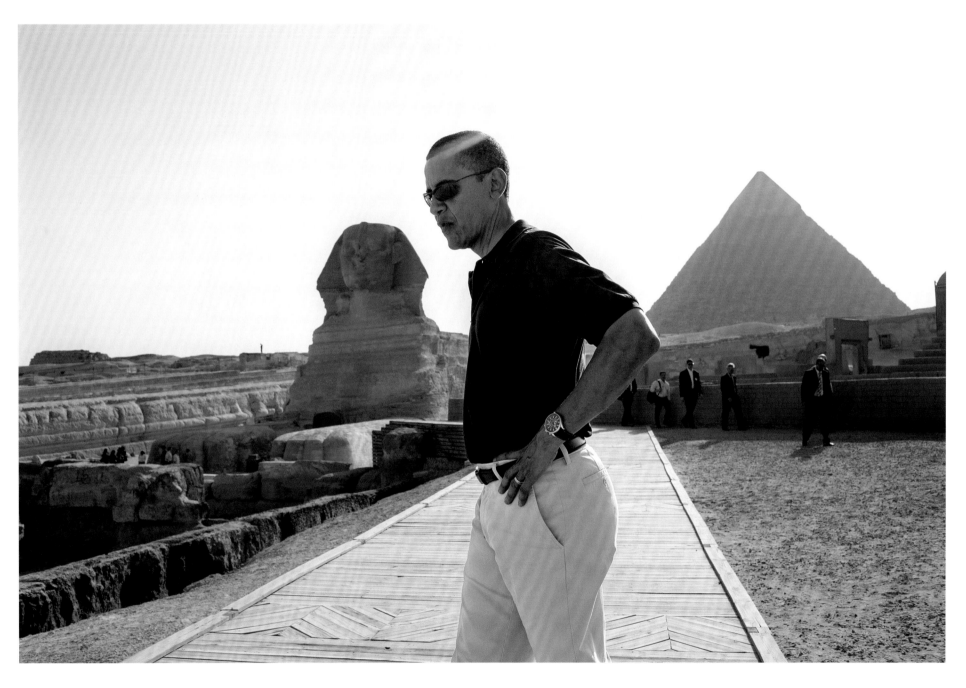

Visiting the Sphinx and the Great Pyramid of Giza. In his first trip to a predominantly Muslim country, the President also delivered a speech titled "A New Beginning" at Cairo University. *June 4, 2009*

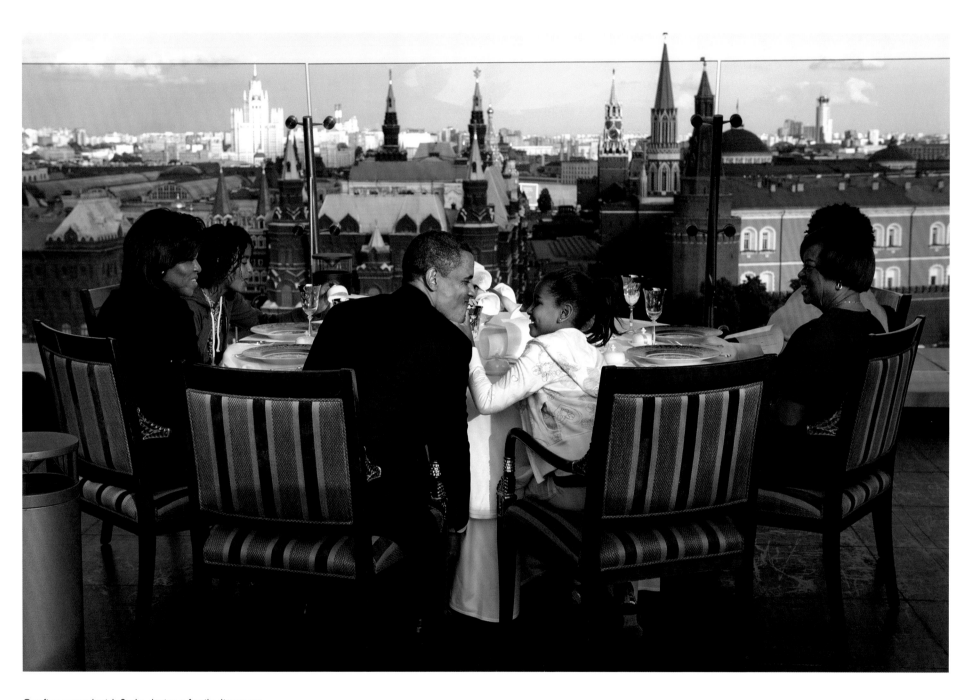

Goofing around with Sasha during a family dinner on
the roof of the Ritz-Carlton hotel in Moscow, Russia. *July 7, 2009*

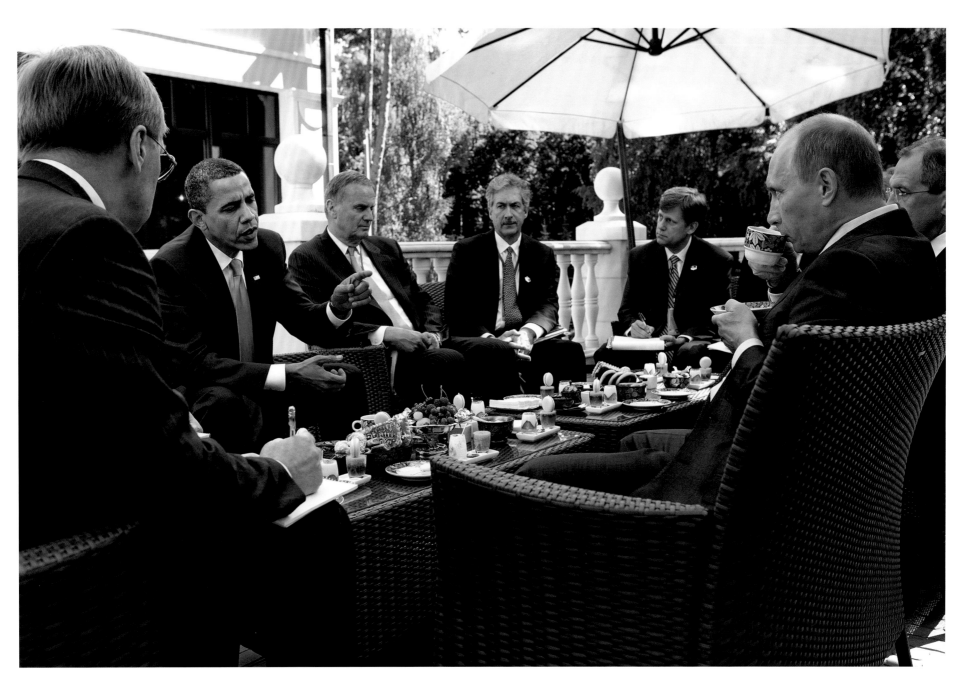

Meeting for the first time with then–Prime Minister
Vladimir Putin at his dacha outside Moscow. *July 8, 2009*

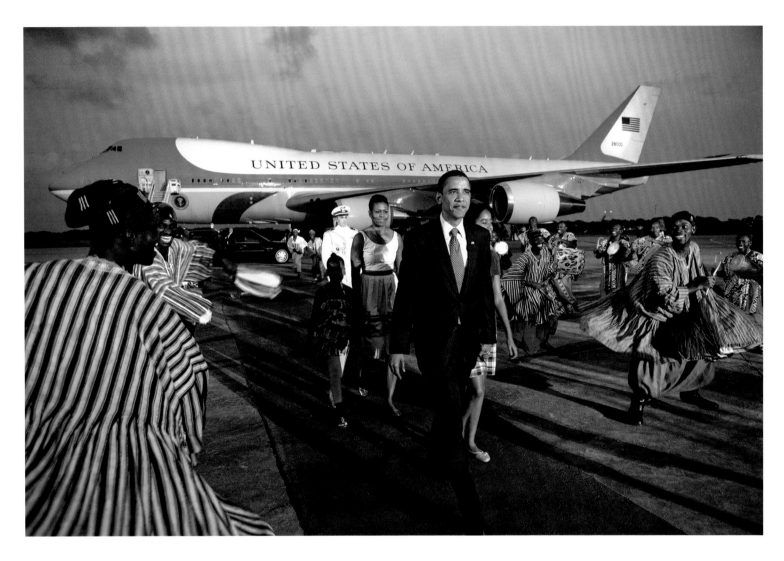

With the First Family at Accra airport, Ghana. *July 11, 2009*

OPPOSITE: Waving farewell following his speech there. *July 11, 2009*

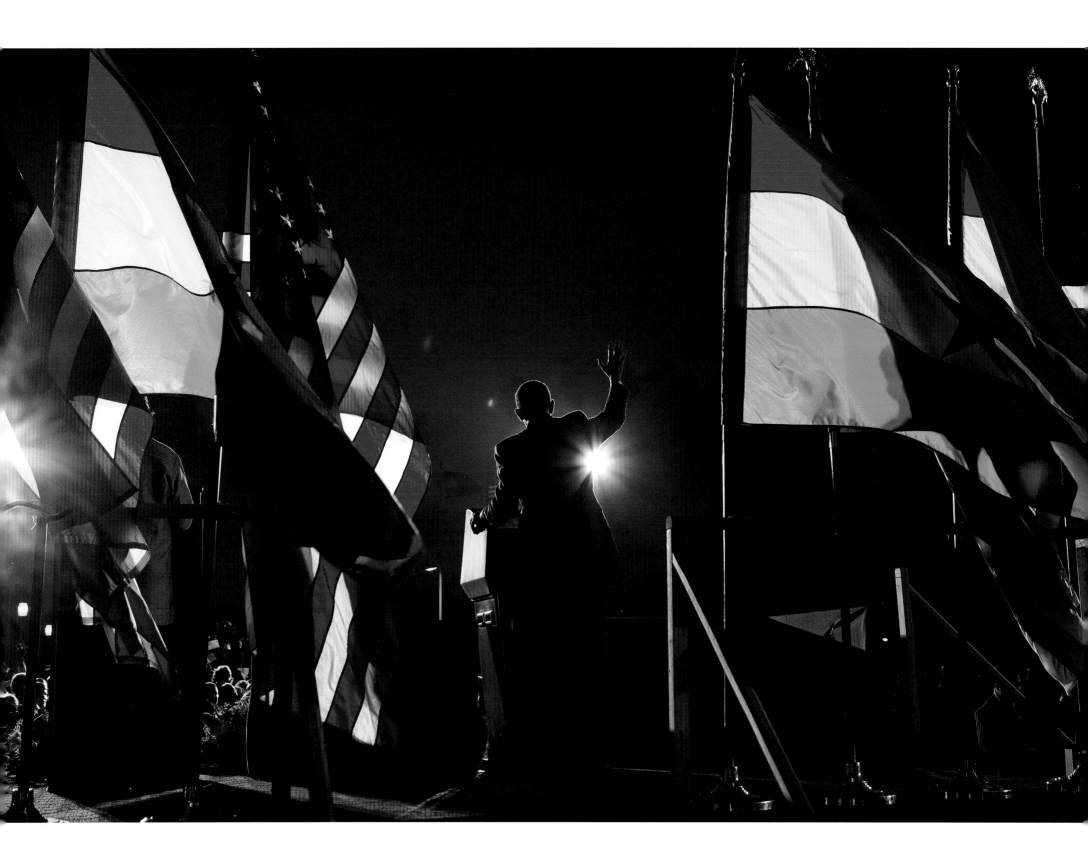

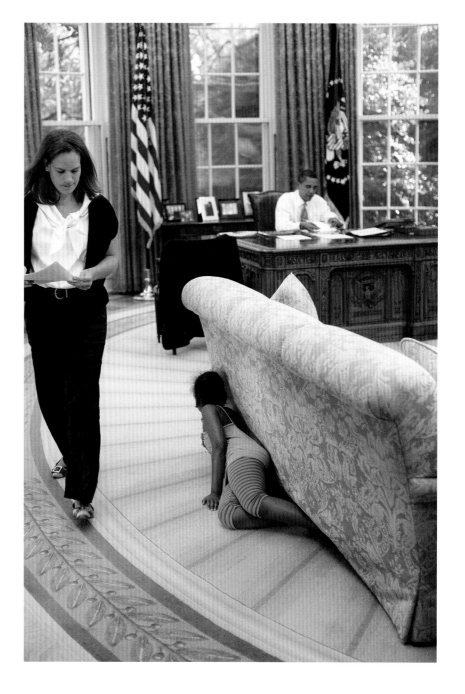

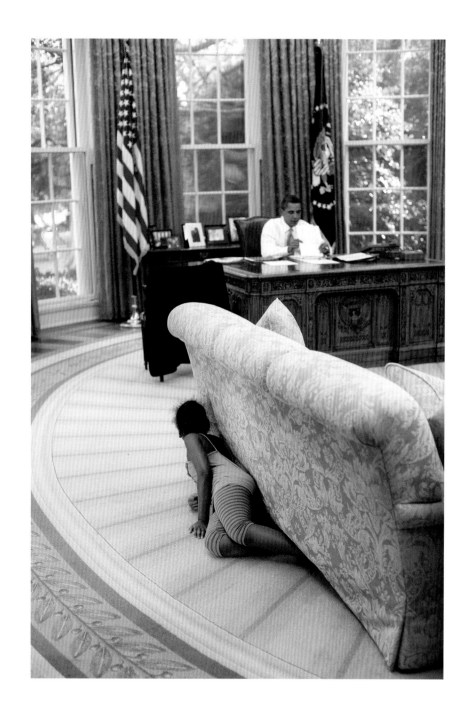

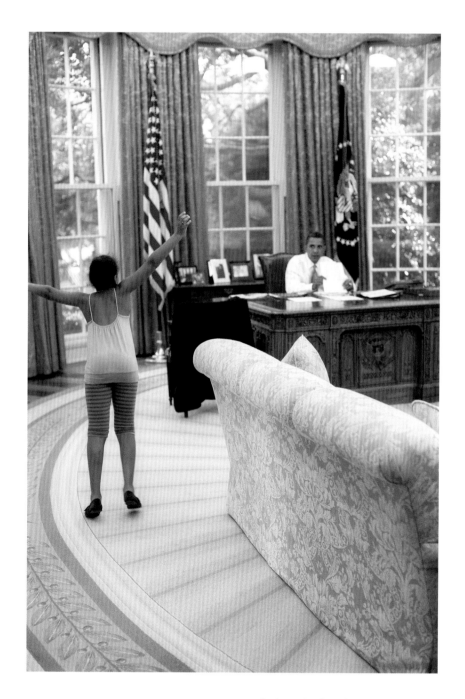

Sasha in the Oval Office. *August 5, 2009*

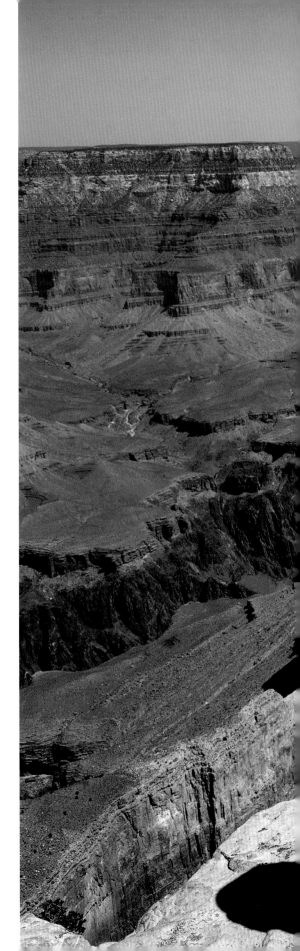

On a family trip to the Grand Canyon, in Arizona. *August 16, 2009*

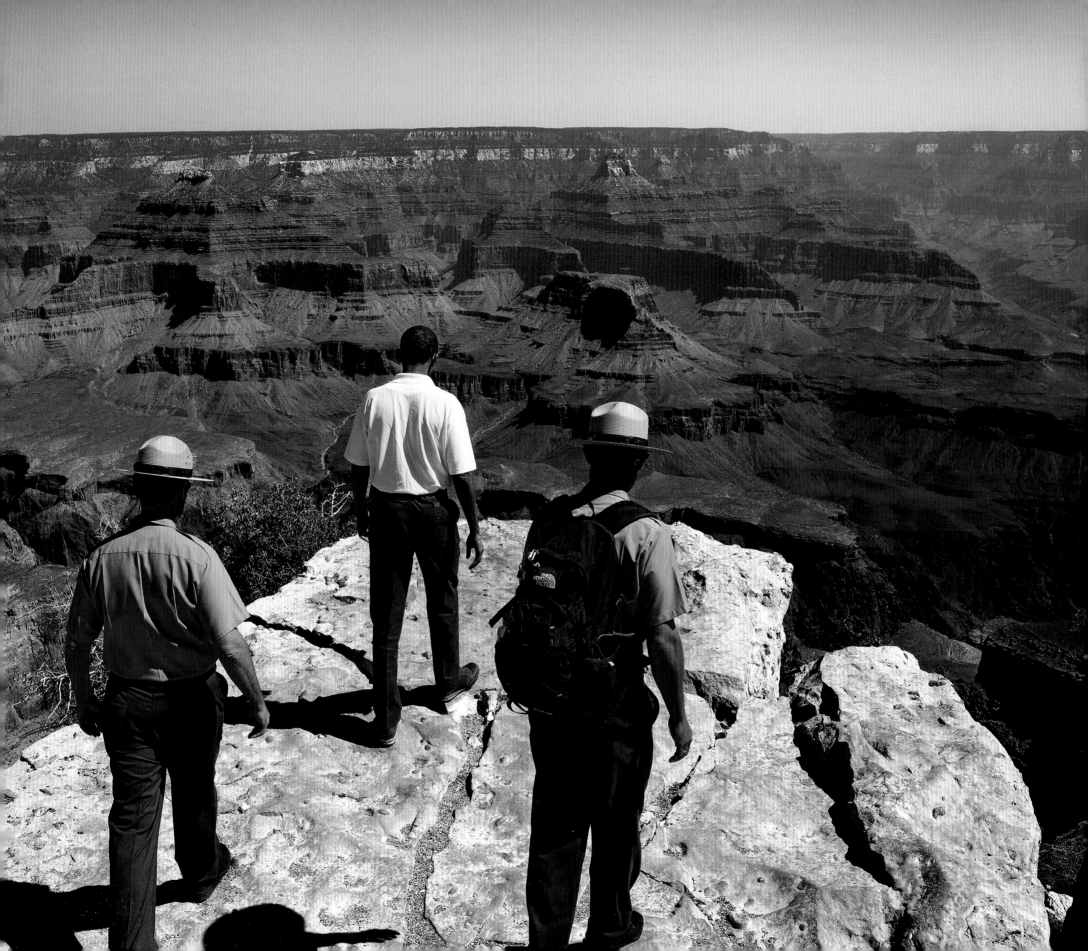

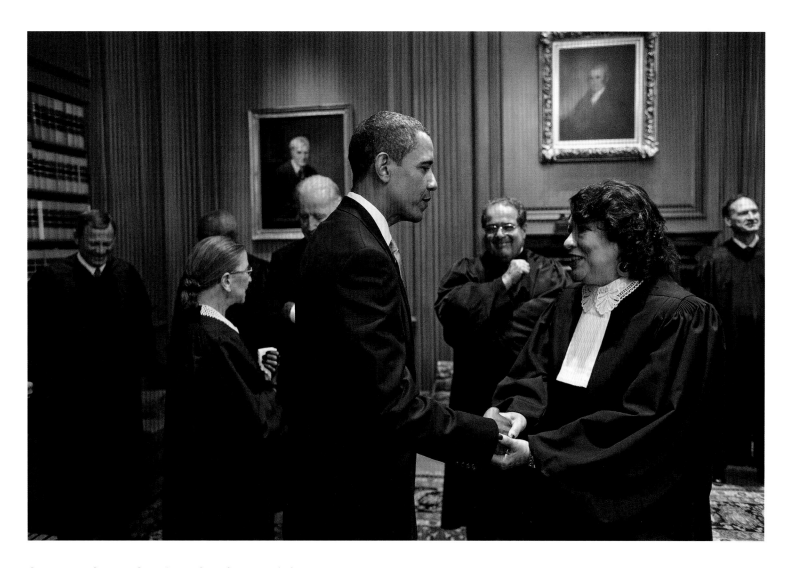

Greeting new Supreme Court Justice Sonia Sotomayor before
her investiture ceremony at the court. *September 8, 2009*

Talking policy with legislative aide Phil Schiliro while press secretary
Robert Gibbs horses around with "body man" Reggie Love. *September 1, 2009*

Editing a speech on health care with
Jon Favreau. *September 9, 2009*

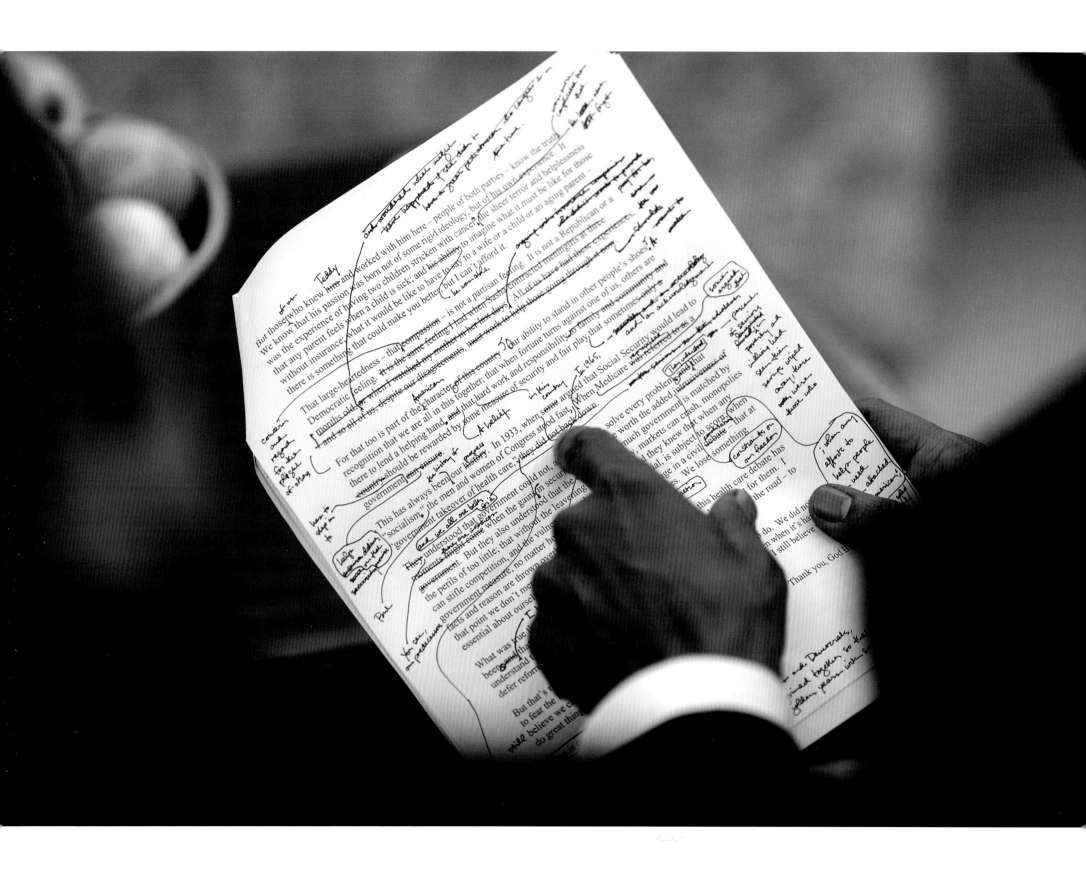

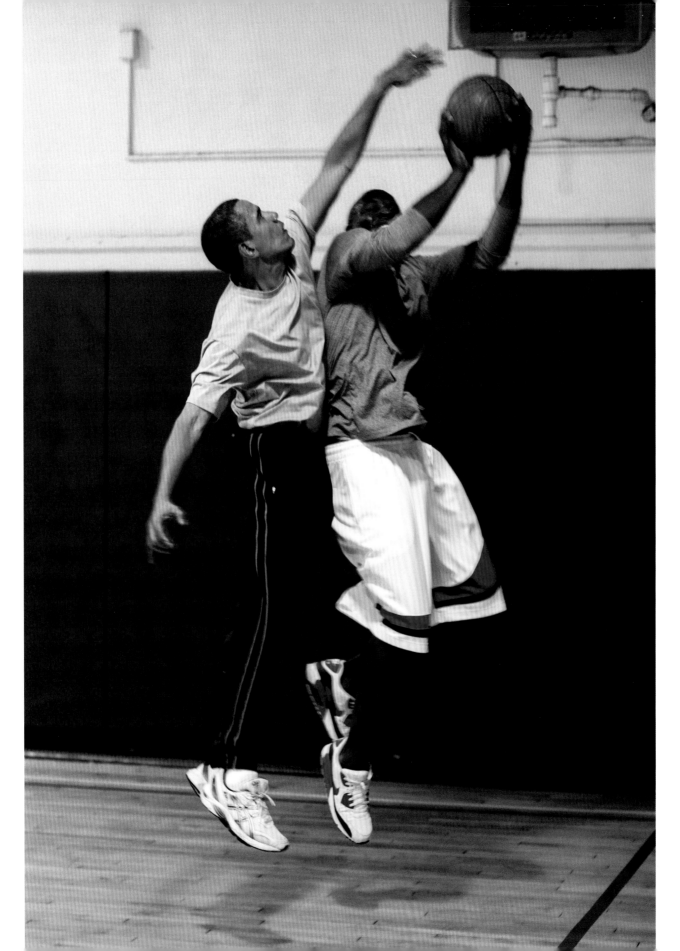

An intense game of one-on-one with personal aide Reggie Love in New York, a few hours after speaking to the United Nations General Assembly. The President was so proud of his blocked shot that he made Reggie sign an enlargement of the picture. Reggie's inscription: "Mr. President, nice block—Reggie Love."

OPPOSITE: That night, around 10 p.m., with National Security Chief of Staff Denis McDonough at the Waldorf Astoria, in New York. *September 23, 2009*

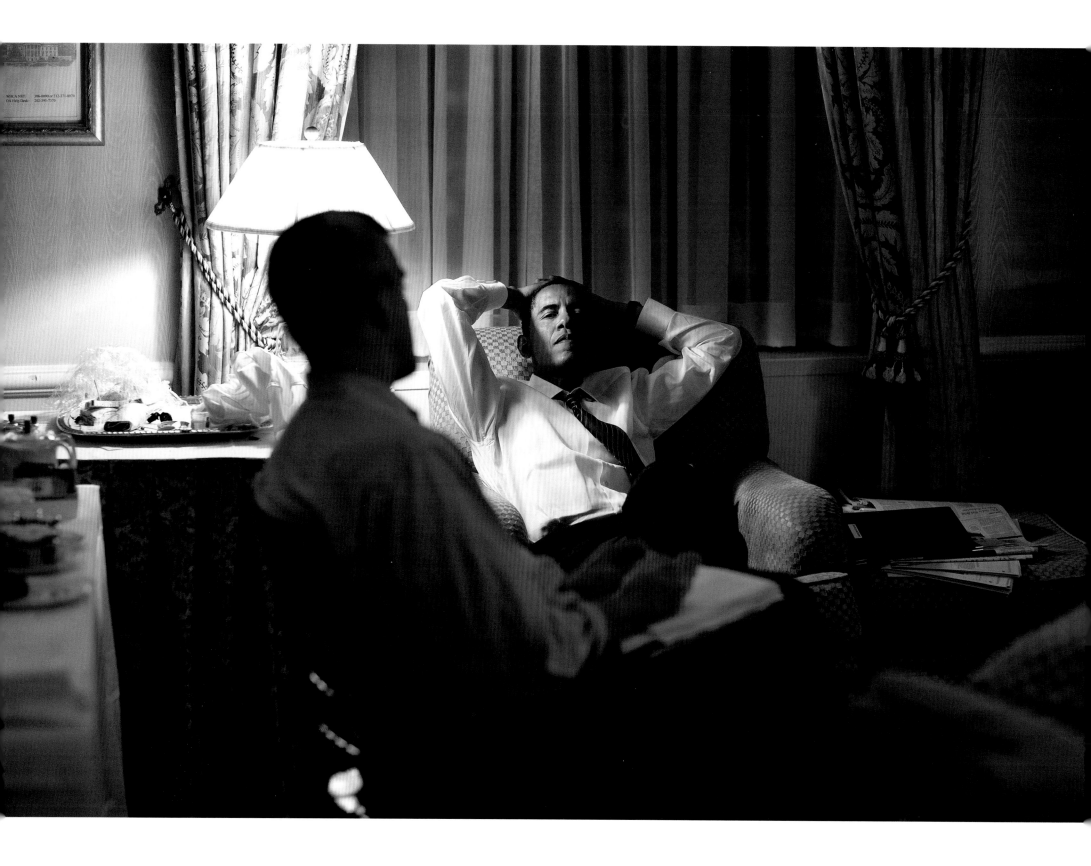

A detail of the Resolute Desk in the Oval Office, where the President
kept his morning paperwork. *October 5, 2009*

OPPOSITE: Being congratulated by the residence staff after winning
the Nobel Peace Prize. *October 9, 2009*

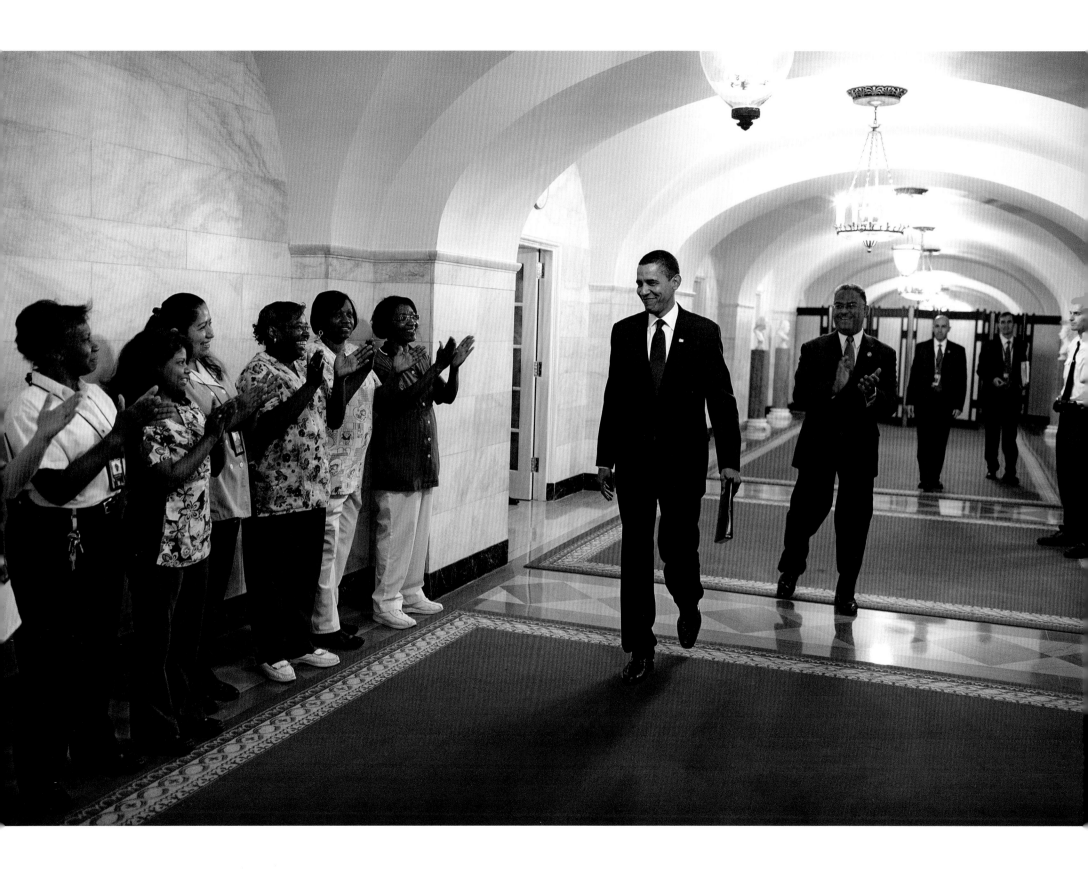

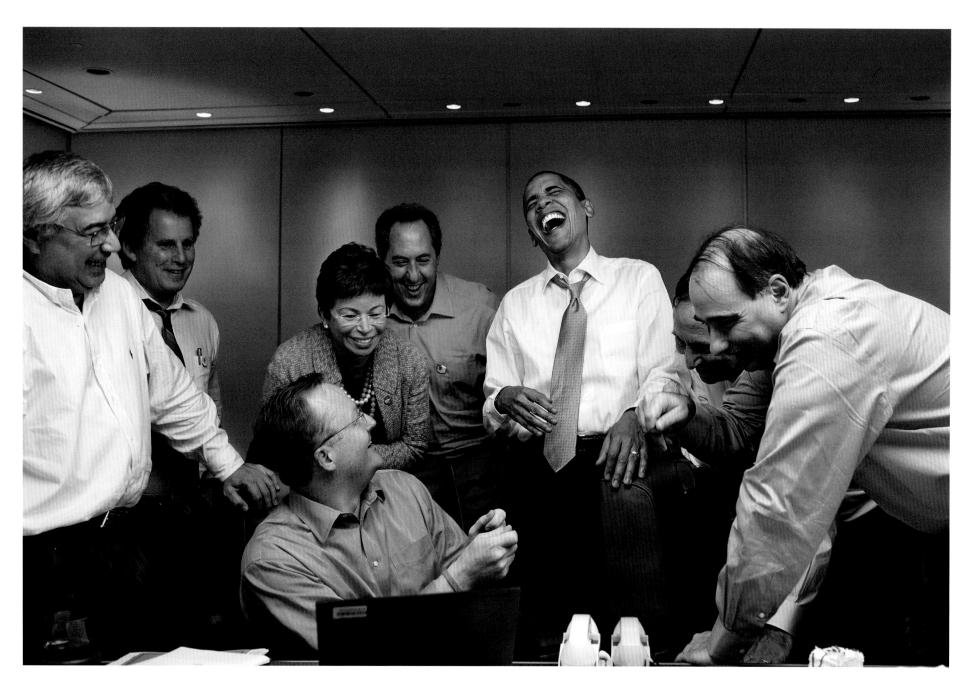

On *Air Force One*, flying to the Association of Southeast Asian
Nations (ASEAN) summit in Singapore. Robert Gibbs had pulled up
photographs of the colorful batik shirts that previous
Presidents had worn to the event in past years. *November 14, 2009*

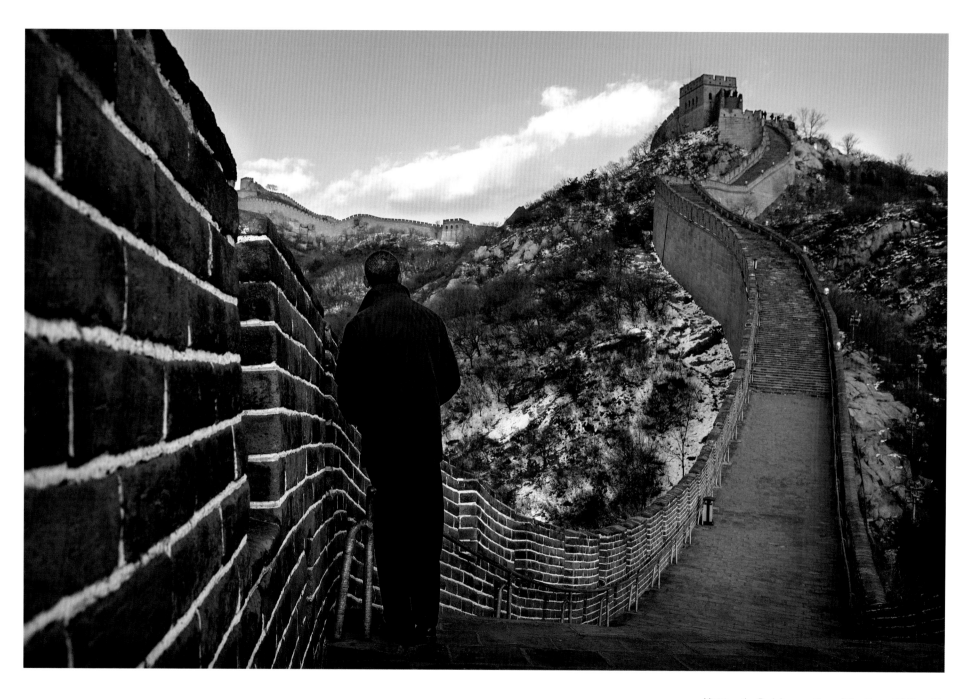

Visiting the Badaling section of the Great Wall on his
first trip to China as President. *November 18, 2009*

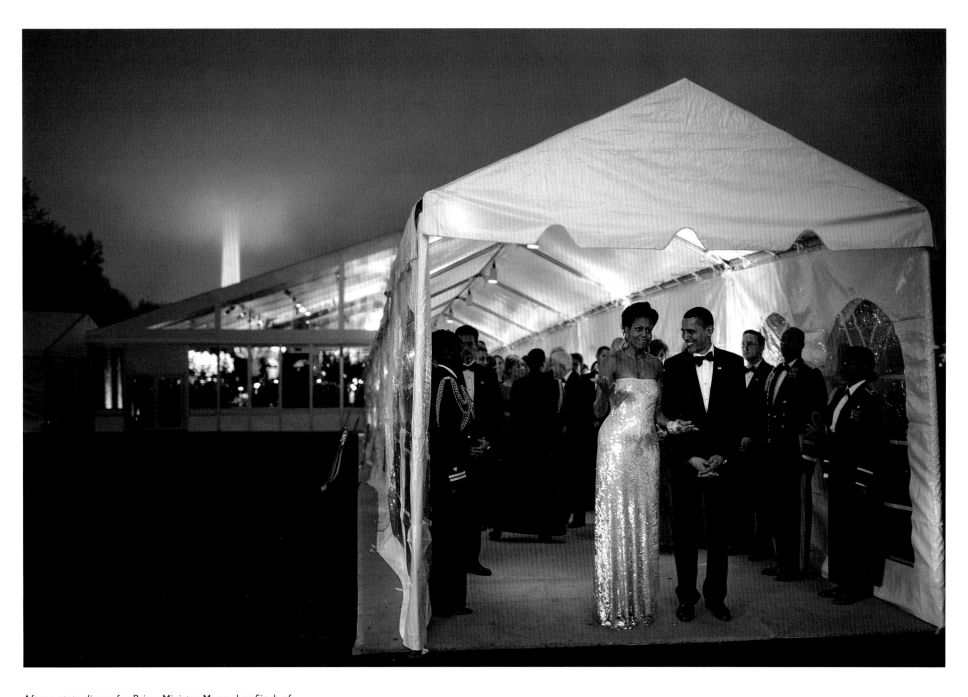

After a state dinner for Prime Minister Manmohan Singh of
India, on the South Grounds of the White House. *November 24, 2009*

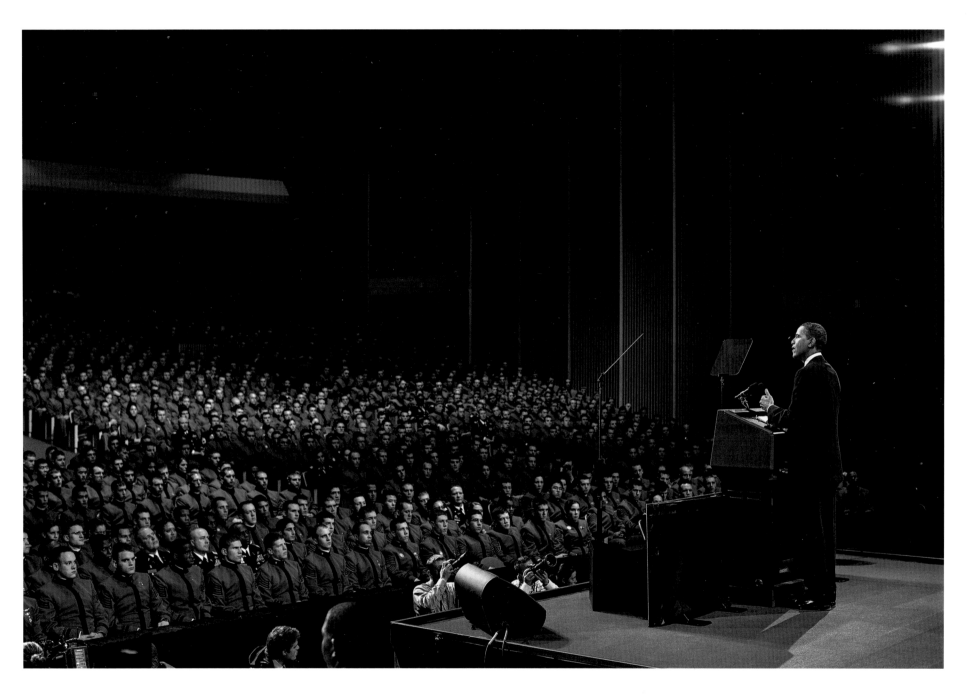

Announcing his decision to send 30,000 more U.S. troops to Afghanistan during a speech to West Point cadets, many of whom would eventually be deployed. *December 1, 2009*

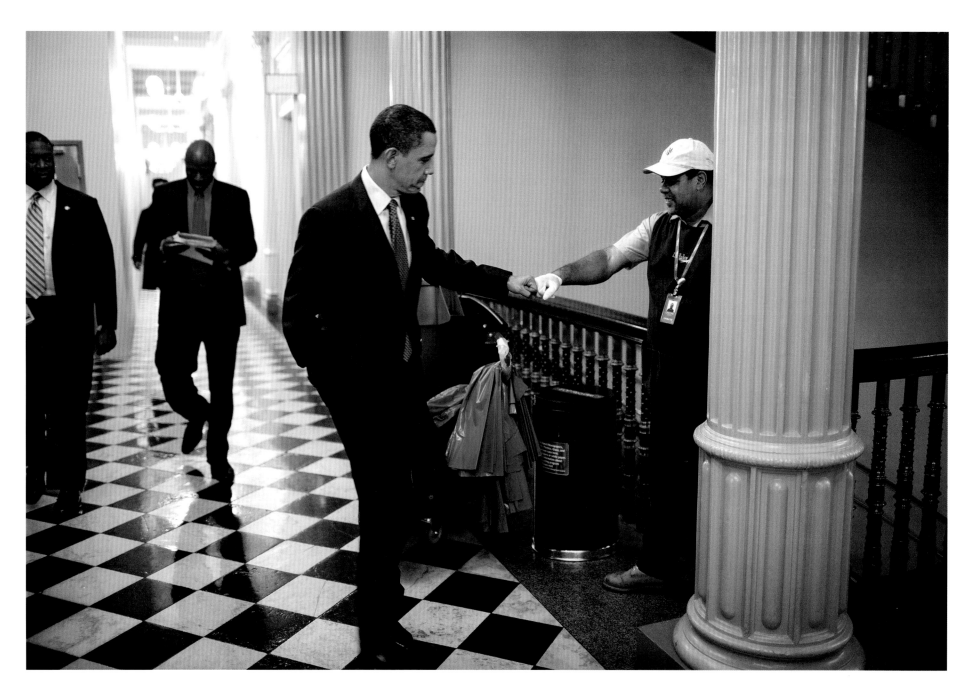

Fist-bumping Larry Lipscomb, a General Services Administration
worker, following a White House forum on jobs and economic growth,
in the Eisenhower Executive Office Building. *December 3, 2009*

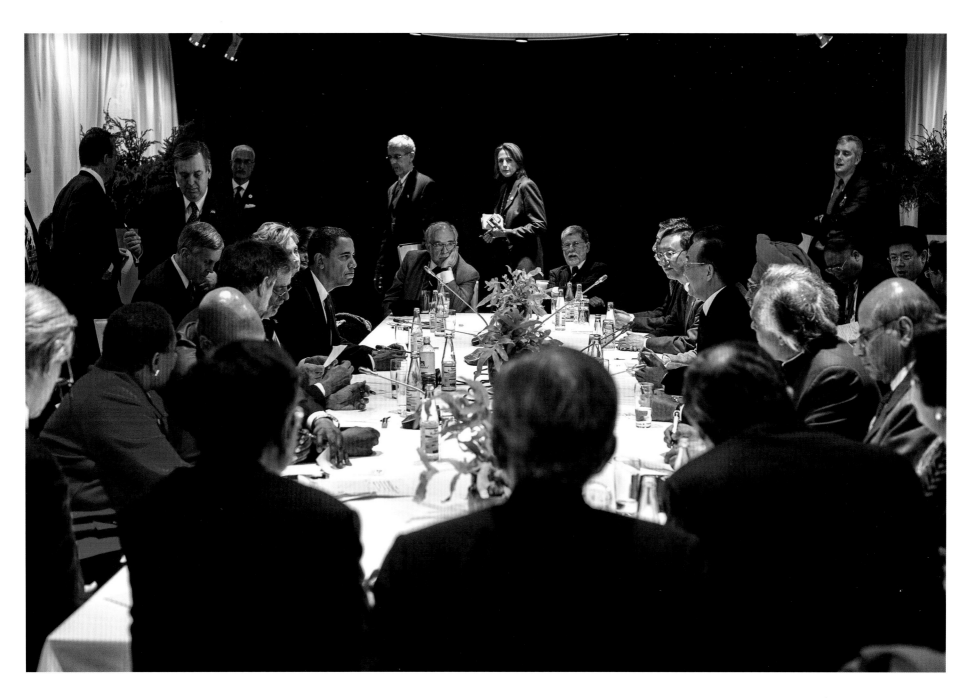

Busting in, uninvited, on a meeting about climate change
hosted by China in Copenhagen, Denmark. *December 18, 2009*

Golfing at the Luana Hills Golf Course during his Christmas family vacation in Kailua, Hawaii. Although basketball was the President's sport of choice, a round of golf was as close as he could get to escaping the Presidential bubble for a few hours. Because Secret Service and military personnel always accompanied him, I never in eight years caught him more alone on the golf course than in this photograph. *December 28, 2009*

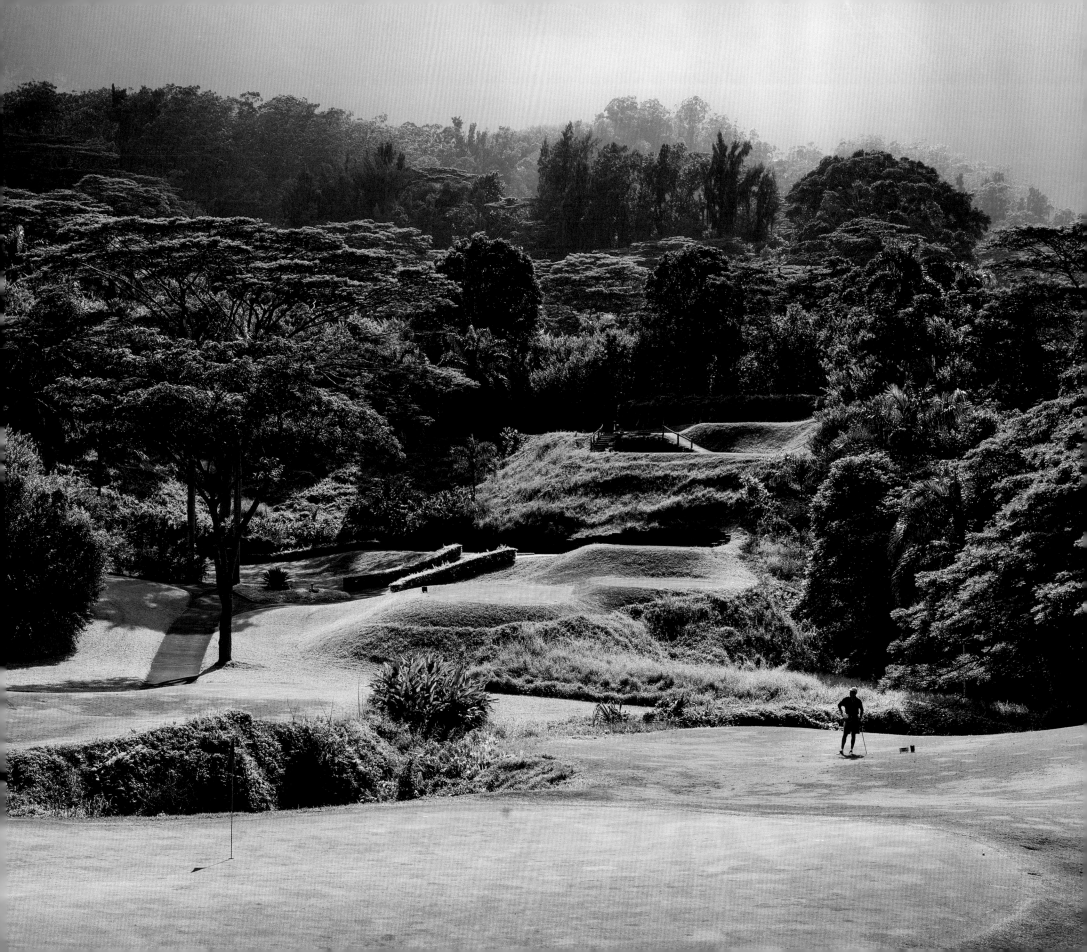

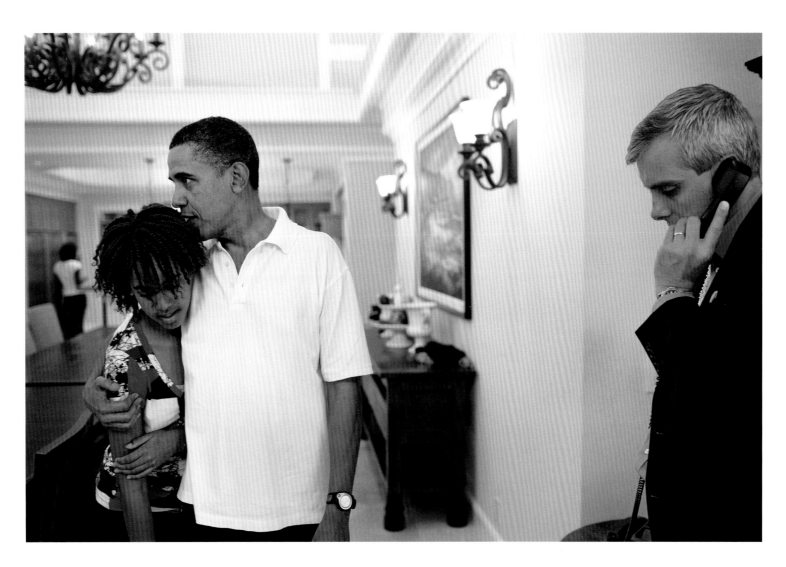

With Malia on vacation in Kailua, waiting for Denis McDonough to connect him
to his National Security team for updates on an averted terrorist act. A man with plastic
explosives sewn into his underwear had unsuccessfully attempted to bomb
a plane as it flew from Amsterdam to Detroit on Christmas morning. *December 29, 2009*

OPPOSITE: Bodysurfing at Pyramid Rock Beach, in Kaneohe Bay, Hawaii. In the next
frame I shot of this scene, the President disappeared behind the waves.
When I showed it to the Secret Service agent near me, he joked, "My job is
to save him from others, not himself." *January 1, 2010*

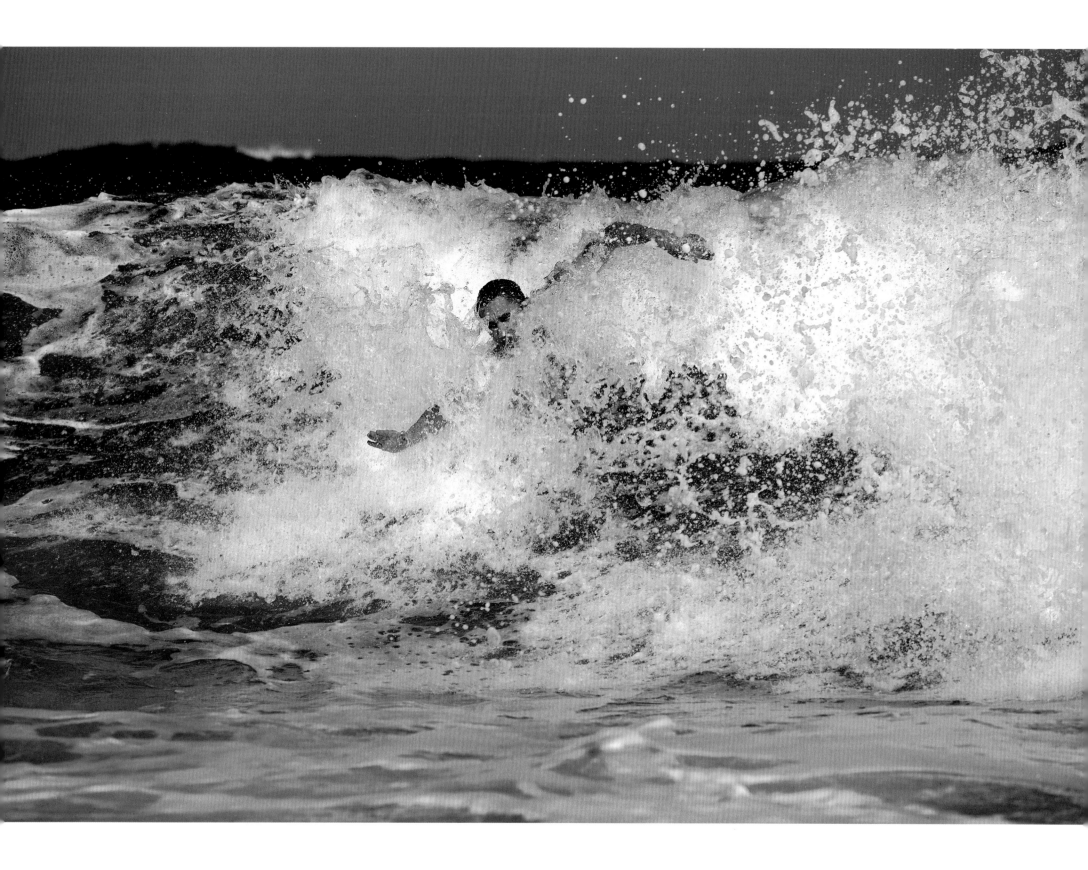

3

THE FIGHT FOR HEALTH CARE

SNOW DAY

CONGRESS PASSES THE AFFORDABLE CARE ACT

CELEBRATING ON THE TRUMAN BALCONY

MEETING AN ARMY RANGER—AGAIN

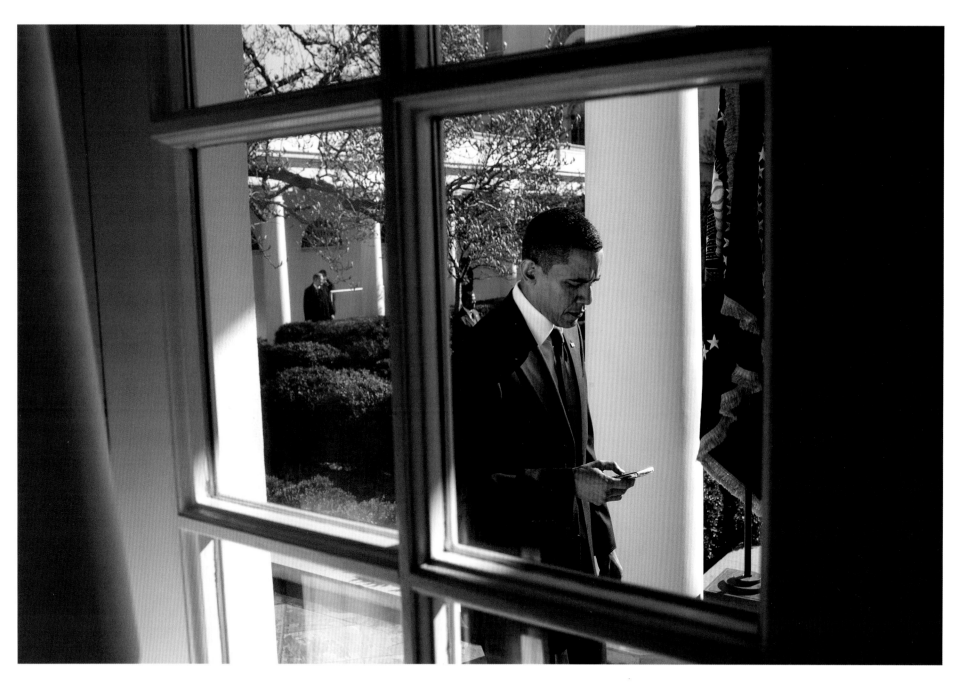

Checking his BlackBerry during his morning walk to the Oval Office. *March 18, 2010*

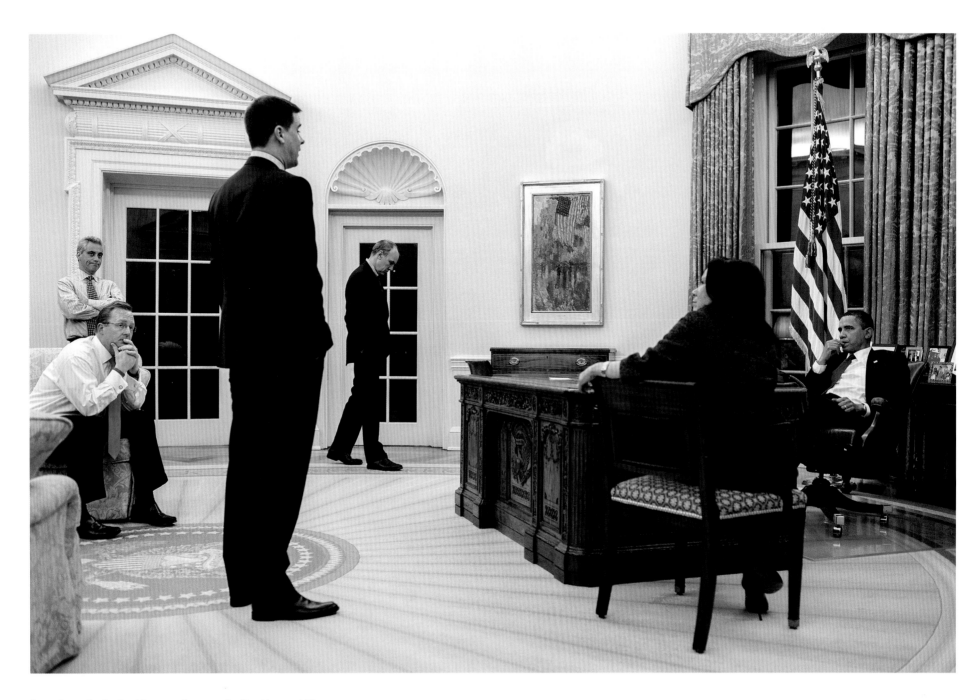

A turning point for health care reform, as the President and his team
discussed strategy the day after Republican Scott Brown unexpectedly
won a special election for the Massachusetts Senate seat vacated
by Senator Edward M. Kennedy's death. *January 20, 2010*

OPPOSITE: With Health and Human Services Secretary
Kathleen Sebelius and health care point person Nancy-Ann DeParle
during a meeting with Democratic Senators. *January 20, 2010*

THE FIGHT FOR HEALTH CARE

Health care reform was more than a campaign promise. It was the singular domestic issue that equated hope and change. Though many of his advisors cautioned him against trying to push for this too soon, the President was adamant that now was the time to fight for the people who could not afford health insurance. He heard from them in town halls and in many of the ten letters he would read every night, chosen representatively from the thousands that the White House received every day.

Though the process for passing the Affordable Care Act began in 2009, the first three months of 2010 were when the fight became an all-out focus of the administration. Meetings and phone calls were an everyday occurrence. An all-day bipartisan discussion was carried live on C-SPAN. The House Republican Caucus invited the President to their retreat to grill him on the bill; that backfired on them when the President made a much more effective case in outlining the benefits for their own constituents.

His lobbying of individual Congressmen for their vote was nonstop and persistent. *Do the right thing* was his motto. "What do you need from me?" he said to one wavering Democrat on the phone. "You want me to wash your car? I'll come wash your car."

Even a massive snowstorm in Washington that shut down the government for days sidelined him only for a few hours, when he played in the snow with Sasha and Malia. He was back at it the next day. And the day after that. Right up until March 21, when the House would vote on the bill.

The staff gathered that night with the President in the Roosevelt Room to watch the historic vote on TV. After the celebration, I was alone for a moment with him before he started making congratulatory calls from the Oval Office. "The bad days aren't as bad as they seem," he said quietly to me, "and the good days aren't as good as they seem." I responded, "Yeah, but this is a pretty good day." He smiled and repeated, "This is a pretty good day."

I knew that passing the ACA meant more to him than being elected President; he had gotten something important done for the benefit of the country. *(Photographs continue through page 85.)*

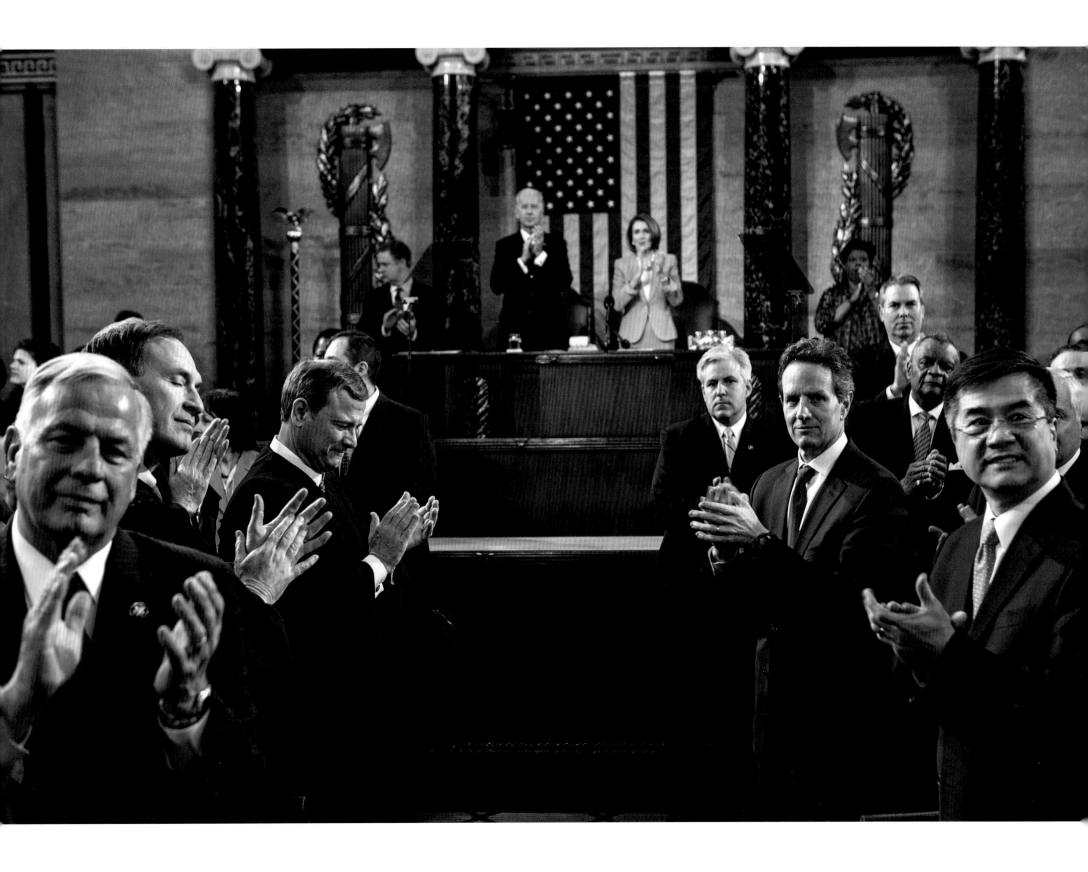

Concluding an hours-long Q&A on health care reform, which was
broadcast live on C-SPAN, with Representative Mike Pence
of Indiana and the House Republican Caucus. *January 29, 2010*

OPPOSITE: Being welcomed into the House chamber for a speech on health
care reform before a joint session of Congress. *January 27, 2010*

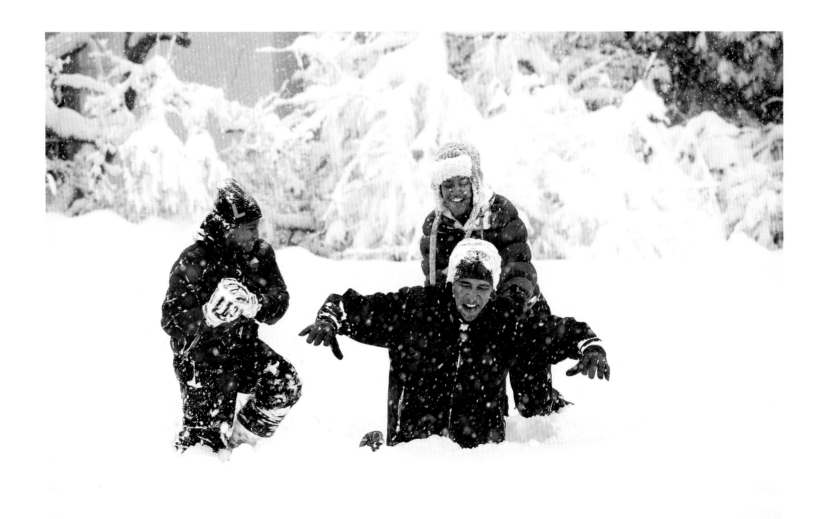

ABOVE AND OPPOSITE: With Sasha and Malia
during a break in the health care fight
because of a massive snowstorm. *February 6, 2010*

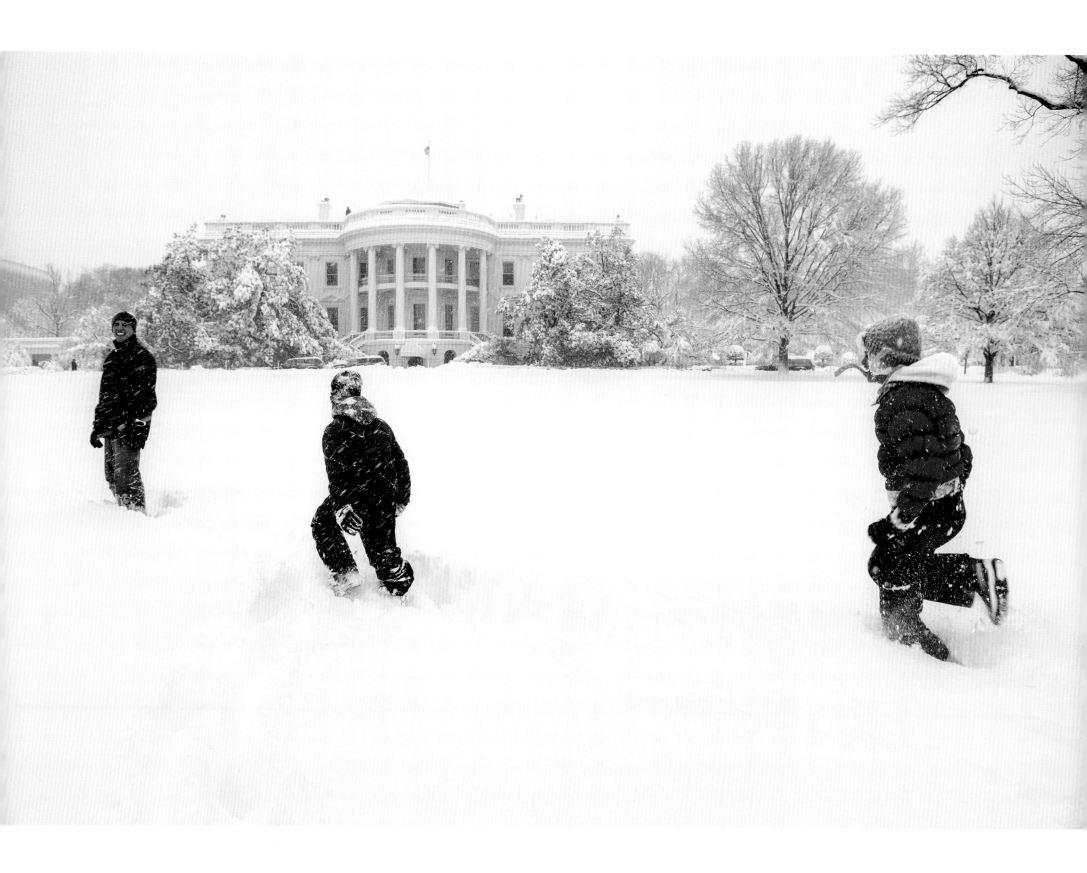

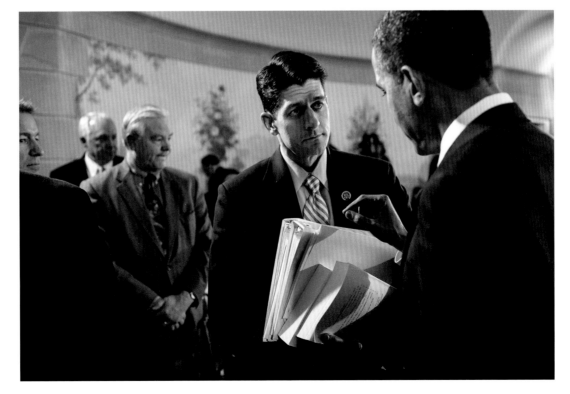

TOP: Press secretary Robert Gibbs's to-do list. *February 9, 2010*

BOTTOM: With Representative Paul Ryan of Wisconsin after an all-day discussion on health care at the Blair House. *February 25, 2010*

OPPOSITE: With speechwriter Jon Favreau in his West Wing basement office. *March 3, 2010*

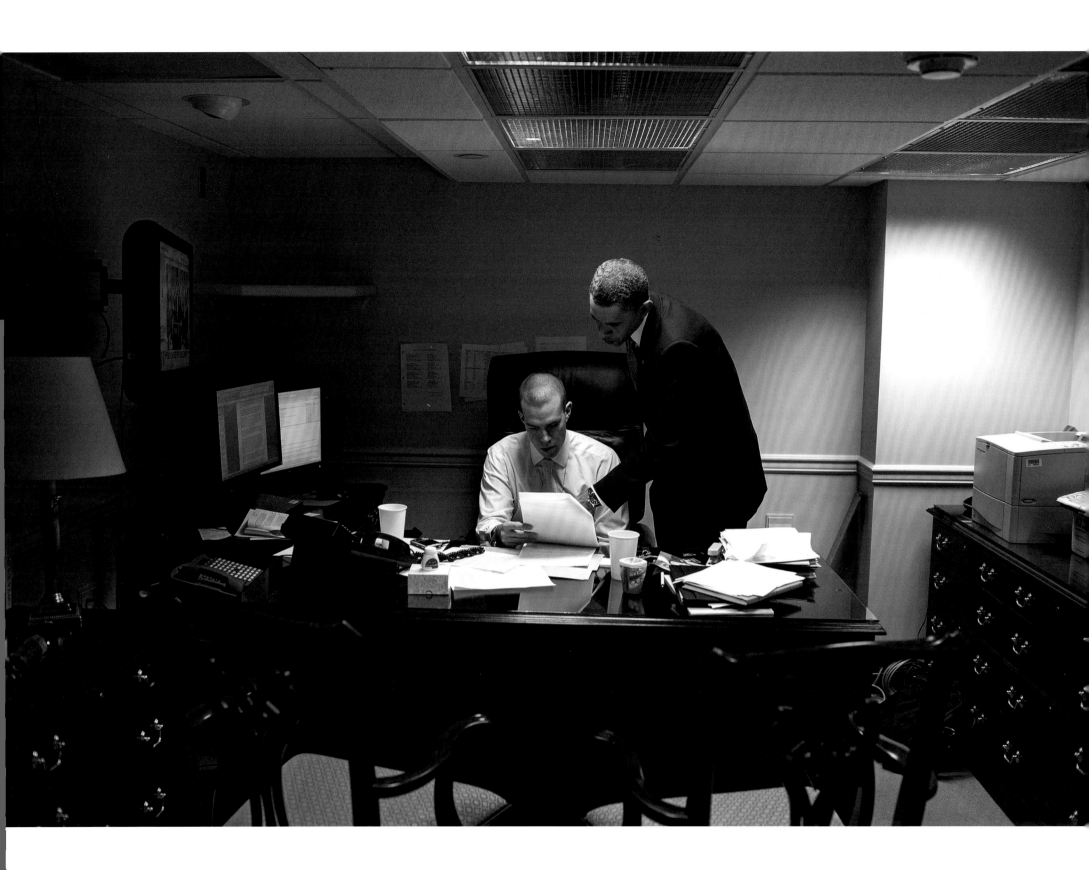

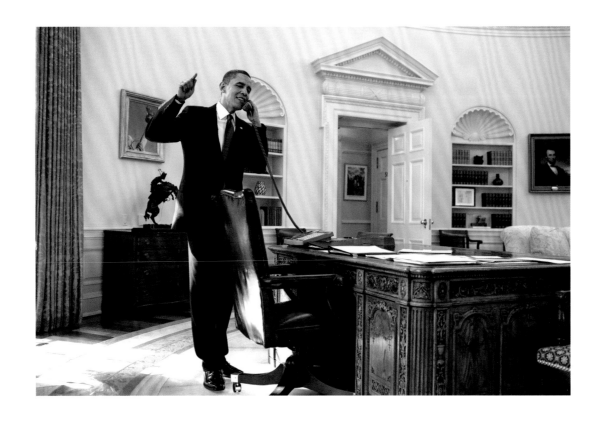

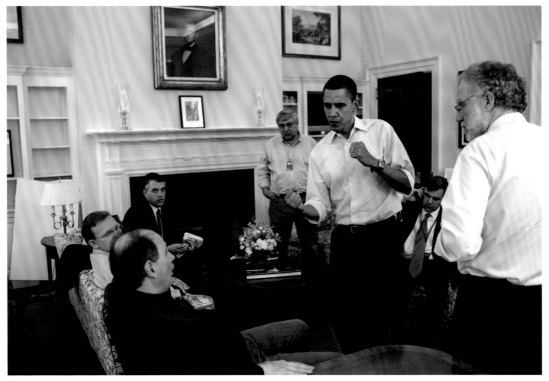

TOP: Lobbying a Democratic Congressman for his vote. *March 19, 2010*

BOTTOM: In the chief of staff's office during the last hours before the House vote. *March 21, 2010*

OPPOSITE: Watching a television broadcast of Congress passing the Affordable Care Act, in the Roosevelt Room. *March 21, 2010*

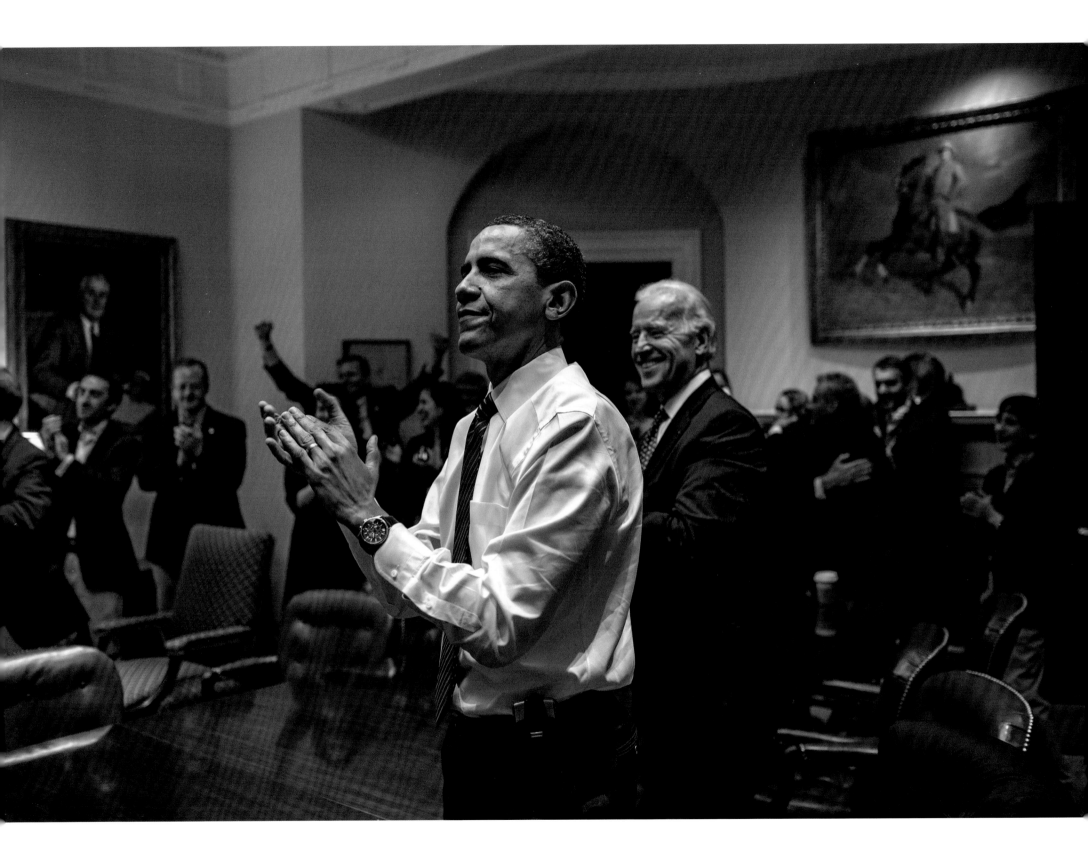

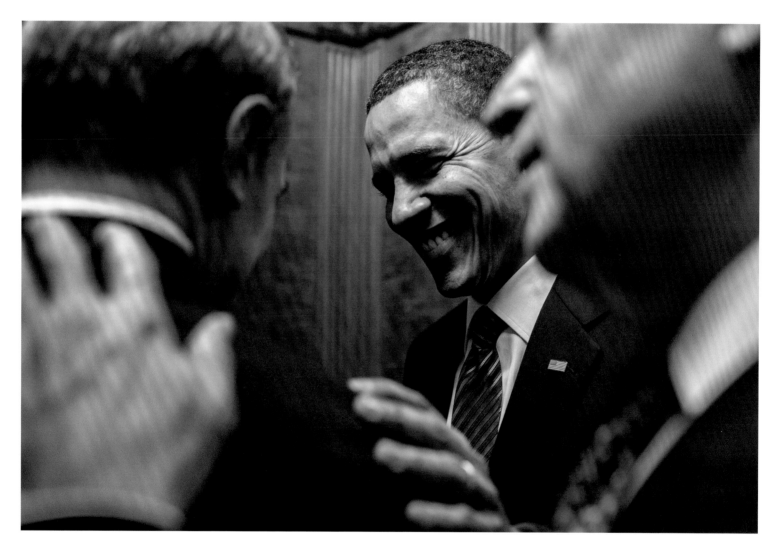

On the elevator to the private residence after the successful
ACA vote, with Phil Schiliro and the Vice President. *March 21, 2010*

OPPOSITE: Toasting the health care victory with staff on the
Truman Balcony. *March 21, 2010*

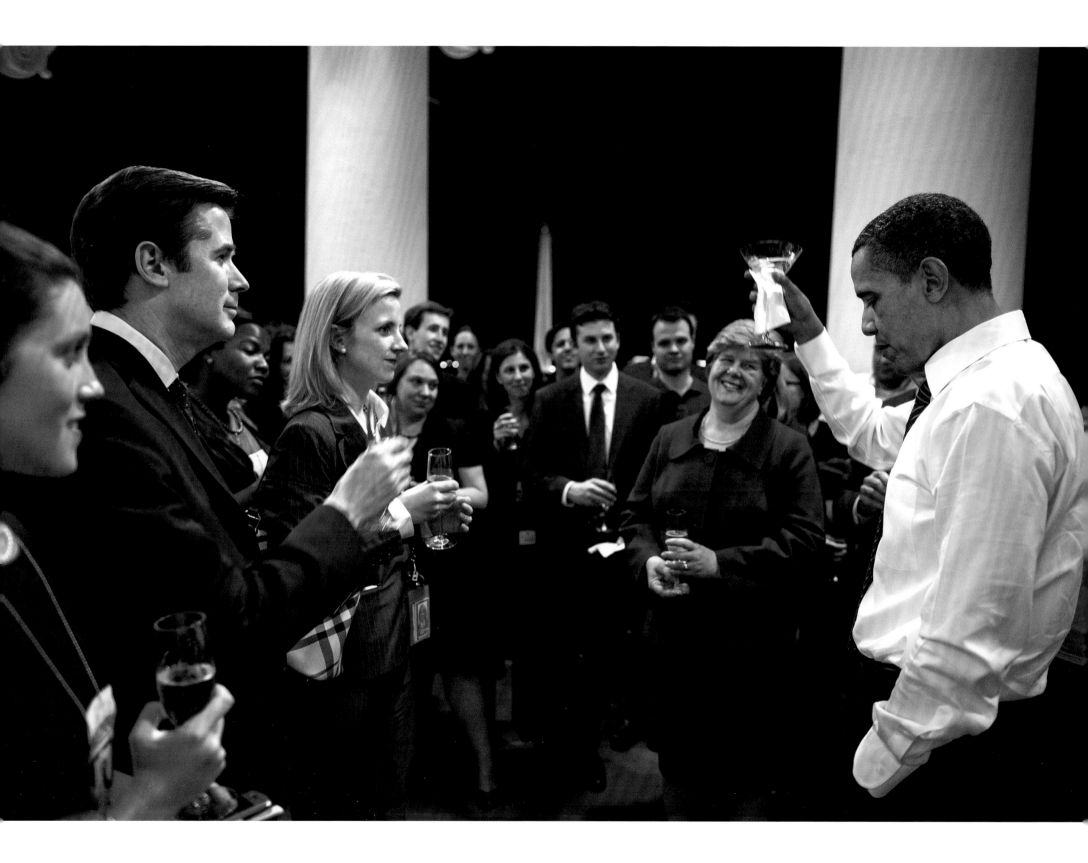

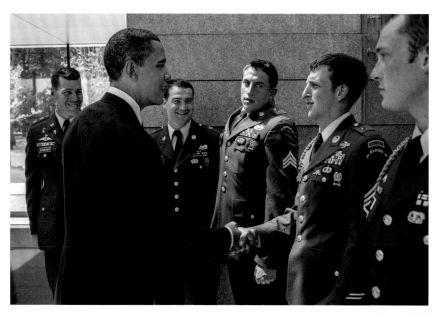

June 6, 2009

MEETING AN ARMY RANGER—AGAIN

Throughout his administration, President Obama made regular visits to wounded members of the armed services at Walter Reed hospital. The tenth patient he visited on February 28, 2010, was Cory Remsburg. He had suffered a severe brain injury caused by a roadside explosion in Afghanistan.

Before entering his room, the President was told that he had previously met Cory in Normandy the year before. But I had no immediate memory of that encounter, and Cory didn't look at all familiar to me. As the President presented him with a Presidential coin, it wasn't clear that Cory could fully understand what the President was saying to him.

Cory's family asked the President if he would sign a photograph that was hanging in his hospital room. And there it was—a photograph that I had taken eight months before of Army Ranger Cory Remsburg firmly shaking the hand of President Obama. I was stunned as I looked at the 8-by-10-inch glossy print from June 6, 2009.

My mind raced back in time. It had been a whirlwind day in France. We'd had an event with U.S. embassy personnel in Paris; a flight on *Air Force One* from Paris to Caen; a

state visit with President Nicolas Sarkozy of France; a picturesque helicopter ride into Normandy; the 65th anniversary of D-Day; a helicopter ride, then a plane ride back to Paris; and, finally, a tour with the Obama family at the Cathedral of Notre Dame. The President and First Lady greeted hundreds of people that day, including a small group of Army Rangers in Normandy. That was when he had met Cory.

"God bless…" the President began his inscription on the photo.

The contrast between the two Cory Remsburgs was almost too much to bear: a strong, healthy, and confident Cory shaking hands with the President in 2009, and less than a year later, a severely injured Cory lying in the bed in front of me, partially paralyzed, with dozens of stitches across the right side of his skull.

I was shaken when I left the hospital that day. I had seen many soldiers wounded in Iraq or Afghanistan during my visits to Walter Reed with the President. Some had suffered severe head or eye injuries. Others had lost an arm or a leg. But I had never photographed any of these patients before their injuries too. That changed with Cory.

I wondered whether he would be able to fully function again.

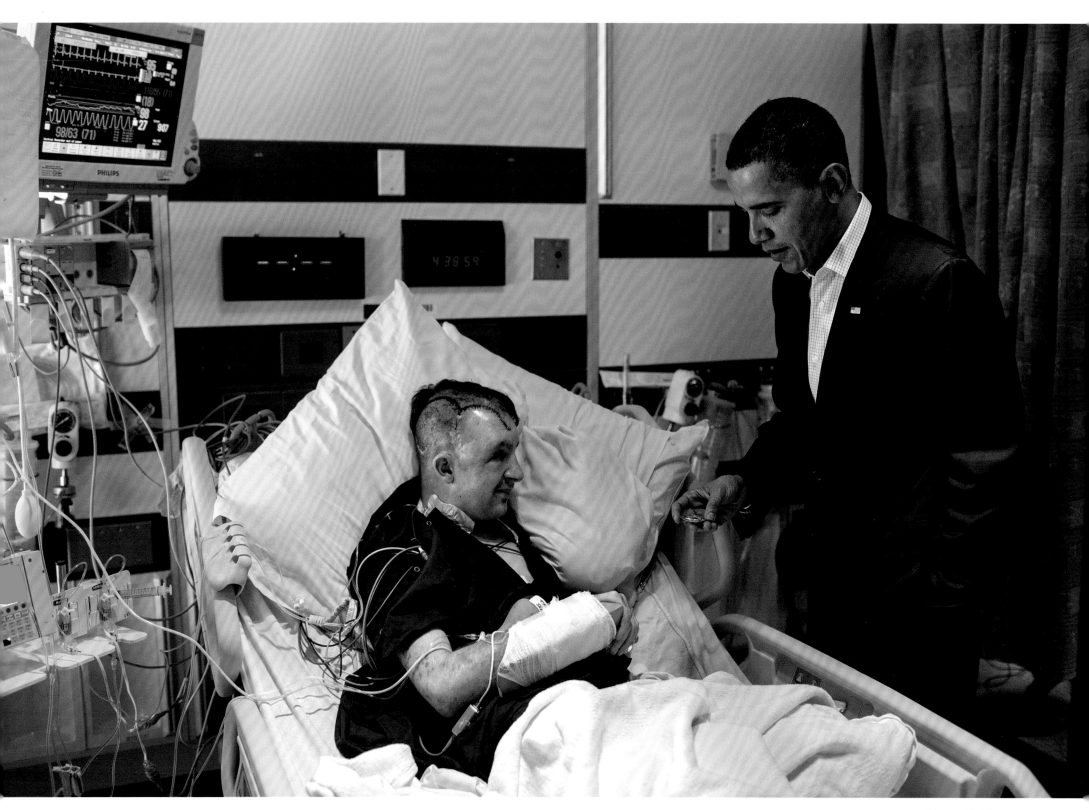

February 28, 2010

4

A SECRET OVERNIGHT TRIP TO AFGHANISTAN

MANAGING THE BP OIL SPILL

A BEATLE SINGS "MICHELLE" TO MICHELLE

TIPPING THE SCALES IN TEXAS

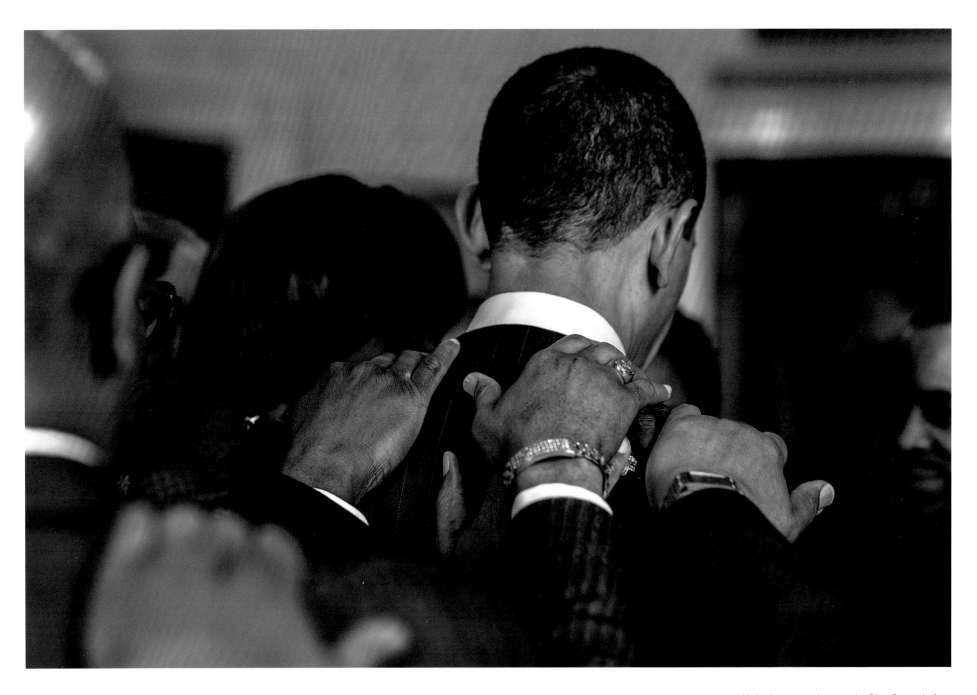

With clergy members in the Blue Room before
a prayer breakfast. *April 6, 2010*

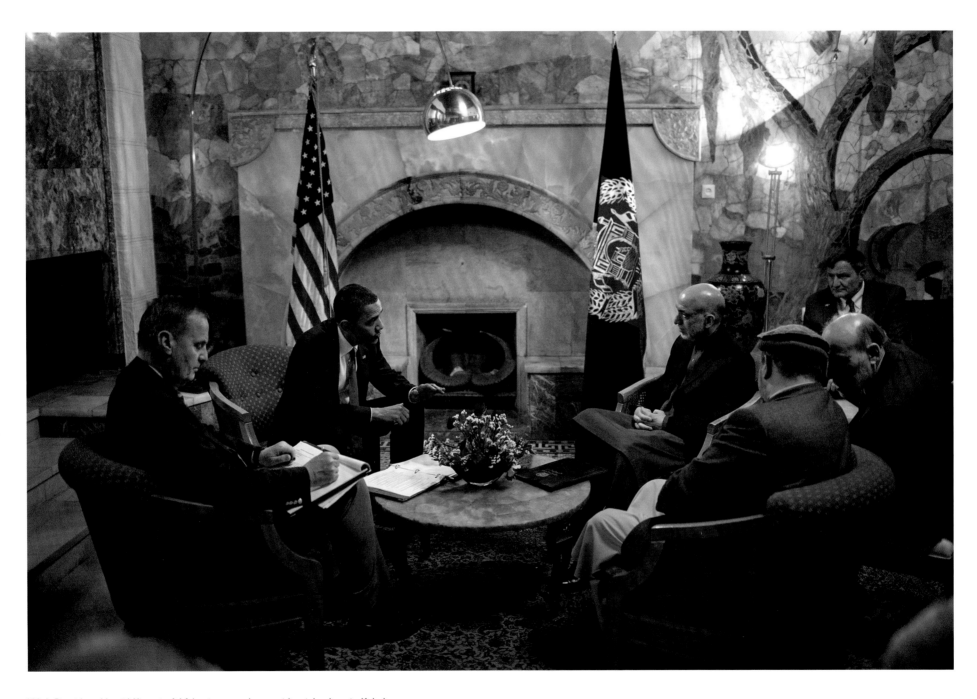

With President Hamid Karzai of Afghanistan at the presidential palace in Kabul.
The visit was unannounced and took place under cover of night. *March 28, 2010*

OPPOSITE: Riding back to Bagram Airfield from Kabul just before
midnight, in a helicopter that had been darkened for security. *March 28, 2010*

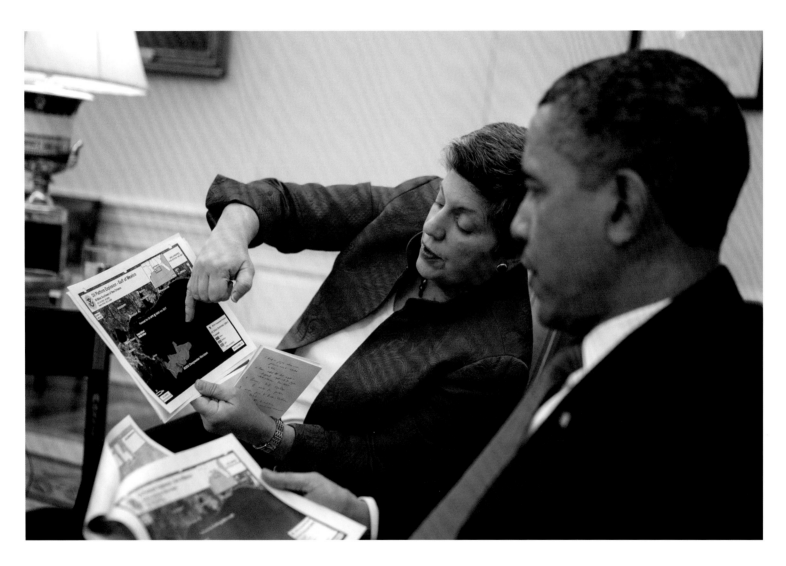

With Secretary of Homeland Security Janet Napolitano nine
days after BP's *Deepwater Horizon* oil spill. It was the
largest accidental marine oil spill in U.S. history; millions of barrels
of oil were discharged into the Gulf of Mexico. *April 29, 2010*

OPPOSITE: Responding to the oil spill with Louisiana
state and federal officials in Venice, Louisiana. *May 2, 2010*

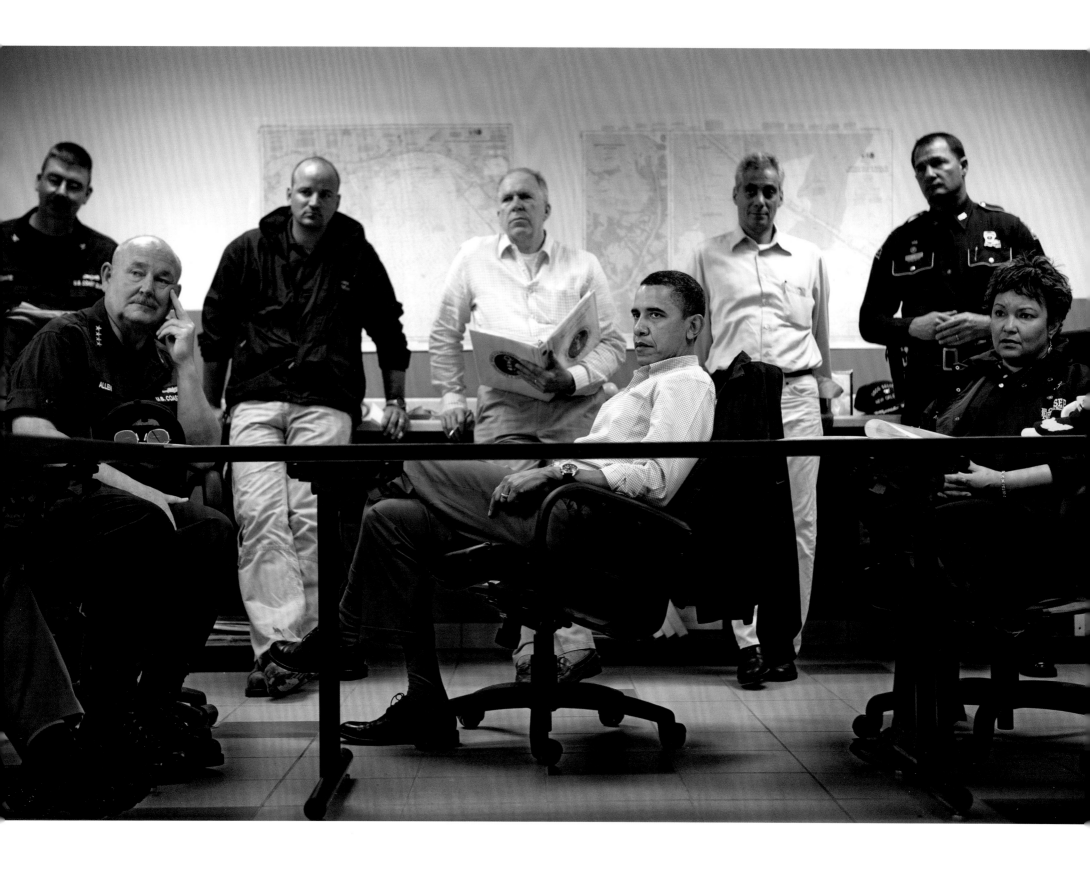

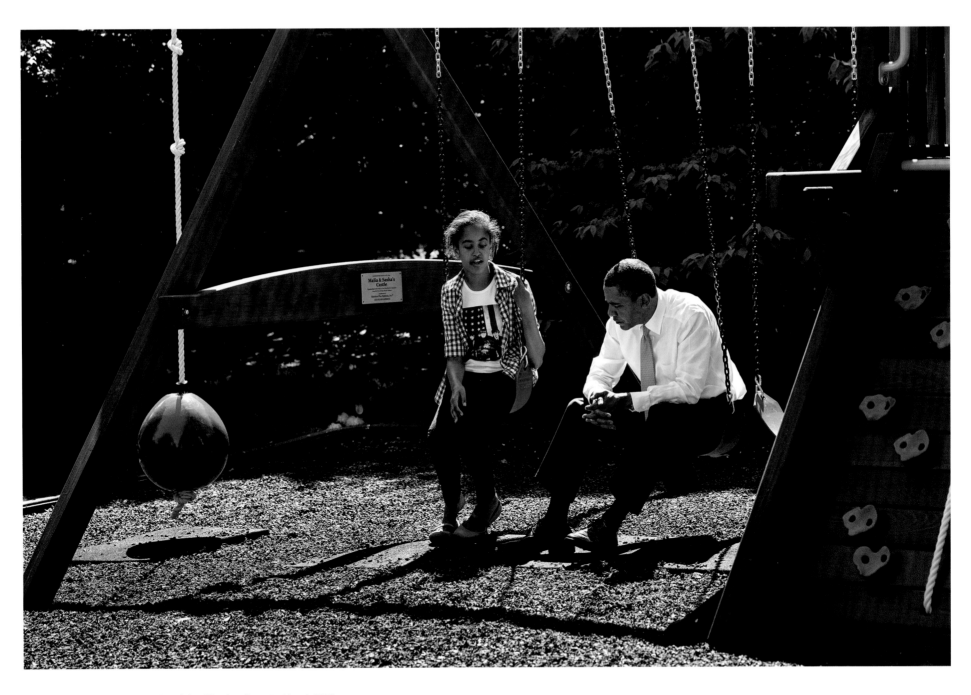

Chatting with Malia in the midst of the BP oil spill crisis. *May 4, 2010*

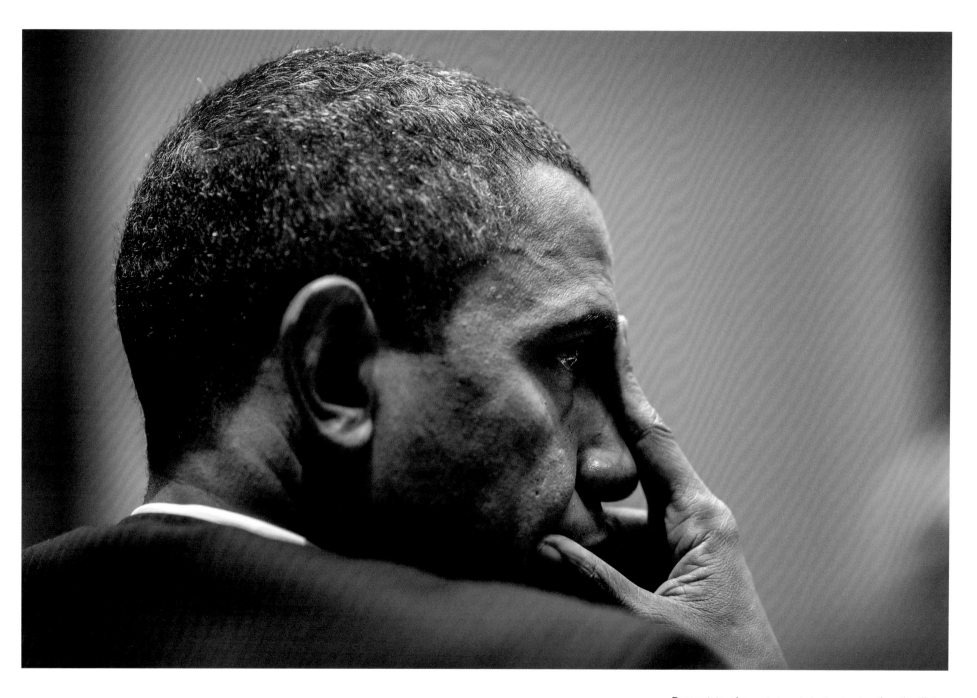

Determining the next steps in trying to stop the oil spill, in a meeting with members of his cabinet. *May 14, 2010*

Bo boarding *Air Force One* for a weekend trip to Chicago. *May 27, 2010*

OPPOSITE: Stealing a few moments for a call in a parking garage in San Francisco. *May 25, 2010*

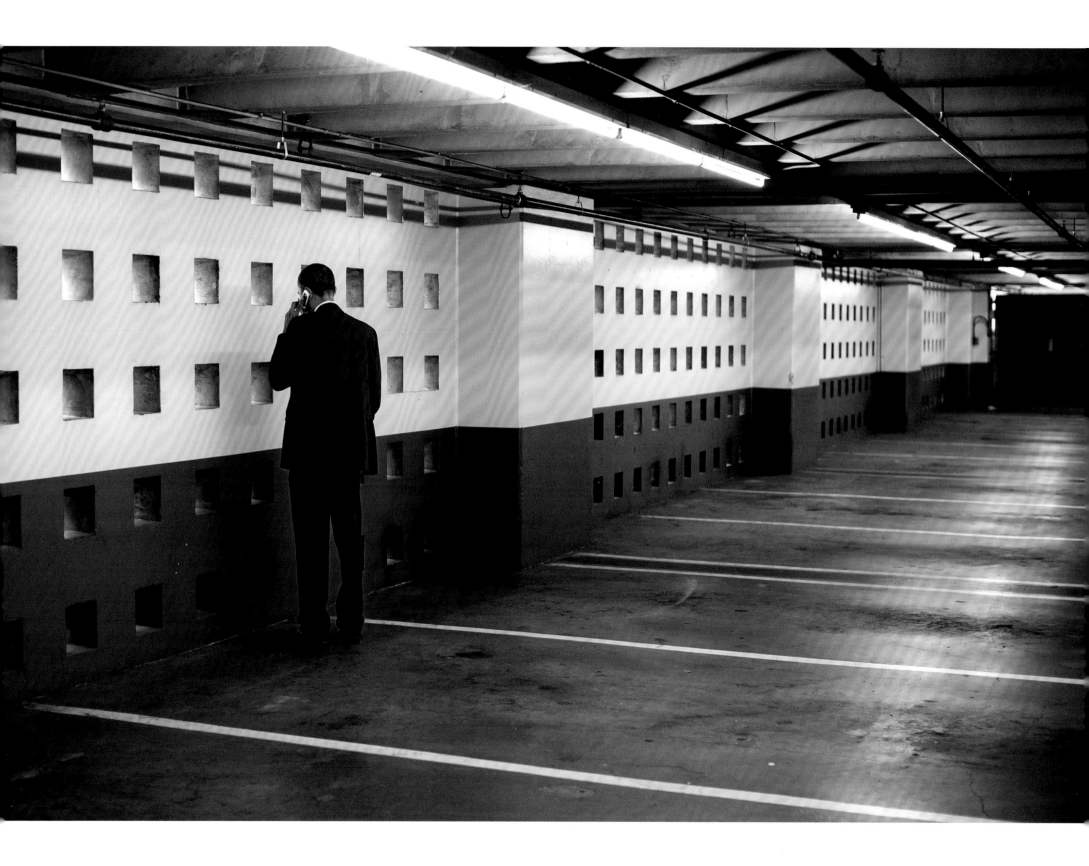

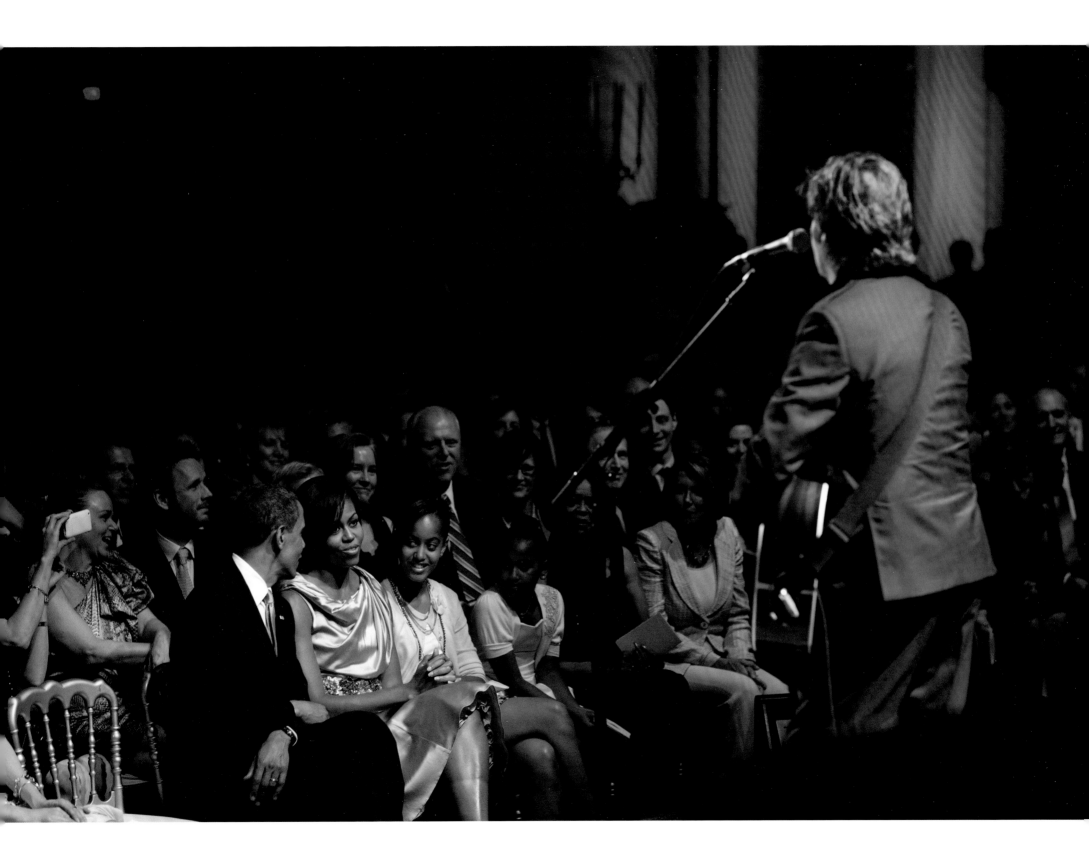

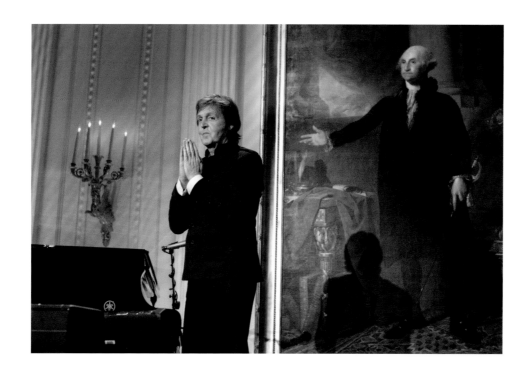

MICHELLE, MA BELLE

Paul McCartney had been awarded the Gershwin Prize for Popular Song in a ceremony in the East Room. For most of the evening, other artists performed his songs. But for the conclusion, McCartney went onstage to sing some classics. Then he sang "Michelle" to Michelle Obama. I didn't realize how special the moment was until the next day, when I was talking to the President. What were the odds, he said to me, that an African-American girl from the South Side of Chicago would one day be sitting in the front row of the White House, as the First Lady of the United States, while a member of the Beatles sang her name? *Wow, just wow*, I thought. *June 2, 2010*

Reflecting on a difficult decision moments after accepting the resignation of Army General Stanley McChrystal, commander of U.S. forces in Afghanistan. McChrystal had made unflattering comments about the Vice President and other administration officials in a *Rolling Stone* article. *June 23, 2010*

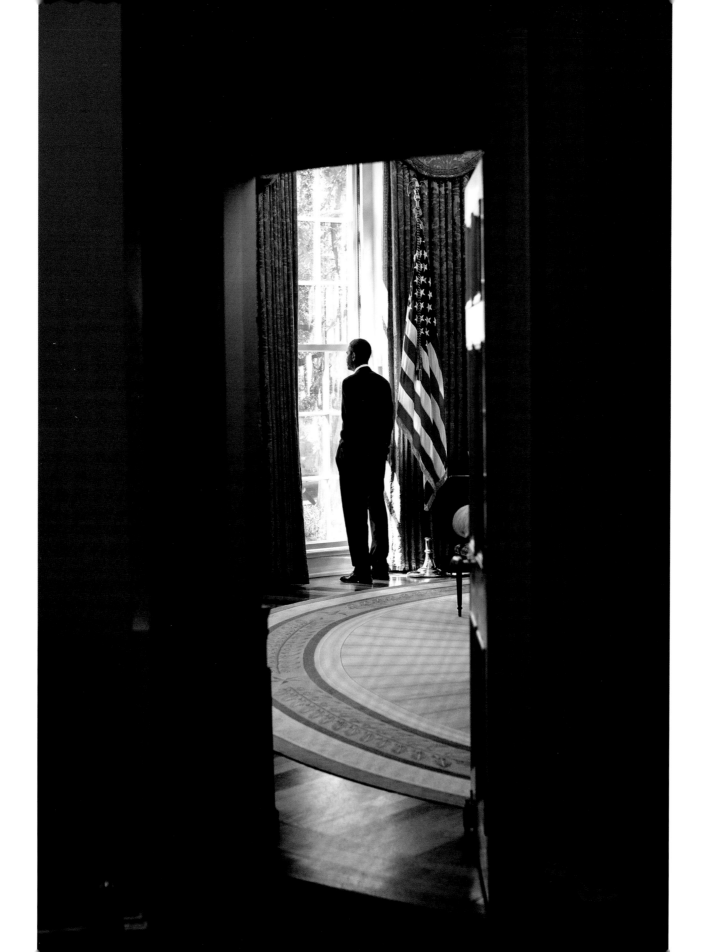

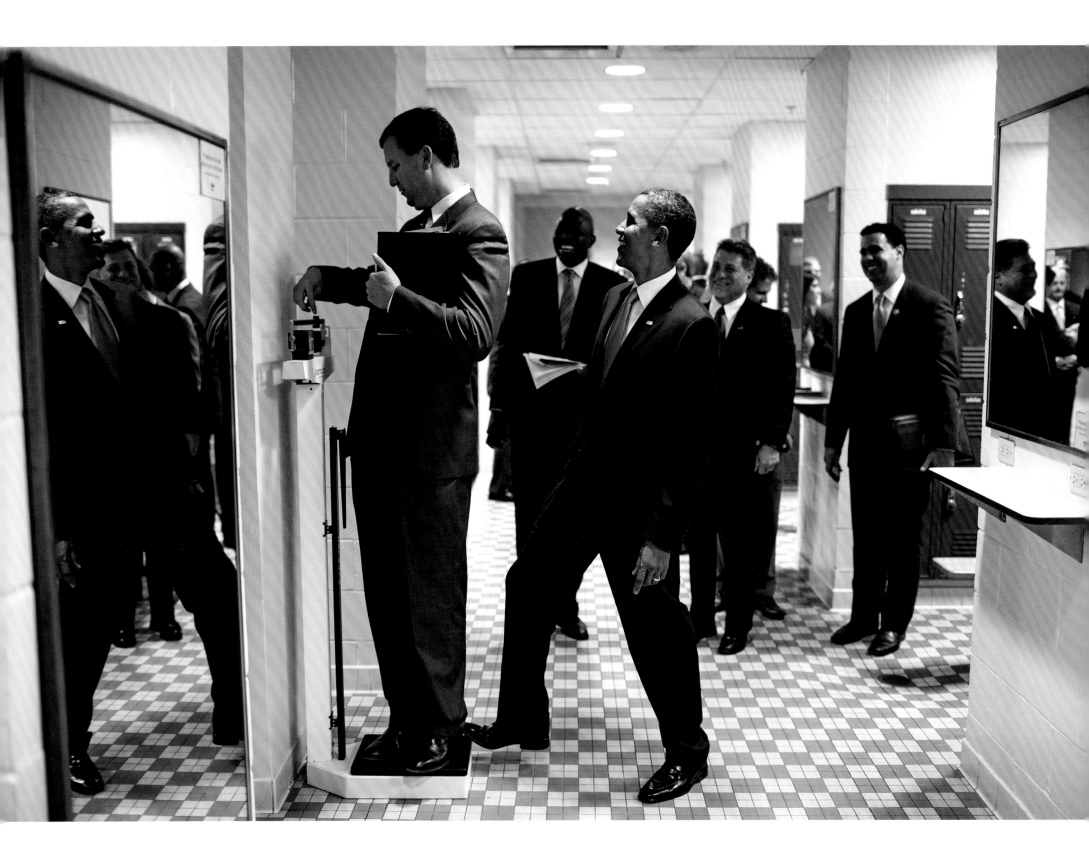

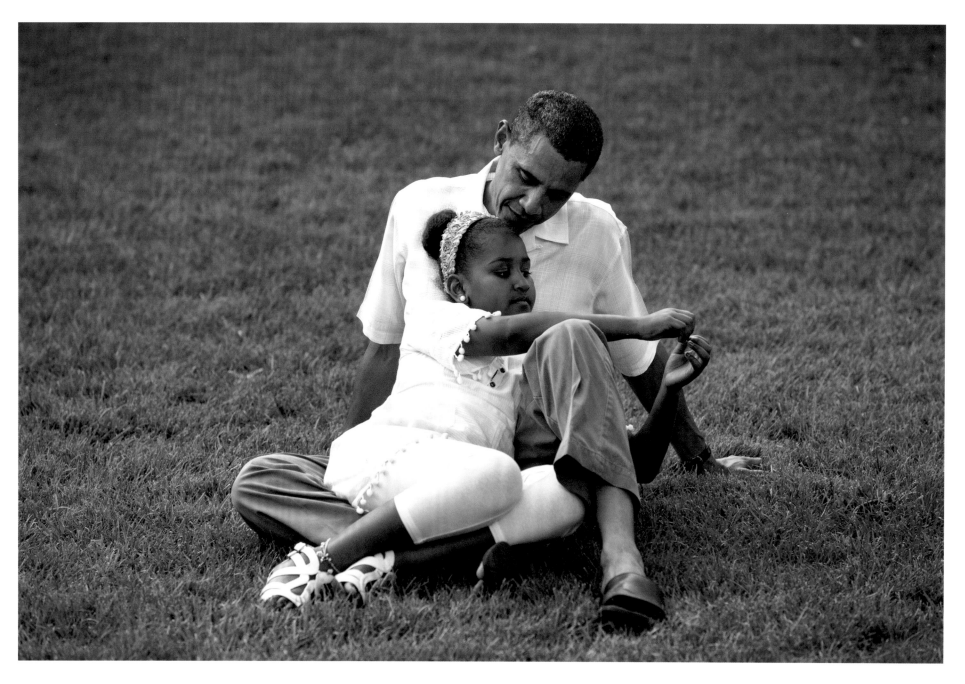

With Sasha on his 49th birthday. *August 4, 2010*

OPPOSITE: Tipping the scales on the unwitting trip director Marvin Nicholson while walking through the volleyball locker room at the University of Texas at Austin. For security purposes, we often made circuitous routes through closed-off areas in public buildings. *August 9, 2010*

On a boat with the First Lady to promote
tourism in the Gulf Coast after the BP oil spill. *August 15, 2010*

OPPOSITE: On vacation in Martha's Vineyard, Massachusetts.
August 28, 2010

5

A RAINY NIGHT IN WESTCHESTER

WATCHING THE FIRST LADY DANCE IN INDIA

A MEMORIAL FOR VICTIMS OF GUN VIOLENCE

THE ARAB SPRING UNFOLDS

COACHING THE VIPERS

THE OSAMA BIN LADEN RAID

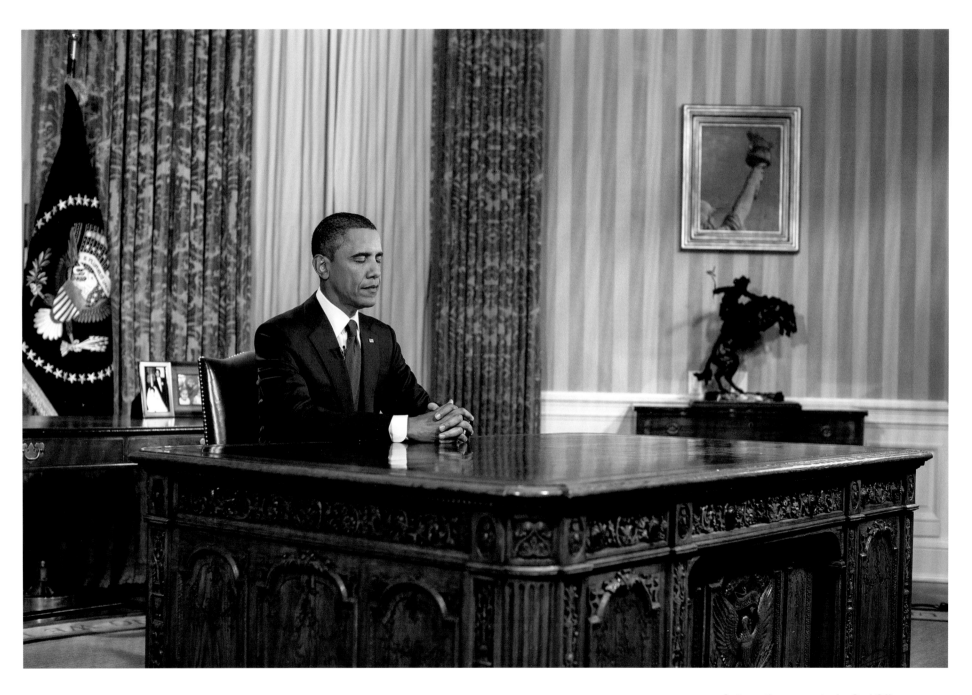

Saying a silent prayer in the Oval Office moments
before announcing to the nation the end of the U.S.
combat mission in Iraq. *August 31, 2010*

Waiting in the motorcade for Reggie Love, who had his umbrella, before boarding *Marine One* at the Westchester County Airport, New York. *September 16, 2010*

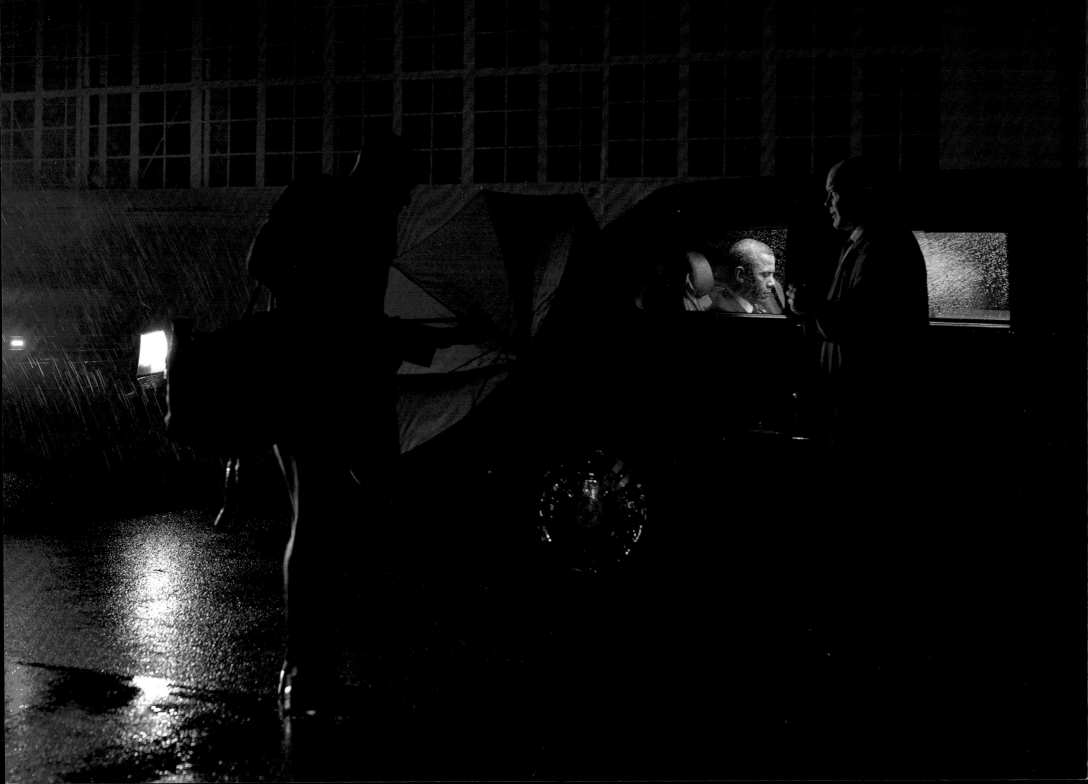

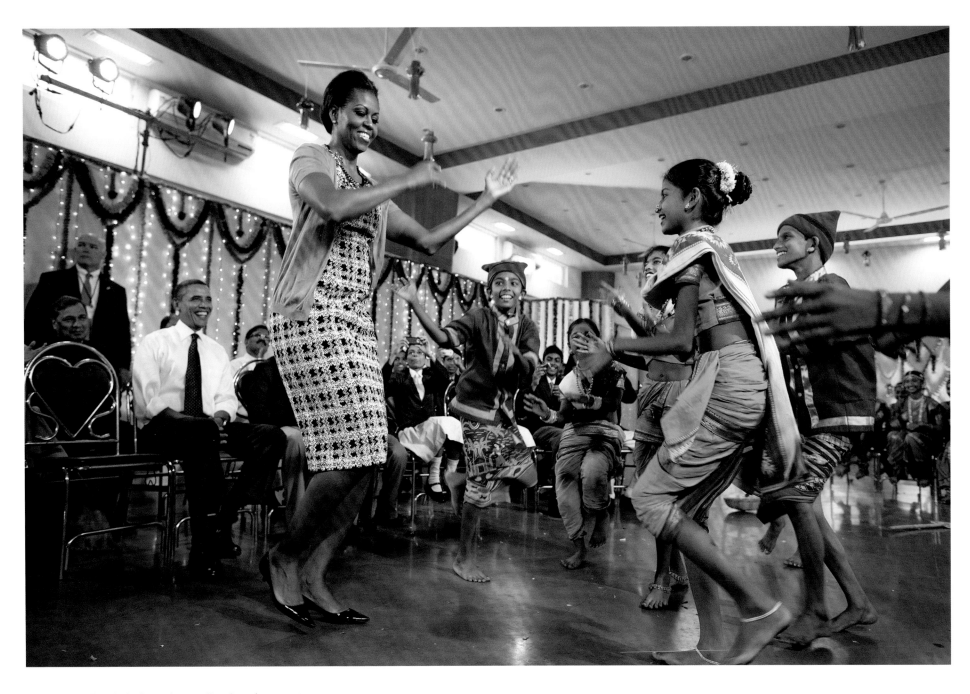

Watching the First Lady dance during a Diwali performance in
Mumbai, India. *November 7, 2010*

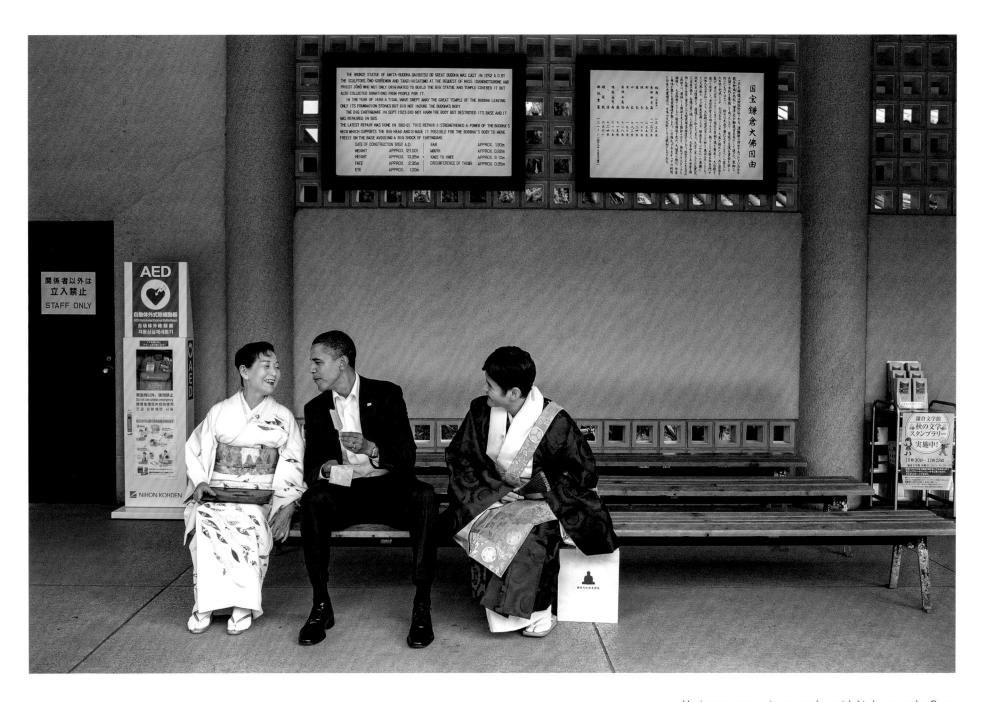

Having a green tea ice cream bar with his hosts at the Great Buddha of Kamakura, Japan. The President later told me he had visited this same Buddha as a child and remembered sitting in the same place, eating the same kind of ice cream. *November 14, 2010*

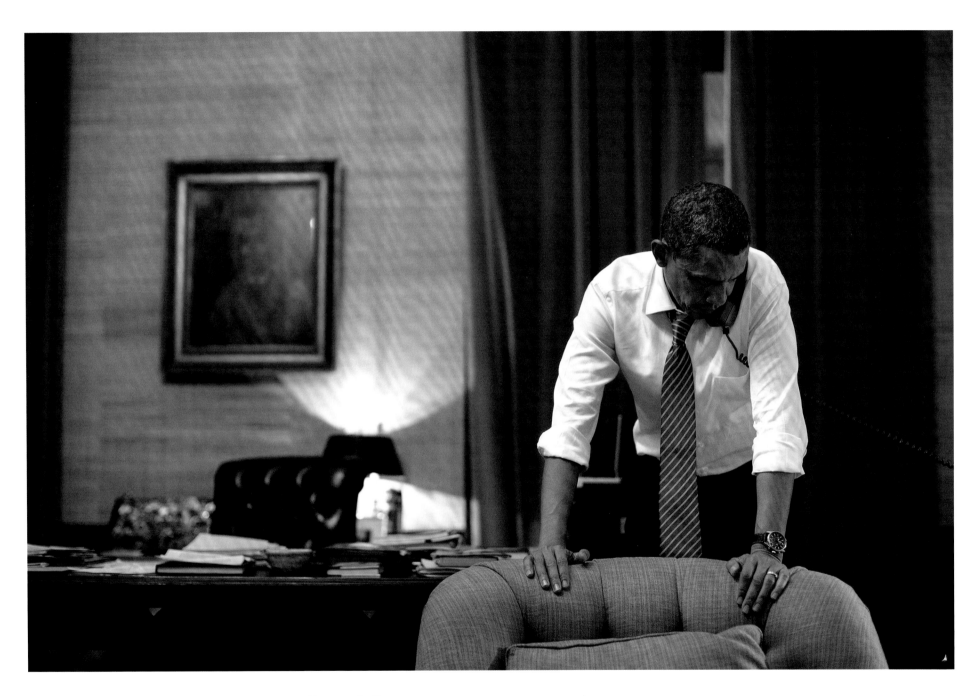

Speaking with President Lee Myung-bak of South Korea at 11:00 p.m. in the Treaty Room in the private residence. North Korea had just conducted an artillery attack against the South Korean island of Yeonpyeong. *November 23, 2010*

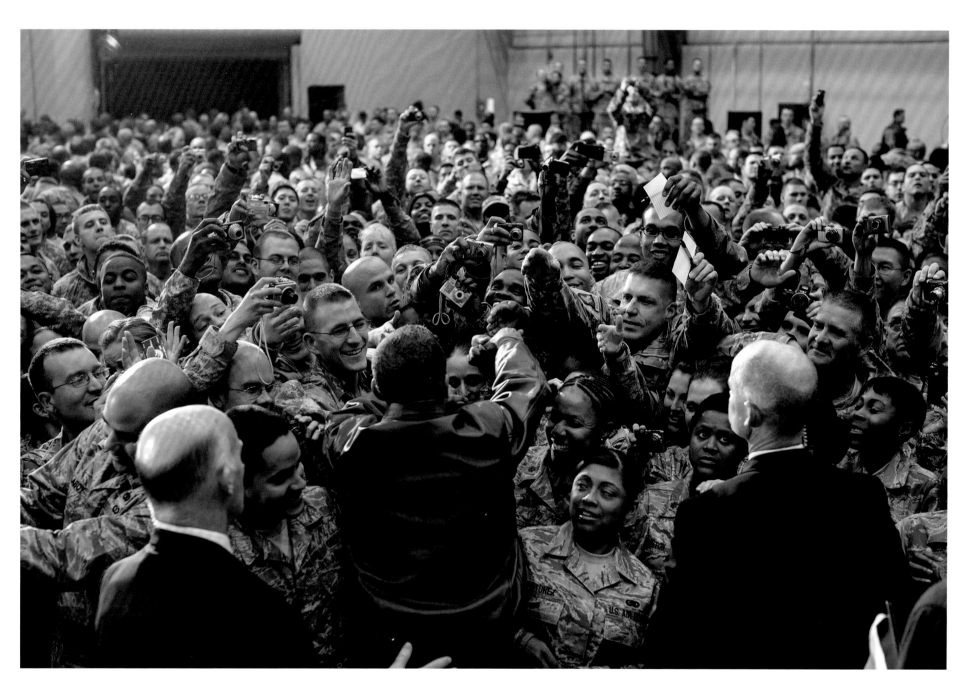

Greeting U.S. troops at Bagram Airfield after a secret all-night trip to Afghanistan. *December 3, 2010*

Comforting Mavy Stoddard during a service in Tuscon, Arizona, for the 19 people shot by a gunman four days earlier at an event for Representative Gabrielle Giffords. Six people were killed, including Mavy's husband, Dorwan, who she believes saved her life by diving on top of her. Representative Giffords was also shot, in the head, and severely injured. *January 12, 2011*

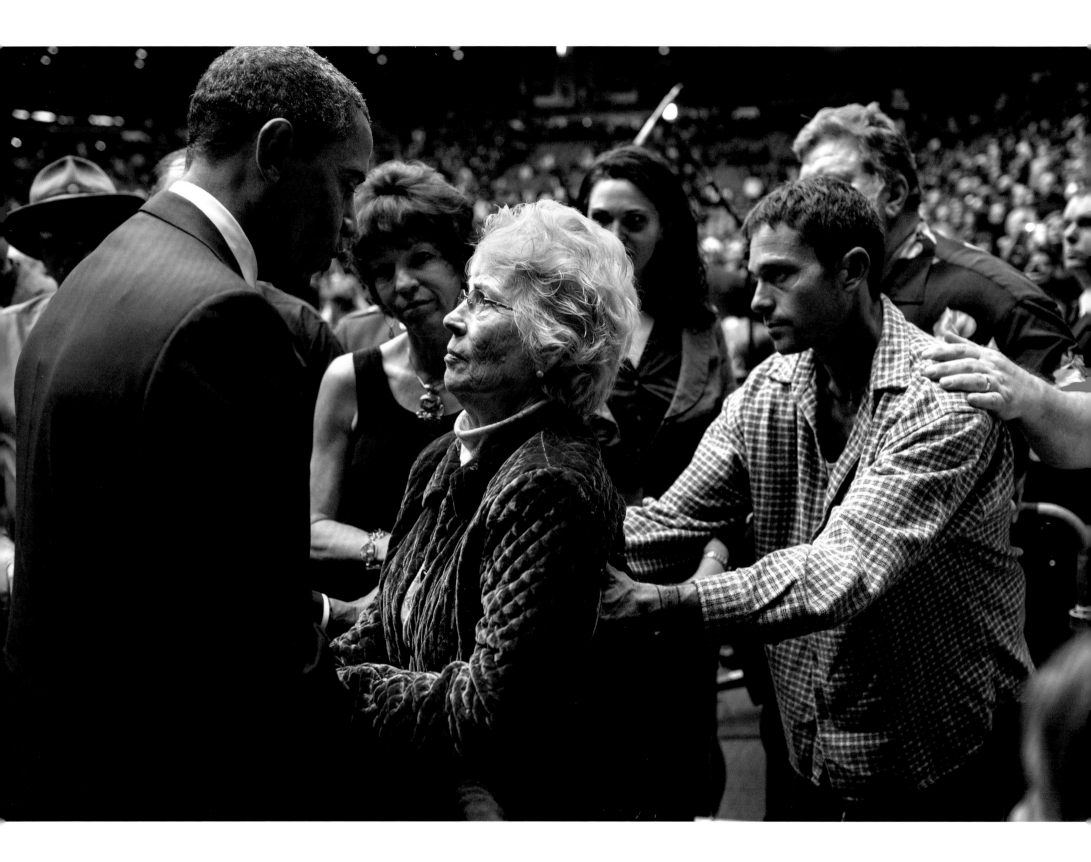

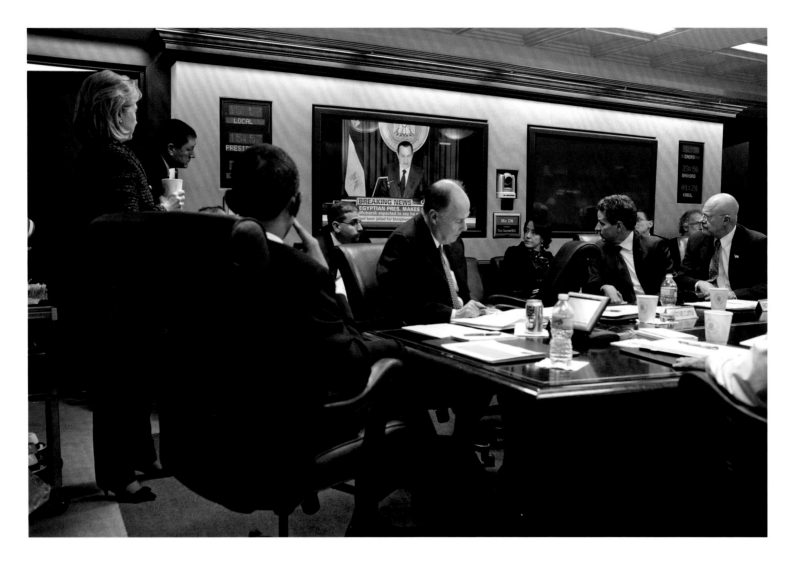

Watching with his National Security team as President Hosni Mubarak
of Egypt made a statement after several days of popular
protests calling for his immediate ouster. *February 1, 2011*

OPPOSITE: Later that night, on the phone with President Mubarak.
Days later, President Obama would urge him to resign. *February 1, 2011*

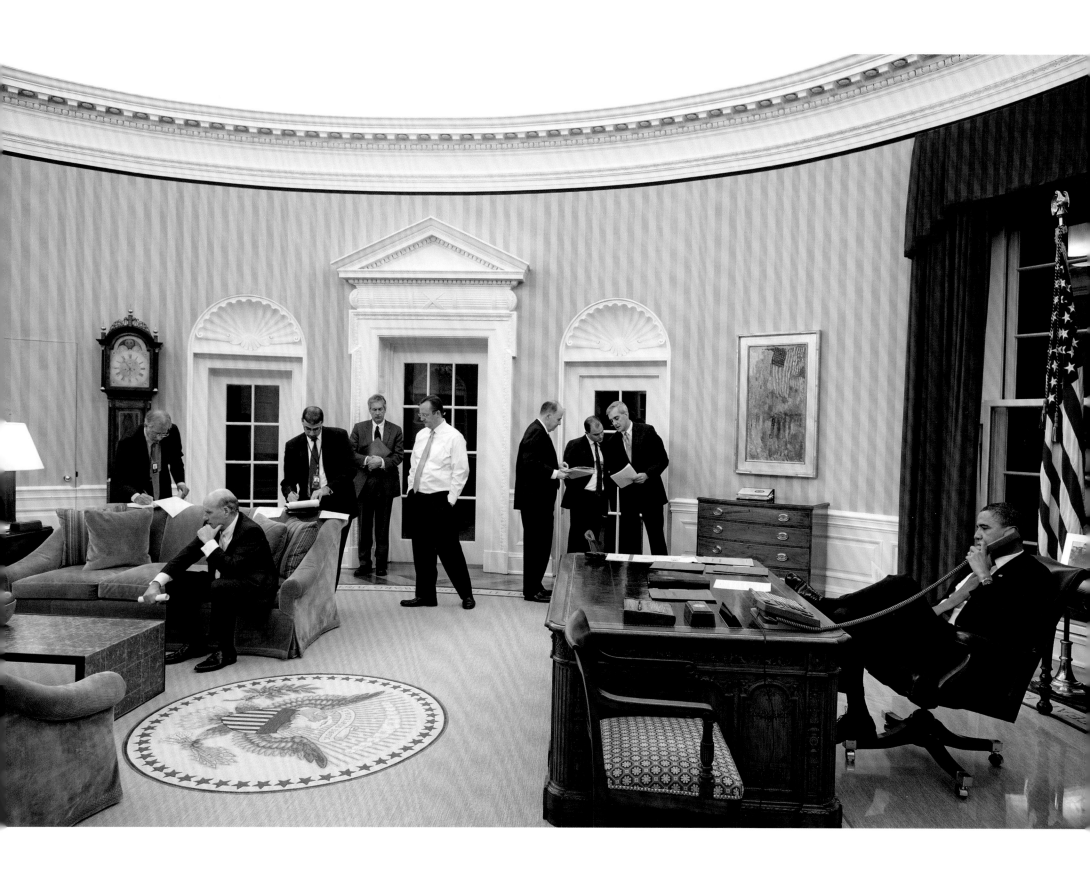

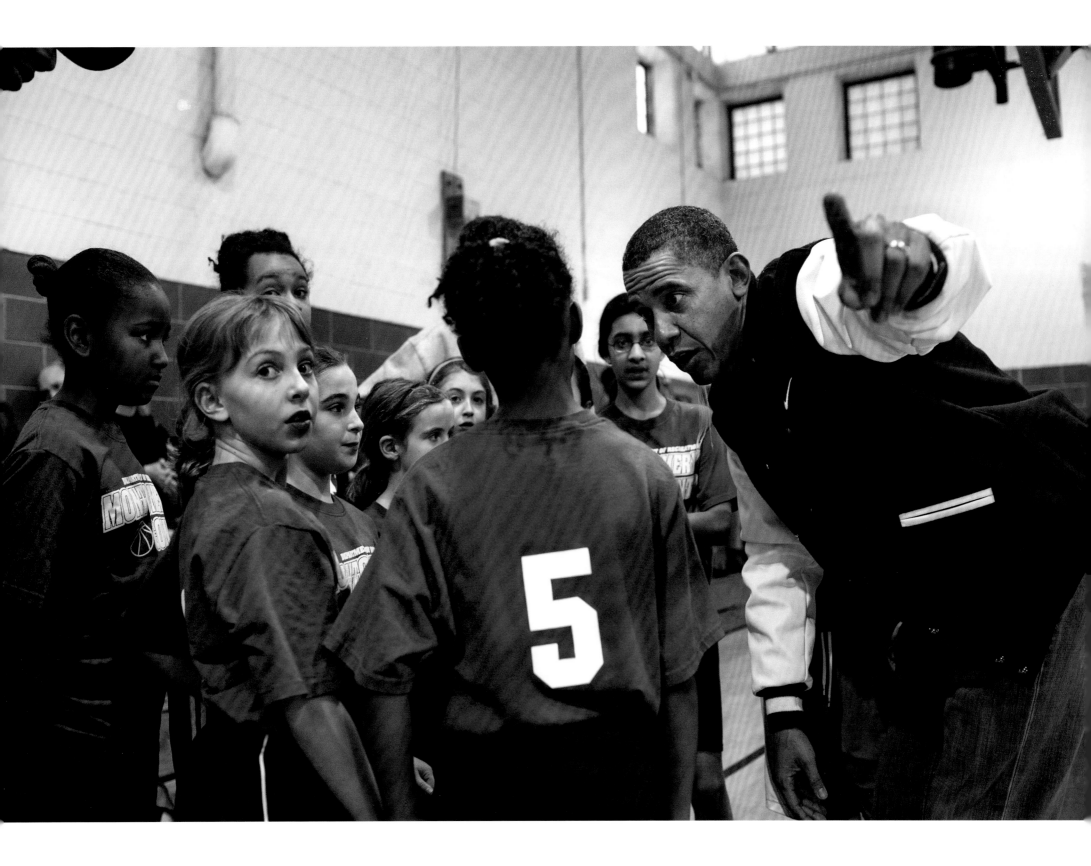

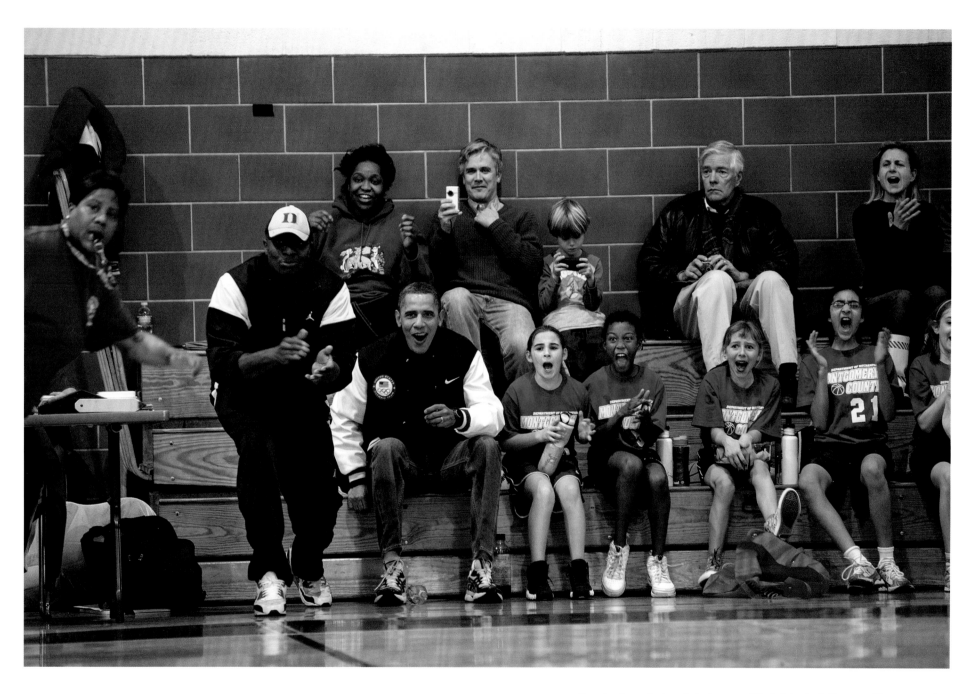

Reacting from the bench during one of Sasha's basketball games. The two coaches for her team—the Sidwell Friends Vipers—couldn't make it to the game, so the President and Reggie Love filled in. *February 5, 2011*

OPPOSITE: Coach Obama giving the team instructions during a time-out. *February 5, 2011*

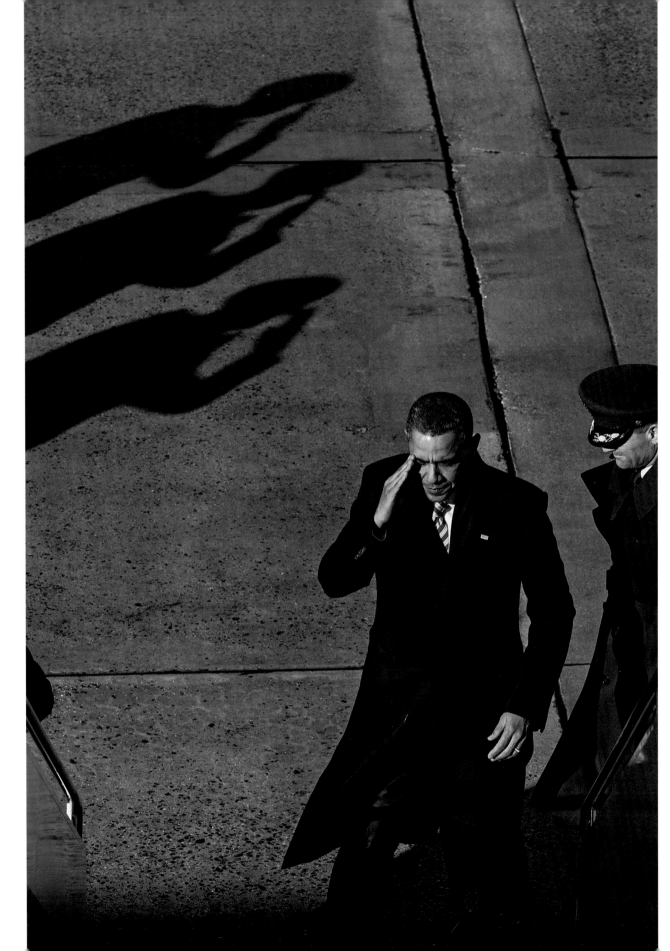

Saluting the Phoenix Ravens
who guard *Air Force One*.
February 10, 2011

OPPOSITE: Making a
point during a phone call.
February 17, 2011

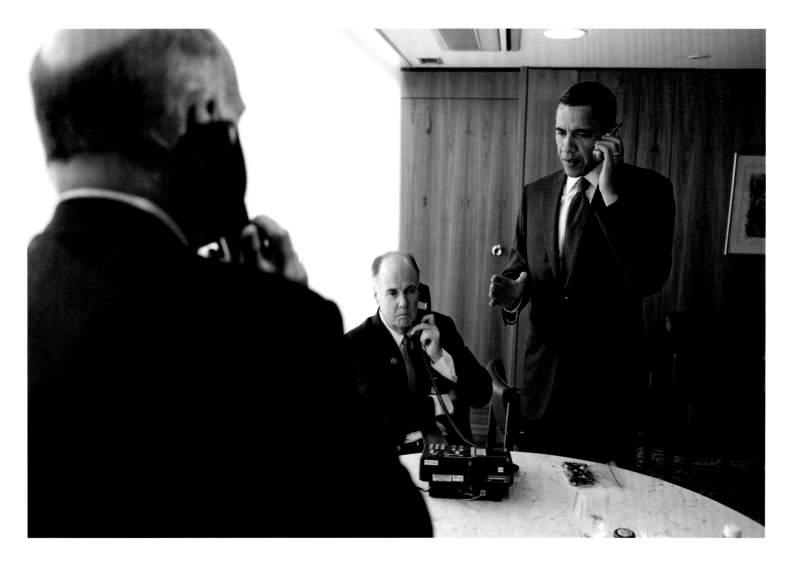

While in Brazil, giving the authorization to
begin a limited military action in Libya in support of an
international effort to protect Libyan civilians. *March 19, 2011*

OPPOSITE: A fist-bump with a boy in the Cidade de Deus
favela in Rio de Janeiro, Brazil. *March 20, 2011*

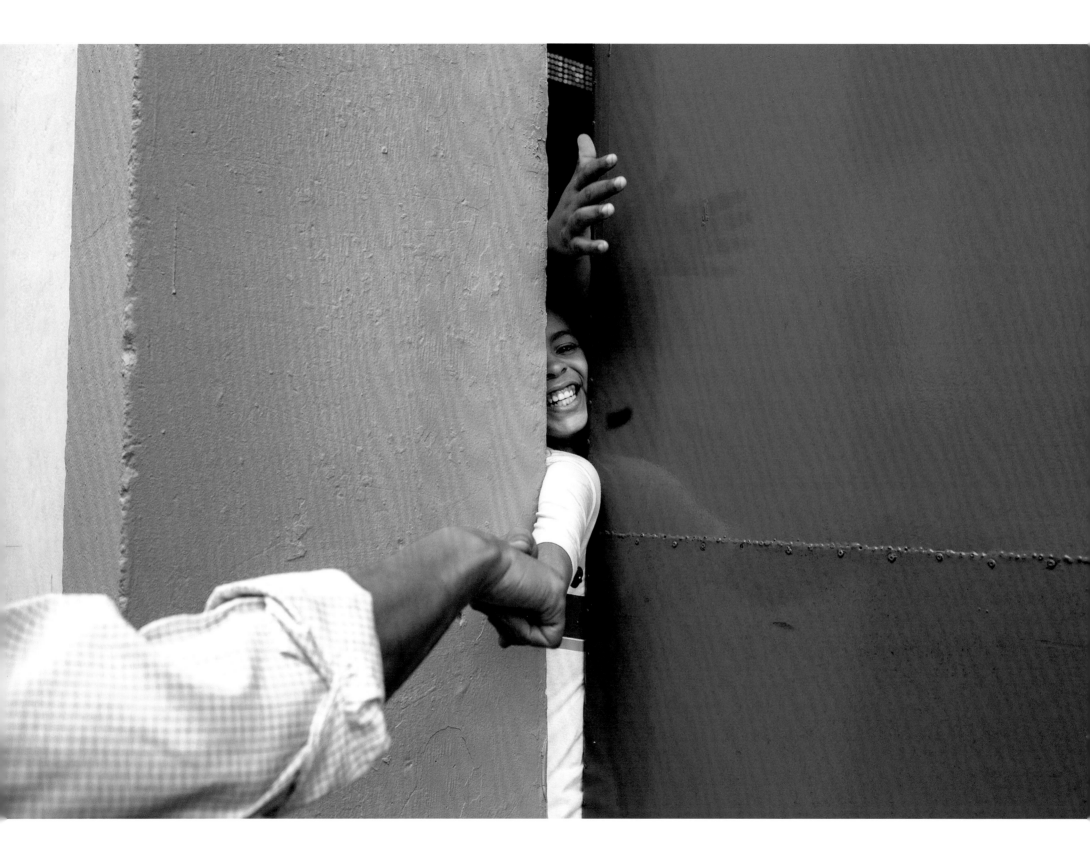

Visiting the Christ the Redeemer statue atop Corcovado Mountain, which overlooks Rio de Janeiro. The Obama family was scheduled to see it before dinner, but when heavy fog rolled in, they canceled the visit. After dinner, the fog had dissipated, and they received word that it would be safe to drive up the mountain. By then, it was late, and some suggested they call it a night. But someone else remarked that they might never get this chance again. So off we went. The sky was clear when we arrived, and then the fog magically rolled back in. *March 20, 2011*

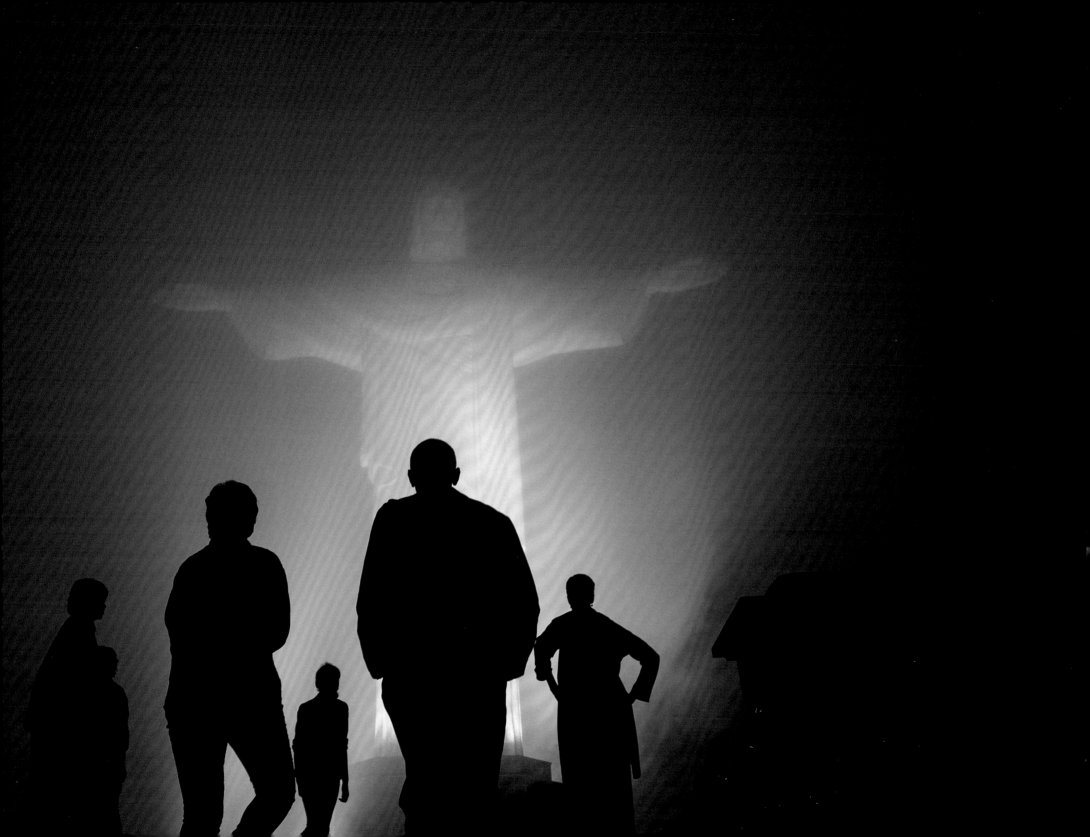

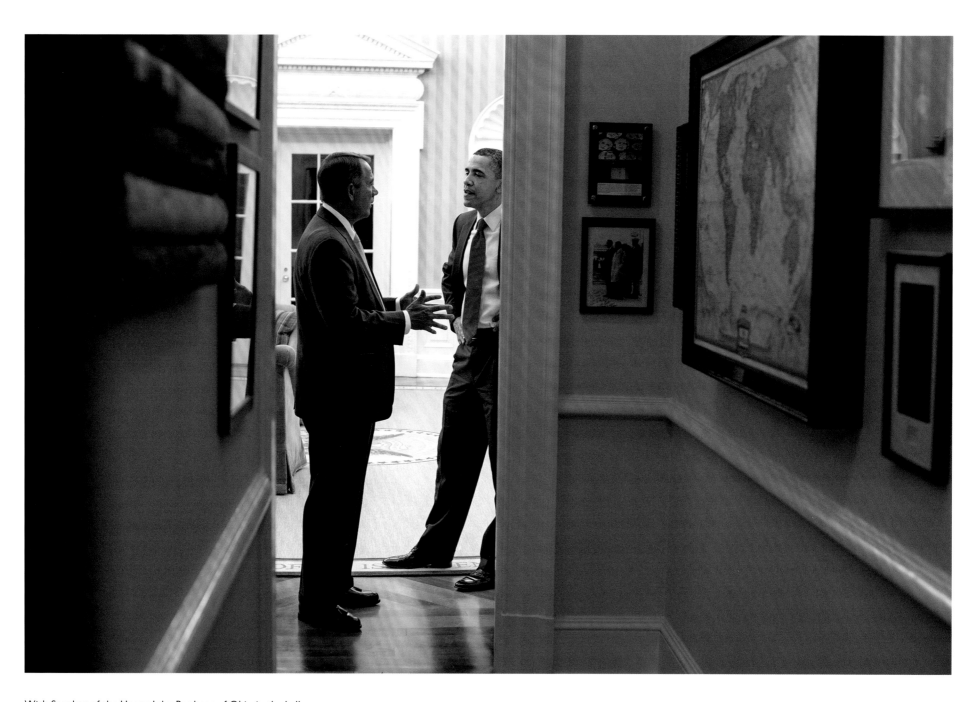

With Speaker of the House John Boehner of Ohio in the hallway
between the Oval Office and the private dining room, after a late-night
budget meeting with Congressional leaders. *April 6, 2011*

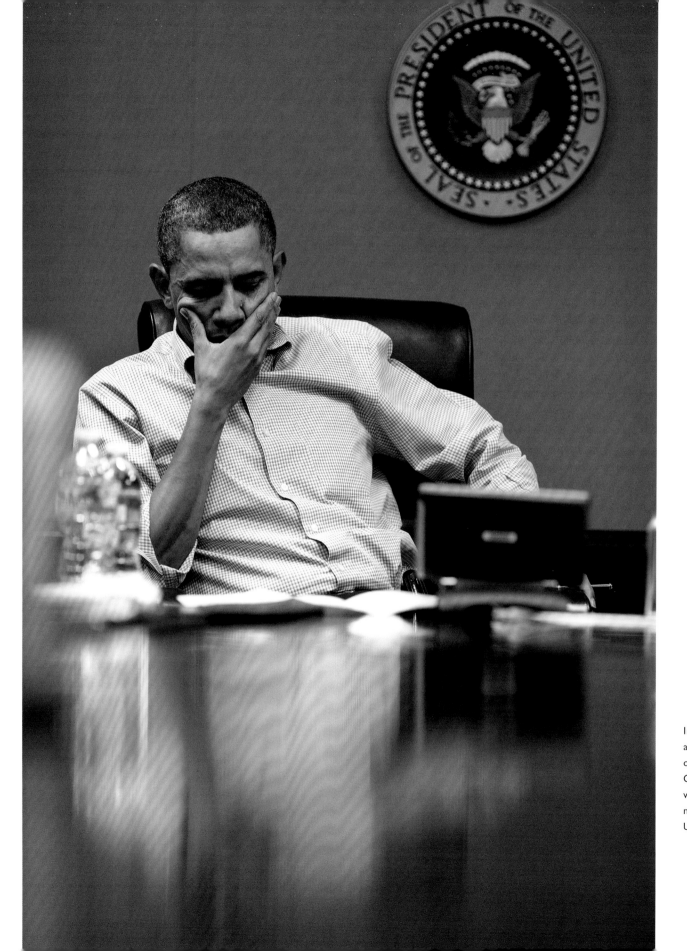

In the Situation Room on
a Saturday, during a discussion
of unfolding events in Libya.
On Monday, the President
would address the
nation, stating the limits of the
U.S. role. *March 26, 2011*

127

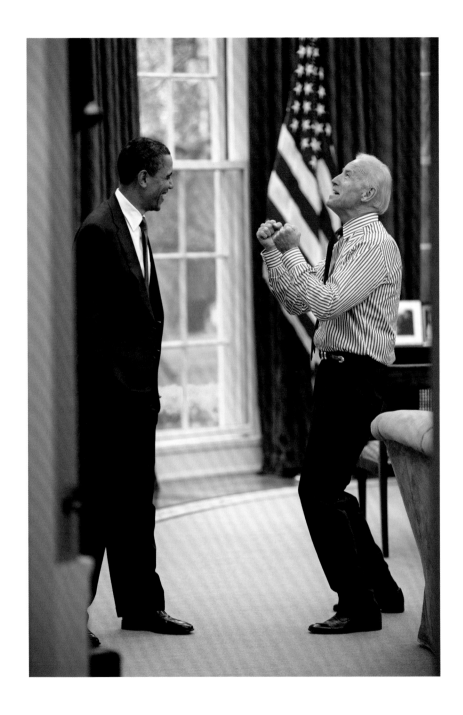

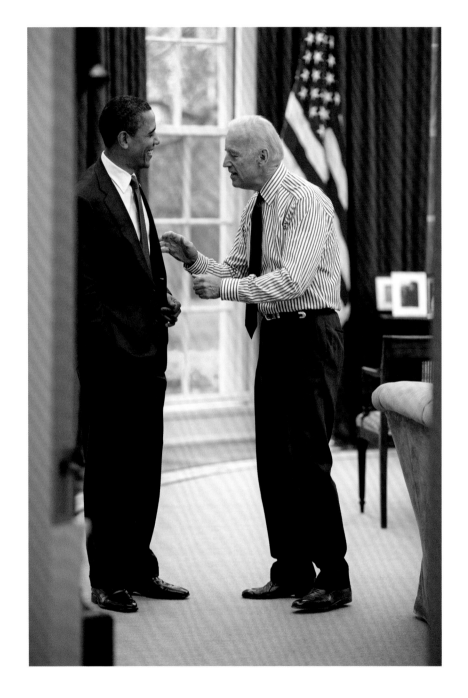

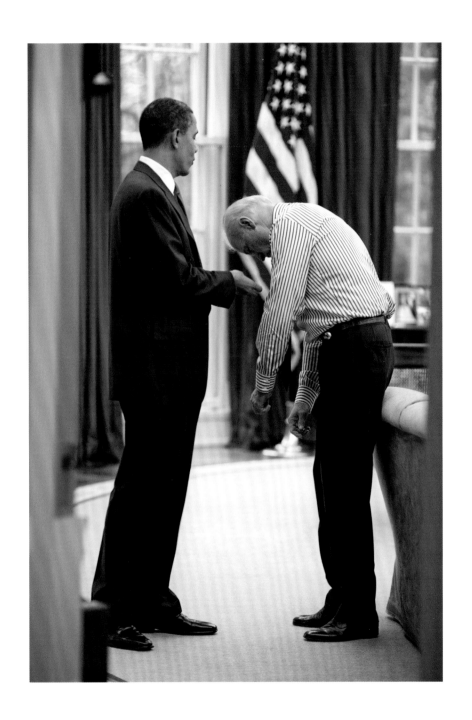

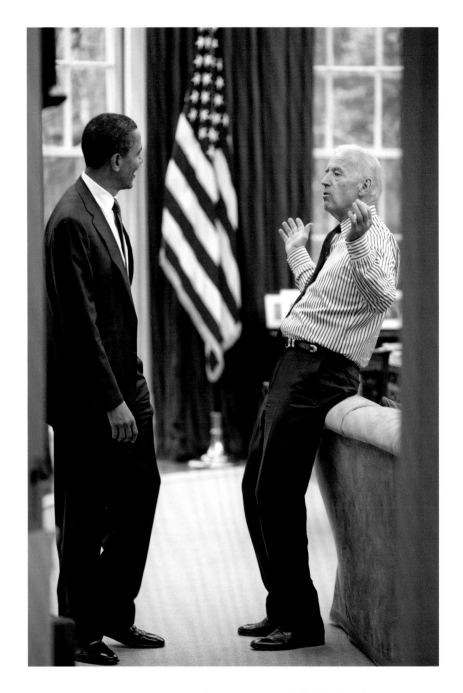

A conversation with the Vice President. *April 8, 2011*

THE OSAMA BIN LADEN RAID

In late April of 2011, an aide to Homeland Security Advisor John Brennan told me to be on standby. Something important would culminate within the next several days. She didn't give details.

As the weekend approached, the President kept to a normal schedule, attending the White House Correspondents' Dinner on Saturday night and heading out for a golf outing on Sunday, May 1. Although he usually played a full 18 holes, he only played nine that day. The press pool report speculated why: "Golf cut short due to chilly weather and rain."

Back at the White House, the President headed directly to the Situation Room, still wearing his golf attire. Principals of the National Security Council were seated around a long table.

National Security Advisor Tom Donilon began the meeting at 2:06 p.m., and the group immediately began discussing a special-operations mission about to commence—to capture or kill Osama bin Laden.

It was the first I had heard of this. I managed to keep my demeanor calm while my adrenaline surged. We were going after bin Laden! The terrorist attacks on September 11, 2001, were the Pearl Harbor moment of my generation. The man responsible—bin Laden—was still on the run. We had launched a war in Afghanistan because of him. And, indirectly, 9/11 had spurred the Bush administration to go to war with Iraq.

Now, almost ten years later, the President and his National Security team were carefully discussing the last-minute details of this mission to take him down. At 2:29 p.m., the President left the meeting, just as two helicopters departed from Afghanistan to fly across the border into Pakistan, where intelligence officials believed they had pinpointed bin Laden's compound.

I followed the President upstairs to the Oval Office. "You know," he said, turning back toward me, "all hell could break loose today."

His decision was risky in so many ways. If the Navy SEAL mission went awry, American lives could be lost. It would be seen as a colossal failure and his entire Presidency would be in jeopardy. It was clear to me that the pictures I would make this day— whether the outcome was good or bad—would become an important part of history.

At 3:27 p.m., the President returned to the Sit Room to rejoin his National Security team. But he did not sit down. Communications linking the mission in Pakistan to the Sit Room had been set up in a small conference room across the hall.

Already seated at the table in the smaller room was Brigadier General Brad Webb, the assistant commanding general of Joint Special Operations Command, who was handling the special-ops communications linkup to Washington. He was about to give up his chair at the head of the table to the President, but the President told him to stay where he was. The President then pulled up an ordinary chair next to General Webb.

While everyone was crowding into the smaller room, I had to make a snap judgment about which side of the table to be on. I wouldn't be able to move around; it was that tight in the room.

I chose the left side and went as far back into the corner as I could. My rear end was pressed up against a laser printer, and I was adjacent to the screen that everyone watched as video streamed in from Pakistan.

At 4:05 p.m., I made frame number 210 of the day, the image that has become known as "the Situation Room photograph." Everyone's eyes were glued to the screen. The President leaned forward in his chair, intently watching what was taking place. Anxiety was high. Once the President had made the final decision to go forward with the raid, there was nothing he or anyone else in that room could do to influence the outcome.

Several minutes later, "Geronimo, KIA" came over the audio feed. "Gerinomo" was the code name for bin Laden; "KIA" meant "killed in action."

Tension ratcheted up as the group waited for the helicopters to lift off from the compound with bin Laden's body aboard. One, we now know, had crash-landed earlier and was being destroyed and left behind.

The helicopters departed, and at 4:13 p.m., the President stood up to shake hands with General Webb and a few others. There was no cheering or fist-bumping; it was an oddly subdued reaction to a historic moment.

Later, the President would say this was the tensest 40 minutes of his life.

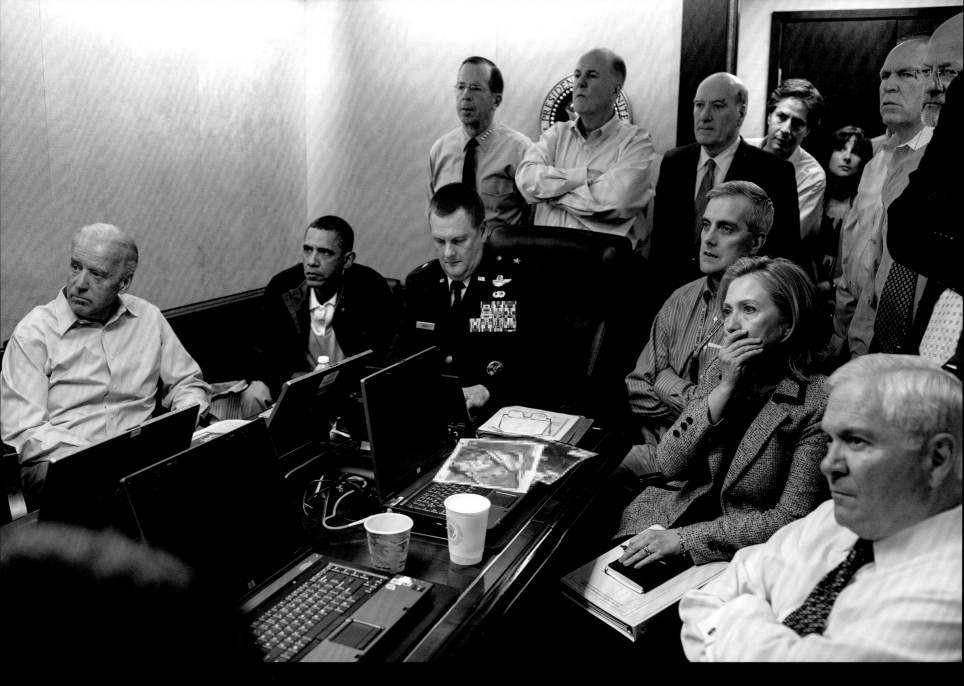

Monitoring the mission in real time with his National Security team. *4:05 p.m., May 1, 2011*

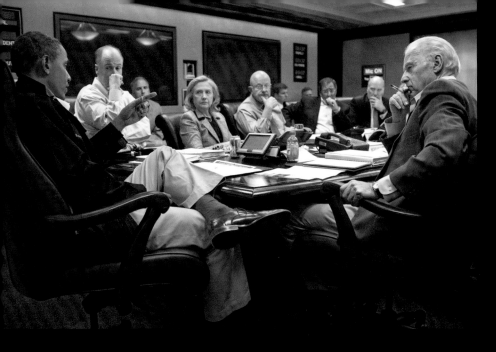

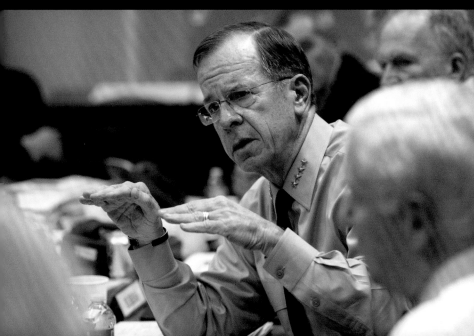
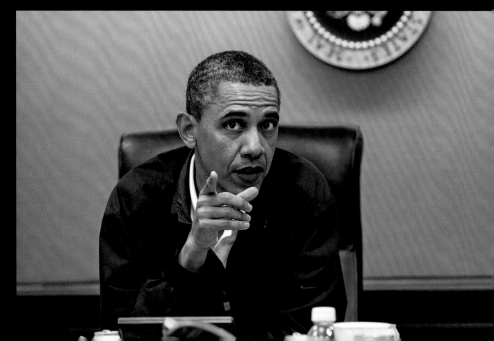

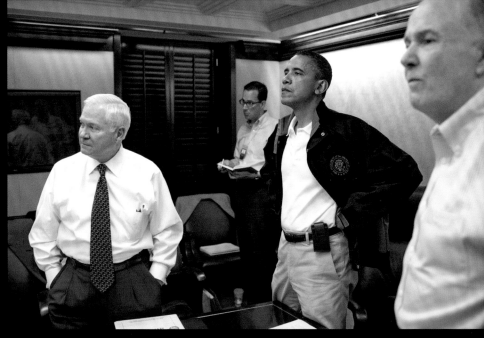
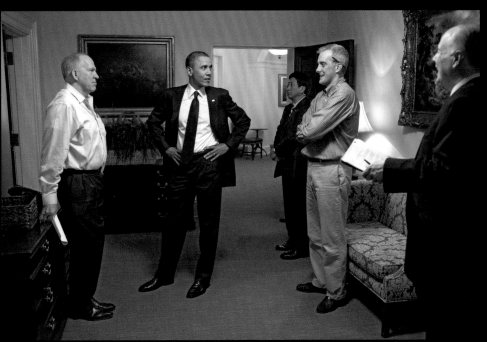
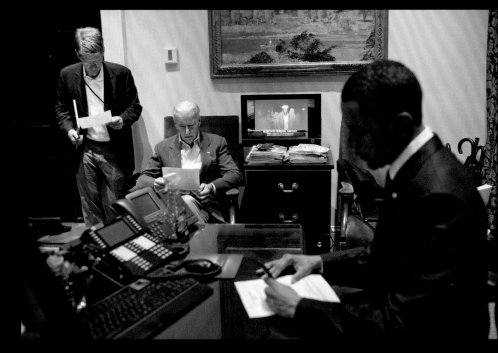

Meeting throughout the day and night, both before and after the special-forces mission. 2:25 p.m. to 11:16 p.m., May 1, 2011

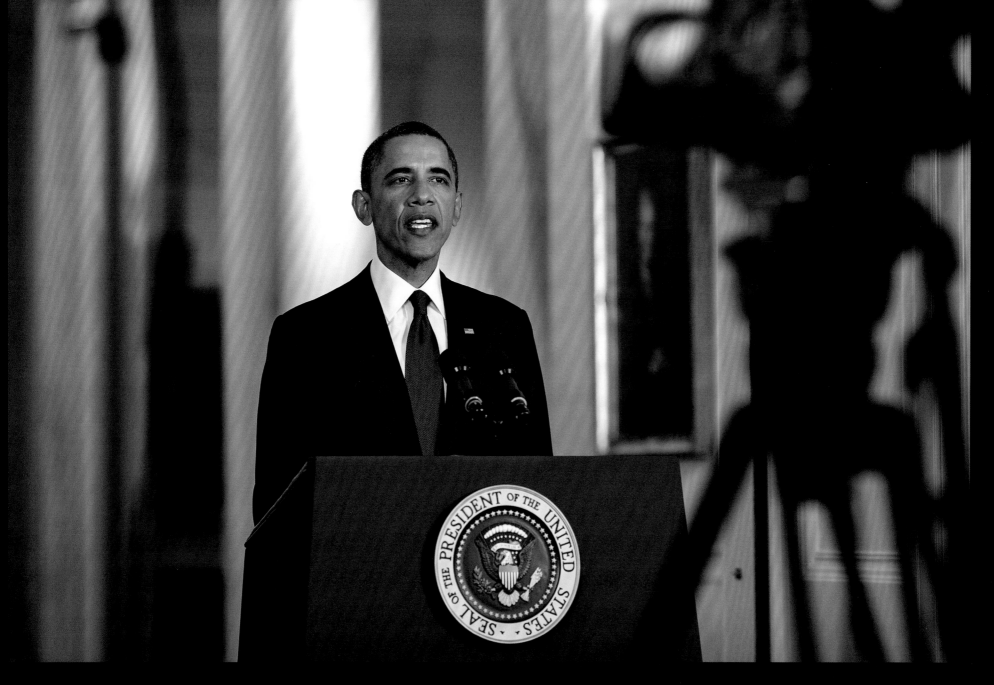
Delivering his live address, confirming the death of bin Laden. *11:42 p.m., May 1, 2011*

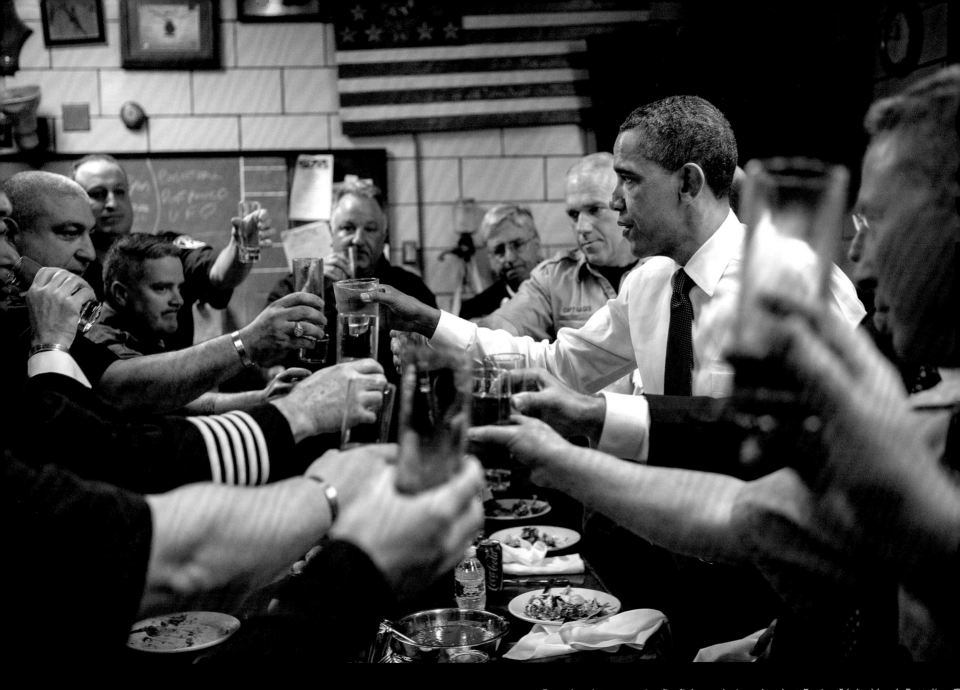

Four days later, toasting firefighters during a lunch at Engine 54, Ladder 4, Battalion ▼ Firehouse in New York City. The firehouse, known as the Pride of Midtown, los 15 firefighters on 9/11—an entire shift, more than any other New York firehouse. May 5, 201

6

A TOAST TO QUEEN ELIZABETH II

DEVASTATION FROM AN F5 TORNADO

THE BABY WHISPERER IS BORN

SQUIRT-GUN FIGHT AT CAMP DAVID

ON THE BRINK OF DEFAULT

After a meeting with Prime Minister Benjamin Netanyahu of Israel in the Oval Office, the President imparted a few last words while walking him to his motorcade. *June 20, 2011*

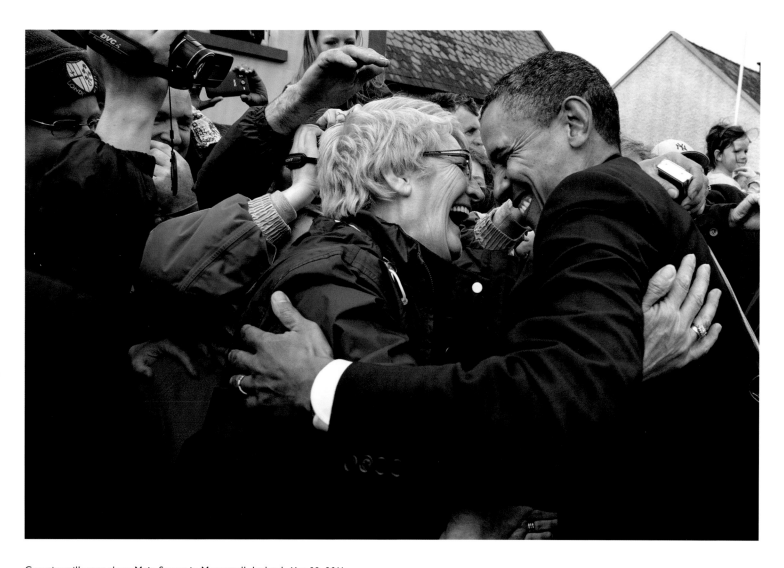

Greeting villagers along Main Street in Moneygall, Ireland. *May 23, 2011*

OPPOSITE: Toasting Queen Elizabeth II during a dinner in
her honor at Winfield House in London. *May 25, 2011*

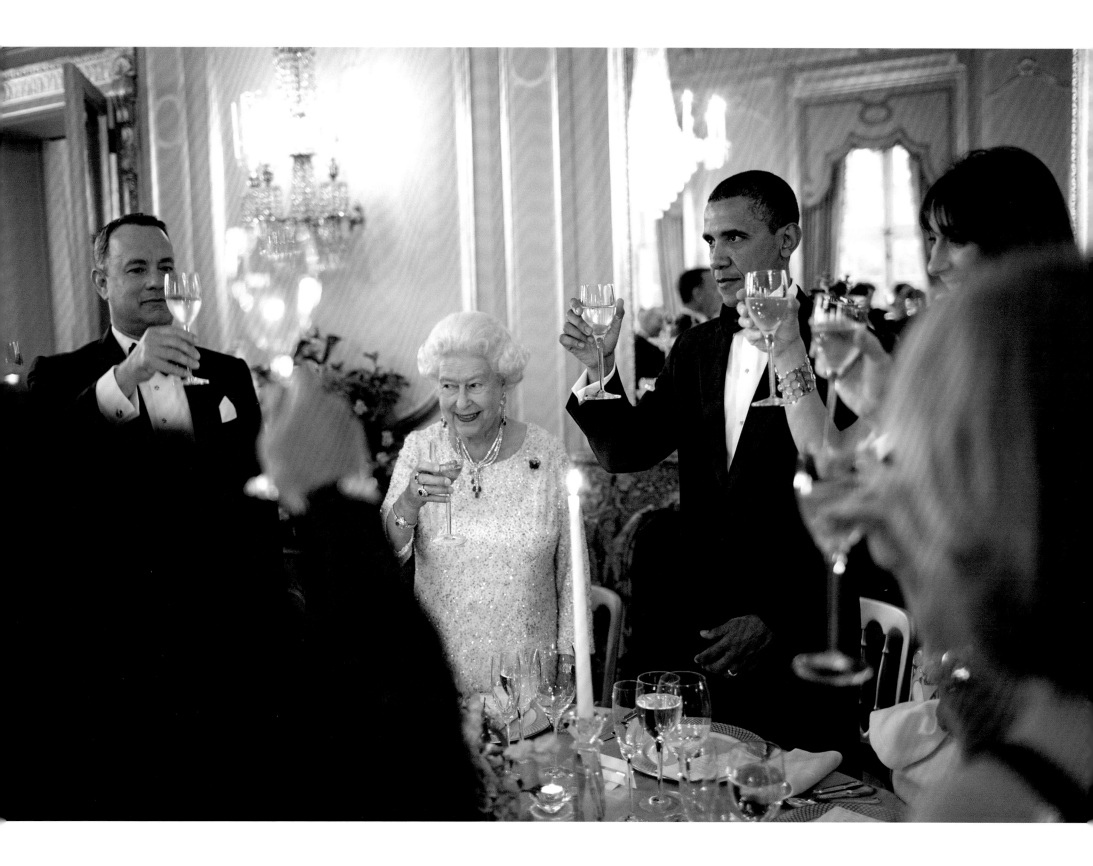

Meeting Hugh Hills, 85, in front of his home in Joplin, Missouri, several days after
an F5 tornado devastated the city and caused more than 150 fatalities and
more than 1,000 injuries. Hills hid in a closet during the tornado, which destroyed
the second floor and half the first floor of his house. *May 29, 2011*

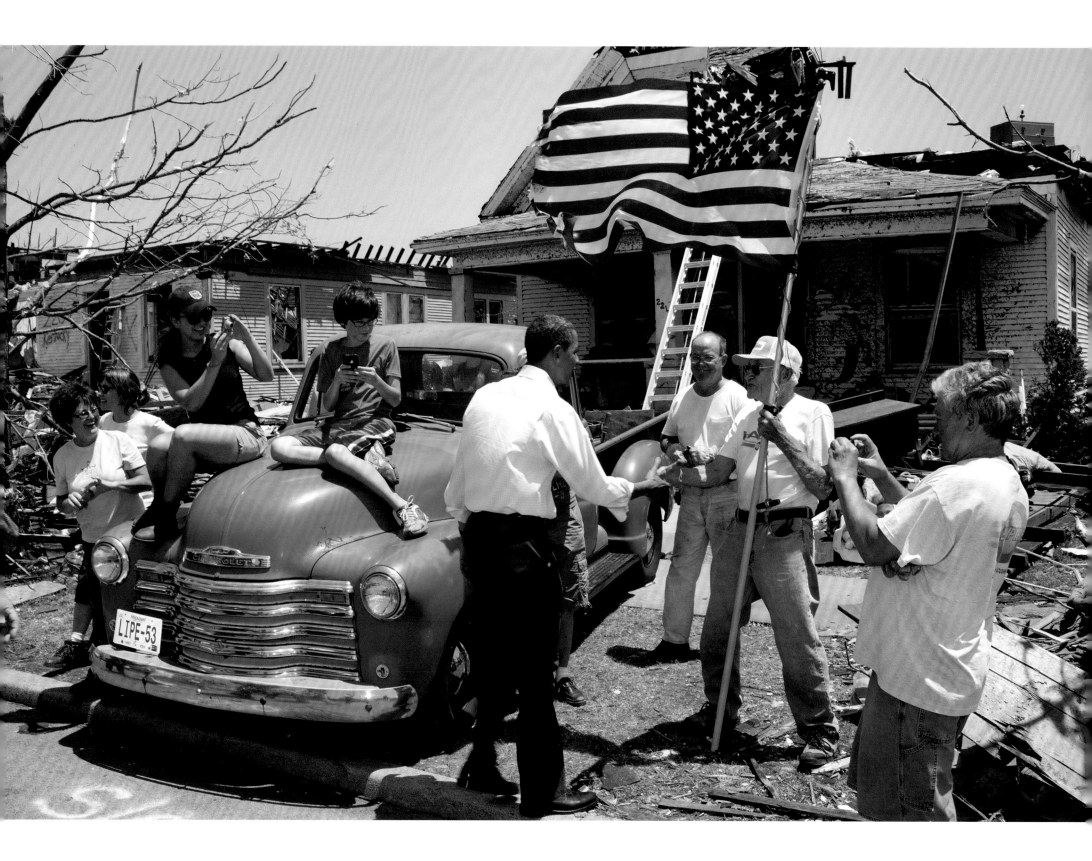

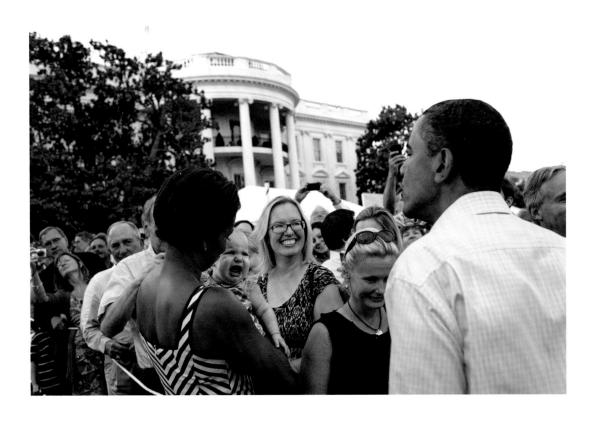

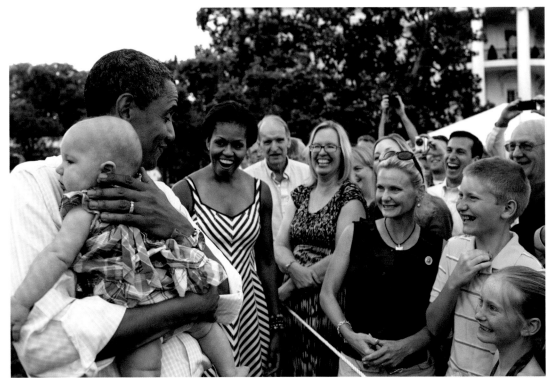

Becoming the official baby whisperer of the Obama family at the Congressional picnic at the White House. *June 15, 2011*

OPPOSITE: Greeting kids at a day-care center in Bethesda, Maryland. The President had traveled to Sasha's school for her fourth-grade end-of-the-year ceremony and spotted the kids next door looking out the window. *June 9, 2011*

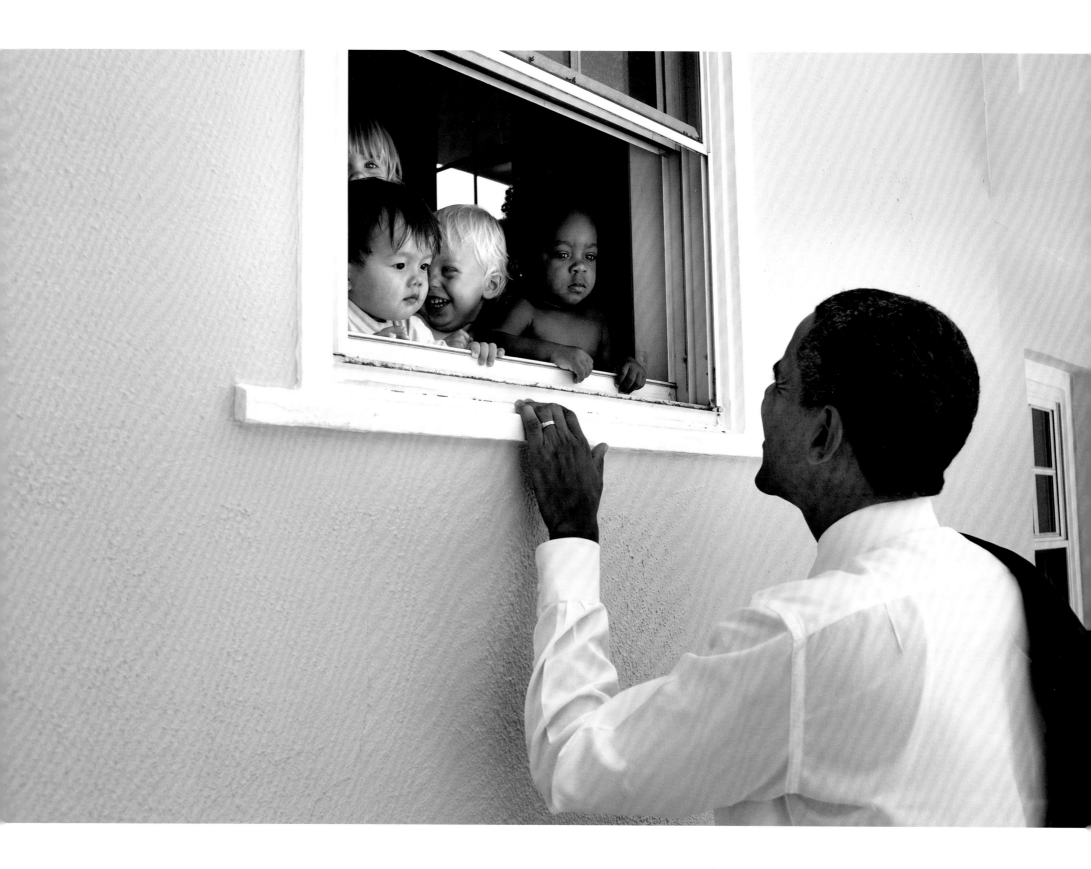

Sasha's tenth birthday party, at Camp David, Maryland. *June 11, 2011*

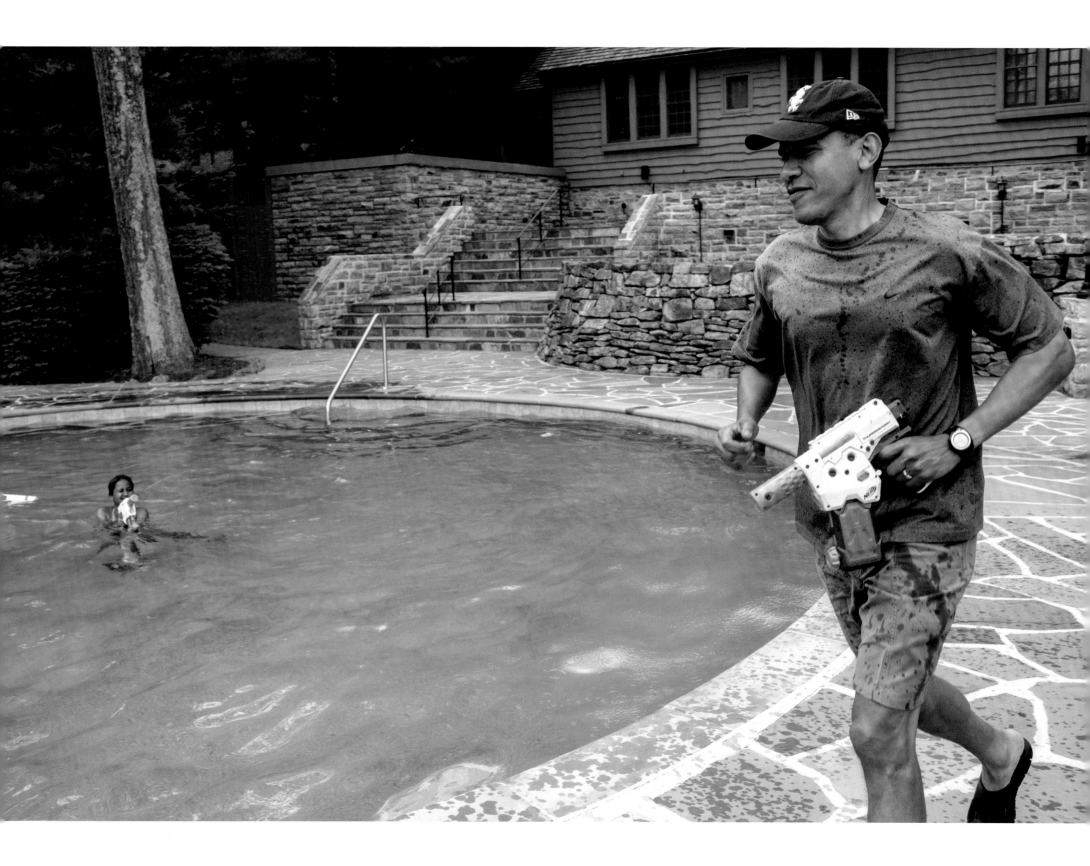

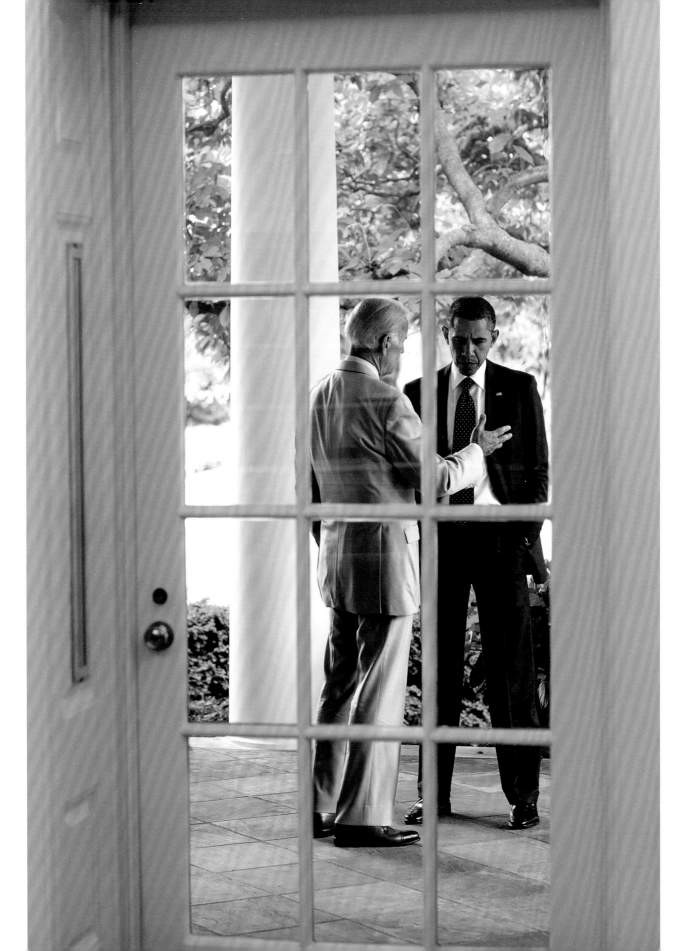

On the Colonnade with
the Vice President. *June 20, 2011*

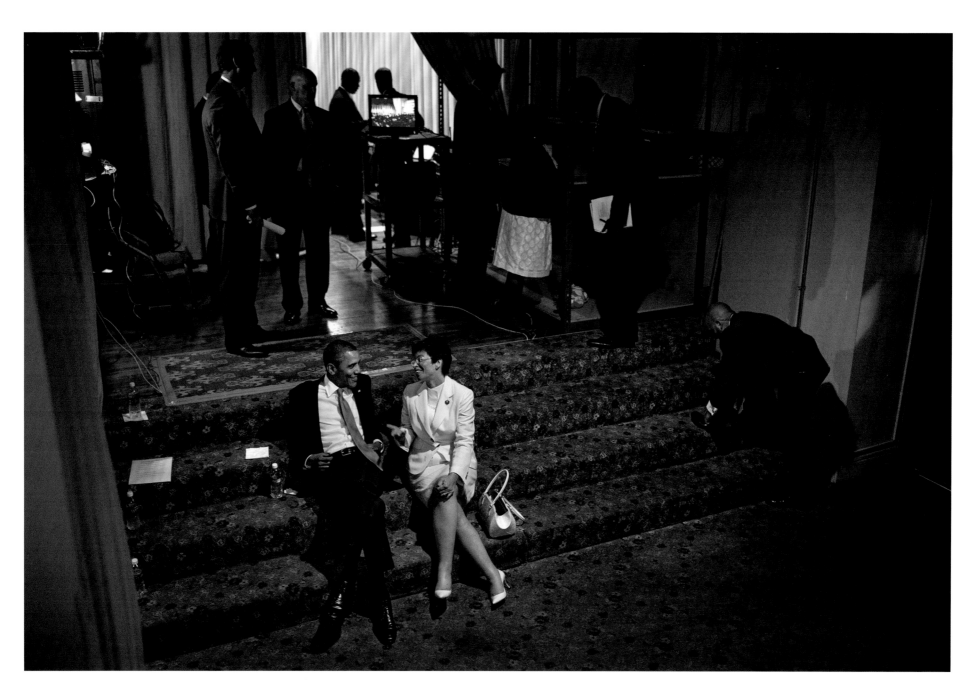

Backstage with senior advisor Valerie Jarrett before
a political event in Philadelphia. *June 30, 2011*

Boarding *Marine One* en route to Camp David for
the July Fourth holiday weekend. *July 1, 2011*

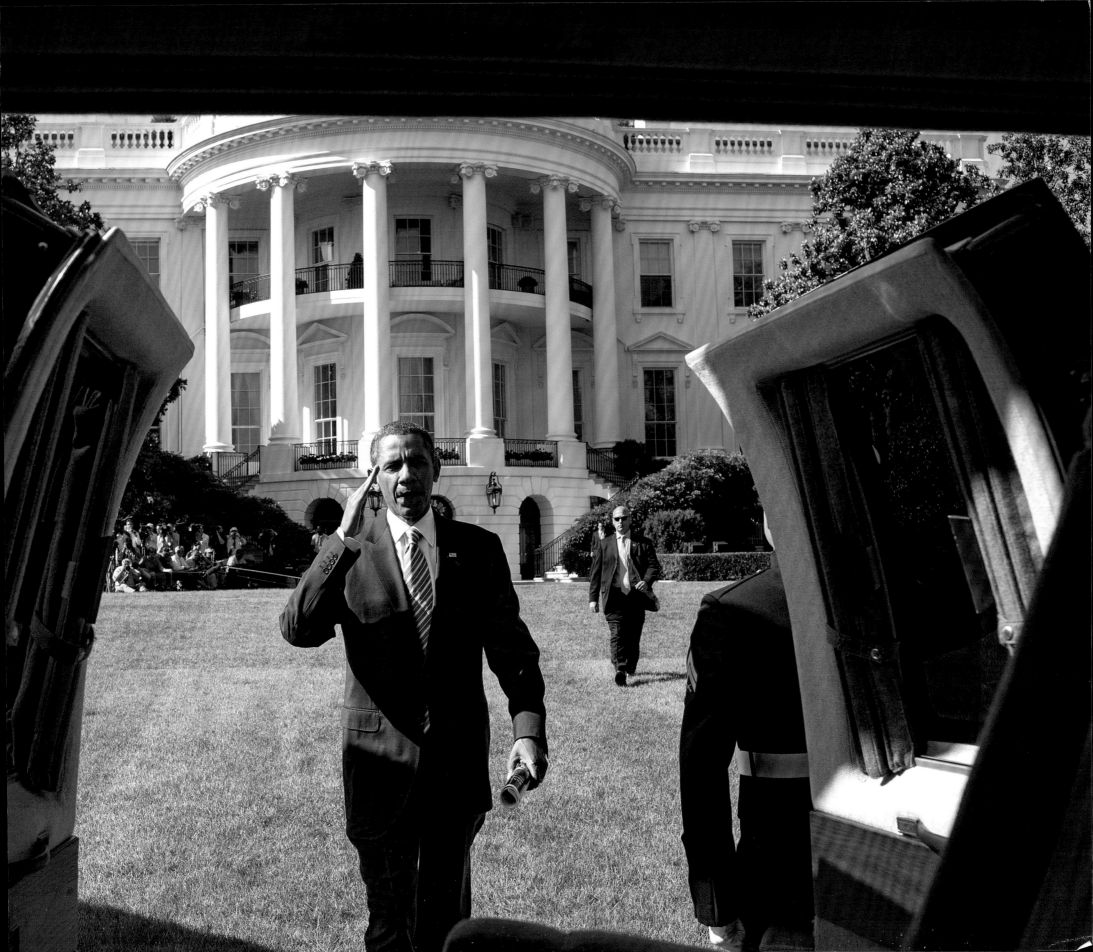

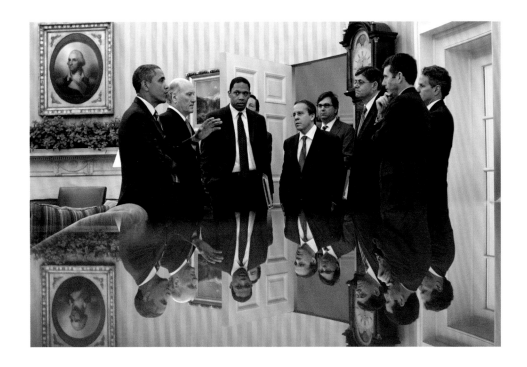

ON THE BRINK OF DEFAULT

In the summer of 2011, as part of a series of escalating confrontations, Congressional Republicans warned the President that they would not raise the country's debt ceiling unless he was willing to negotiate over deficit reductions. Raising the debt ceiling would allow the U.S. Treasury to borrow money to pay for spending that had already been approved. It had nothing to do with deficit reduction or curbing additional government spending.

If the United States were to breach its debt ceiling, the Treasury would default on payments to its creditors and thrust the country into economic crisis. Social Security checks would be halted. Global markets would be thrown into flux.

The government had never defaulted on its payment; it was unspeakable for Congress to even consider doing so. But that July, Congressional Republicans were using the debt ceiling as a form of blatant political blackmail. The next few weeks were dominated by this issue as the President met constantly to try to reason with leaders in Congress, and with his economic team to prepare for the worst-case scenario of default. This is what governing looks like. *(Photographs continue through page 155.)*

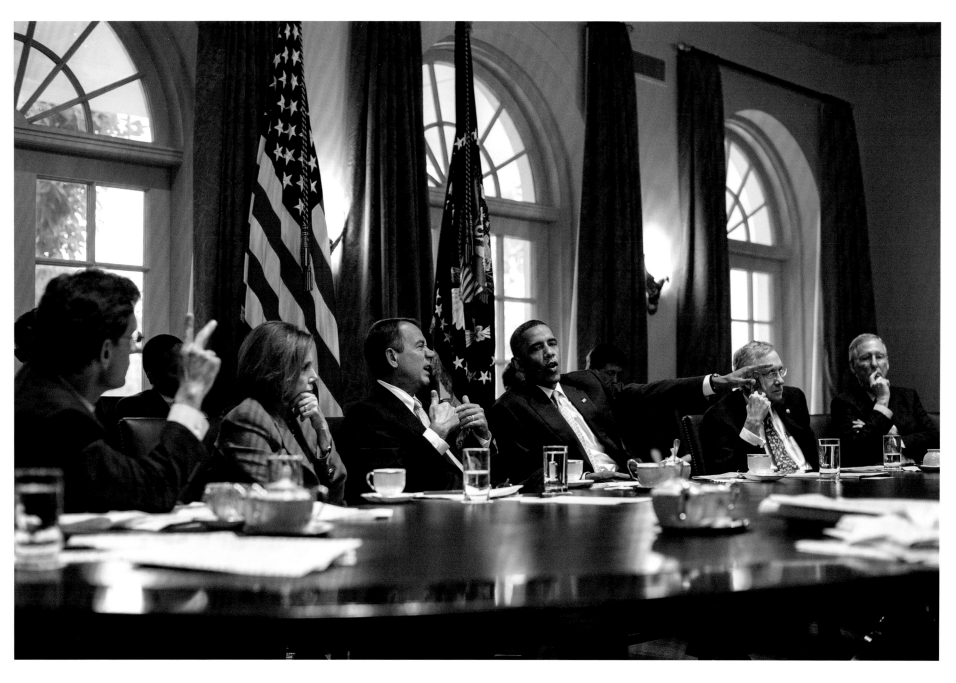

Arguing with Speaker Boehner during a meeting
with Congressional leaders. *July 13, 2011*

OPPOSITE: With his economic team following
a Congressional meeting. *July 7, 2011*

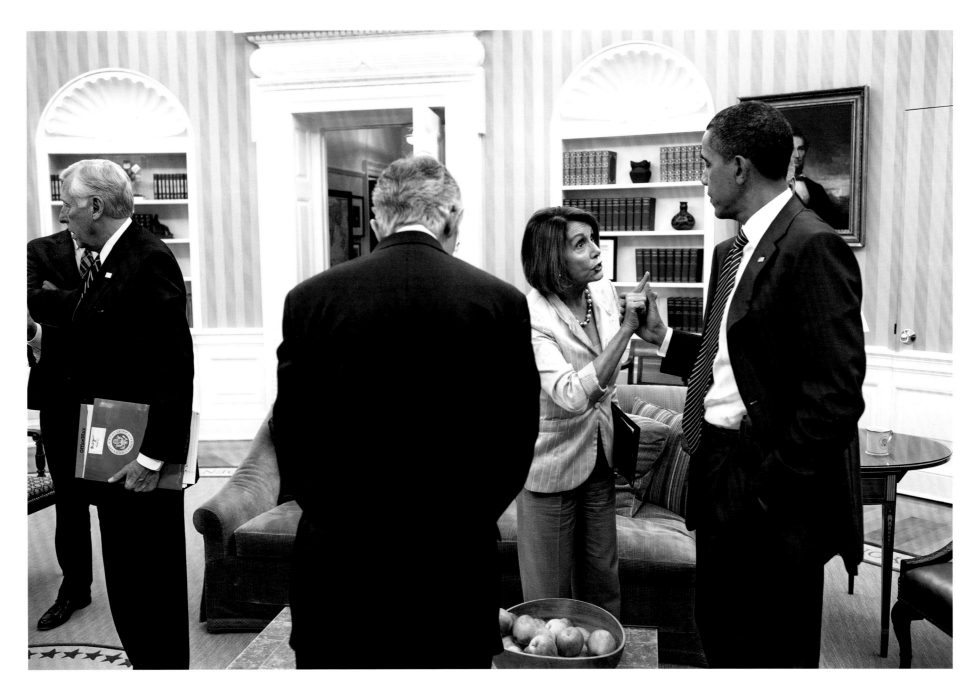

With Nancy Pelosi after a meeting with Congressional Democrats. *July 21, 2011*

OPPOSITE: On the South Grounds of the White House with the Vice President during a
break in the debt ceiling negotiations. *July 24, 2011*

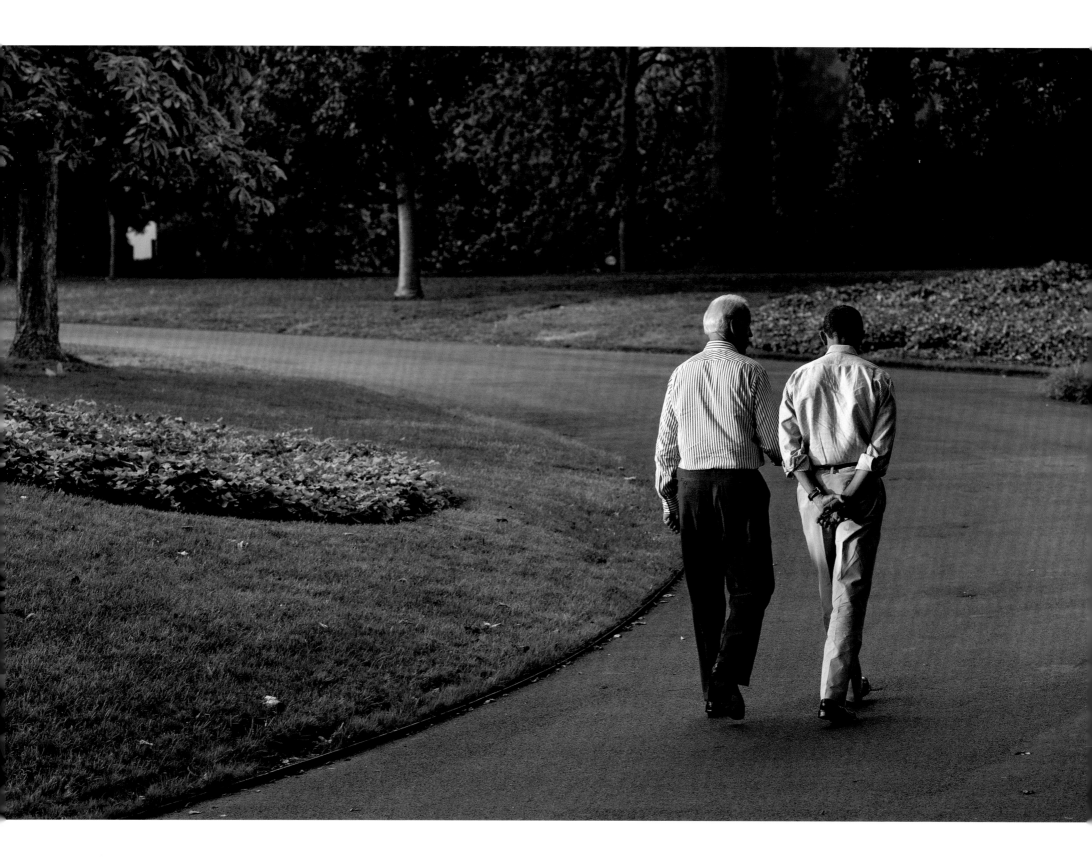

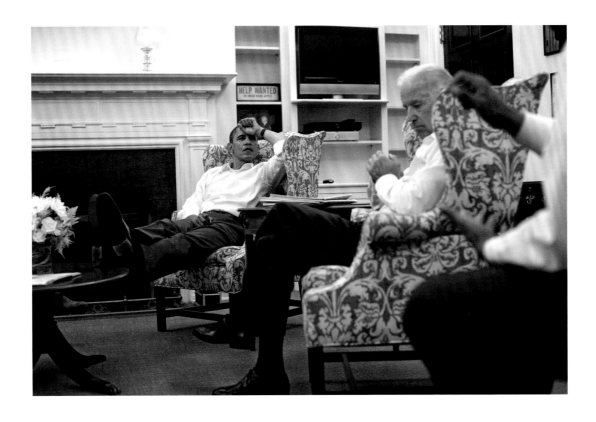

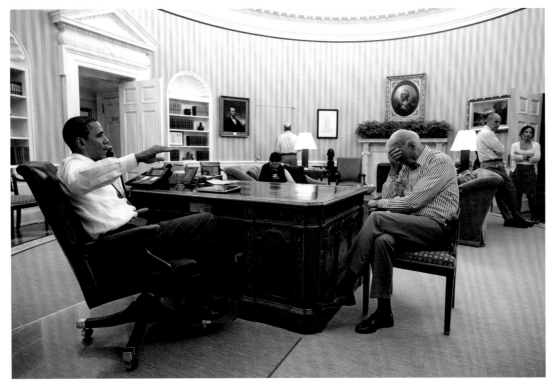

TOP: With the Vice President, listening to legislative aide Rob Nabors as the deadline neared for the nation to default. *July 30, 2011*

BOTTOM: On the phone, trying to reason with Speaker Boehner as the deadline loomed. *July 31, 2011*

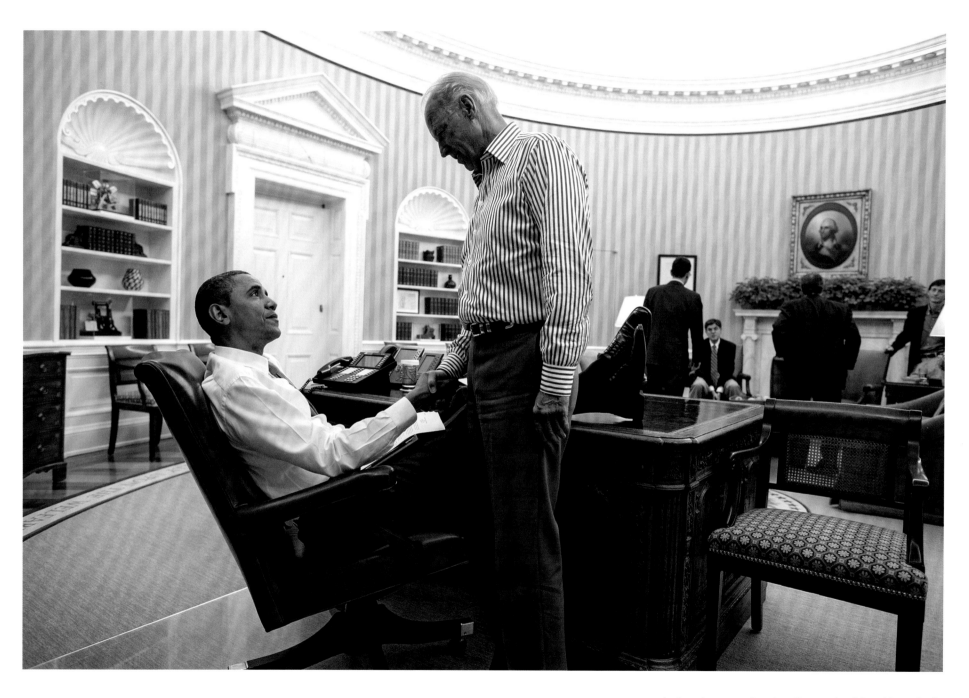

An hour later, reacting after Congressional Republicans finally
agreed not to let the country default. *July 31, 2011*

7

GRIEVING ON THE TENTH ANNIVERSARY OF 9/11

THE FIRST LADY BECOMES A MAJORETTE

A FAMILY VISIT TO THE NEW MLK MEMORIAL

AN IMPROMPTU SONG FROM BONO

CHRISTMAS SHOPPING WITH BO

SITTING ON THE ROSA PARKS BUS

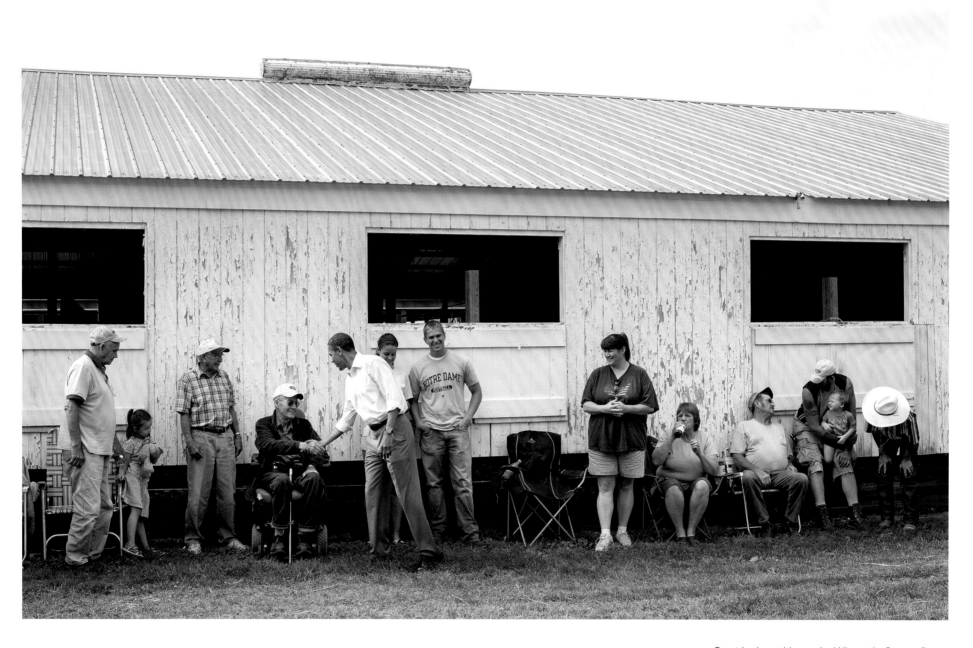

Outside the stables at the Whiteside County Fair in Morrison, Illinois, during a three-day bus tour of the Midwest to promote his economic agenda. *August 17, 2011*

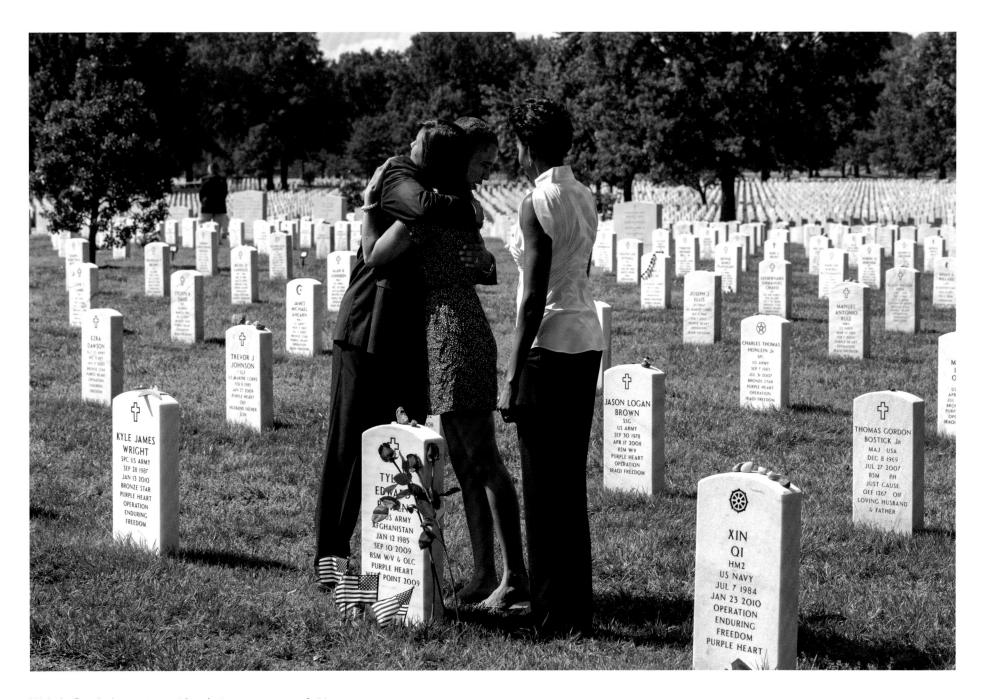

With the First Lady, greeting a widow during an unannounced visit to
Section 60 of Arlington National Cemetery, Virginia, the day before 9/11.
Section 60 is reserved for military personnel who lost their lives
in Afghanistan and Iraq. *September 10, 2011*

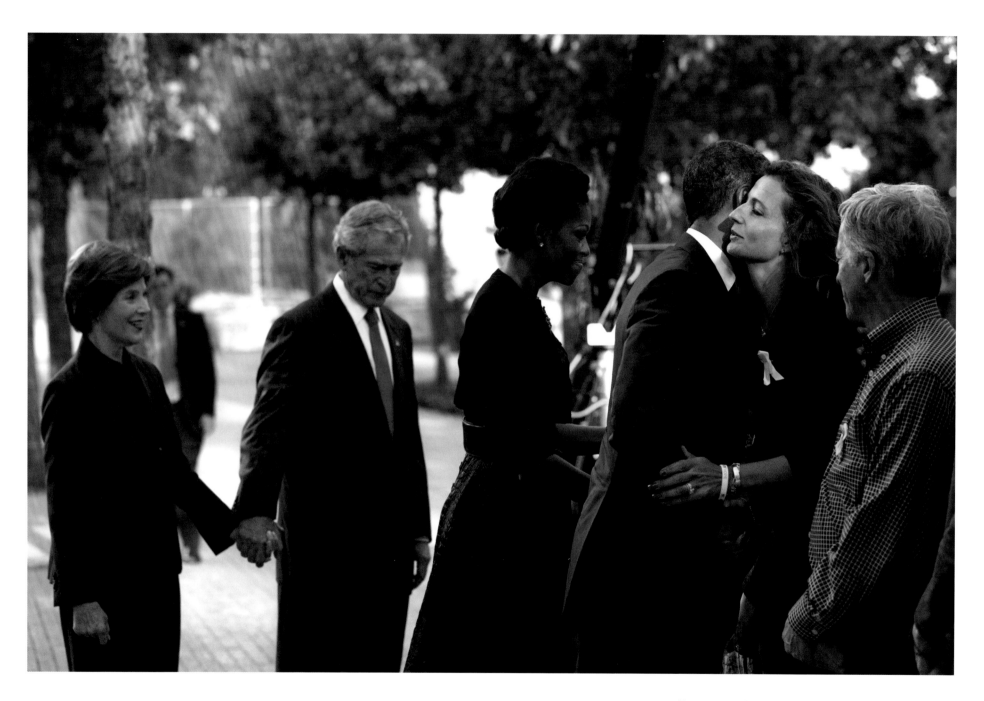

Visiting with 9/11 families, accompanied by the First Lady and former President George W. Bush and former First Lady Laura Bush, at the National September 11 Memorial, in New York. The President was at the World Trade Center site to mark the tenth anniversary of the attacks. *September 11, 2011*

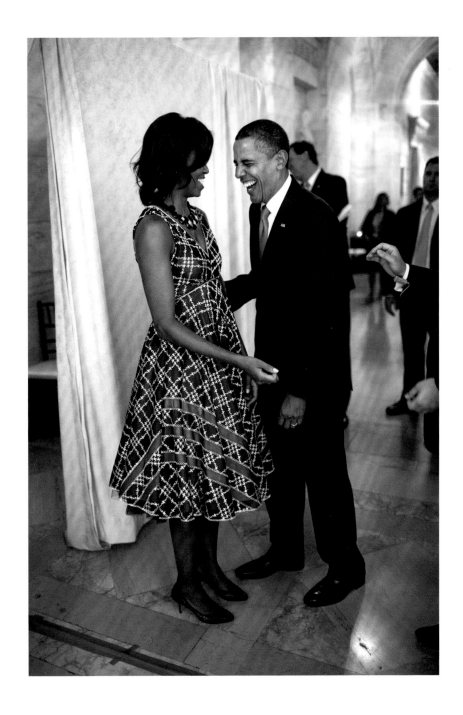
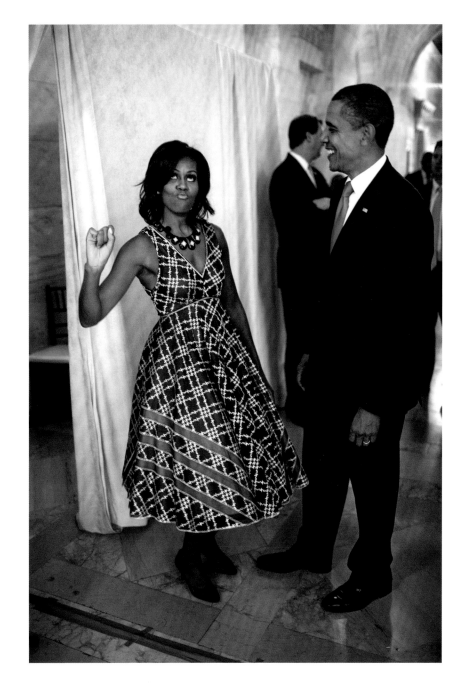

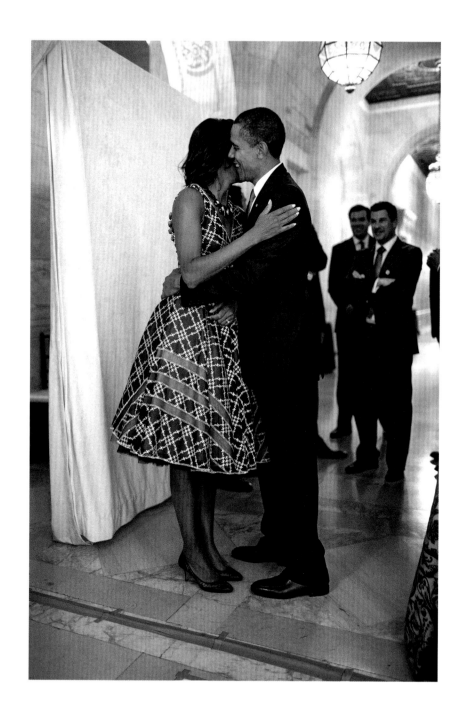

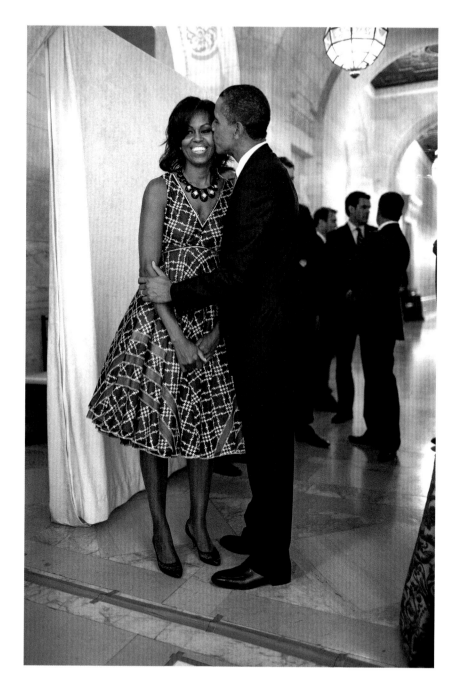

The First Lady pretending to be a majorette while a marching band played. She and the President were waiting to be introduced at a reception for the United Nations General Assembly at the New York Public Library. *September 21, 2011*

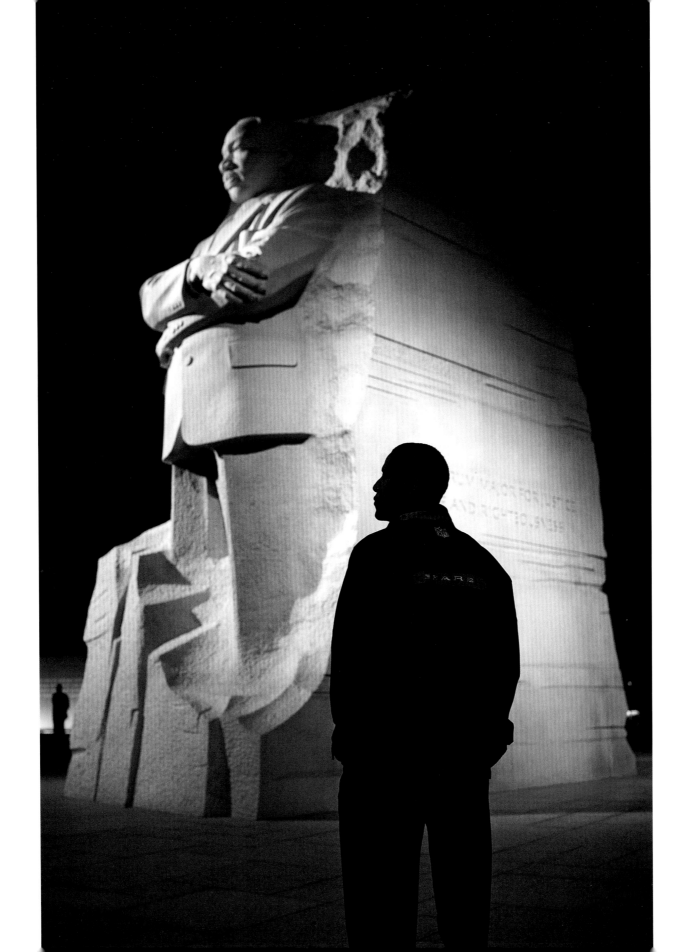

Visiting the new Martin Luther King, Jr. National Memorial, in Washington, with the First Lady and their daughters. The President would speak at its dedication two days later. "Without Dr. King's glorious words," he said, "we might not have had the courage to come as far as we have." *October 14, 2011*

SINGING FOR A CHAIR

"How cool is this?" the President asked me, incredulous, as I captured this moment. He had invited Bono, lead singer of U2, and singer-songwriter Alicia Keys to lunch in his private dining room adjacent to the Oval Office. When Bono walked in, he asked where he should sit. The President told him to sit anywhere there was a chair. Bono spotted a guitar case in the corner of the room. He opened it up to find a Rock the Vote guitar that the President had been given during the campaign. Bono quickly tuned it and started playing "Norwegian Wood," by the Beatles. Why? Because the second verse goes: "She asked me to stay / And she told me to sit anywhere / So I looked around / And I noticed there wasn't a chair." *December 1, 2011*

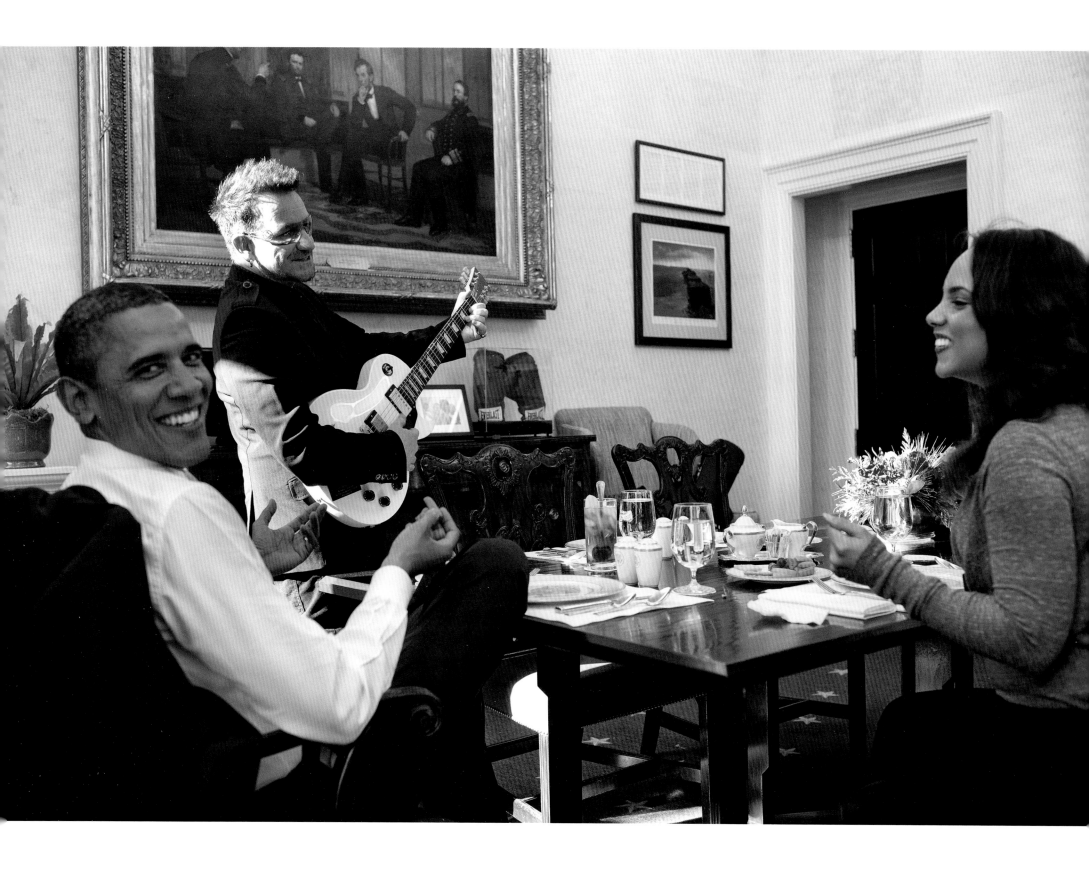

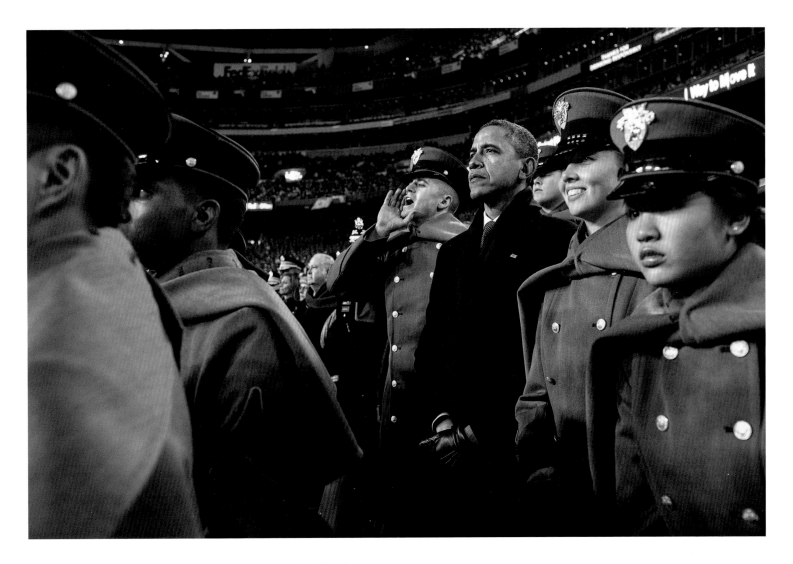

Attending the Army–Navy football game in Landover, Maryland. For the first half, he stood with the Navy Midshipmen. For the second half, shown above, he stood with the Army Cadets. *December 10, 2011*

OPPOSITE: With troops at Fort Bragg, North Carolina, marking the end of America's combat role in Iraq. *December 14, 2011*

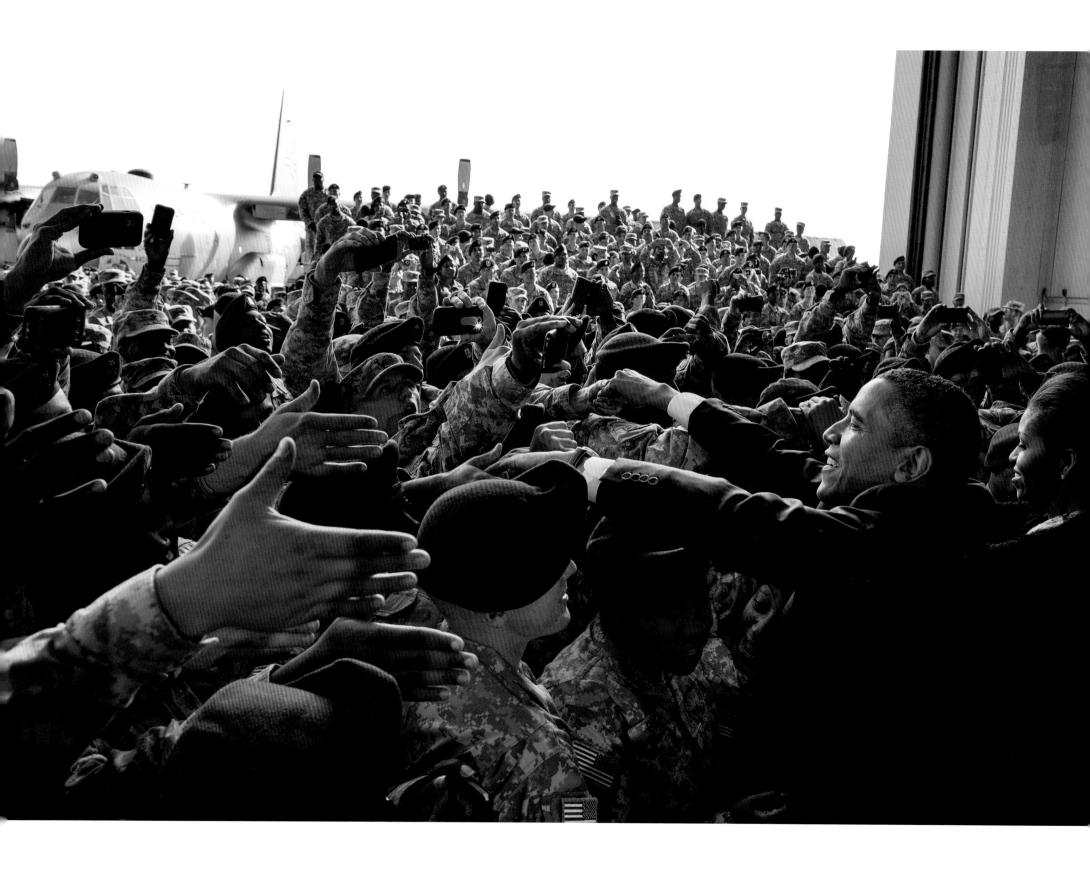

In the motorcade to go Christmas shopping. I asked the President if I could ride with him so I could photograph him with Bo. When he told me our first stop would be at PetSmart in Alexandria, I mentioned that was usually where I bought my crickets. He started laughing right away as I explained that I had a couple of lizards—a bearded dragon and a blue-tongued skink—who ate them. He teased me about that for the next five years. "How's the skink?" he would ask. *December 21, 2011*

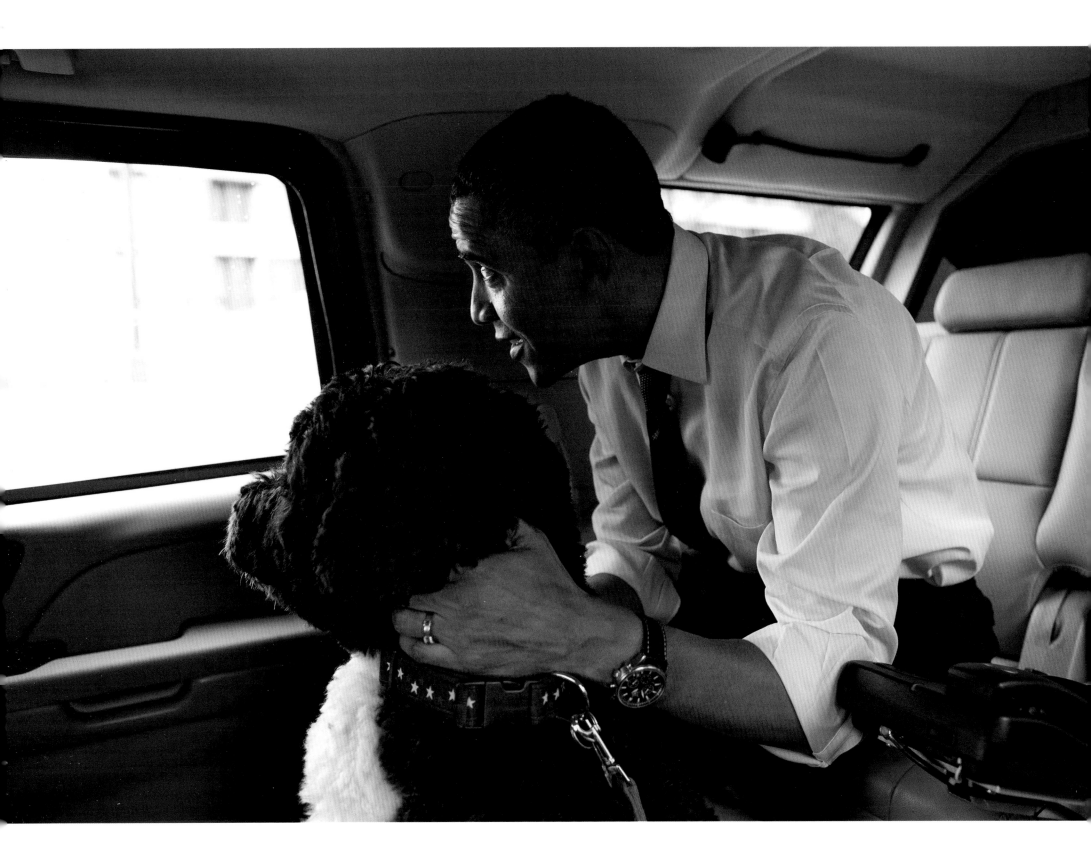

Rehearsing his State of the Union address in the Map
Room of the White House. *January 24, 2012*

OPPOSITE: That evening, hugging Representative Gabrielle Giffords
before his address at the U.S. Capitol. It was remarkable to
see her smiling and in good spirits, just a year after she had been shot
in the head by a gunman in Arizona. *January 24, 2012*

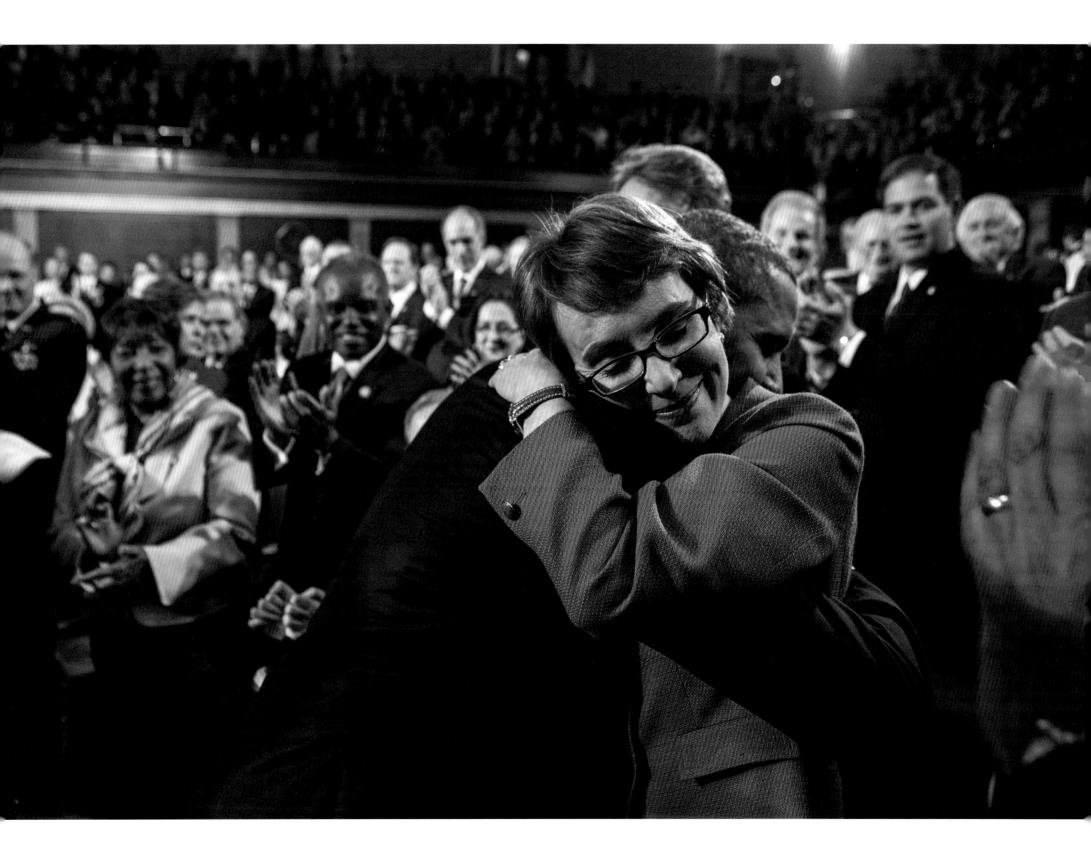

Teasing me for photographing Secretary of State Hillary Clinton after
she accidentally dropped all her briefing papers on the rug. *January 30, 2012*

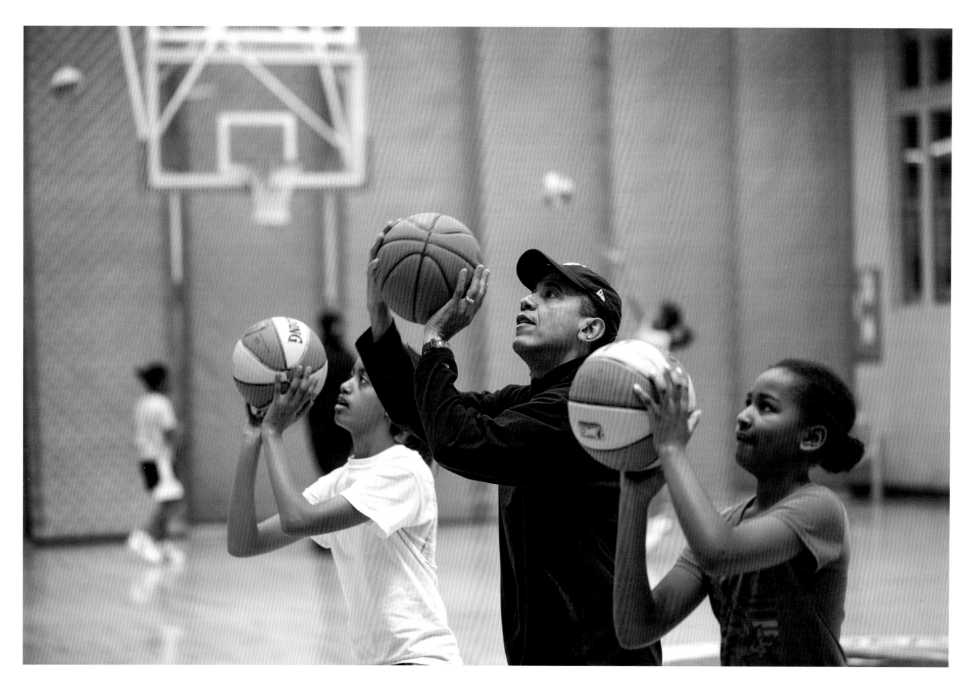

A basketball clinic with Malia and Sasha. *March 30, 2012*

On the famed Rosa Parks bus at the Henry Ford Museum, in Dearborn, Michigan. The President was at the museum for a political event and began strolling through the automobile exhibits. Before I knew what was happening, he had walked onto the bus. He looked out the window for only a few seconds, just long enough for me to make a couple of pictures. *April 18, 2012*

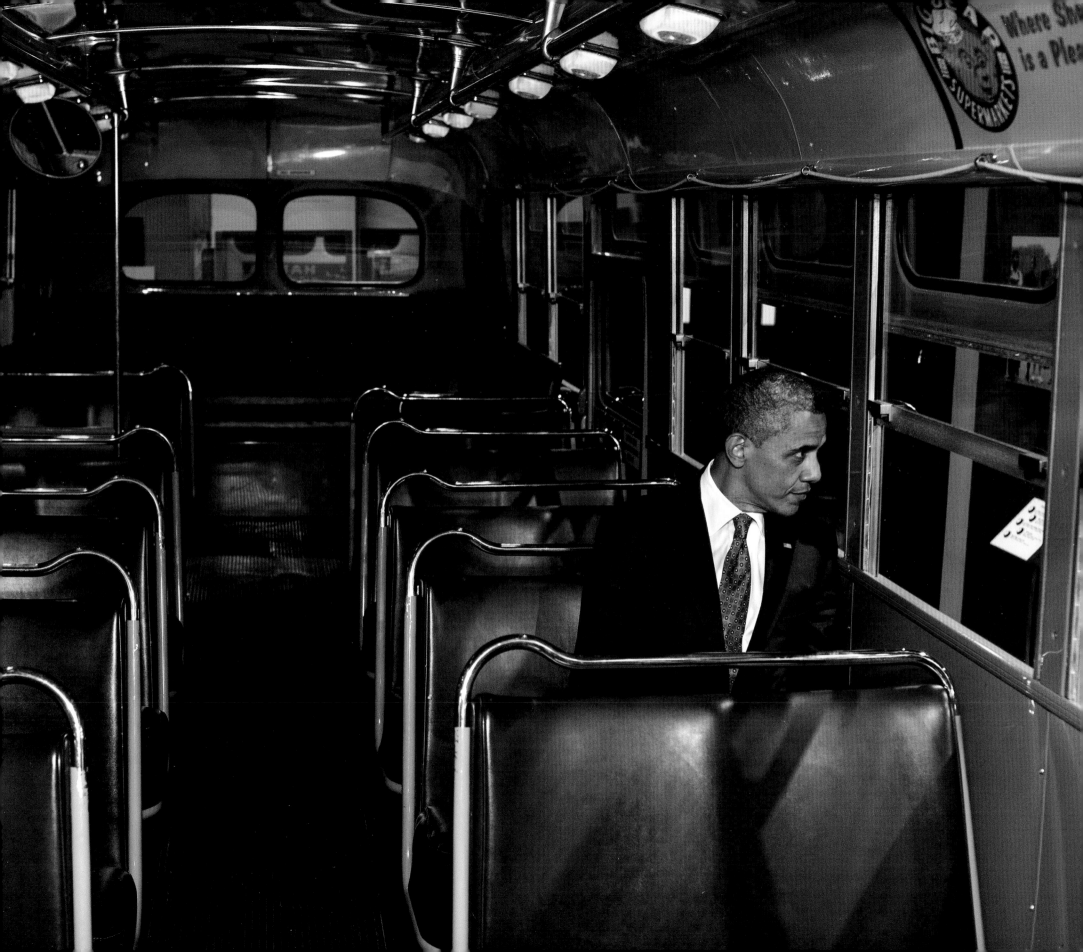

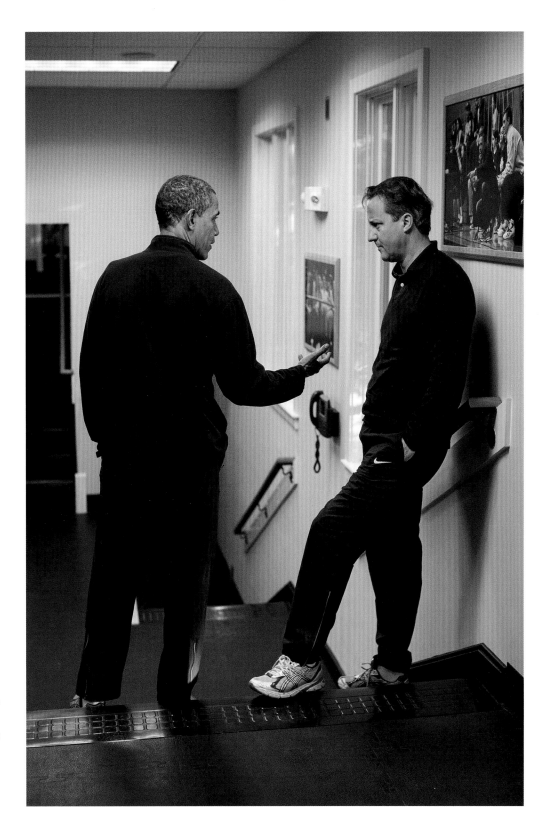

Before a workout with Prime Minister David Cameron of the United Kingdom, in the midst of the G8 summit. *May 19, 2012*

OPPOSITE: Holding court with European leaders at Camp David during the summit. *May 19, 2012*

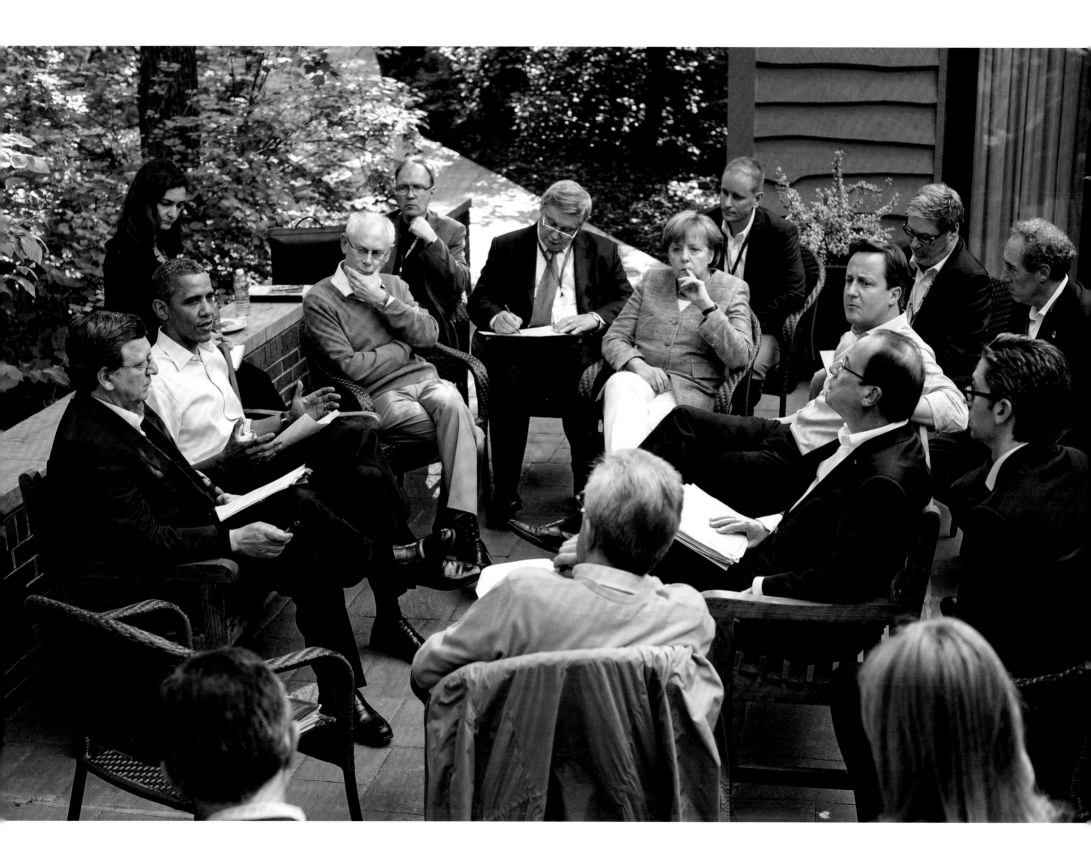

UNITED STATES

At Soldier Field, in Chicago, during a break at the NATO summit, which immediately followed the G8. It was the thrill of a lifetime for the President to throw a football on the field of his home team, the Chicago Bears. *May 20, 2012*

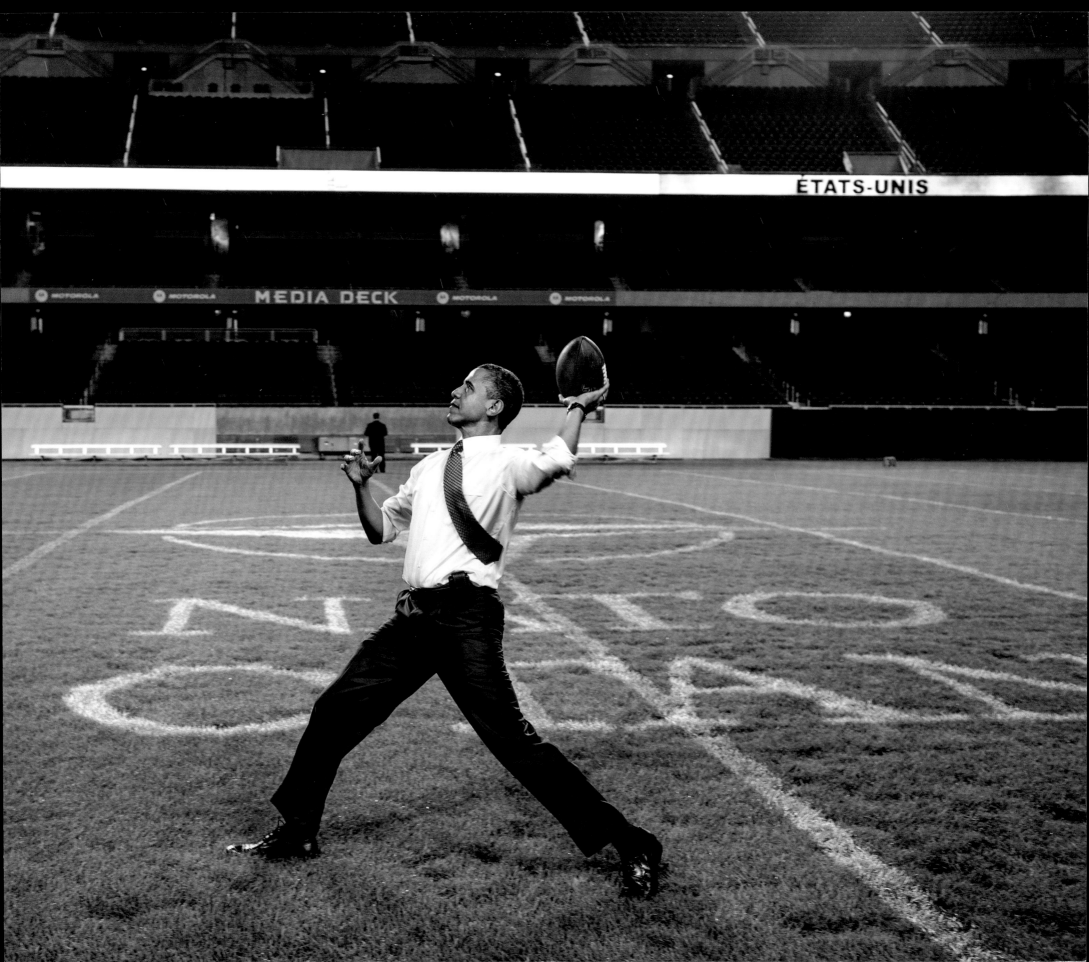

8

COLORADO WILDFIRES

SHARING SOME STRAWBERRY PIE

HITTING THE CAMPAIGN TRAIL

ZAPPED BY SPIDER-MAN

CELEBRATING REELECTION TO A SECOND TERM

THE WORST DAY OF HIS PRESIDENCY

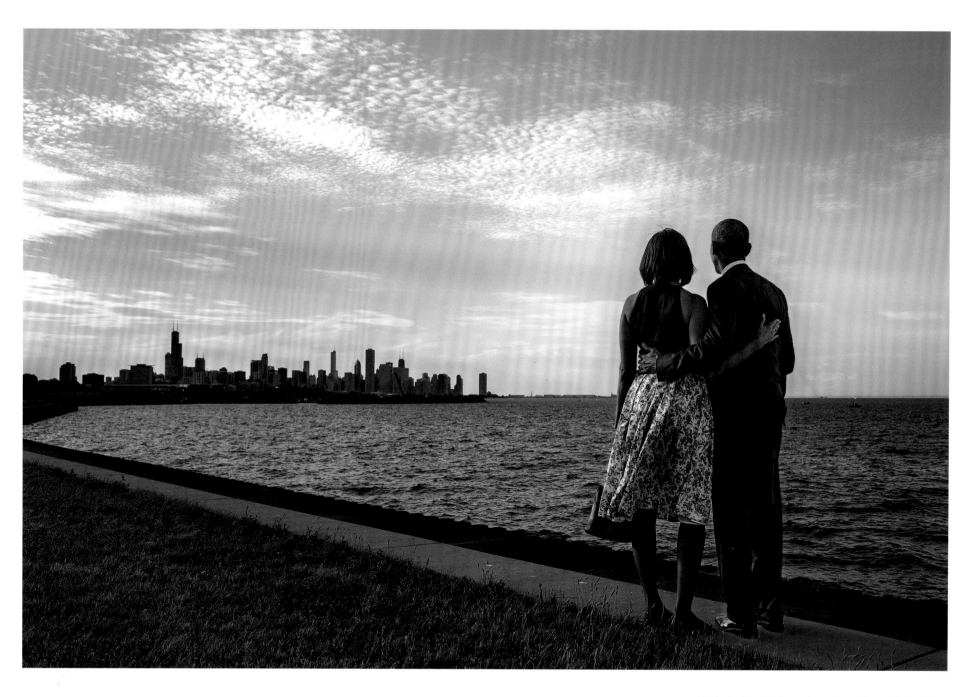

With the First Lady, gazing at the Chicago skyline from the shores of Lake Michigan. *June 15, 2012*

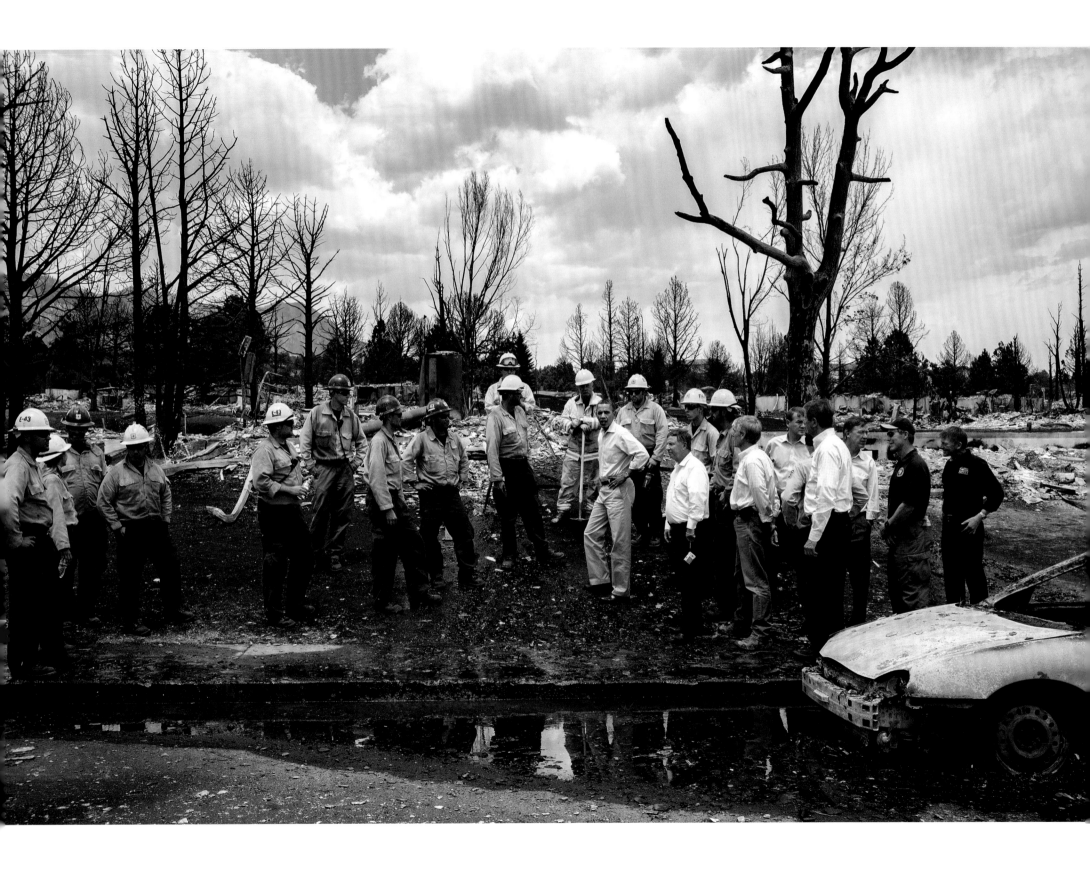

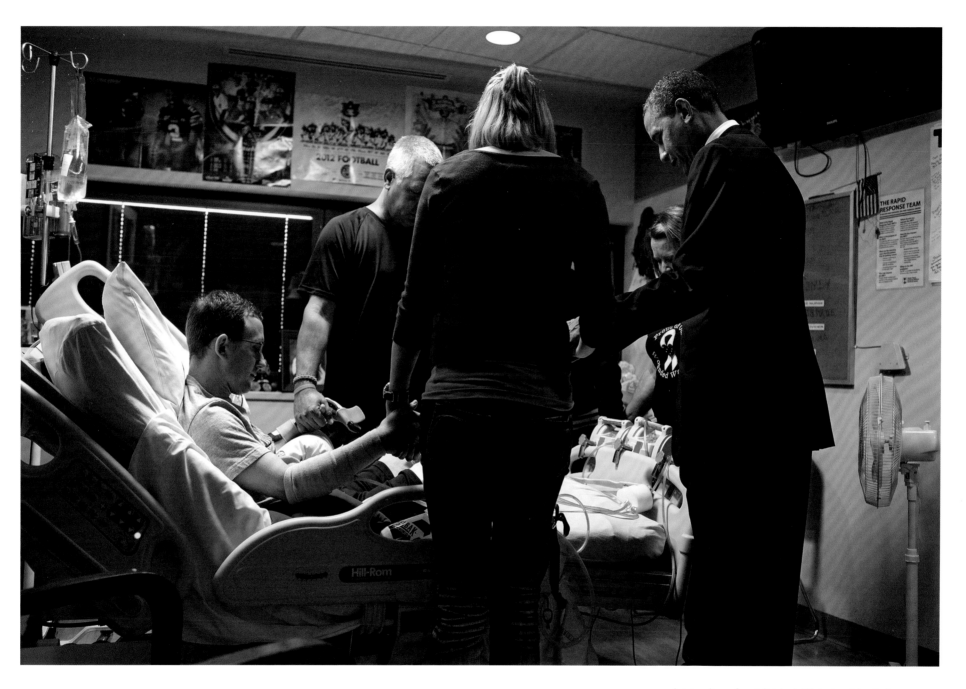

Joining Army Specialist Josh Wetzel and family for a prayer
at Walter Reed National Military Medical Center.
Wetzel had lost both his legs in Afghanistan. *June 28, 2012*

OPPOSITE: Touring damage in Colorado Springs, Colorado,
from the Waldo Canyon wildfire. More than 32,000 people had been
evacuated, and more than 340 homes were destroyed. *June 29, 2012*

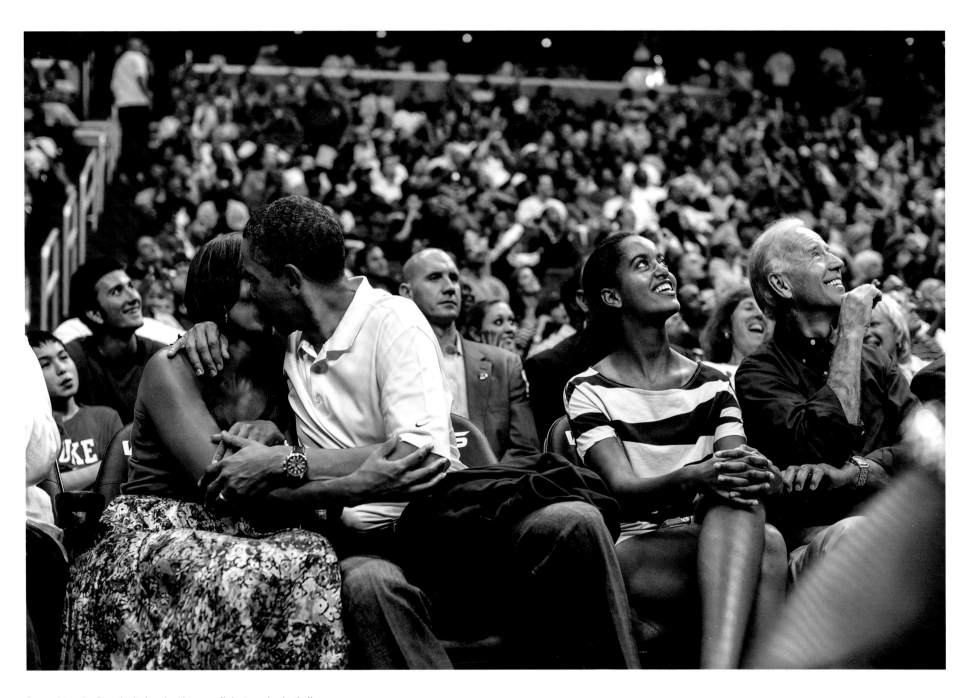

Smooching the First Lady for the "kiss cam" during a basketball
game between the U.S. men's Olympic team and
Brazil at the Verizon Center, in Washington. *July 14, 2012*

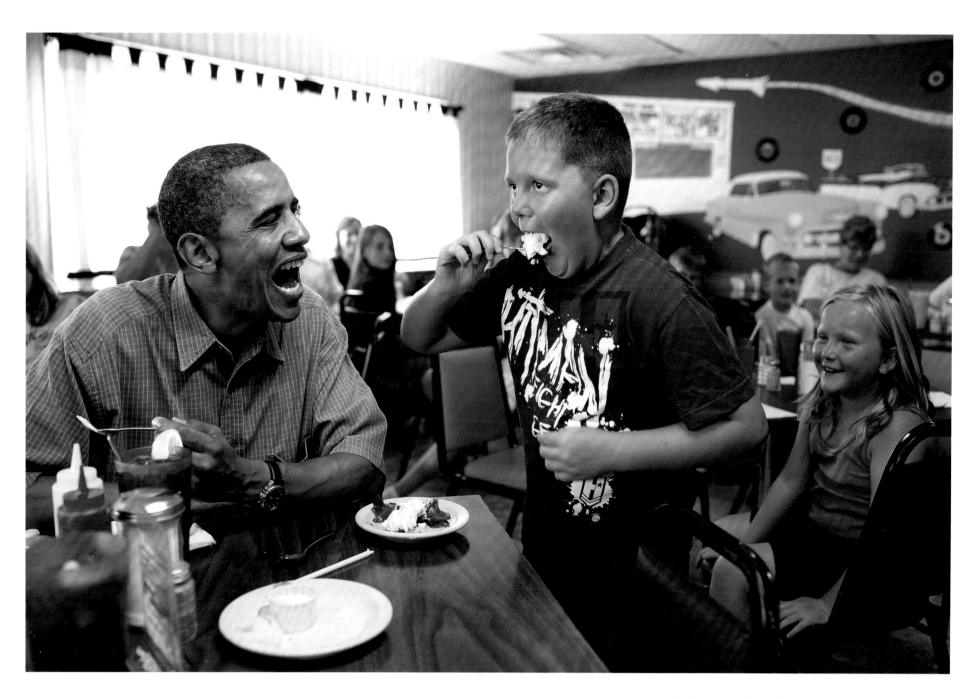

Sharing a piece of strawberry pie with a young patron at Kozy Corners in Oak Harbor, Ohio. On his travels across the country, the President liked to drop in, unscheduled, to engage with citizens in what we called OTRs (off the record visits). *July 5, 2012*

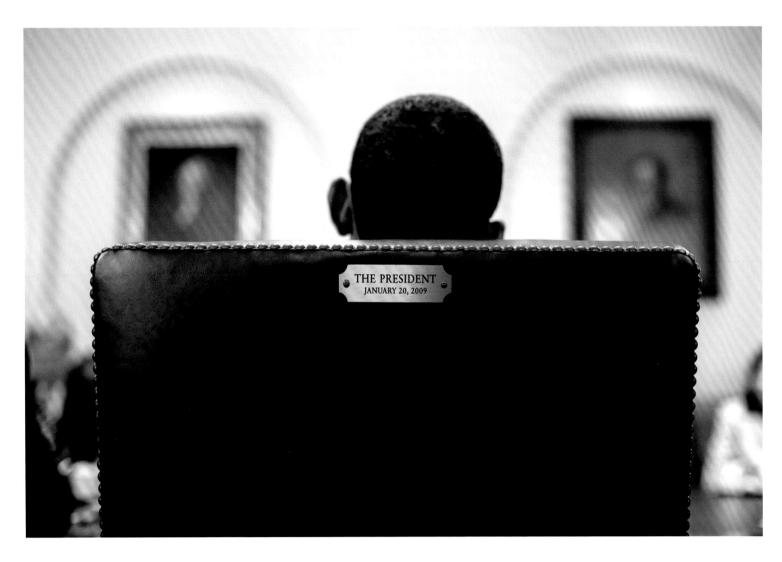

Cabinet meeting. *July 26, 2012*

OPPOSITE: A surprise visit from Malia on her return
home from summer camp. *August 16, 2012*

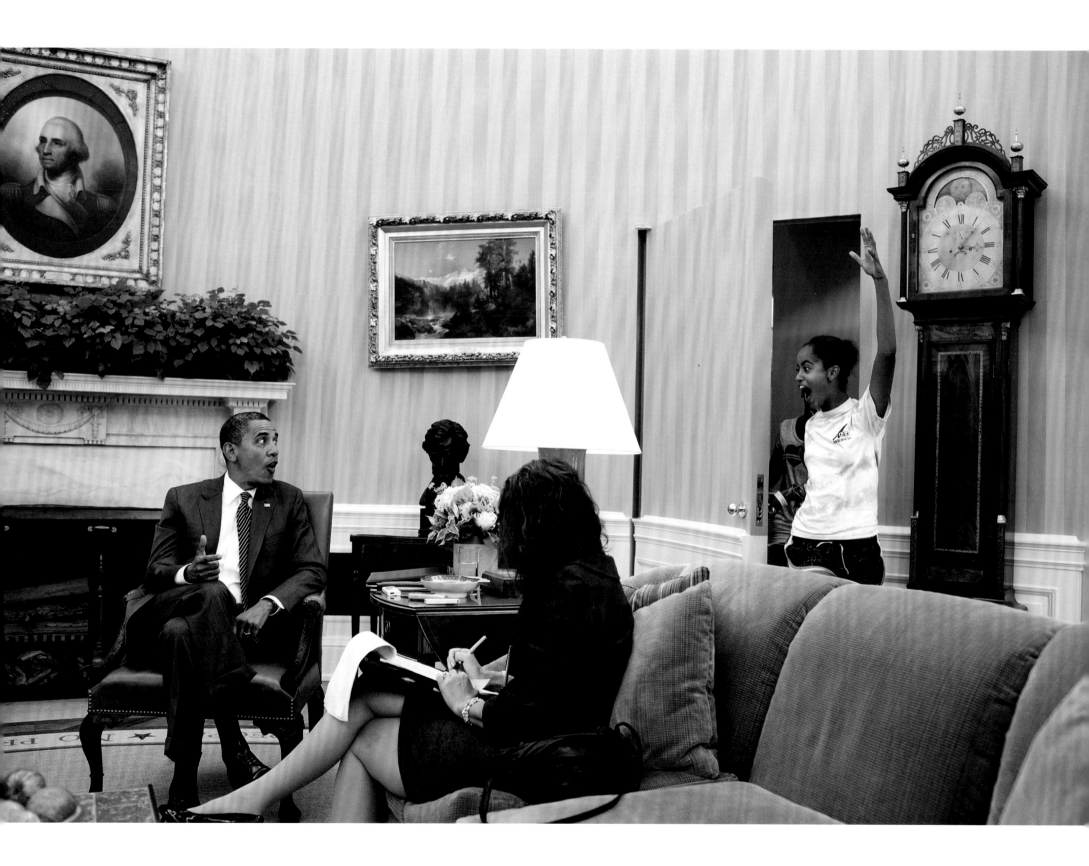

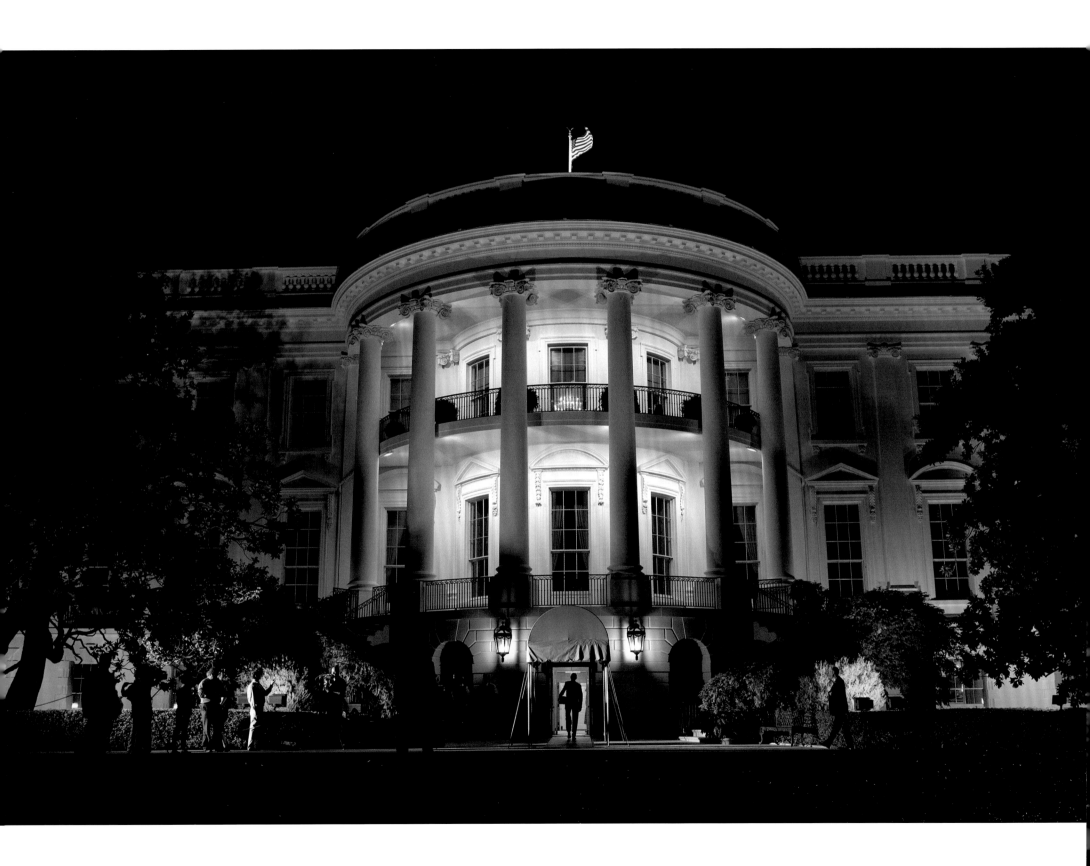

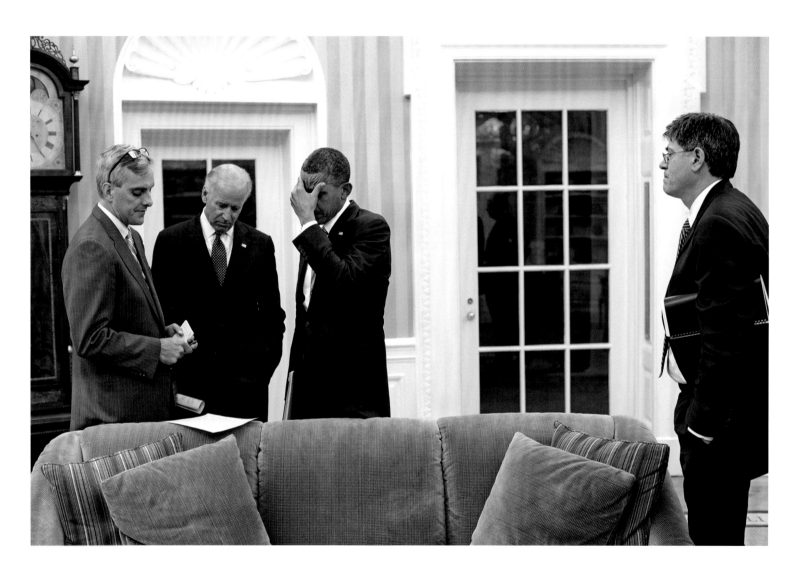

Being updated on the attack on the U.S. diplomatic post in Benghazi, Libya. *September 11, 2012*

OPPOSITE: Returning home after a trip to Wisconsin. *September 22, 2012*

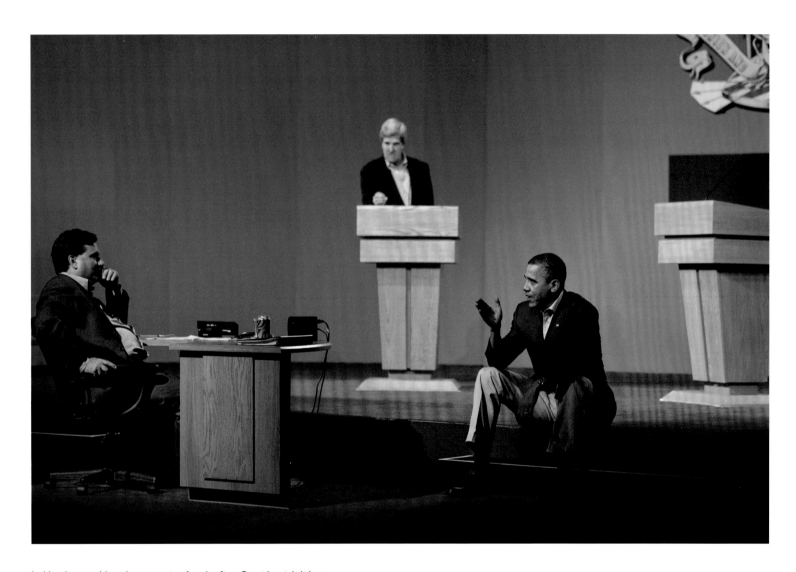

In Henderson, Nevada, preparing for the first Presidential debate
of the 2012 election, with Ron Klain, former aide
to Vice President Joe Biden, and Senator John Kerry of
Massachusetts, who played Mitt Romney. *October 2, 2012*

OPPOSITE: Unwinding on an abandoned golf course
later that evening with Marty Nesbitt,
one of the President's closest friends. *October 2, 2012*

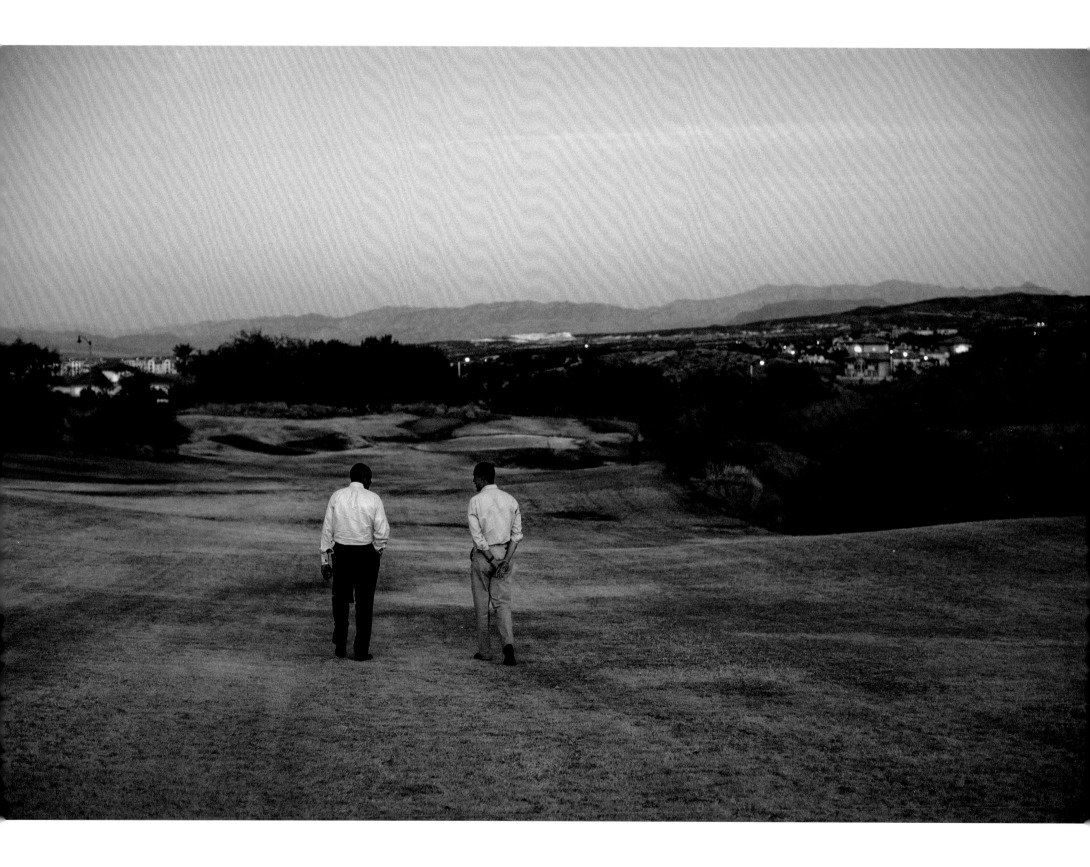

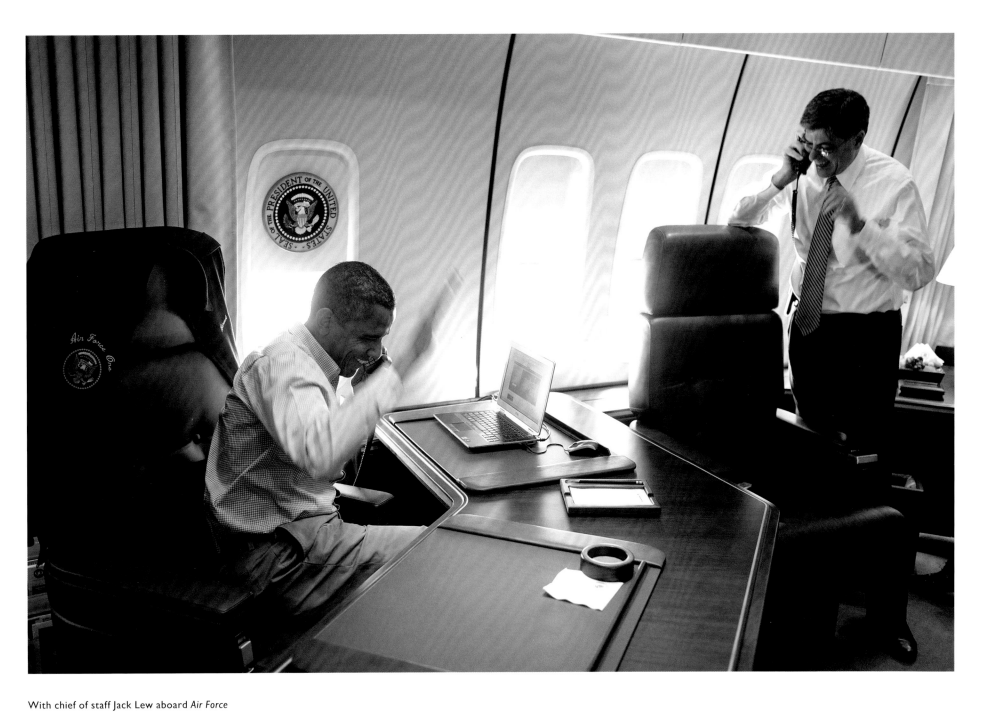

With chief of staff Jack Lew aboard *Air Force One* after hearing the latest positive job numbers, a month before the election. *October 4, 2012*

OPPOSITE: A campaign rally at the University of Wisconsin, in Madison. *October 4, 2012*

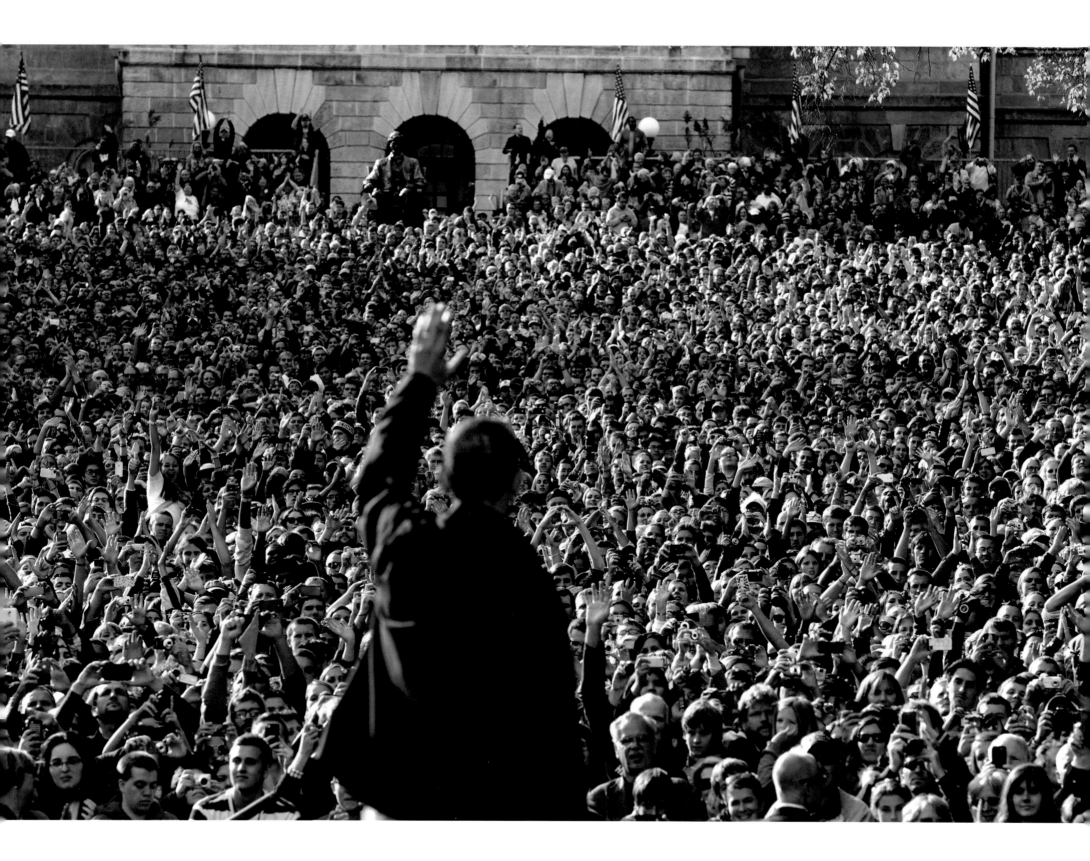

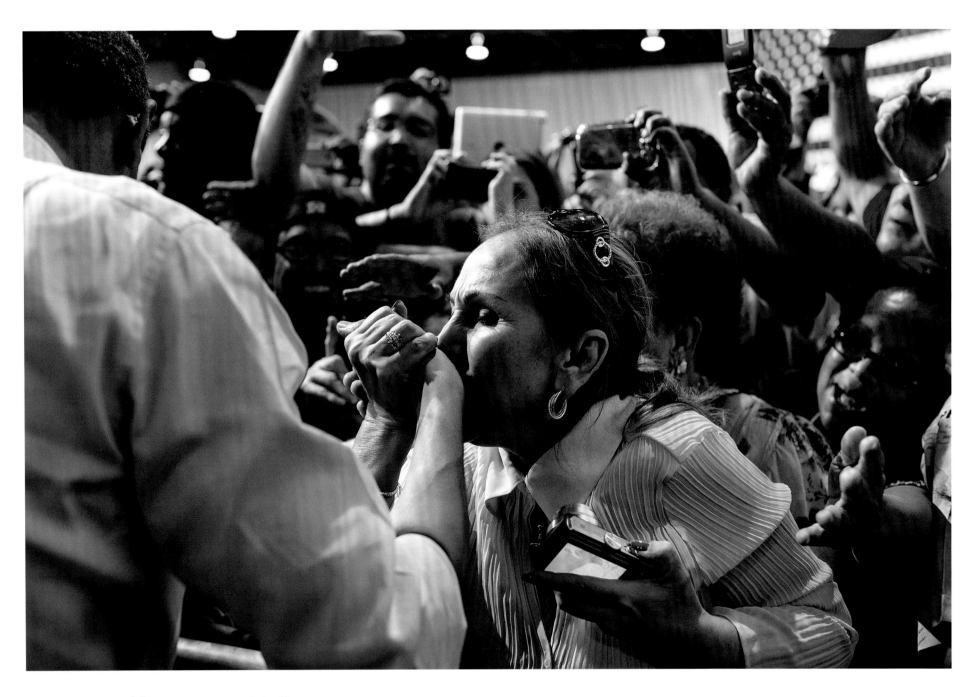

Working the rope line following campaign events in Las Vegas.
September 12, 2012 (above) and *October 24, 2012* (right)

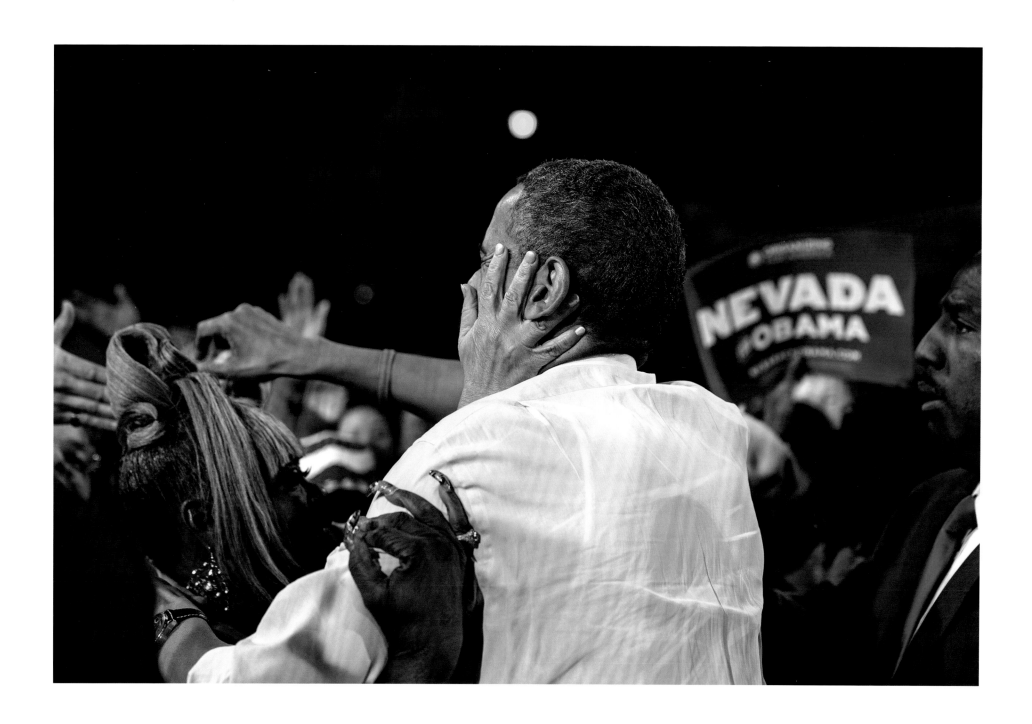

ZAPPED BY SPIDER-MAN

Nicholas Tamarin, aka Spider-Man (age three), had been trick-or-treating with his father, White House aide Nate Tamarin, during an early Halloween celebration in the Eisenhower Executive Office Building. The President's secretary told Nate to bring his son by the Oval Office. After spending a few minutes with them, POTUS turned back toward Nicholas and said, "Zap me one more time."

I can never commit to calling any one picture my favorite, but the President told me that this was his favorite photo of the year when he saw it hanging in the West Wing a couple of weeks later. Of course, his favorite changed every time he saw a new picture of him with Sasha or Malia. *October 26, 2012*

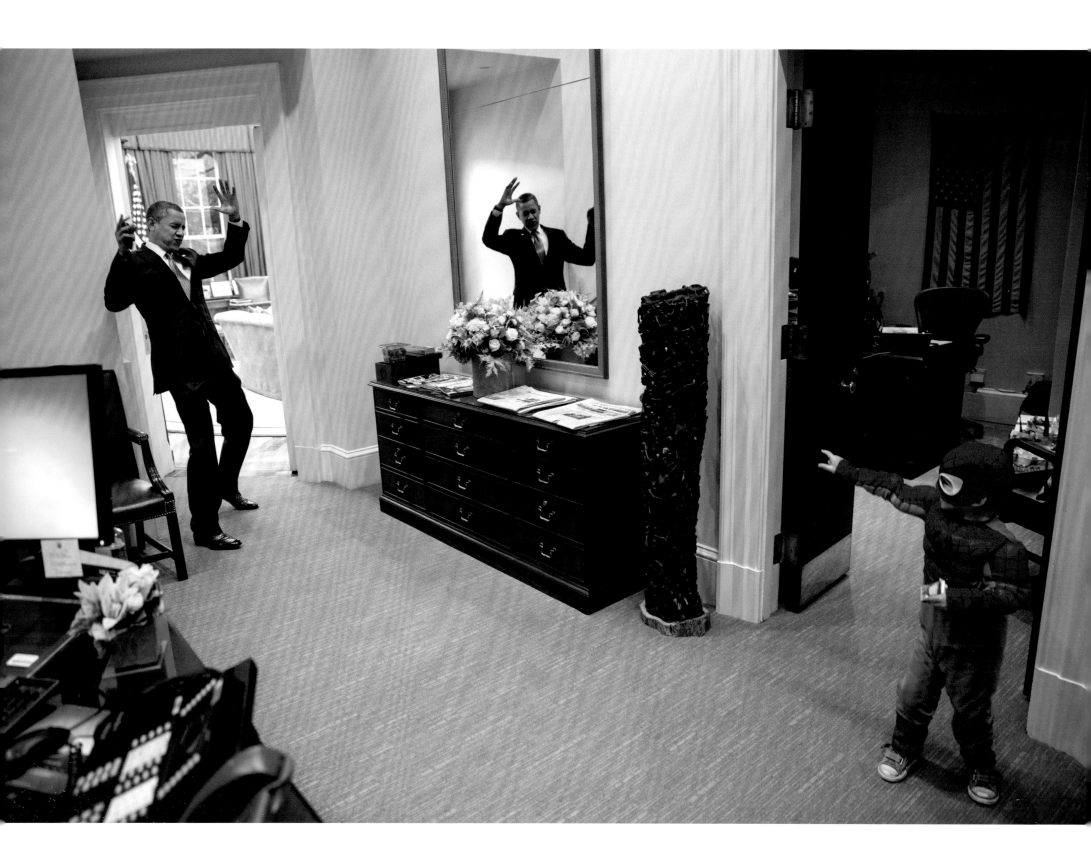

Moments after the network TV stations projected he would be reelected
as President of the United States. *11:18 p.m., November 6, 2012*

Receiving congratulations
from Republican Presidential
nominee Mitt Romney, who
had just conceded the election.
12:35 a.m., November 7, 2012

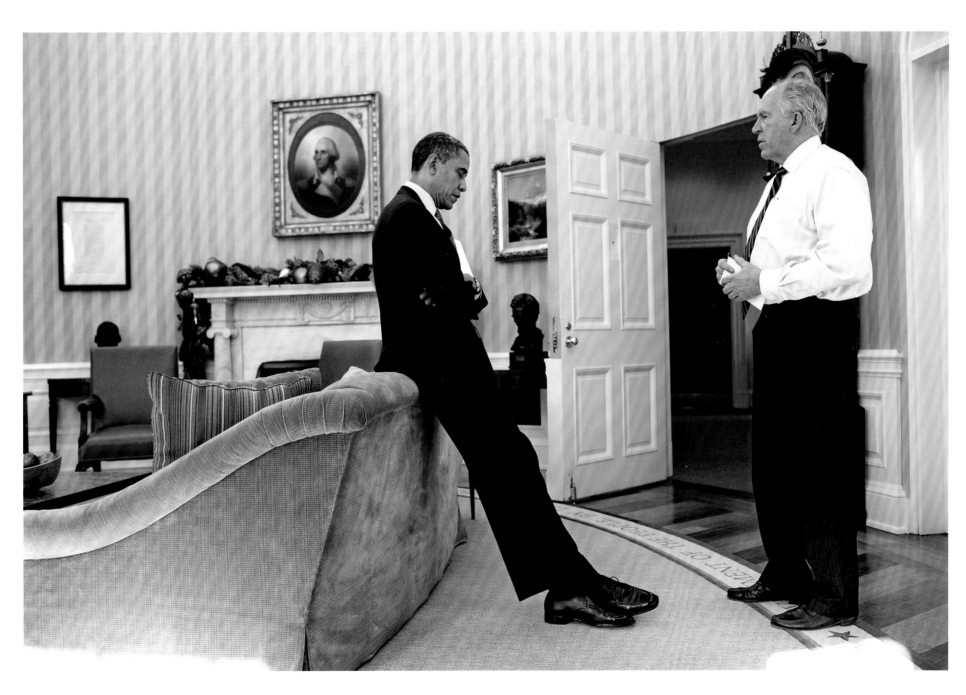

Hearing the awful news about the Sandy Hook Elementary School shootings
from Homeland Security Advisor John Brennan. *December 14, 2012*
OPPOSITE: With Malia in the private residence later that same day.
The President hugged her for a long time. *December 14, 2012*

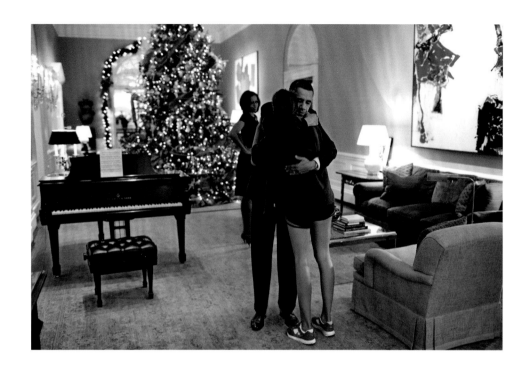

THE WORST DAY OF HIS PRESIDENCY

December was everyone's favorite month. Days after Thanksgiving, the White House transformed into a magical place, with Christmas decorations in every room, including the Oval Office. But the news that arrived on the morning of December 14, 2012, brought the holiday spirit to a halt. Reports began flashing on the TV outside the Oval: another mass shooting, this time at Sandy Hook Elementary School, in Newtown, Connecticut.

A couple of hours later, it was difficult to even push the shutter. John Brennan confirmed to the President that 20 of the 26 killed were first-grade students, six or seven years old. The President slumped in reaction against the Oval sofa, visibly deflated. I'm sure he was thinking foremost of the parents, imagining the horror of learning that their six-year-old son or daughter had been shot to death by a madman and would never come home. He would come to say that it was the worst day of his Presidency.

Two days later, we attended a memorial service in Newtown. The President had to miss Sasha's dance recital to attend, so he watched the dress rehearsal before boarding the plane to Connecticut. The auditorium was mostly empty, and at one point, I wandered down to the front seats to take some pictures of Sasha dancing. Soon after, about 25 young performers filed out from backstage and sat down next to me. A lump filled my throat. "How old are you?" I asked one girl. "Six," she replied nervously. I looked at that row of kids seated in the auditorium and began to cry. *(Photographs continue through page 203.)*

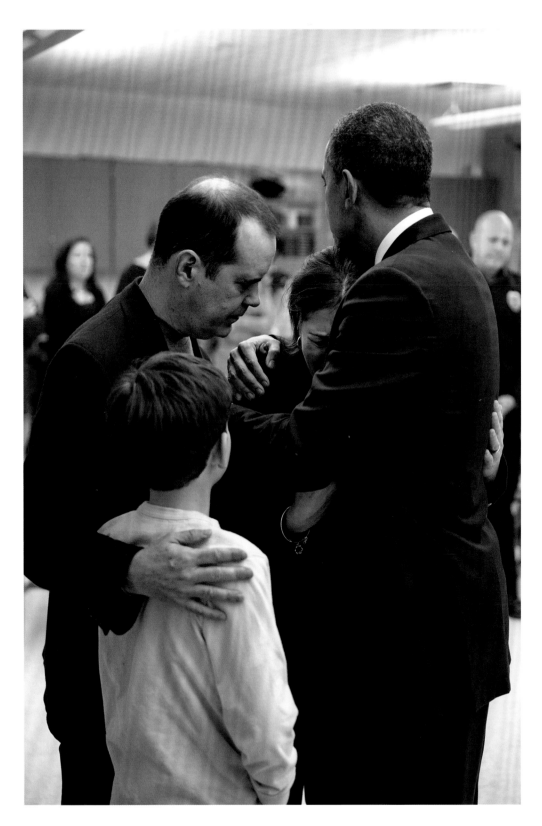

Comforting the Wheeler family, whose son Ben had been shot and killed at Sandy Hook. *December 16, 2012*

Going over his remarks before the memorial service in a classroom at Newtown High School. Two teachers had written a note on the whiteboard: "Dear President Obama, the Newtown community is so thankful that you are coming to help us heal. In times of adversity it is reassuring to know that we have a strong leader to help us recover." The President wrote his response on the board: "You're in our thoughts and prayers." *December 16, 2012*

SECOND TERM

——

9

THE LIGHT IN PETRA

BOSTON MARATHON BOMBING

FOUR LAUGHING PRESIDENTS

SLEEPING DURING A PRESIDENTIAL EVENT

VISITING MANDELA'S PRISON CELL

THE BEAR IS LOOSE

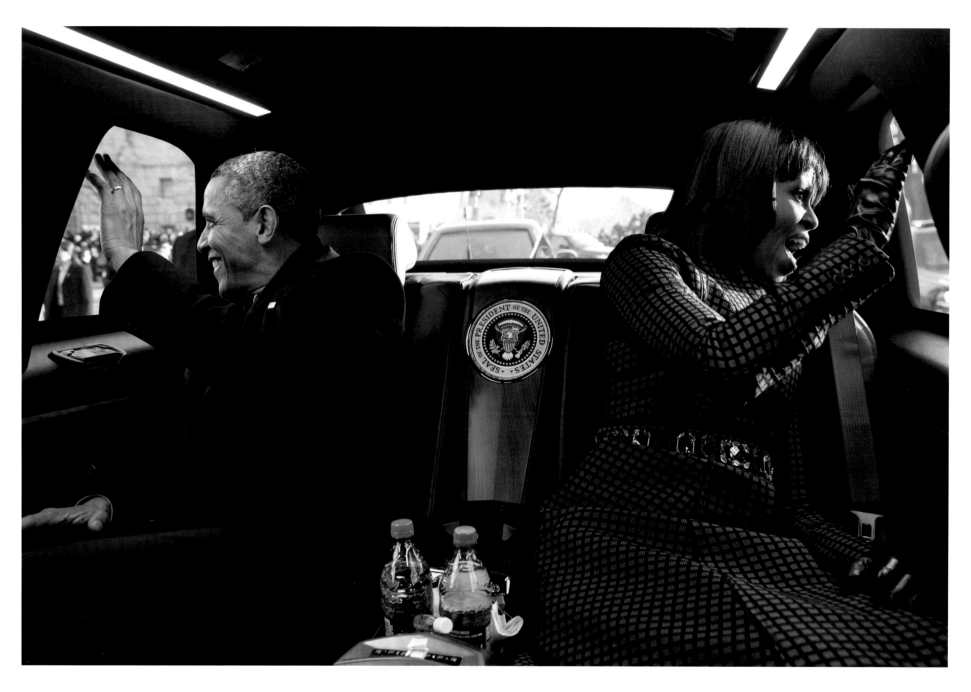

Riding up Pennsylvania Avenue in "the Beast" with the Obamas after the second inauguration ceremony. When I asked POTUS if I could join them in the limousine, he said, straight-faced, "Michelle and I were planning to make out." *January 21, 2013*

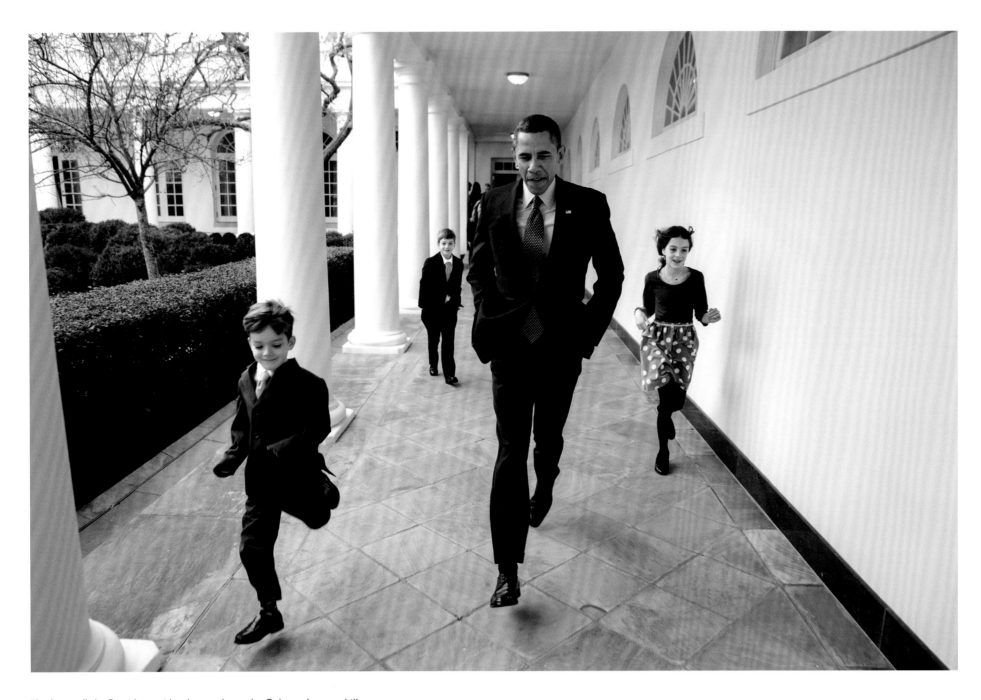

"Let's race," the President said as he ran down the Colonnade on a chilly
afternoon with Denis McDonough's children. They were headed
to the ceremony naming their dad the new chief of staff. *January 25, 2013*

OPPOSITE: Visiting the Yad Vashem Holocaust History
Museum, in Jerusalem, with President Shimon Peres,
Prime Minister Benjamin Netanyahu, and others. *March 22, 2013*

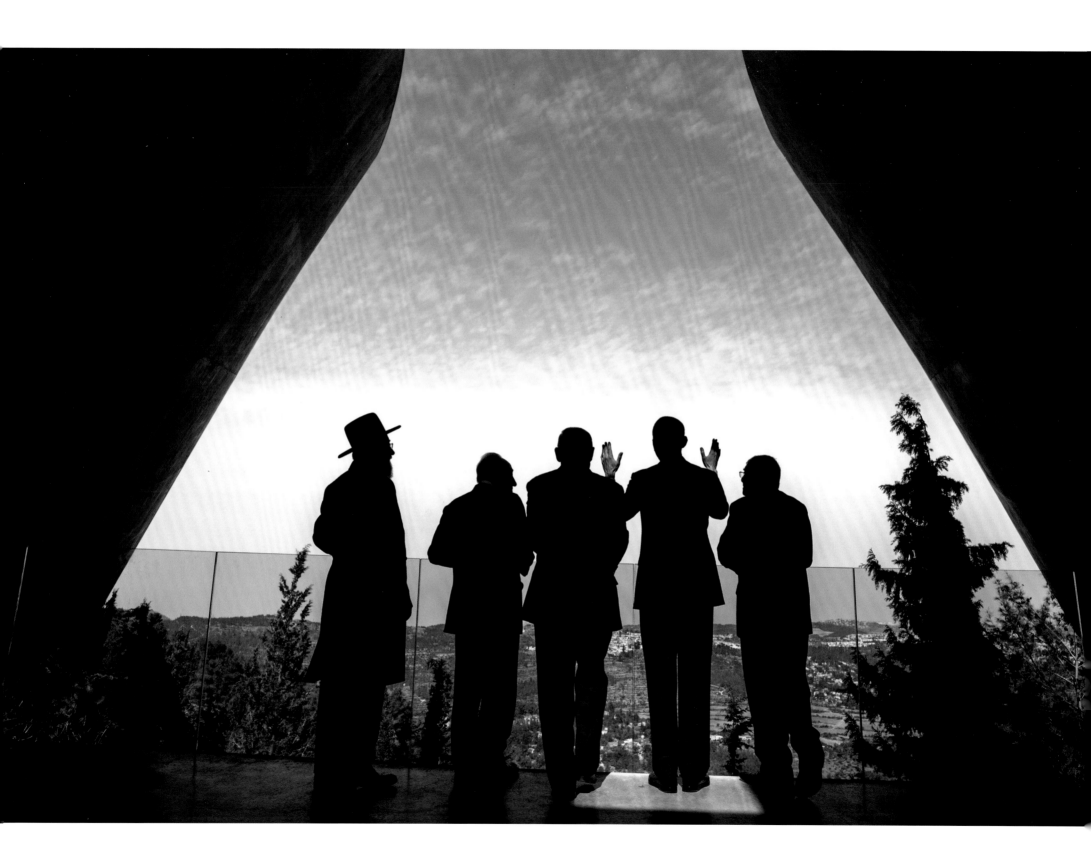

Marine One arriving outside the ancient city
of Petra, Jordan. *March 23, 2013*

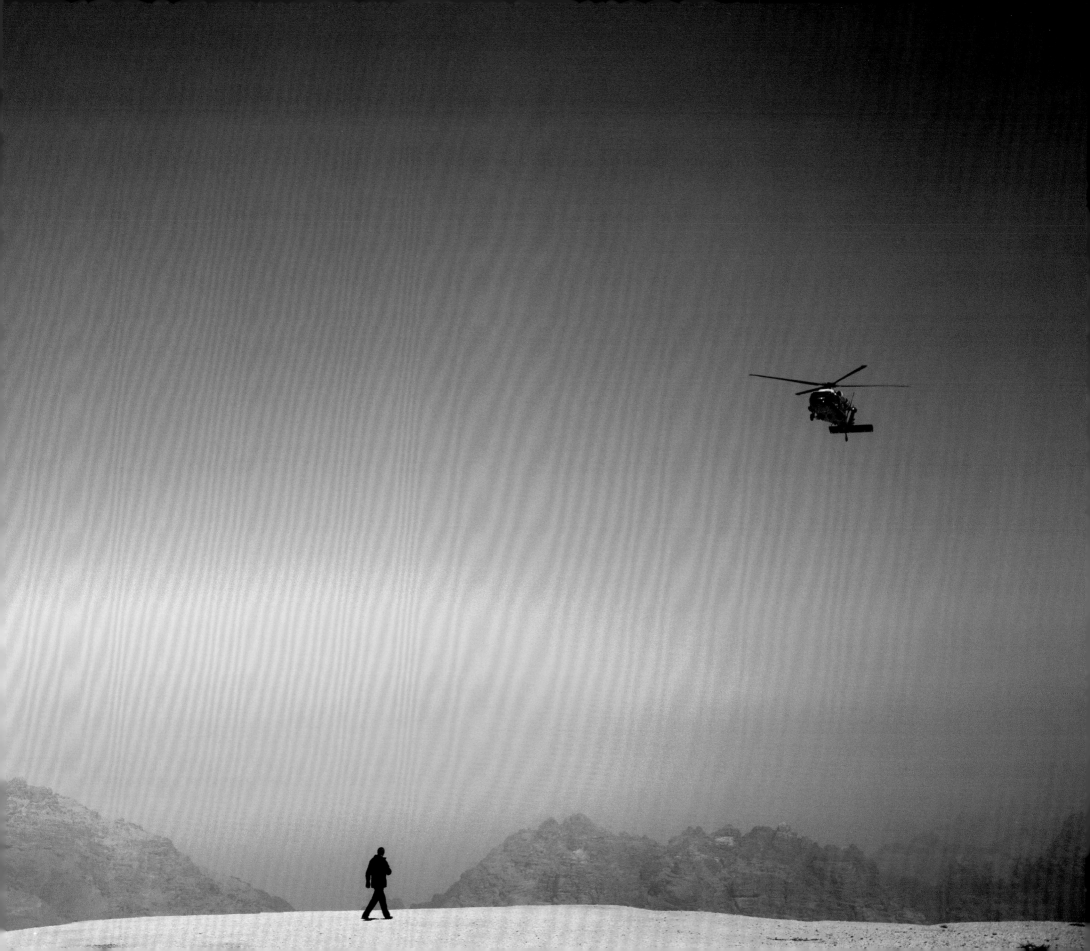

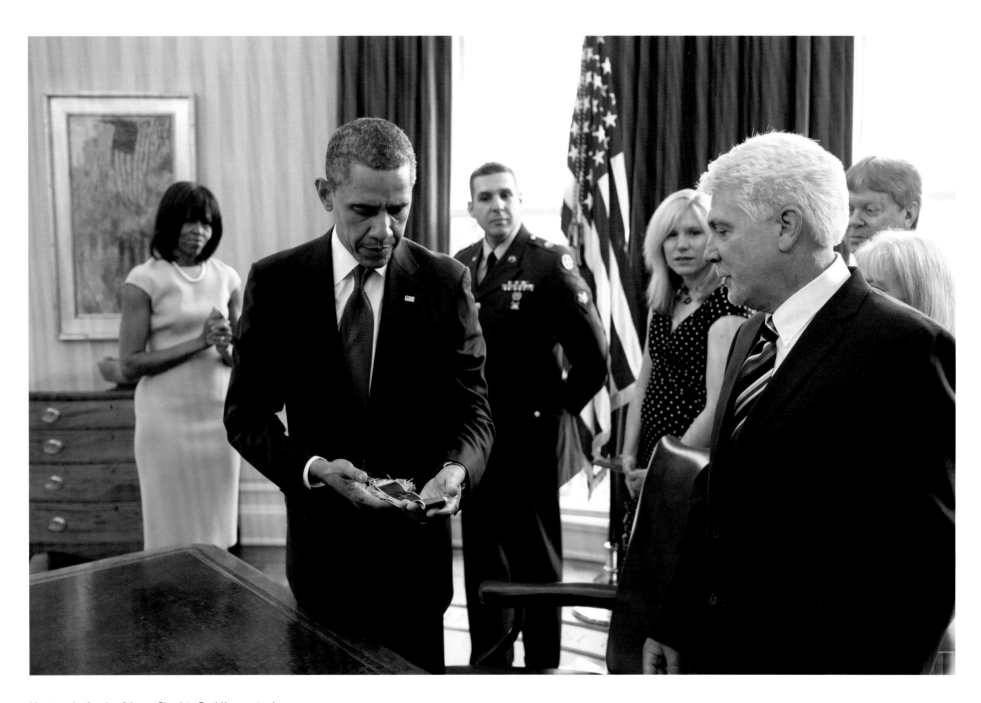

Meeting the family of Army Chaplain Emil Kapaun in the
Oval Office before posthumously awarding him a Medal of Honor.
The chaplain had served in World War II and the Korean War
and died in a P.O.W. camp. *April 11, 2013*

At the end of almost every day, POTUS walked with
chief of staff Denis McDonough along the South
Lawn driveway to discuss the day's events. *April 9, 2013*

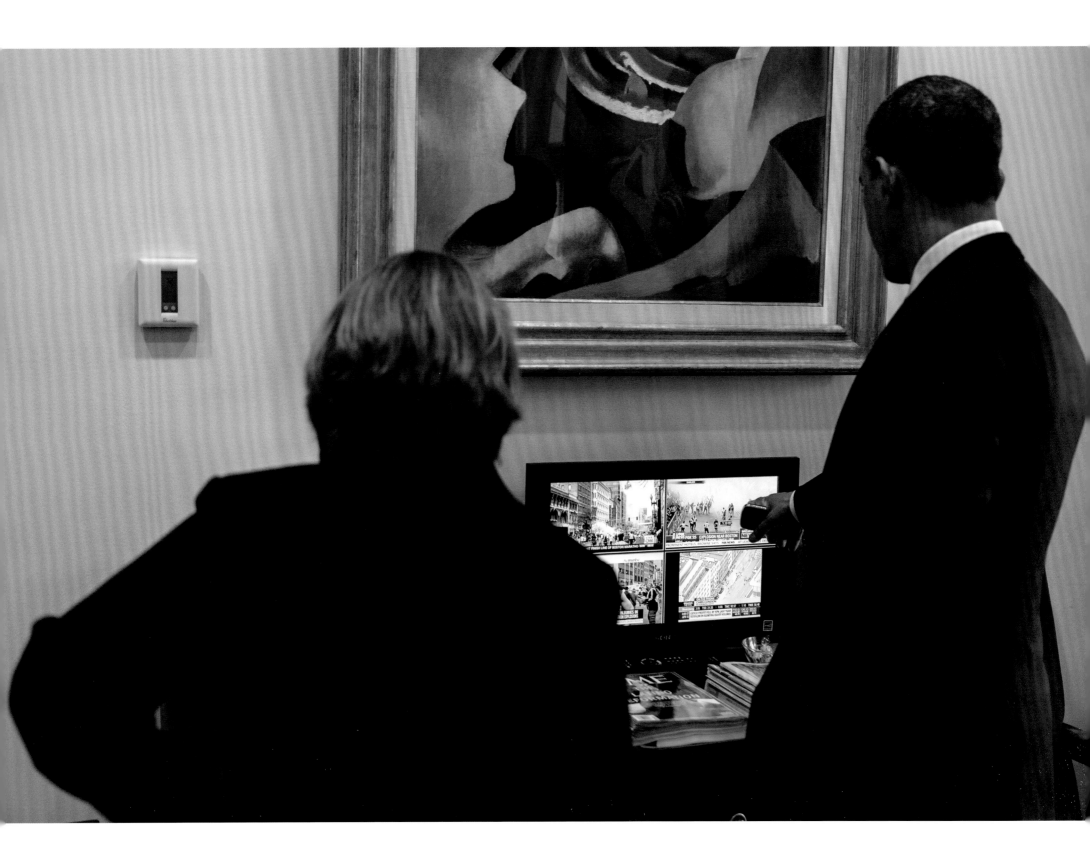

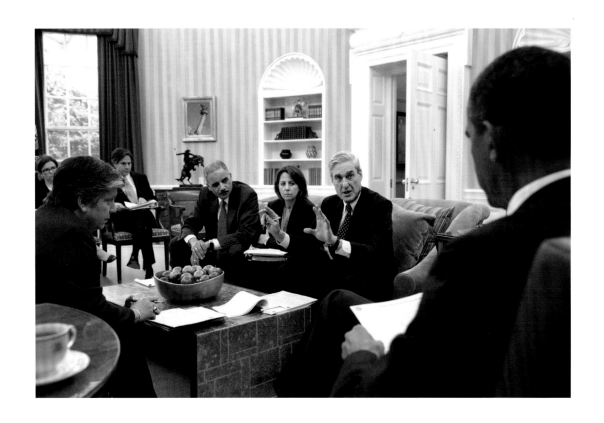

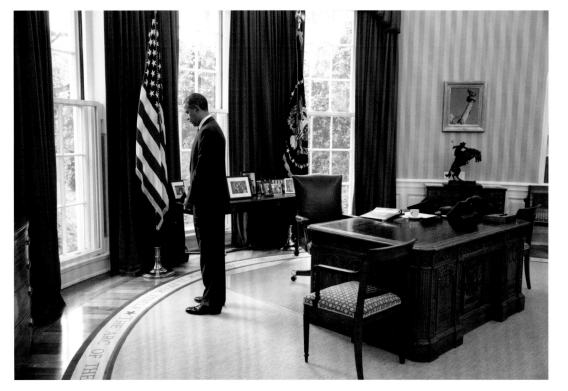

OPPOSITE: Viewing the initial television coverage of the aftermath of the Boston Marathon bombing with Homeland Security Advisor Lisa Monaco. *April 15, 2013*

TOP: A briefing with FBI Director Robert Mueller and other officials on the bombing. *April 16, 2013*

BOTTOM: A moment of silence for the victims of the bombing exactly one week later. *April 22, 2013*

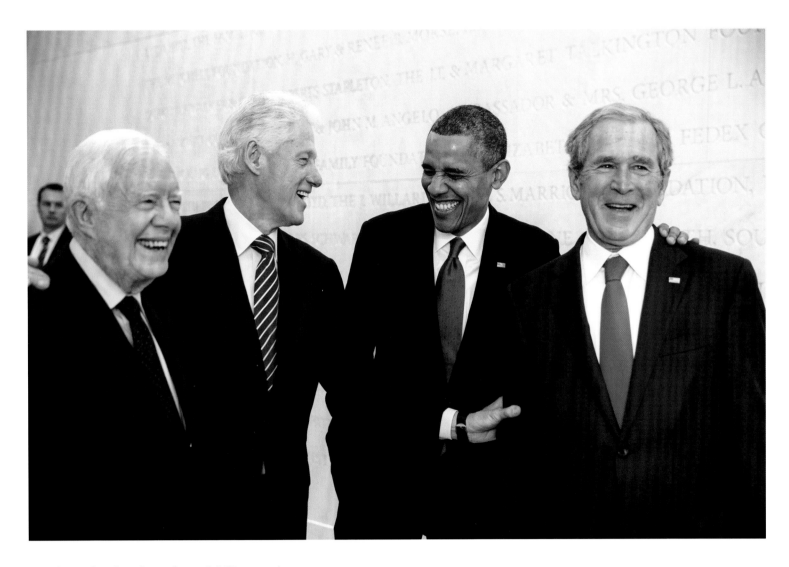

With former Presidents Jimmy Carter, Bill Clinton, and
George W. Bush before the dedication of the George W. Bush
Presidential Library and Museum, in Dallas. *April 25, 2013*

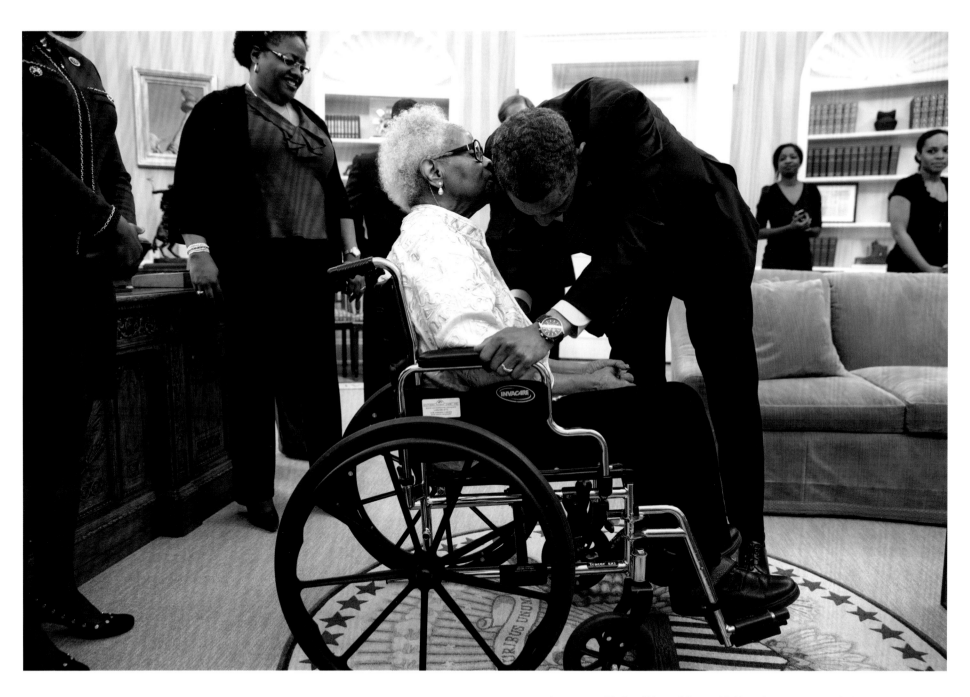

Listening to Thelma "Maxine" Pippen McNair after signing H.R. 360, which provided for a Congressional gold medal to commemorate the four young African-American victims of the 1963 bombing of the Sixteenth Street Baptist Church in Birmingham, Alabama. McNair's daughter, Denise McNair, was one of the victims. *May 24, 2013*

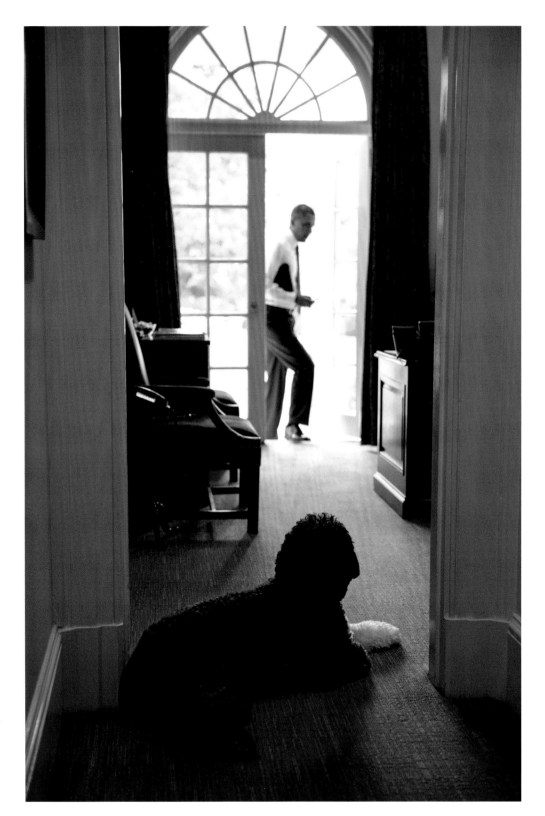

Bo waiting for the President. *June 11, 2013*

OPPOSITE: Posing with a boy who had fallen asleep during the Father's Day ice cream social in the State Dining Room of the White House. "Pete—you've got to get a picture of this," the President called out to me. The boy didn't wake up. *June 14, 2013*

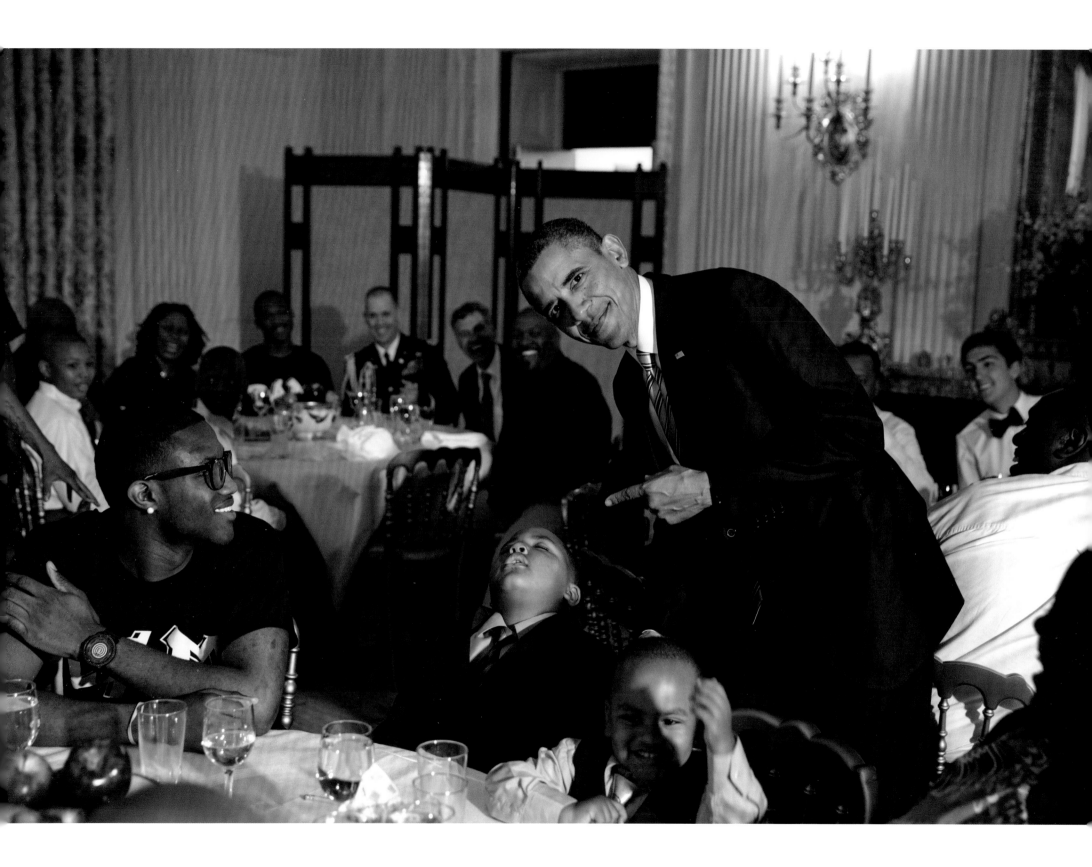

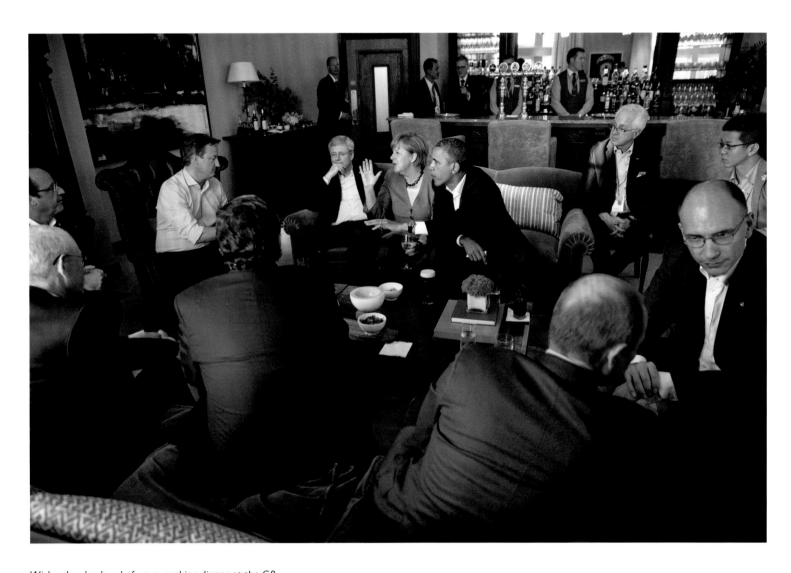

With other leaders before a working dinner at the G8
summit in Northern Ireland. *June 17, 2013*

OPPOSITE: Leaving Berlin, Germany. *June 19, 2013*

VISITING MANDELA'S PRISON CELL

Inside Nelson Mandela's prison cell on Robben Island, off Cape Town, South Africa, the President and his family listened attentively to a first-hand account of what it was like to be imprisoned there during apartheid. Their guide was activist Ahmed Kathrada, who was imprisoned for 18 years. Mandela was imprisoned for 27 years before apartheid ended; he became the first President of South Africa to be elected by a fully free and democratic process. The President had met Mandela, one of his heroes, when he was a U.S. Senator. Mandela was not well enough to receive a visit on this trip, and he died some five months later. *June 30, 2013*

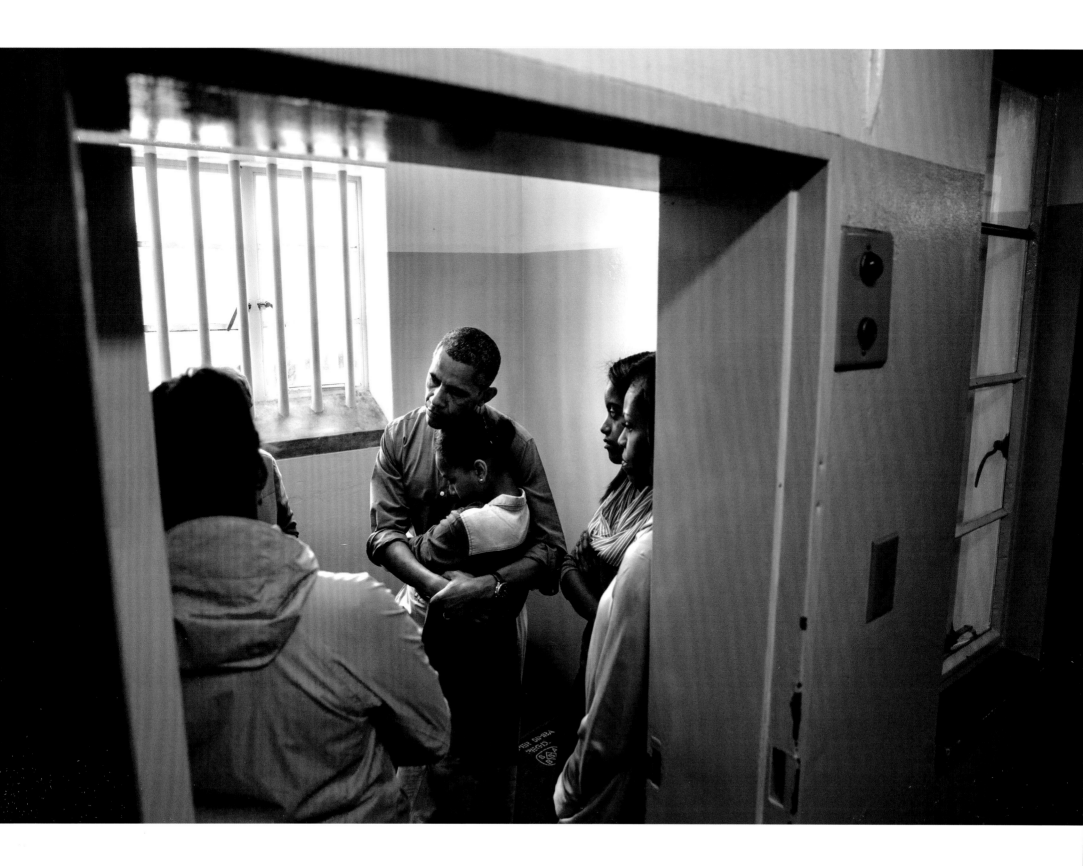

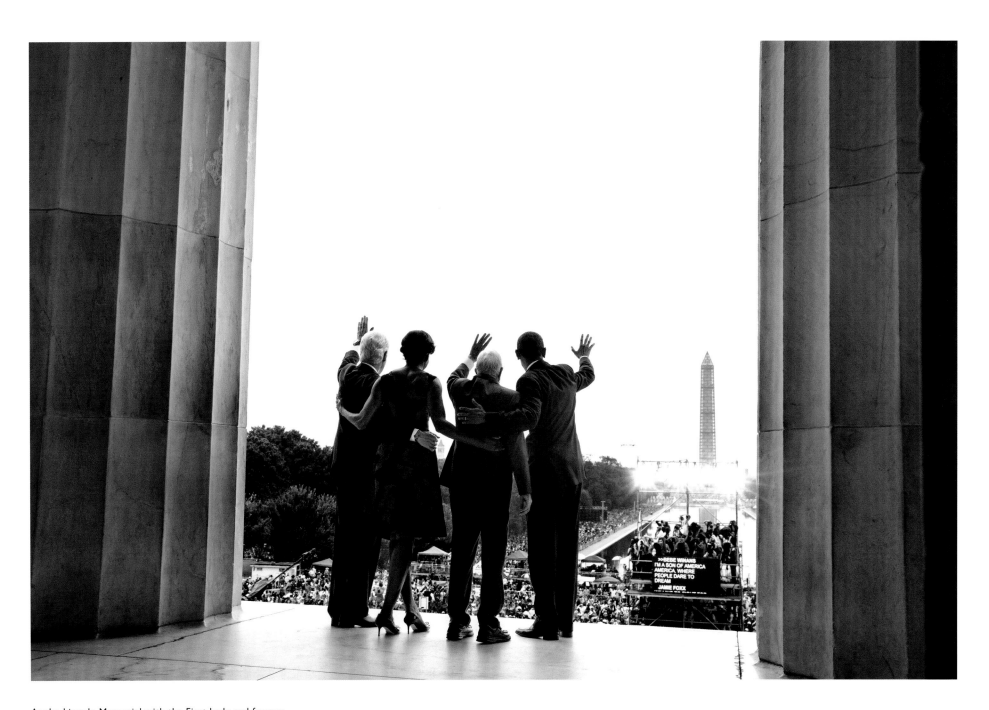

At the Lincoln Memorial with the First Lady and former
Presidents Jimmy Carter and Bill Clinton on the
50th anniversary of the historic March on Washington
for Jobs and Freedom and Dr. Martin Luther King, Jr.'s,
"I Have a Dream" speech. *August 28, 2013*

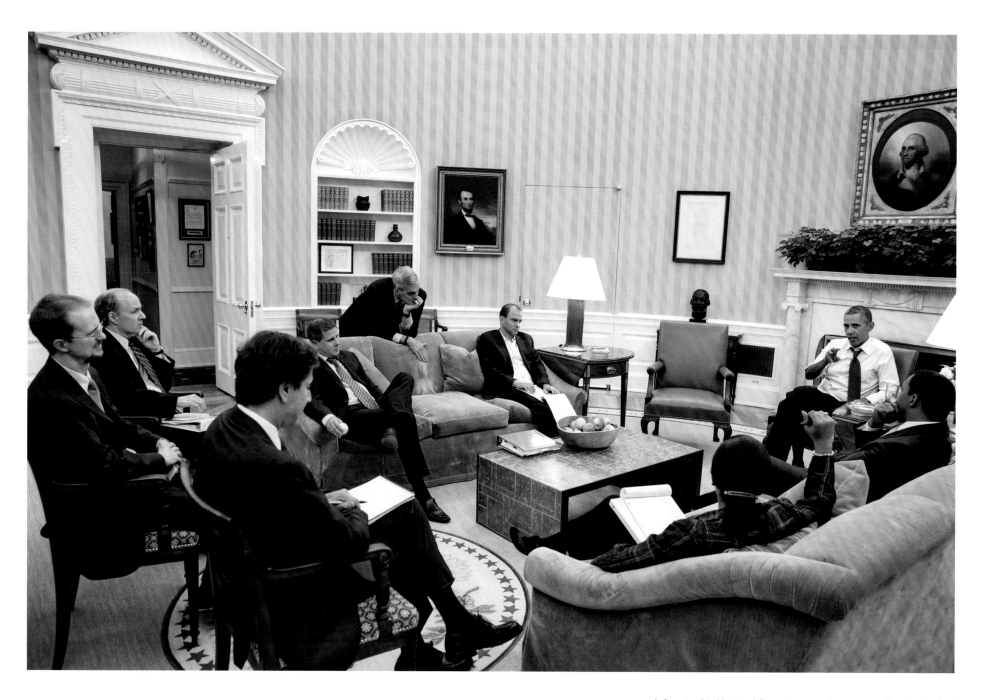

Informing his National Security team that, upon reflection, he had decided to ask Congress for authorization before ordering air strikes in Syria. Congress did not give him that authorization, but the administration was able to negotiate a deal with Russia whereby Syria pledged to hand over all its chemical weapons. *August 30, 2013*

Surrounded by Ford employees after jumping in the cab of
a truck following his speech at Ford's Kansas City Stamping Plant,
in Liberty, Missouri. *September 20, 2013*

Returning to the White House from Taylor Gourmet, a D.C. sandwich shop. The President had walked over to thank them for offering discounts to furloughed workers during the government shutdown. Escaping from the White House made POTUS happy—and the Secret Service nervous. The President gleefully coined the phrase "the bear is loose" for his getaways. *October 4, 2013*

10

NELSON MANDELA'S MEMORIAL SERVICE

A TRIBUTE TO CORY REMSBURG

MEETING WITH THE DALAI LAMA

THE TWO MOST FAMOUS SETS OF EARS IN D.C.

TAKING ON VLADIMIR PUTIN

LUNCH WITH A LETTER WRITER

Air Force One in Seattle. November 25, 2013

Just before speaking at Nelson Mandela's memorial service in
Johannesburg, South Africa. *December 10, 2013*

OPPOSITE: Walking home from the Oval with chief of staff
Denis McDonough. *January 21, 2014*

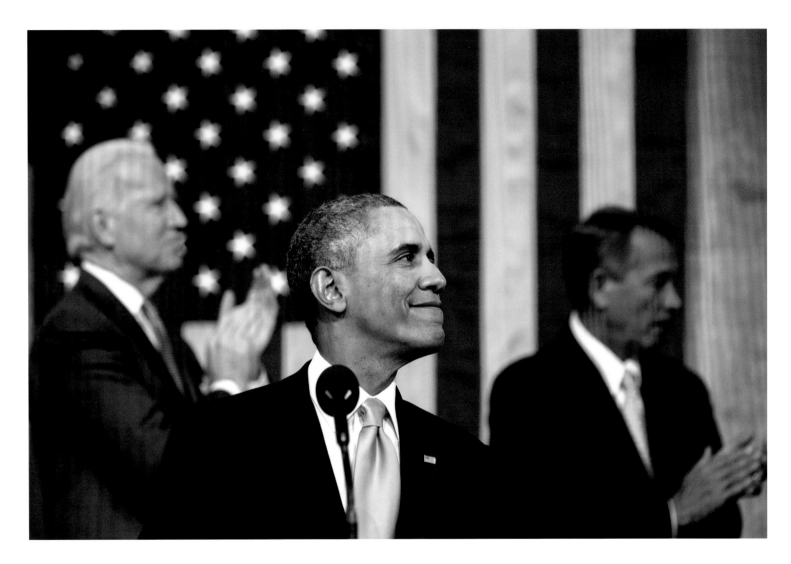

Acknowledging Army Ranger Cory Remsburg at the
State of the Union address. Remsburg was severely injured
in Afghanistan, and the President had met him both
before and after his injuries (see pages 86–87). *January 28, 2014*

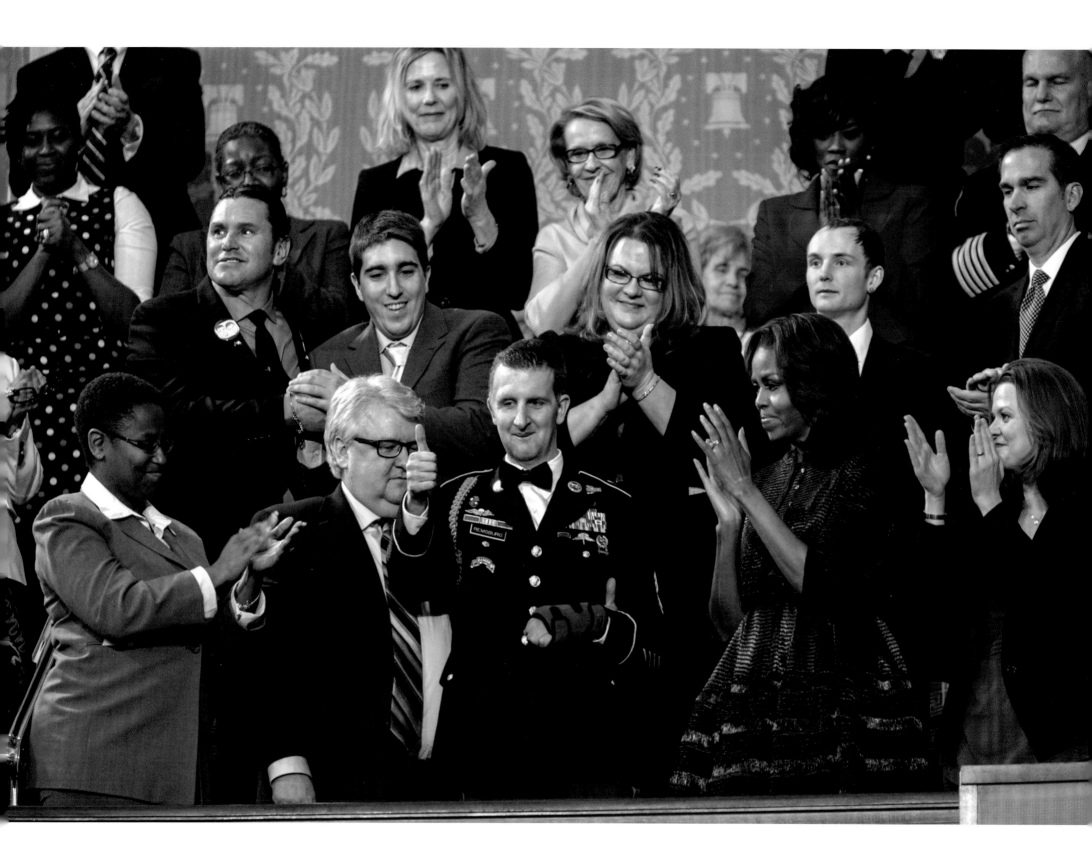

Helping the First Lady off the stage after she thanked the
White House chefs during the state dinner for
President François Hollande of France. *February 11, 2014*

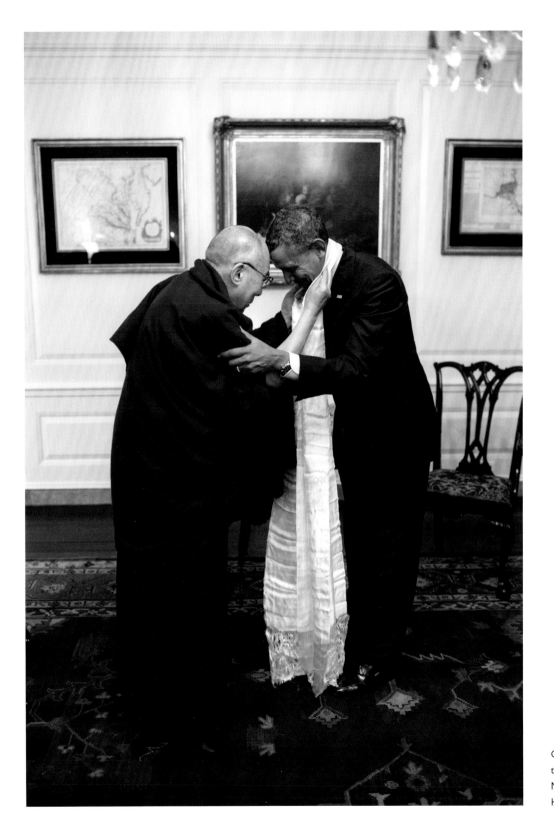

Greeting His Holiness
the 14th Dalai Lama in the
Map Room of the White
House. *February 21, 2014*

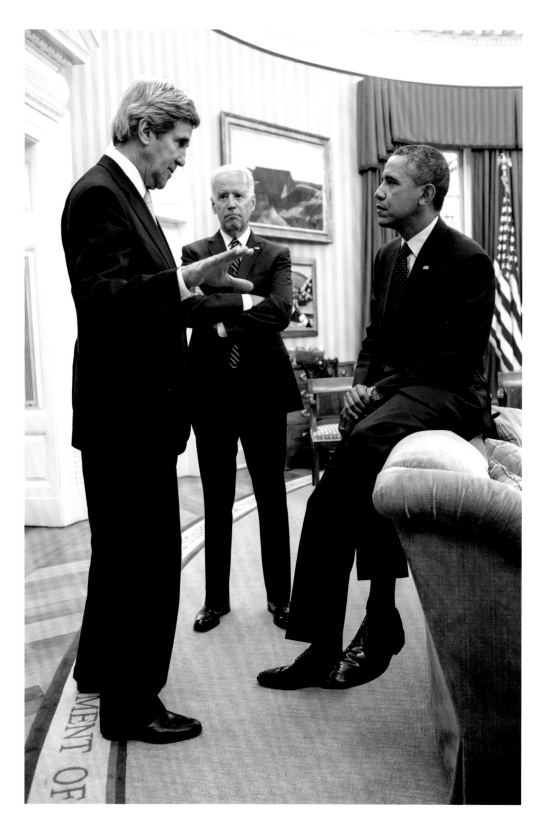

With Secretary of State John Kerry and the Vice President, discussing negotiations for a nuclear agreement with Iran. *March 12, 2014*

OPPOSITE: Walking to the motorcade from *Marine One* in Manila, Philippines. *April 28, 2014*

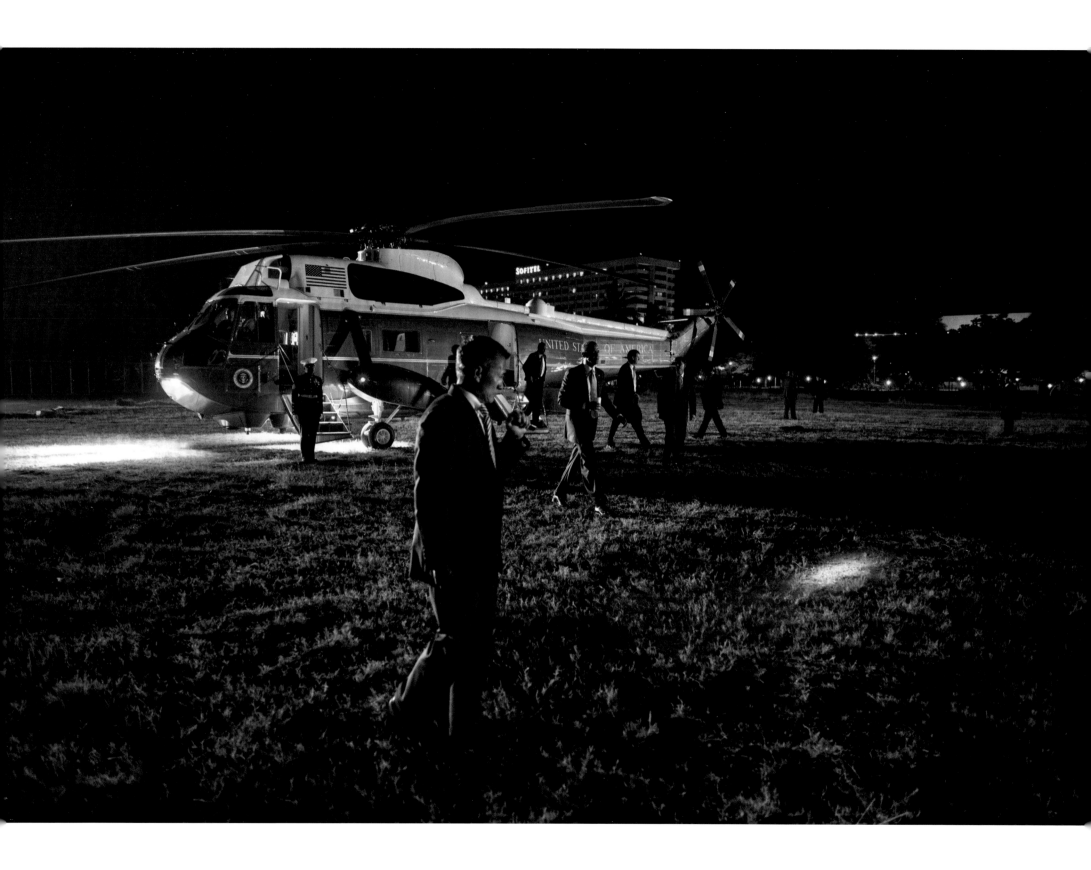

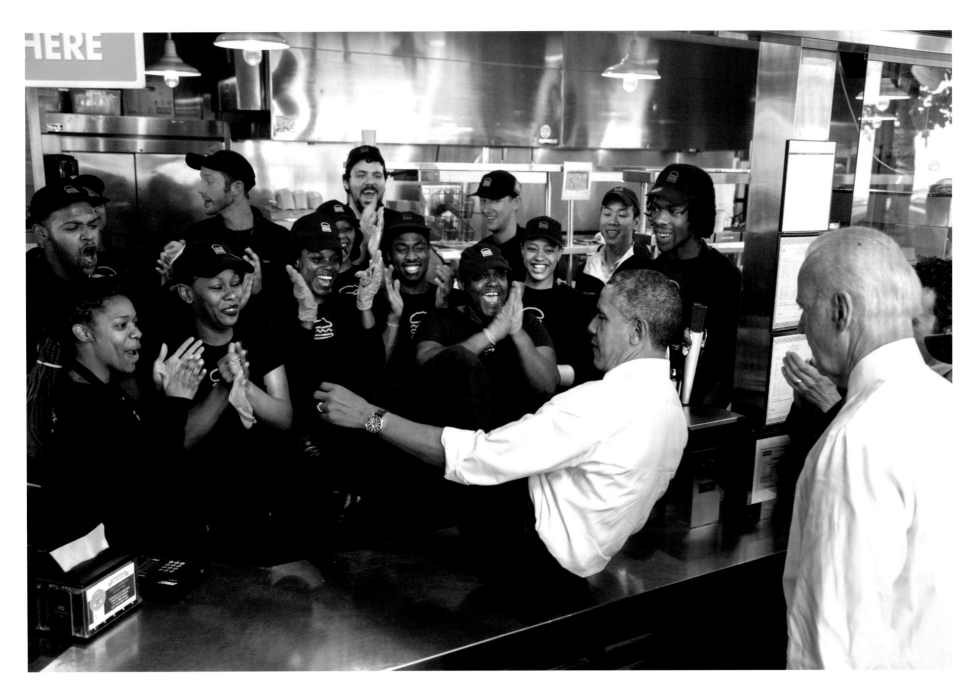

Sliding across the counter to pose for a group photo with employees
at a Shake Shack in Washington. *May 16, 2014*

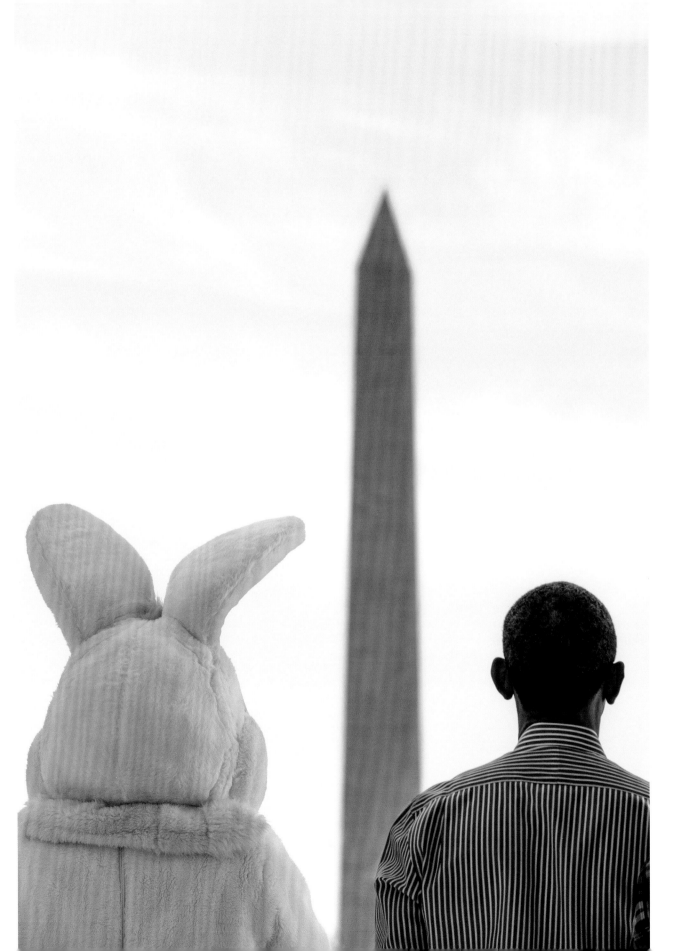

When the President saw this photograph from the Easter Egg Roll hanging in the West Wing, he told me it showed "the two most famous sets of ears in Washington" and asked for a print to give to the girls.
April 21, 2014

237

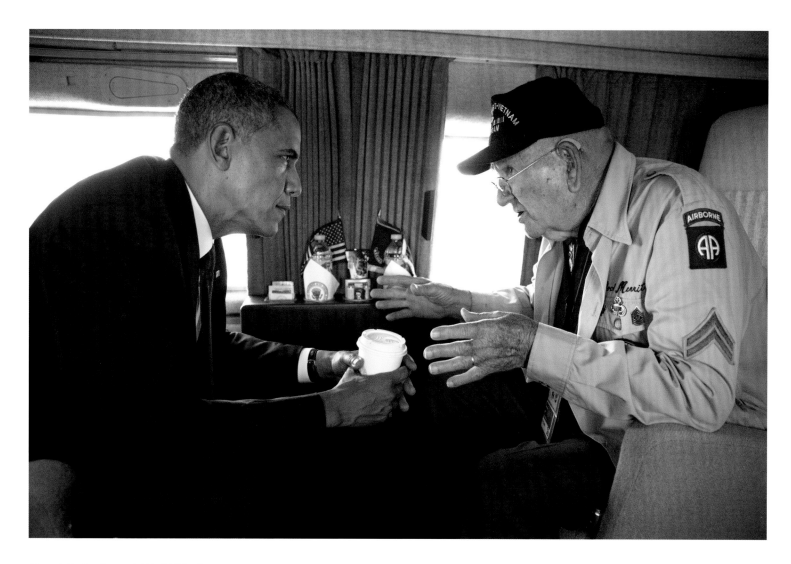

Aboard *Marine One* with World War II veteran
Kenneth "Rock" Merritt after the 70th French-American
Commemoration D-Day Ceremony at the Normandy
American Cemetery and Memorial,
in Colleville-sur-Mer, France. *June 6, 2014*

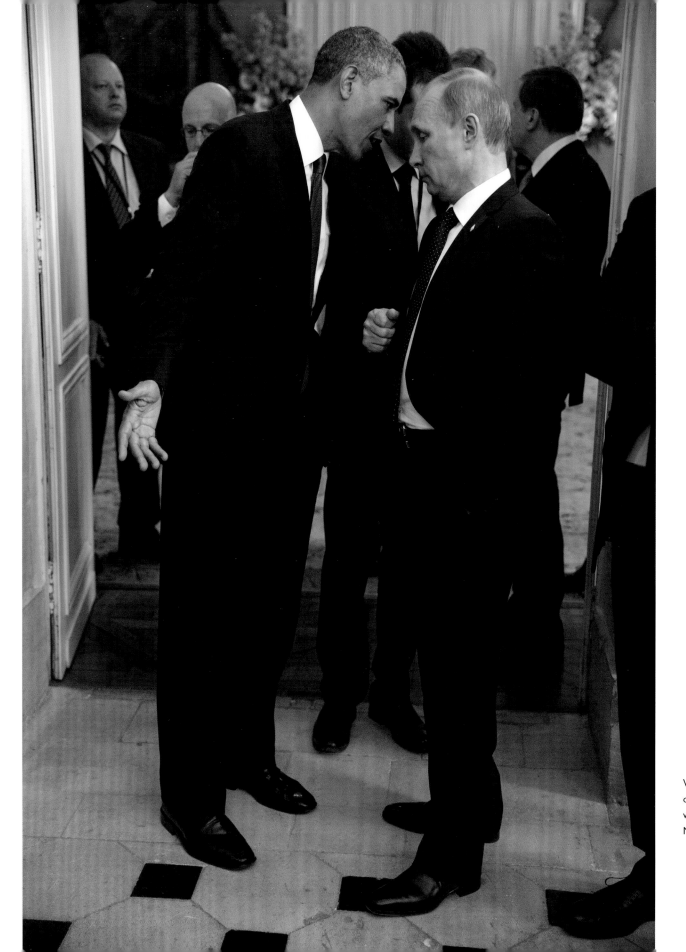

With President Vladimir Putin
of Russia following a lunch
with other foreign leaders in
Normandy. *June 6, 2014*

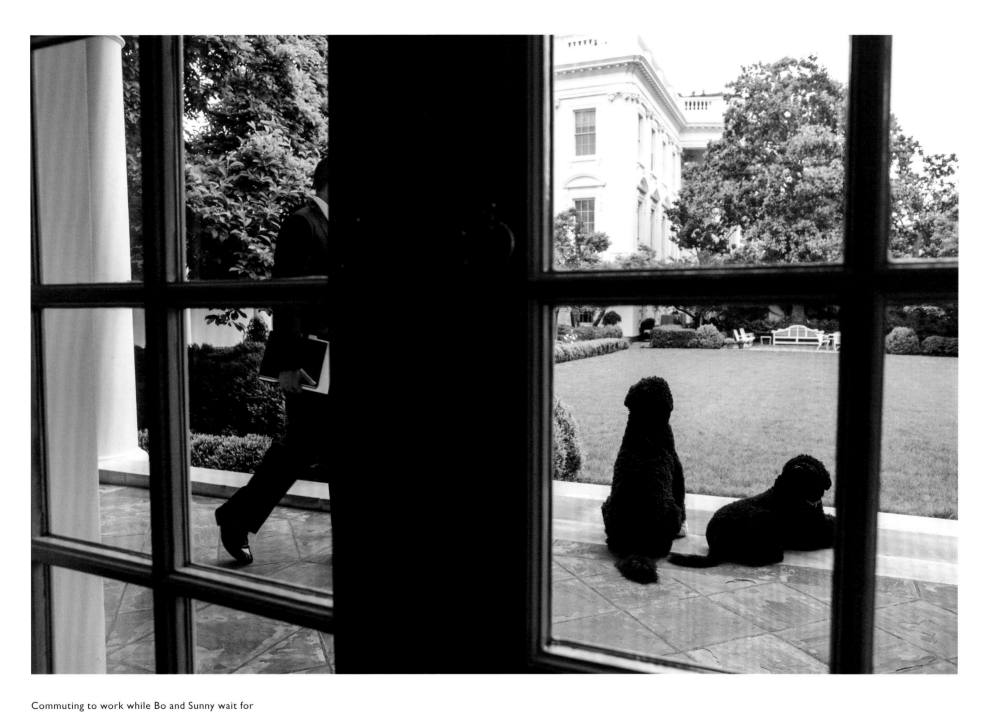

Commuting to work while Bo and Sunny wait for
some squirrel action. *May 21, 2014*

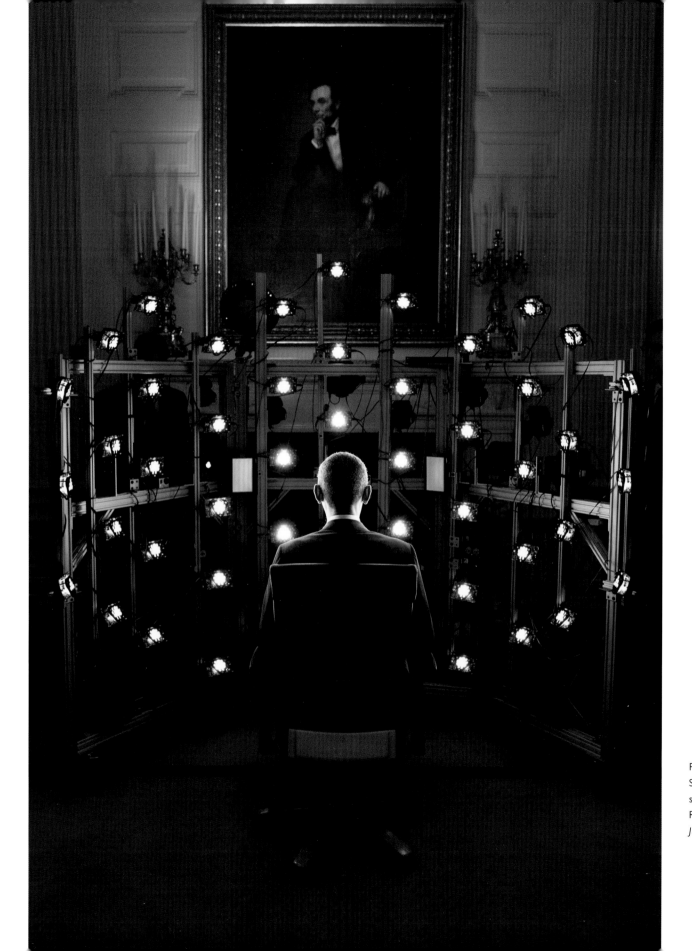

Posing for a 3D image with
Smithsonian Institution
staff in the State Dining
Room of the White House.
June 9, 2014

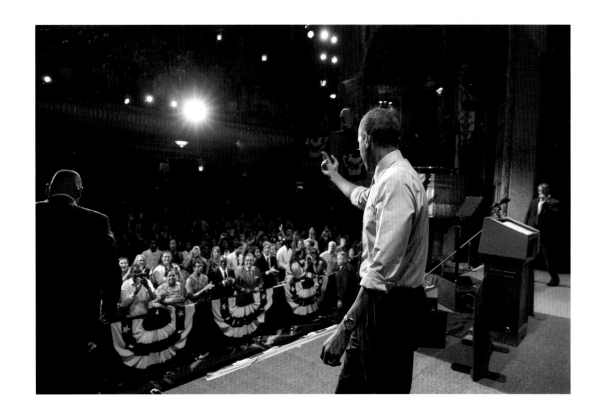

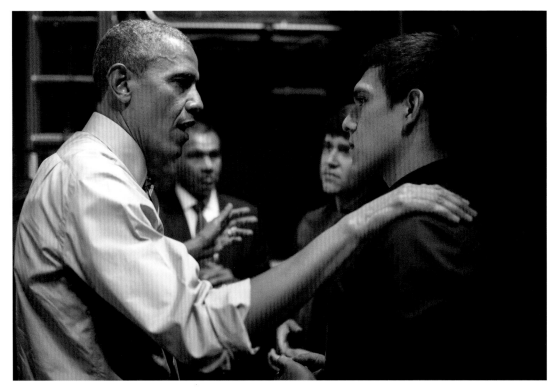

Motioning to two hecklers to meet him backstage after an event to talk about his immigration policy in Austin, Texas (top). He then responded to their concerns (bottom).
July 10, 2014

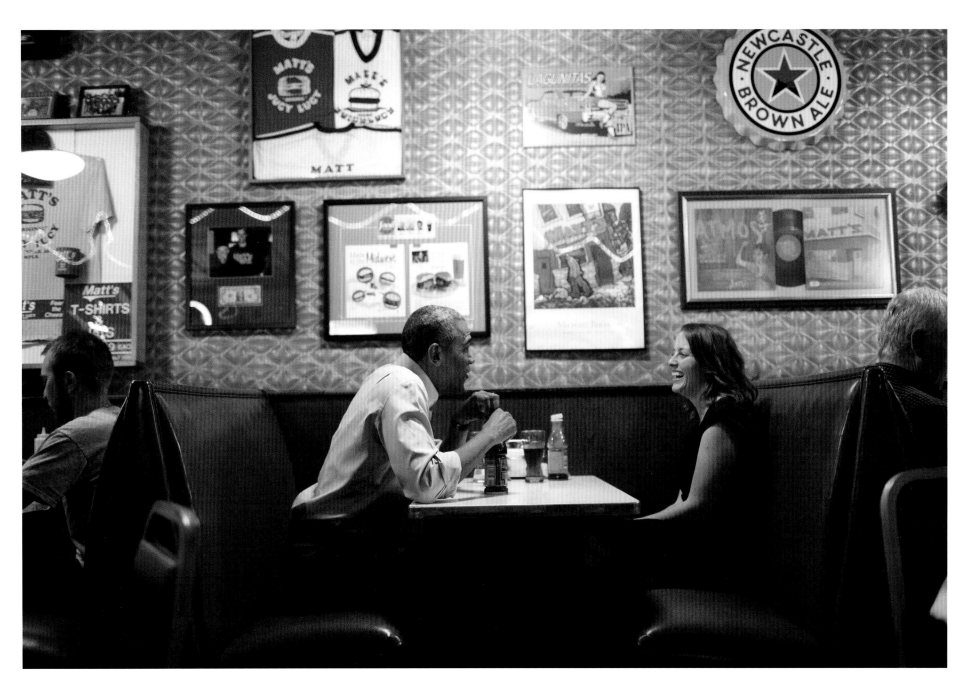

Lunch with Rebekah Erler, who had written him a letter about the challenges
of middle-class life in the new economy, at Matt's Bar in Minneapolis.
The President kept in touch with Erler throughout the rest of his Presidency
and the staff invited her to his farewell speech in 2017. *June 26, 2014*

Viewing the Golden Gate Bridge with his Secret Service detail
after arriving in San Francisco via helicopter. *July 23, 2014*

II

A NEAR EPIDEMIC OF EBOLA

THE 50TH ANNIVERSARY OF BLOODY SUNDAY

A SUMMIT AT CAMP DAVID

EULOGIZING BEAU BIDEN

PRINCE PERFORMS, POTUS DANCES

MIXED EMOTIONS ON A HISTORIC DAY

Discussing a statement about the protests in Ferguson, Missouri, with Deputy National Security Advisor Ben Rhodes and Attorney General Eric Holder. A white police officer had shot Michael Brown, an unarmed black teenager, which caused simmering racial tensions to boil over. The President was on vacation in Martha's Vineyard, Massachusetts. *August 14, 2014*

Reflecting during a discussion on technology in the
Rose Garden. *October 8, 2014*

OPPOSITE: Walking to the basketball court with a group
of mentees after meeting in the White House. The President
met with them on several occasions. *October 14, 2014*

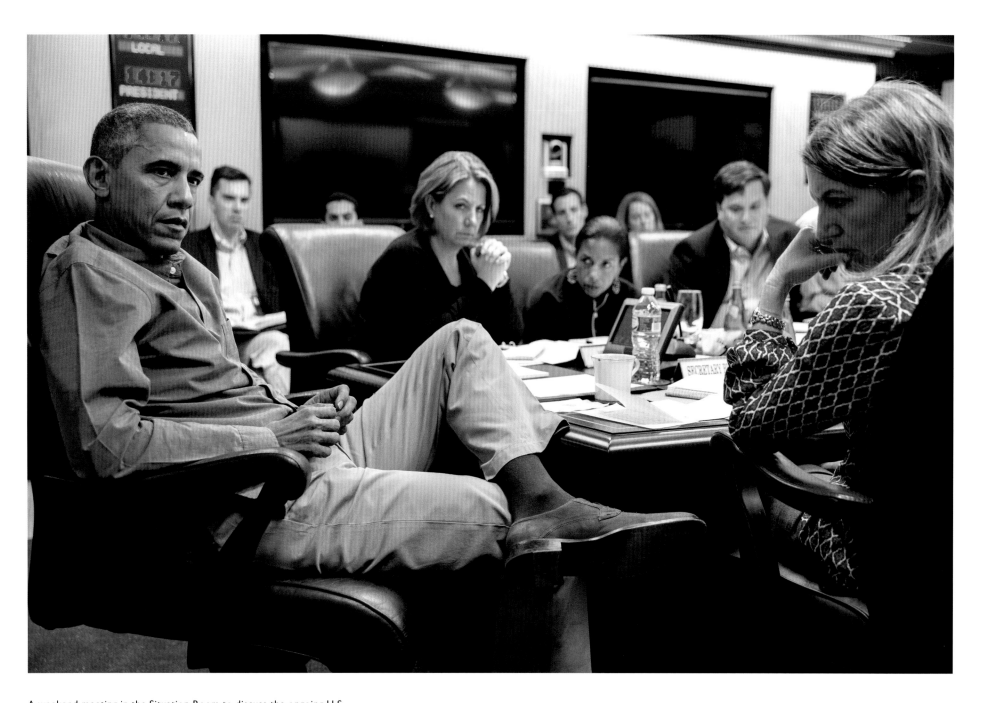

A weekend meeting in the Situation Room to discuss the ongoing U.S.
response to the Ebola epidemic in West Africa. *October 26, 2014*

Embracing nurse Nina Pham, who had been diagnosed with Ebola after caring for an infected patient in Texas. Pham had been declared Ebola-free that day after being treated at the National Institutes of Health. *October 24, 2014*

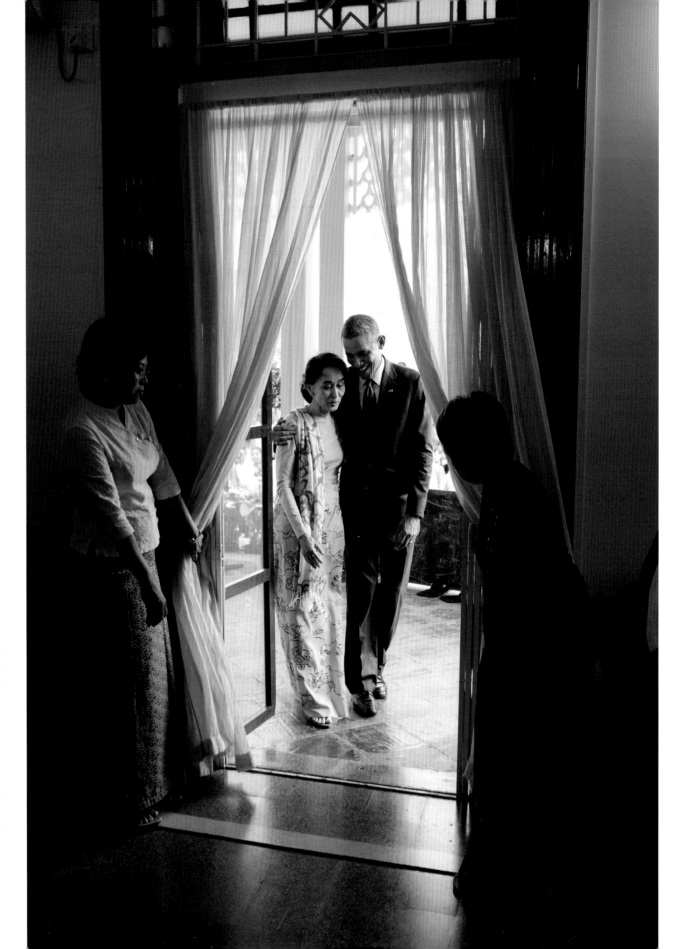

Escorting political activist and Nobel Peace Prize winner Aung San Suu Kyi back into her residence after a joint press conference in Yangon, Myanmar (formerly known as Rangoon, Burma). The two had forged a friendship as she sought to establish diplomatic ties with the United States.

November 14, 2014

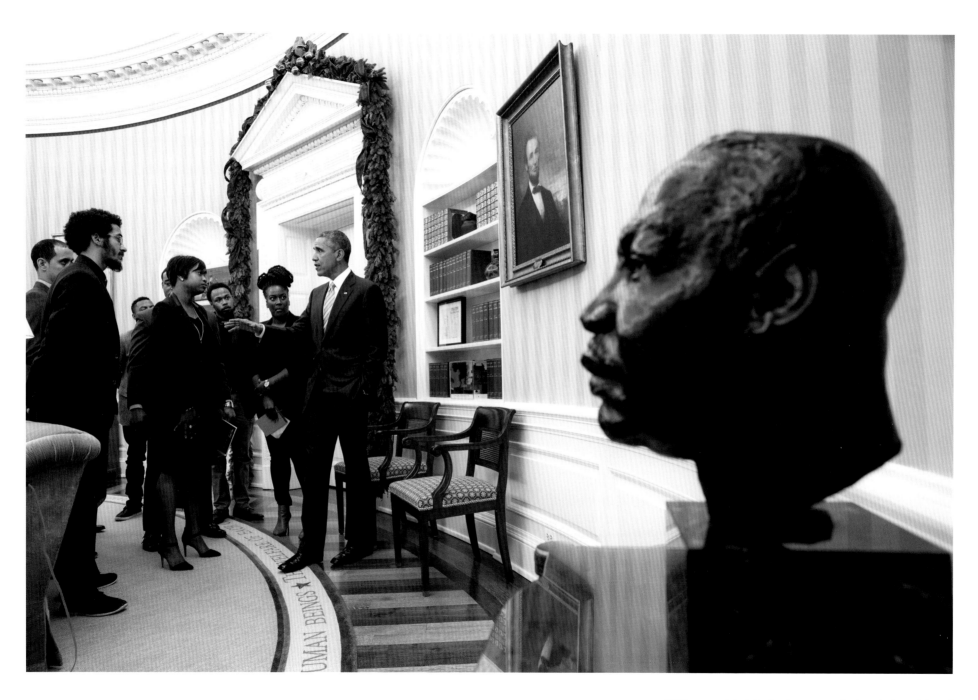

With young civil rights leaders, many of whom had participated
in the protests in Ferguson, Missouri. *December 1, 2014*

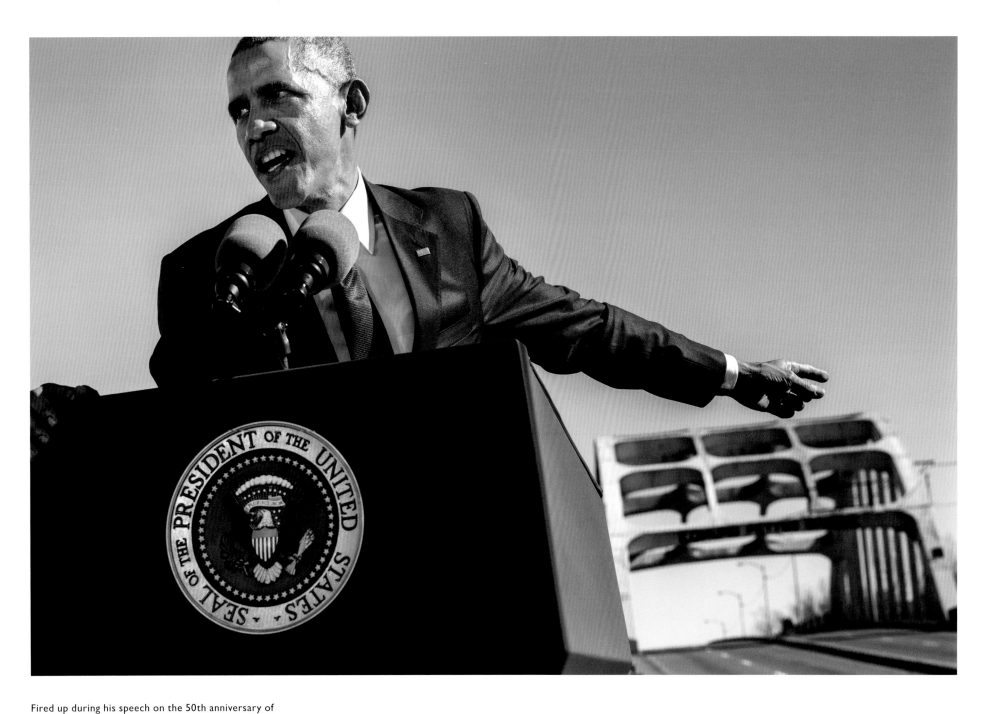

Fired up during his speech on the 50th anniversary of
Bloody Sunday in Selma, Alabama. *March 7, 2015*

OPPOSITE: Walking across the Edmund Pettus Bridge with his family,
Representative John Lewis of Georgia, former President George W. Bush,
former First Lady Laura Bush, and other dignitaries, commemorating
the march from Selma to Montgomery. *March 7, 2015*

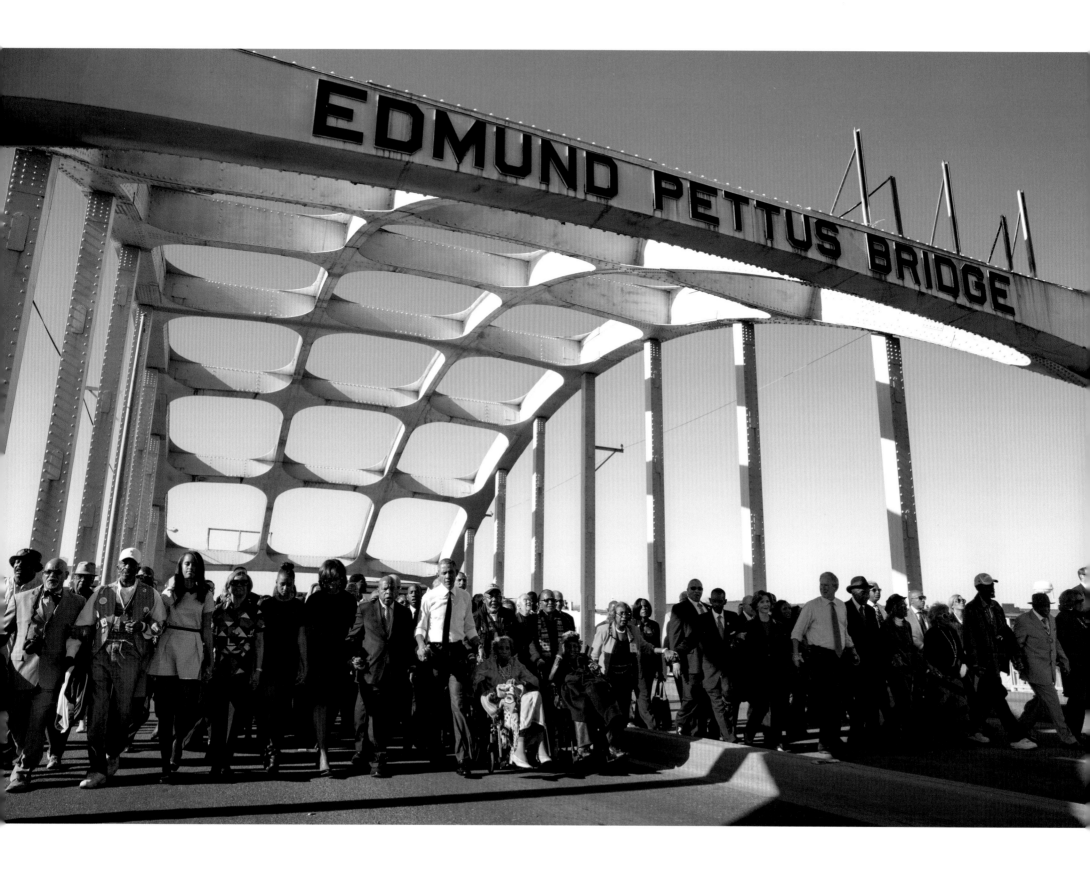

Heading back to the Oval after mingling with members of Congress and others who supported
H.R. 2, the Medicare Access and CHIP Reauthorization Act of 2015, to improve the
affordability and quality of health care for the youngest and oldest in the nation. *April 21, 2015*

An impromptu meeting with aides Beth Cobert, Office of Management
and Budget deputy director; Valerie Green, director of Presidential personnel;
and deputy chief of staff Anita Decker Breckenridge. *March 19, 2015*

Still pleading with House Minority Leader Nancy Pelosi even after she had left their meeting. *April 29, 2015*

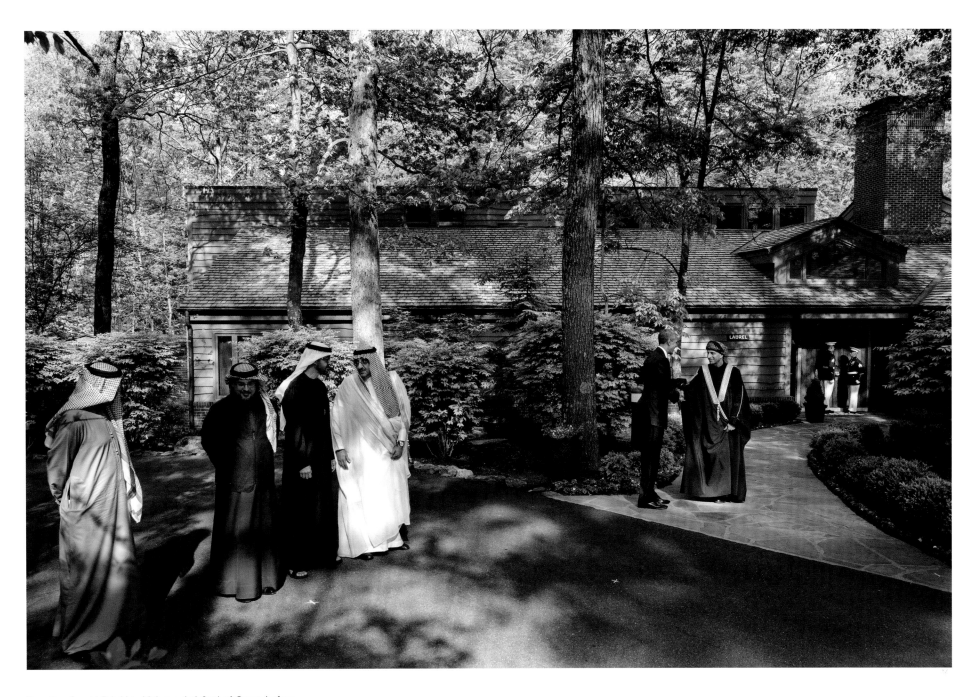

Greeting Sayyid Fahd bin Mahmoud al-Said of Oman before
a group photo with Gulf Cooperation Council leaders during a
summit at Camp David. *May 14, 2015*

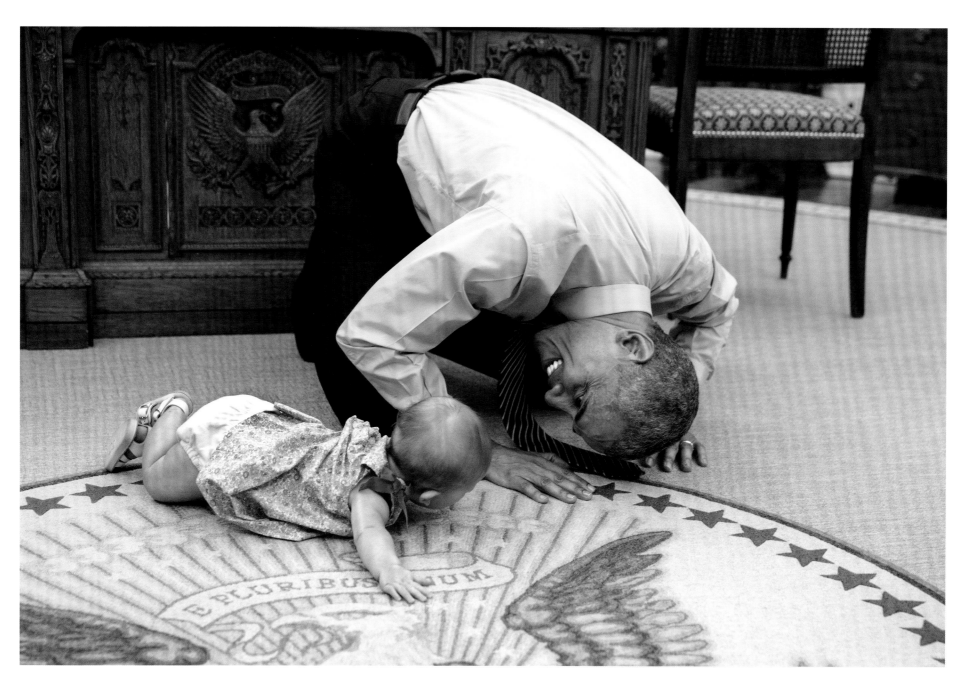

With Ella Rhodes, daughter of Deputy National Security Advisor Ben Rhodes. The President encouraged senior staff to bring their infants in to visit him—a welcome break from the tensions of the day. *June 4, 2015*

Consoling the Vice President after delivering
a eulogy for Beau Biden, his son,
who had died of brain cancer. *June 6, 2015*

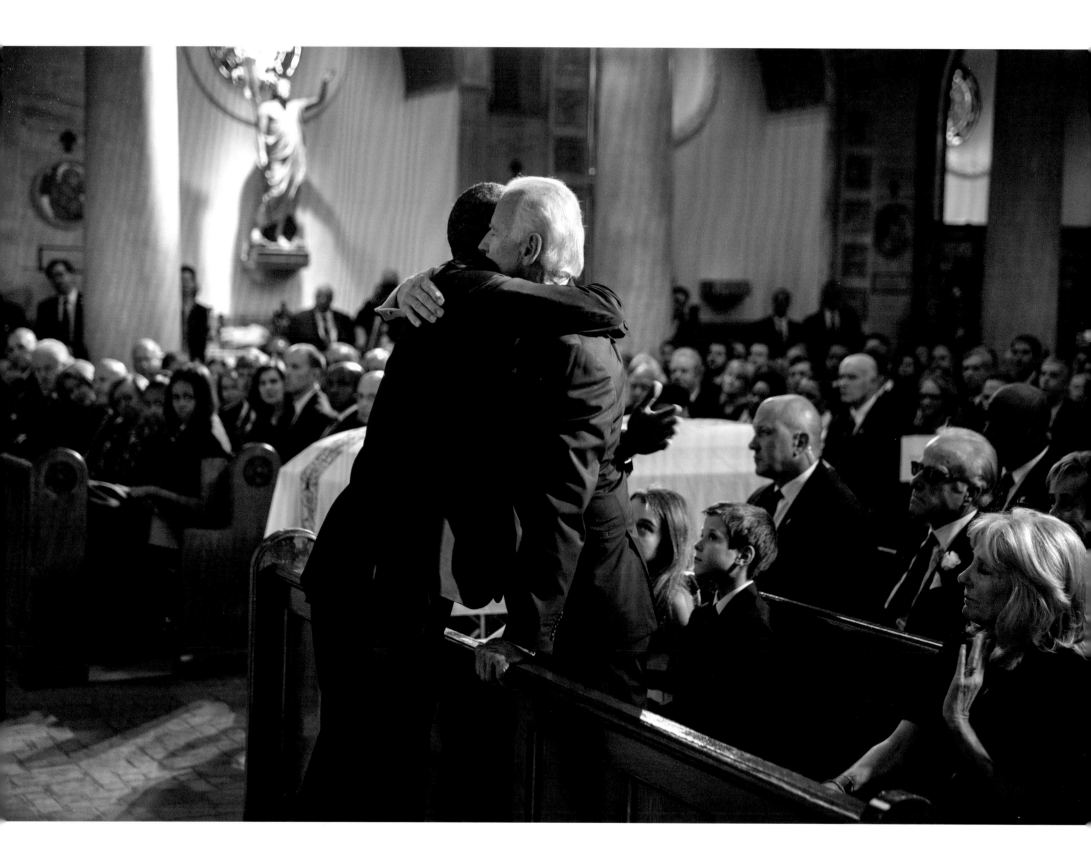

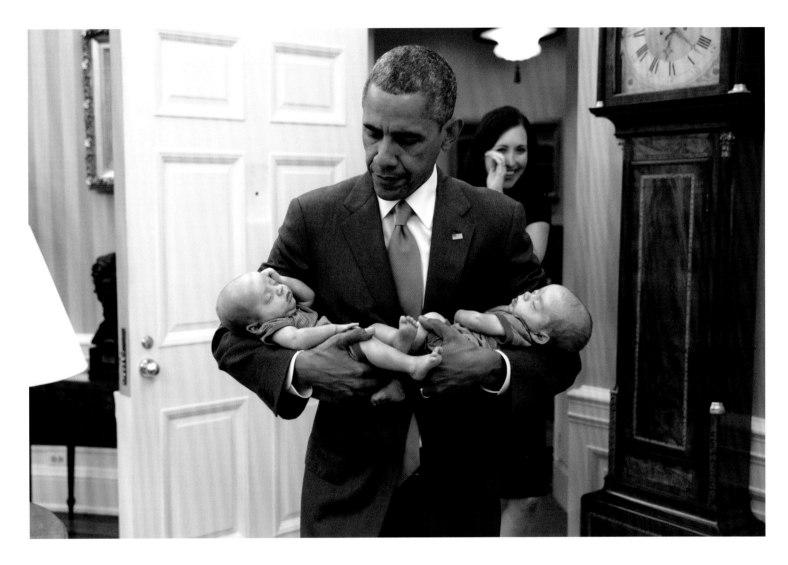

With legislative aide Katie Beirne Fallon's twin boys.
Months earlier, Katie had been rushed from the White House
to the hospital when she went into labor. *June 17, 2015*

OPPOSITE: At the G7 summit in Krün, Germany, with Chancellor
Angela Merkel. The President and Merkel formed a close relationship
over the eight years they were both in office. *June 8, 2015*

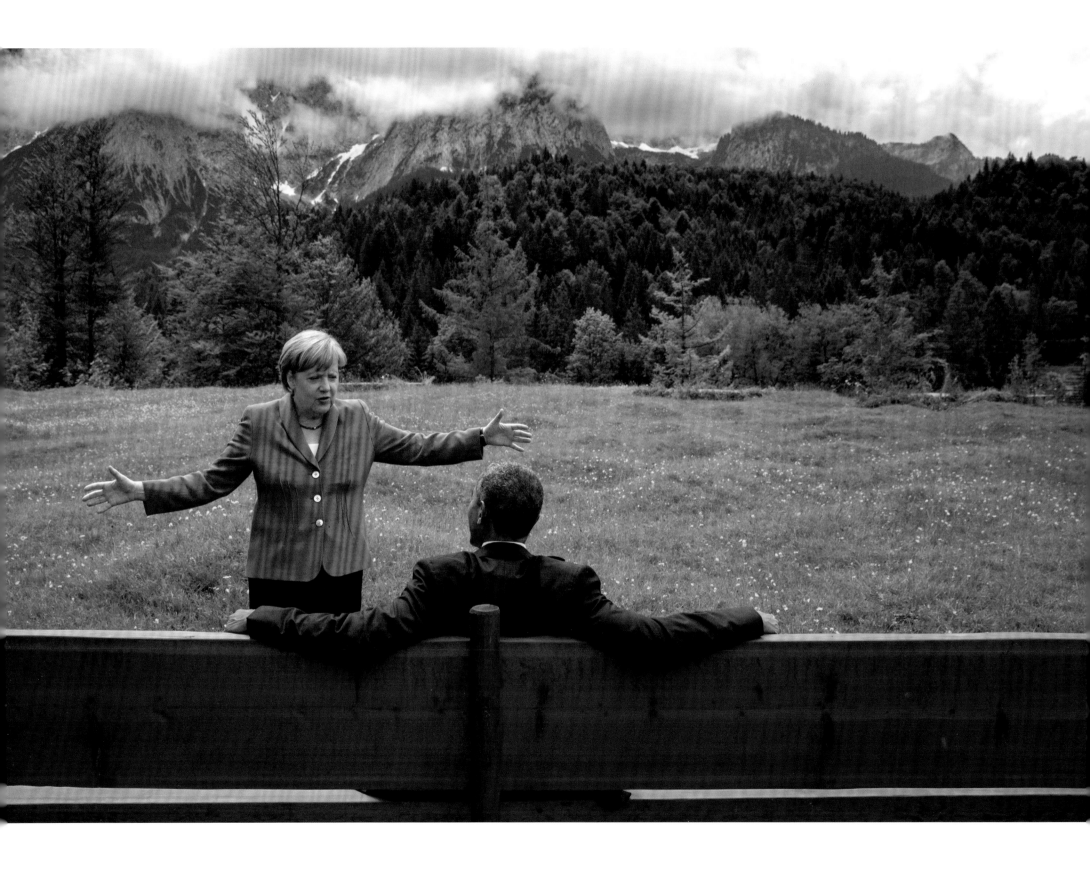

Dancing with Sasha as Prince performs at a party in the East Room. She had pulled her dad onstage toward the end of the night. *June 13, 2015*

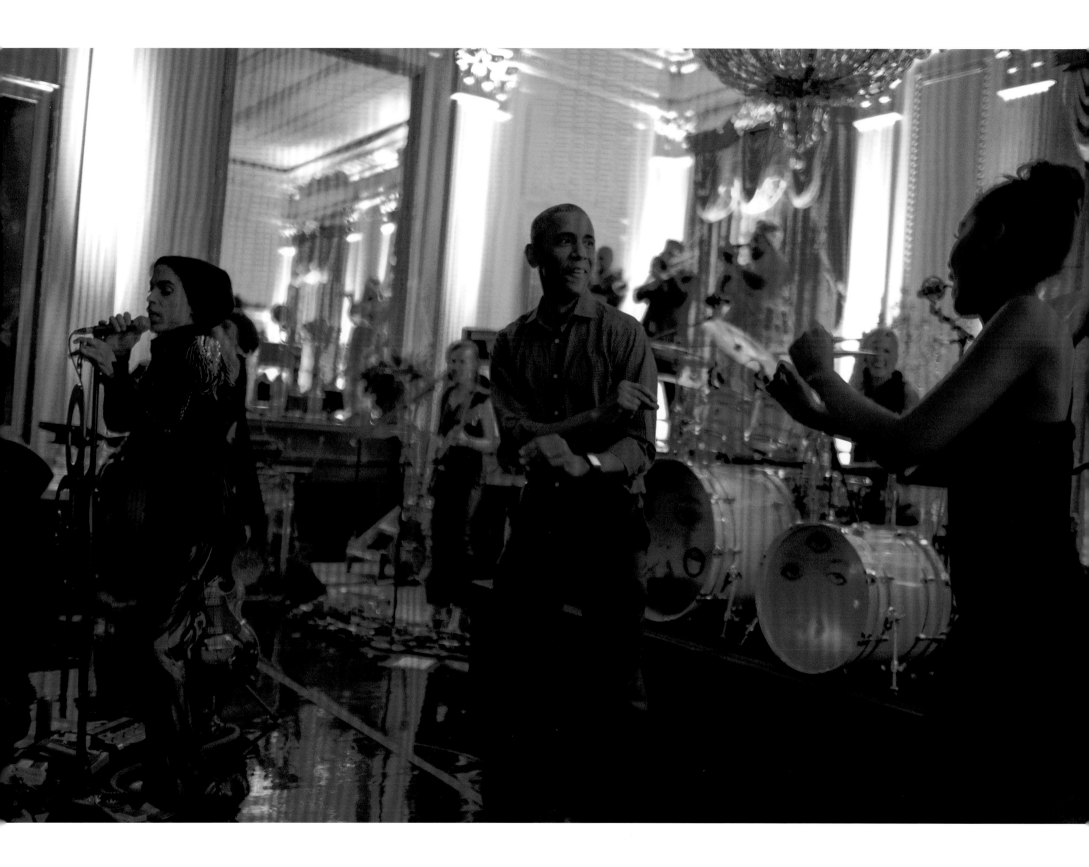

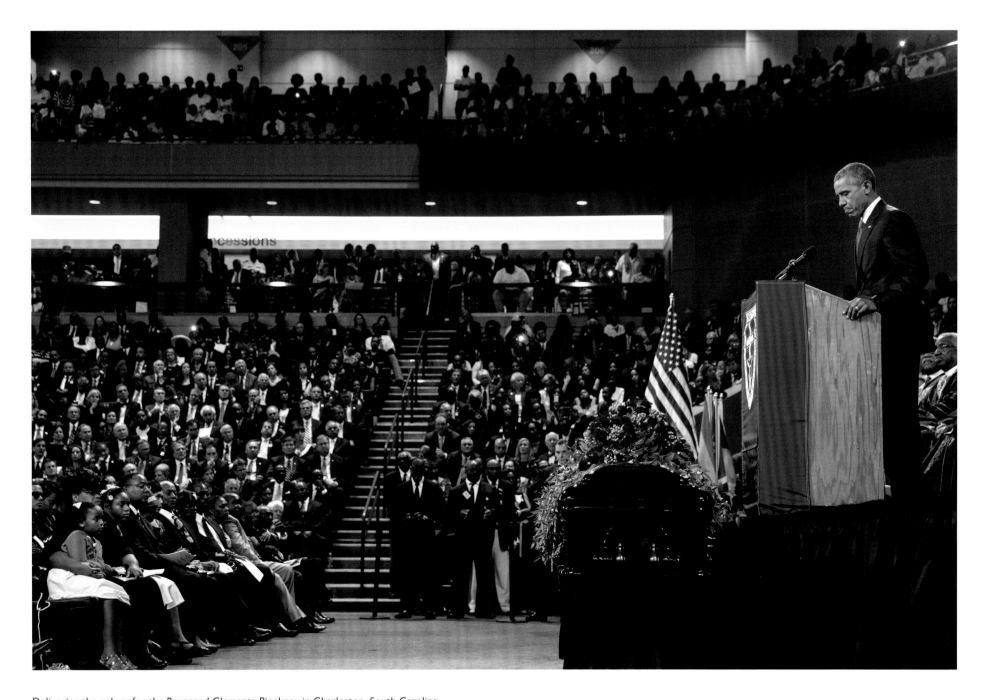

Delivering the eulogy for the Reverend Clementa Pinckney in Charleston, South Carolina. Pinckney was one of nine people shot and killed during a Bible-study session at the Emanuel African Methodist Episcopal Church. His wife and two children are seated in the front row, lower left. The President sang "Amazing Grace" during his eulogy. *June 26, 2015*

OPPOSITE: Later that night, the White House was lit in rainbow colors to celebrate the Supreme Court's decision to uphold same-sex marriage. *June 26, 2015*

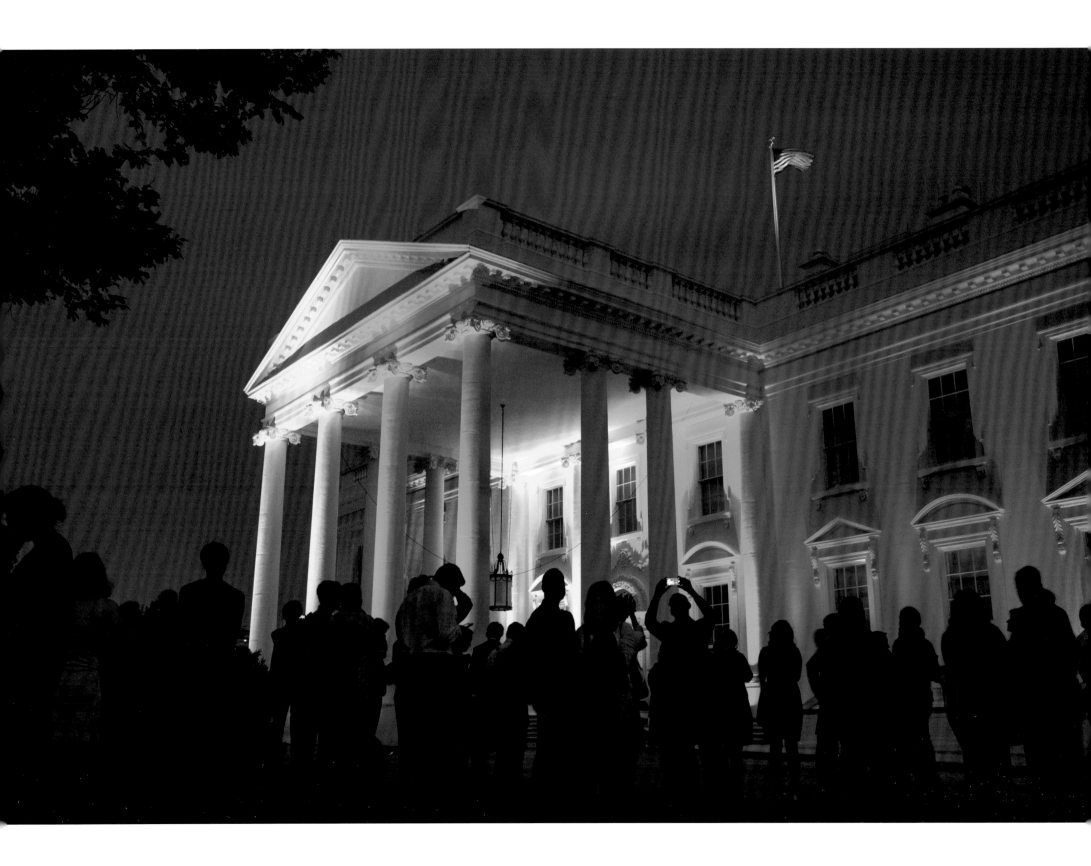

12

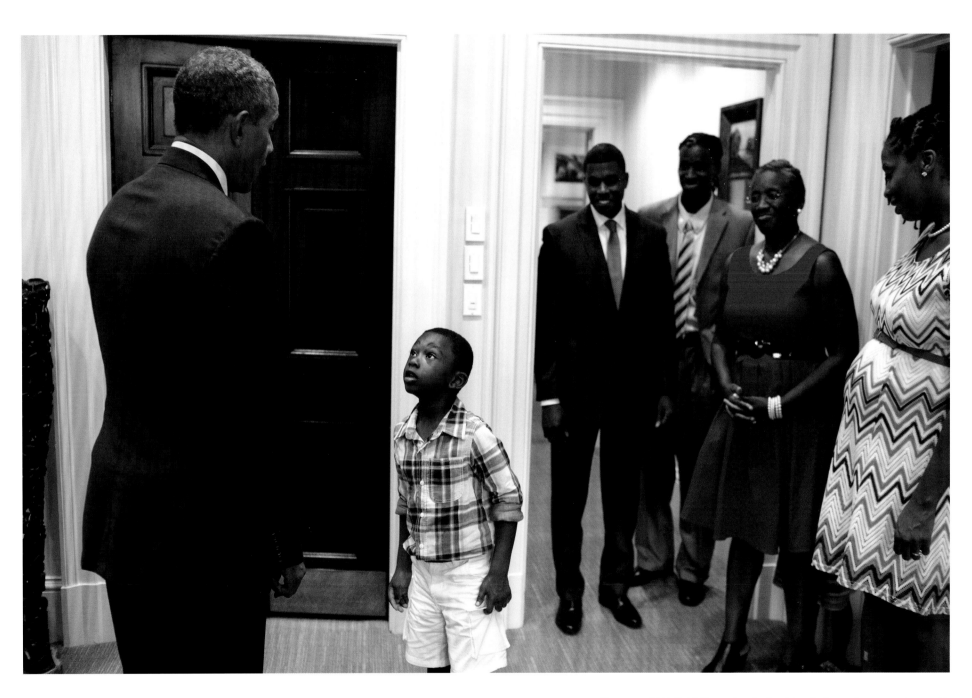

Five-year-old Malik Hall greeting the President before a departure photo with Malik's uncle Maurice Owens, center, and his family. *September 4, 2015*

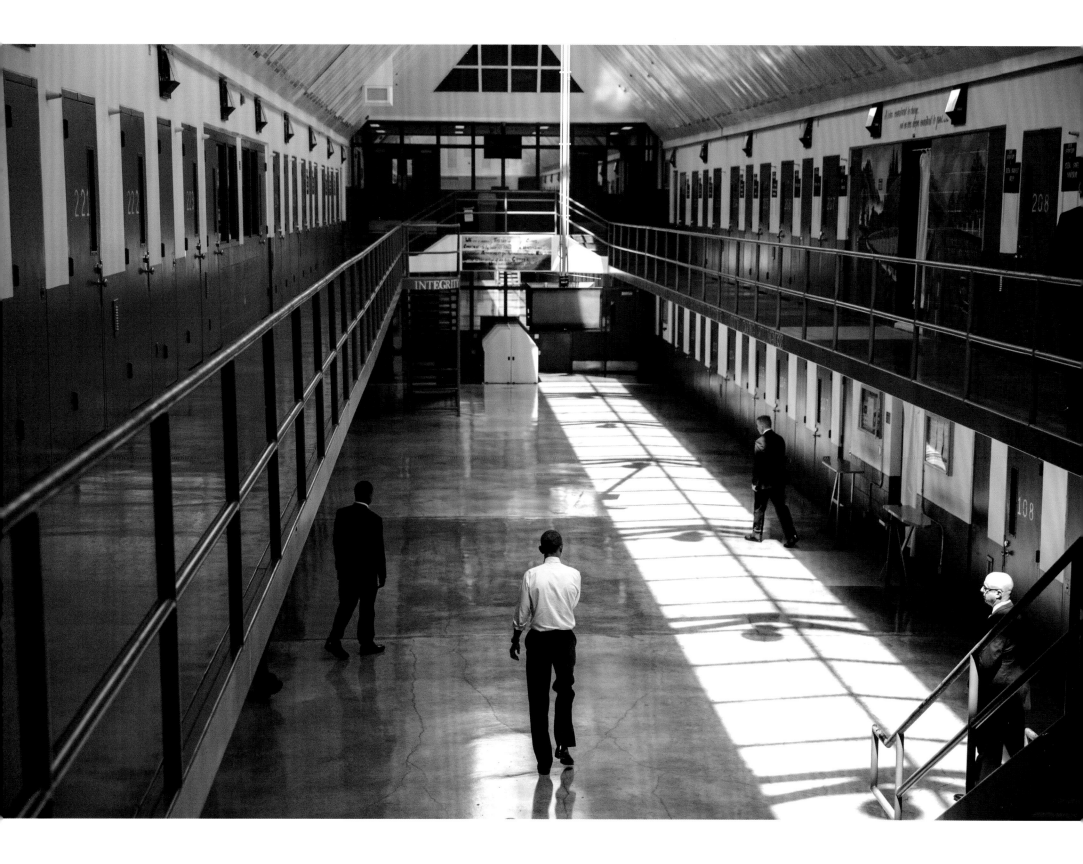

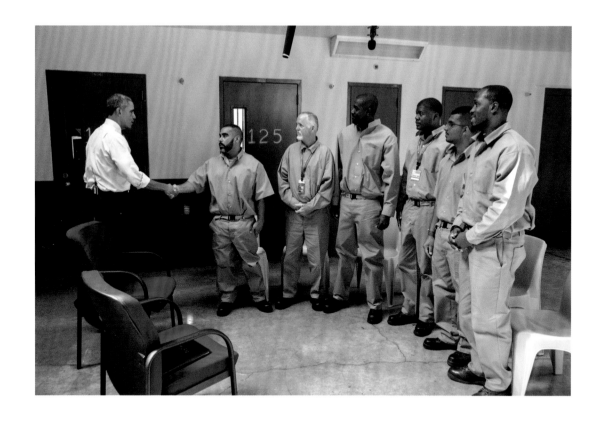

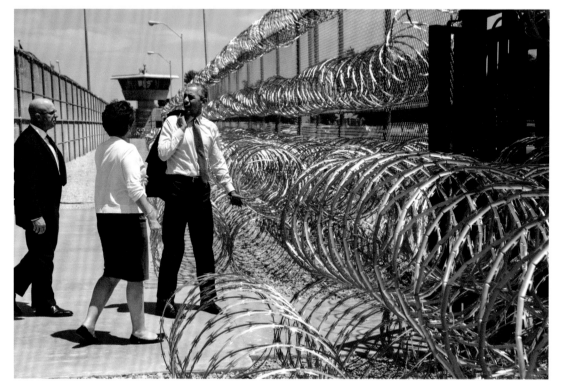

OPPOSITE: At the El Reno Federal Correctional Institution, in Oklahoma, becoming the first sitting President to visit a federal prison. *July 16, 2015*

TOP: Greeting inmates.

BOTTOM: Departing with senior advisor Valerie Jarrett and Secret Service Special Agent in Charge Rob Buster.

Surprising deputy chief of staff Anita Decker Breckenridge
on her birthday. Chase Cushman, director of scheduling, watches
in the background. *July 20, 2015*

OPPOSITE: Touring the Whitney Museum, in
New York City, with Malia. *July 17, 2015*

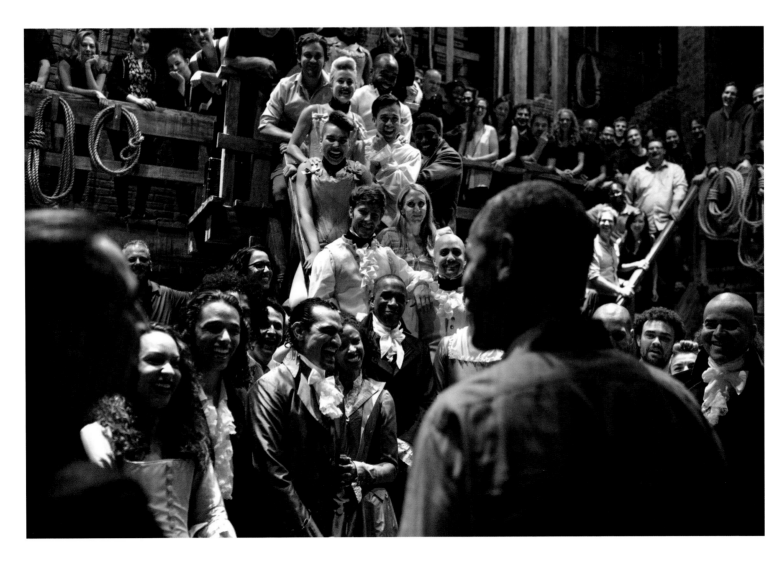

With cast members of *Hamilton* after seeing the musical
with his daughters in New York City. *July 18, 2015*

OPPOSITE: Secret Service agents holding back an excited
crowd after the President's speech in Nairobi, Kenya.
It was his first visit as President to the country where
his father was born. *July 26, 2015*

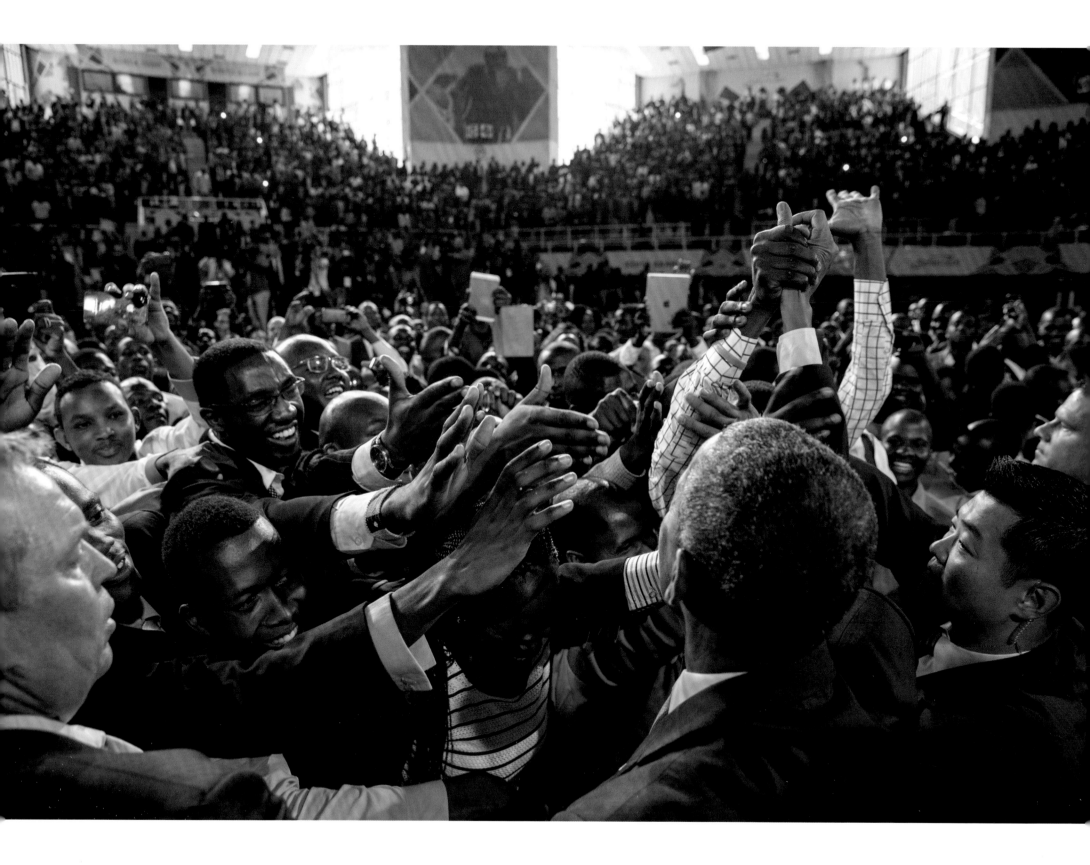

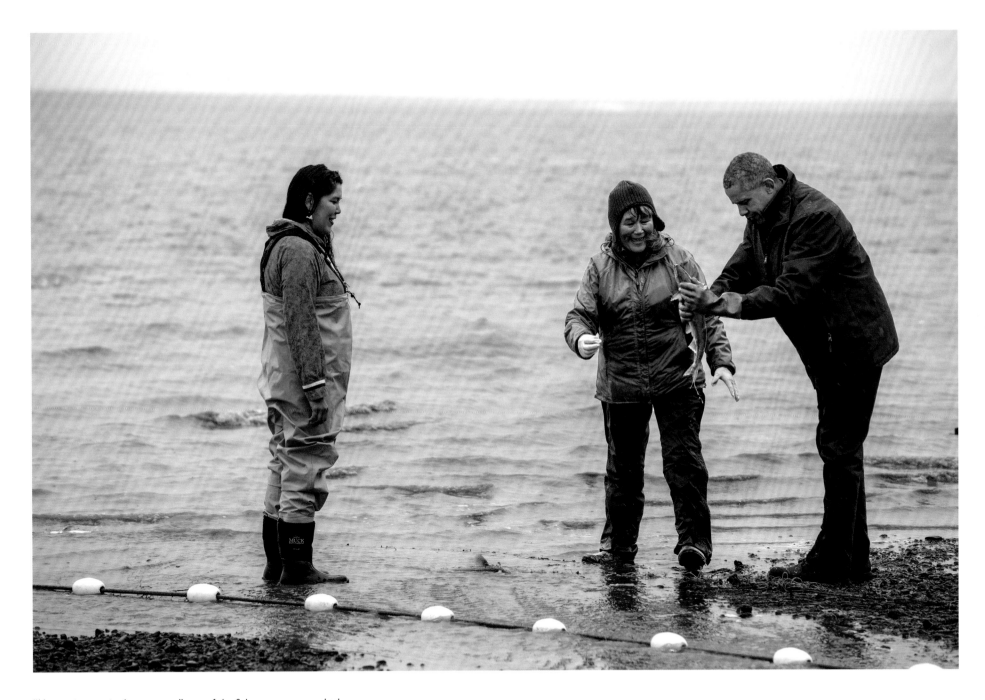

"He was just excited to see you," one of the fisherwomen remarked
after a salmon spawned on the President's boots at Kanakanak Beach, in
Bristol Bay, Alaska. *September 2, 2015*

OPPOSITE: Touring Kenai Fjords National Park, in Alaska. The trip centered
on the effects of climate change on the region. *September 1, 2015*

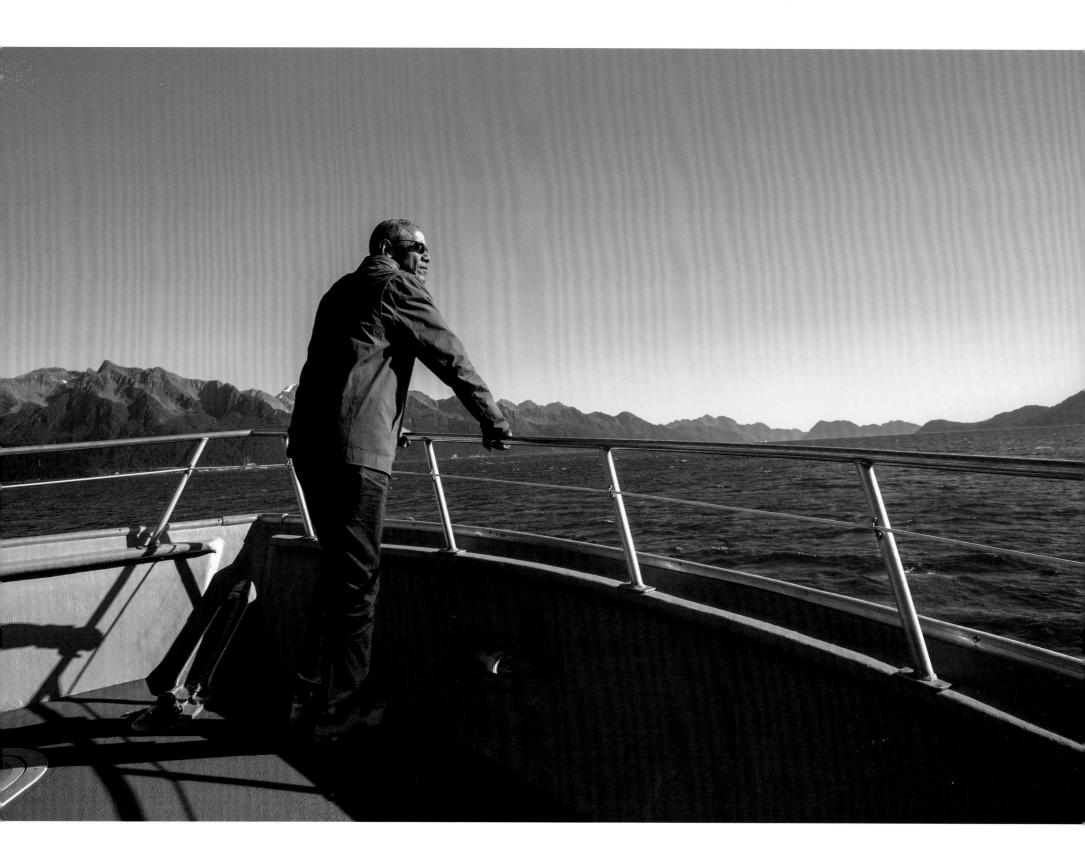

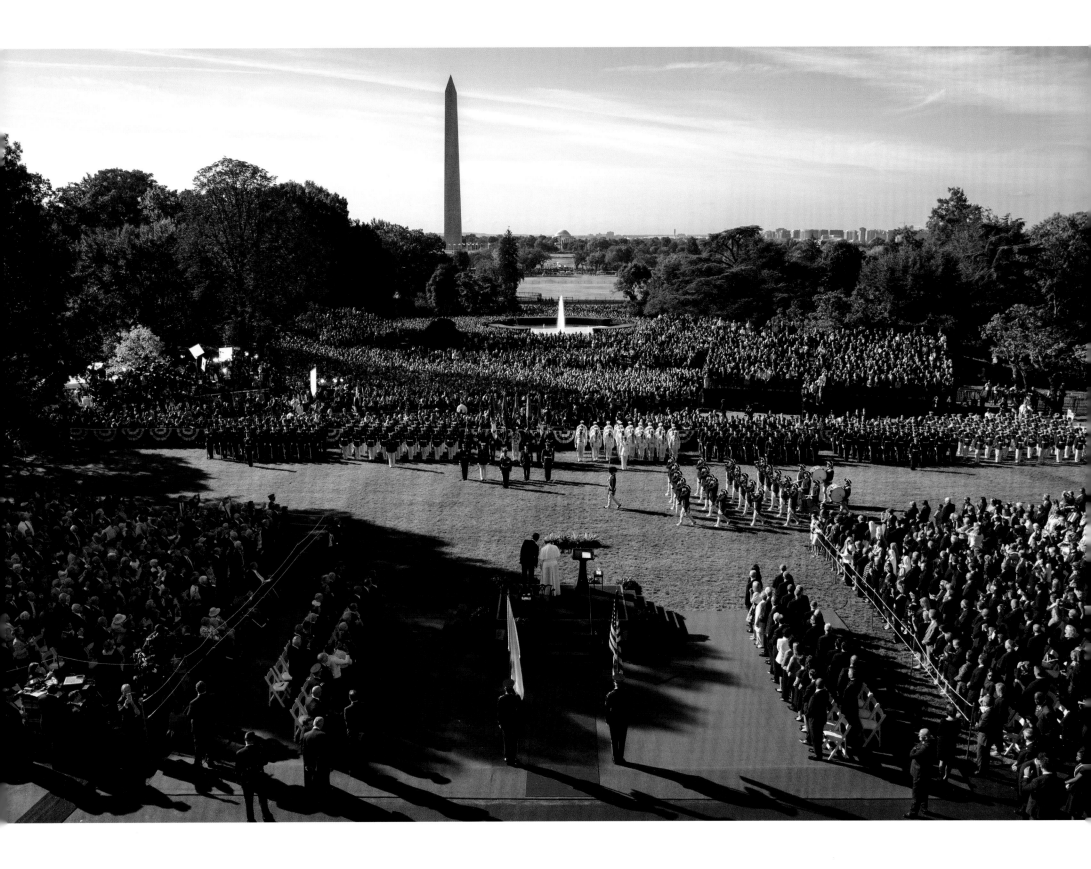

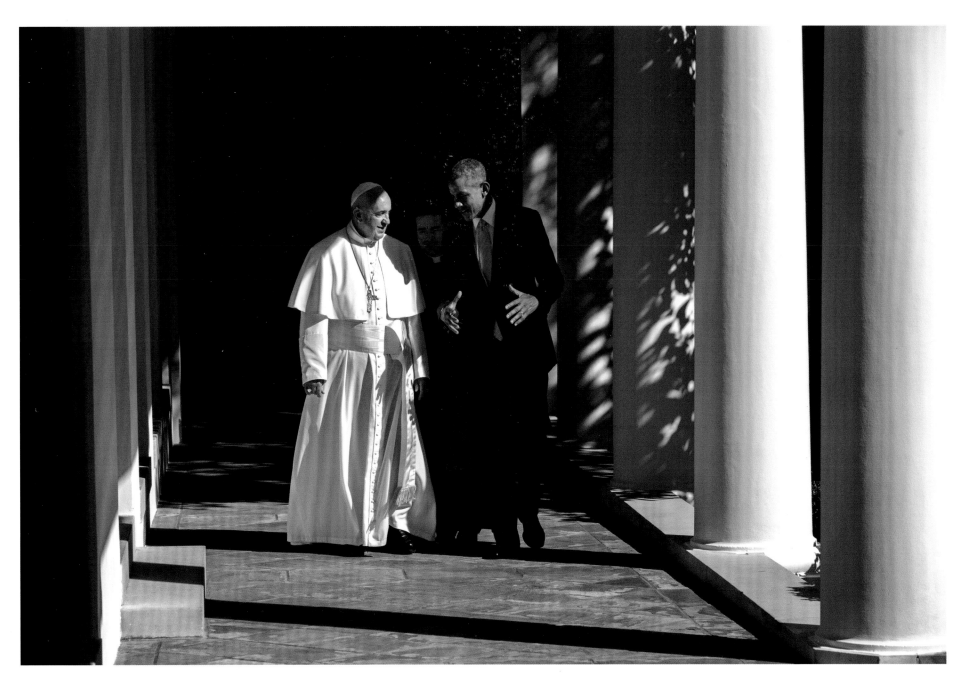

With Pope Francis on the Colonnade, on their way to a meeting in the
Oval Office. It was the Pope's first trip to the United States.

OPPOSITE: Earlier that day, the formal arrival ceremony on the
South Lawn for Pope Francis. I had set up a remote camera on the
Truman Balcony for this overview. *September 23, 2015*

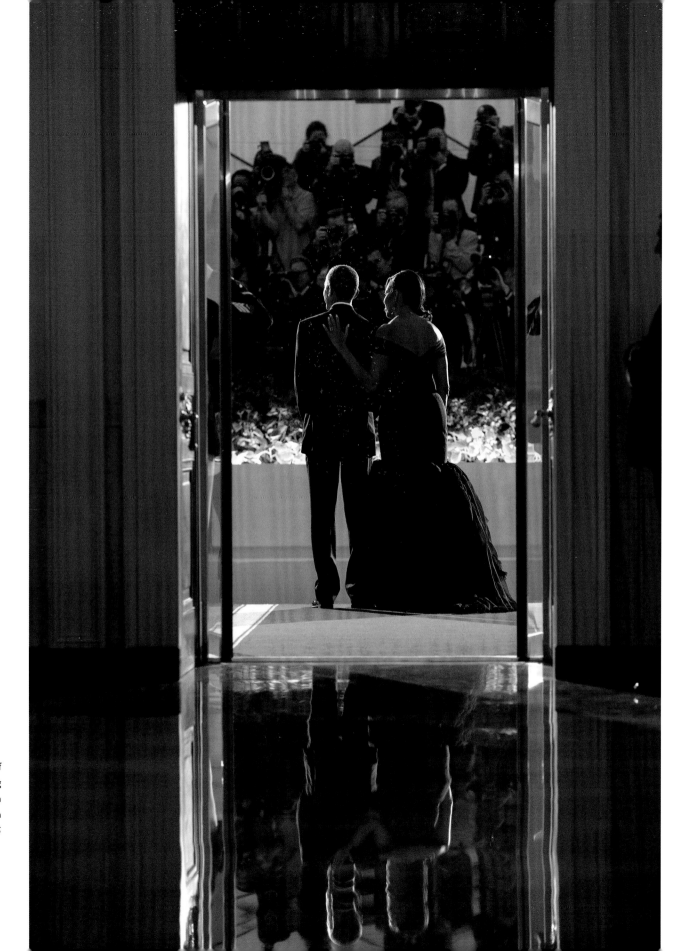

Awaiting the arrival of
President Xi Jinping
and Madame Peng Liyuan
of China on the North
Portico. *September 25, 2015*

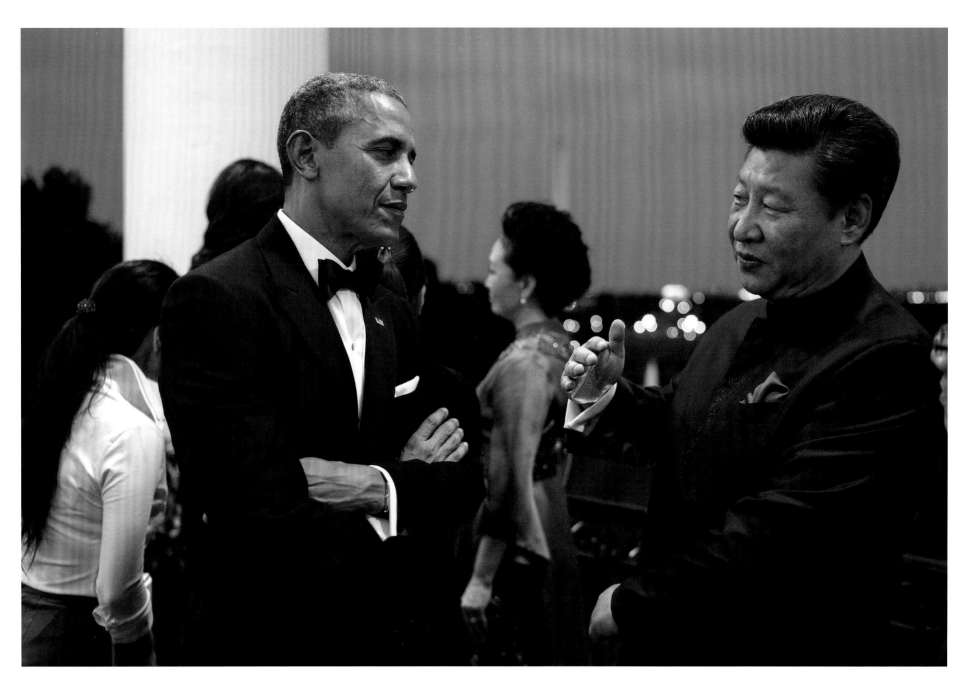

With President Xi on the Truman Balcony before the
formal state dinner. *September 25, 2015*

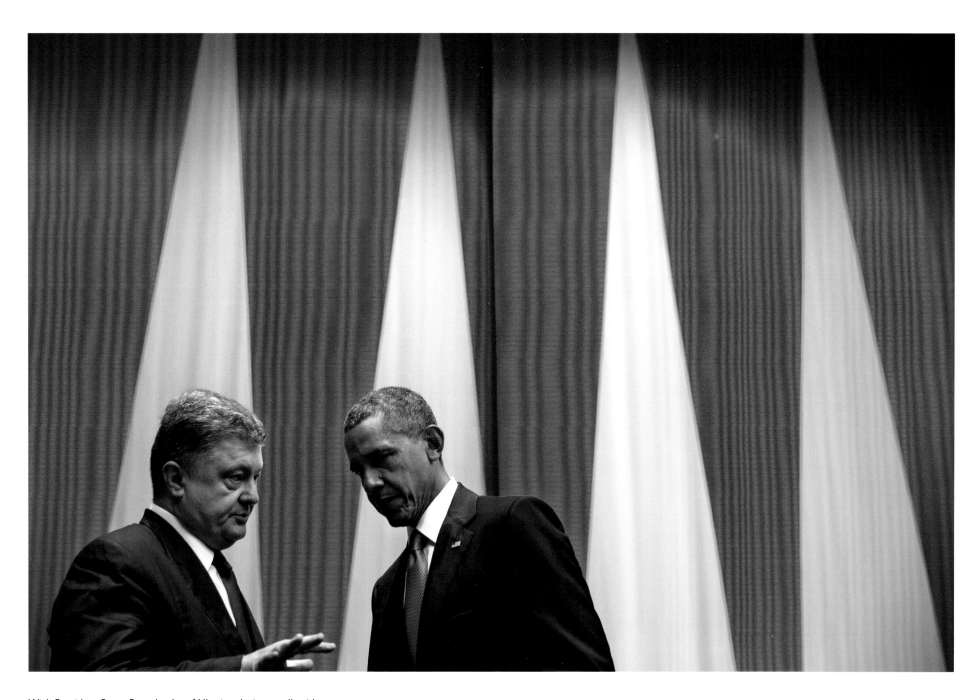

With President Petro Poroshenko of Ukraine during a pull-aside
conversation at the United Nations, in New York. *September 28, 2015*

With Prime Minister Haider al-Abadi of Iraq at the U.N.
The President had asked both delegations to vacate the room so
they could have a private conversation. *September 29, 2015*

Helping the Vice President edit his remarks before he announced
that he would not run for President. *October 21, 2015*

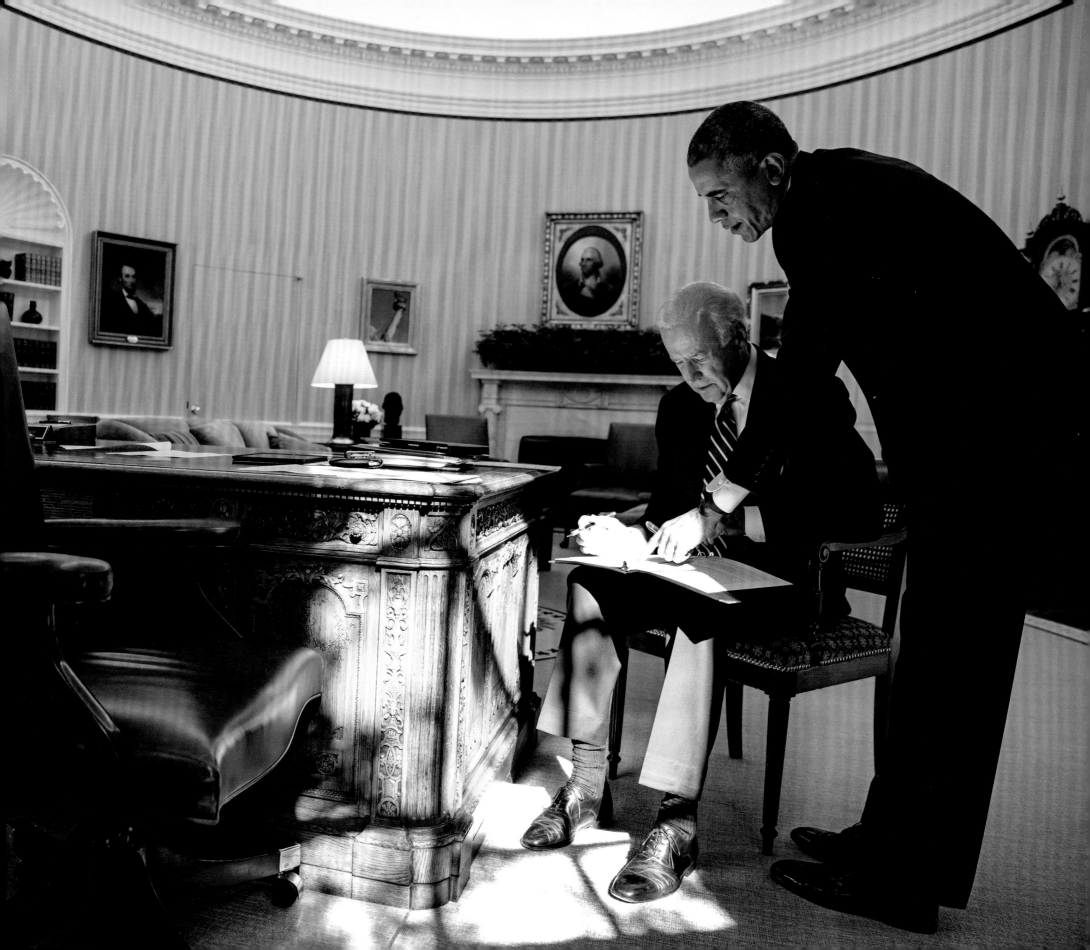

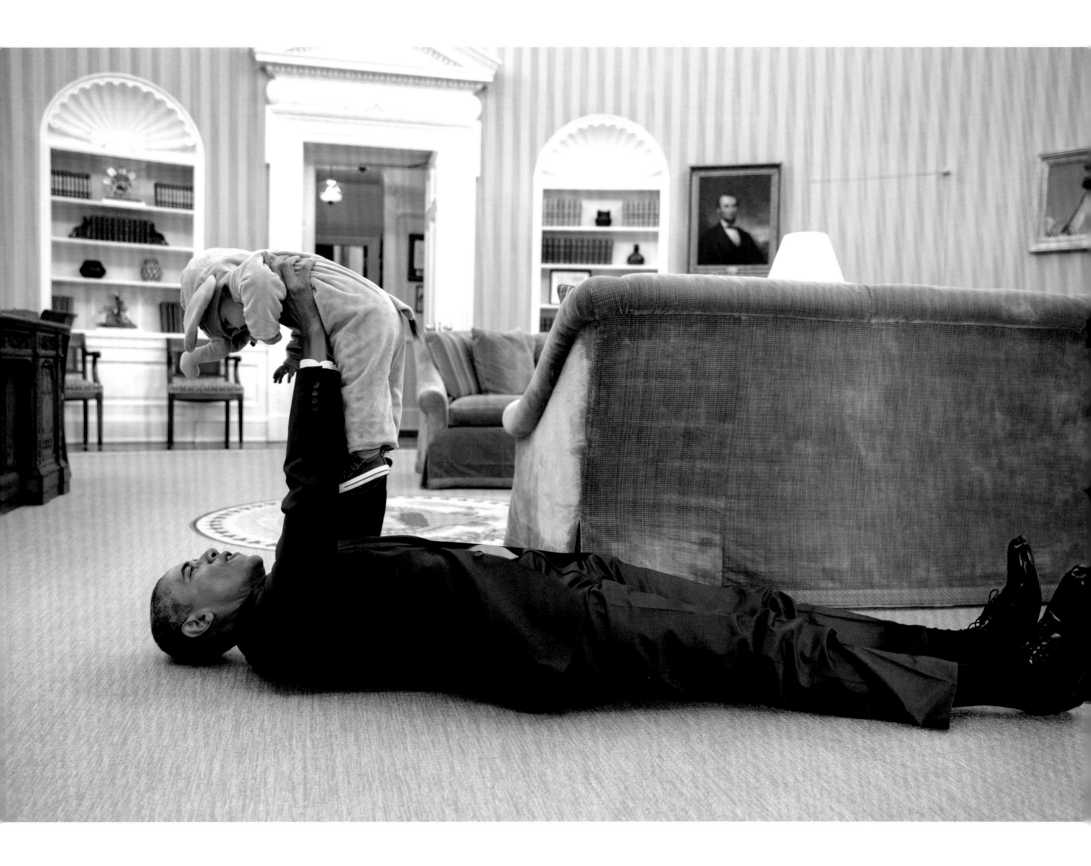

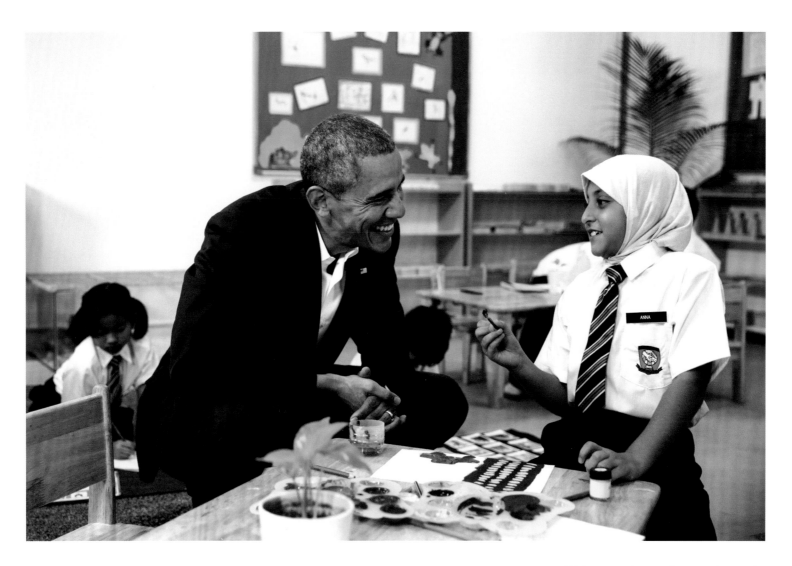

With a young Syrian refugee at a Dignity for Children Foundation classroom in Kuala Lumpur, Malaysia. *November 21, 2015*

OPPOSITE: With Ella Rhodes, in her elephant costume for Halloween. *October 30, 2015*

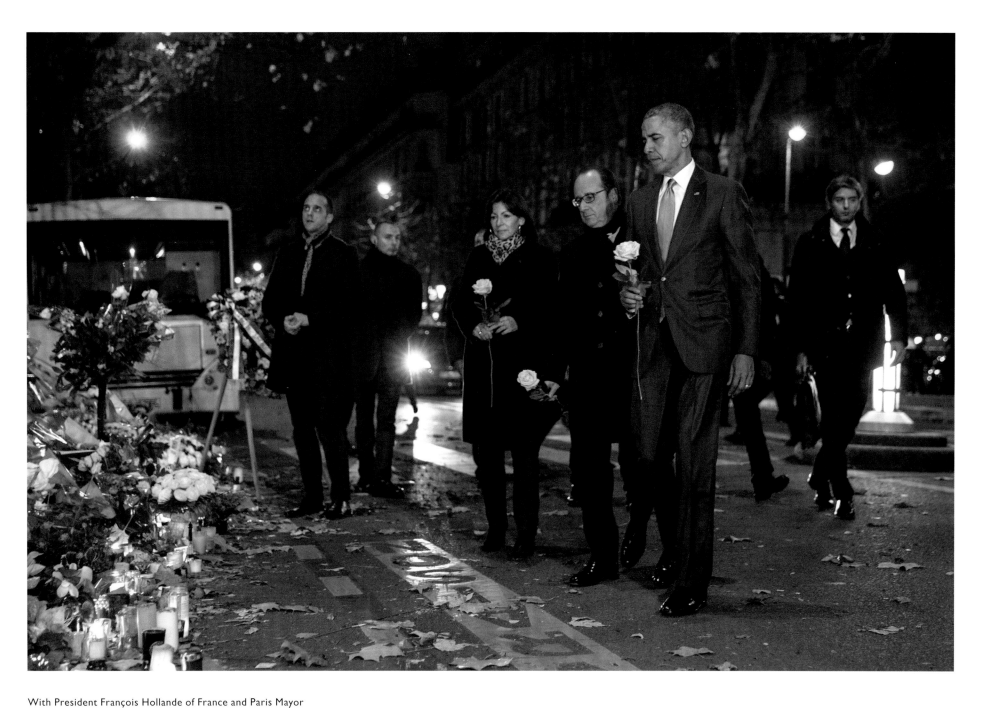

With President François Hollande of France and Paris Mayor
Anne Hidalgo just after midnight at the Bataclan theater, the site of
a terrorist attack a couple of weeks before in Paris. *November 30, 2015*

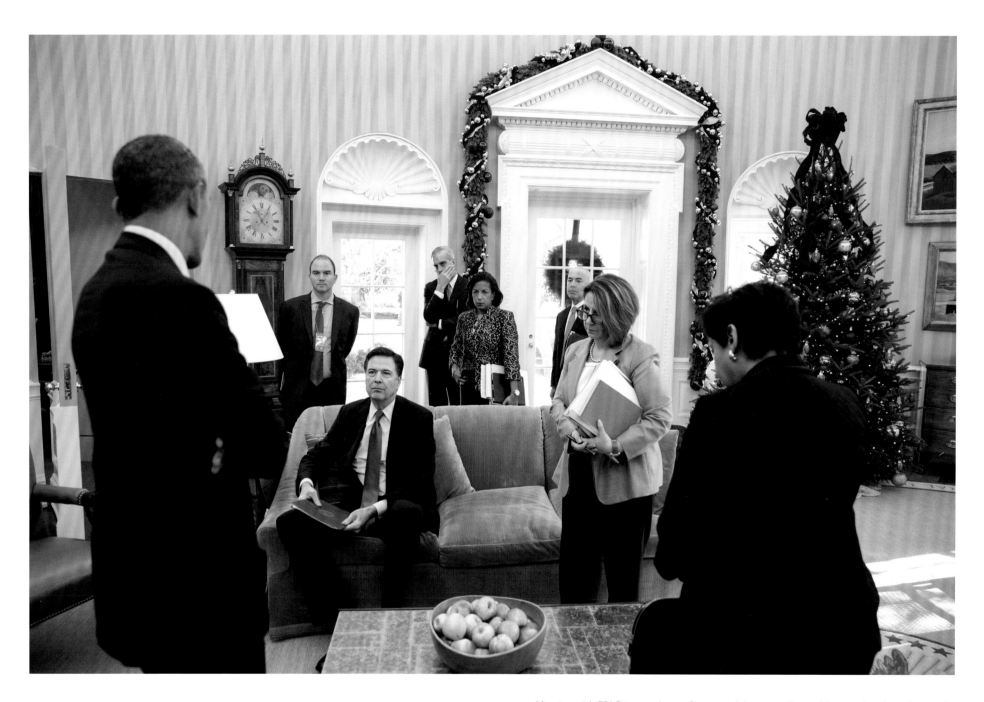

Meeting with FBI Director James Comey and Attorney General Loretta Lynch to discuss the mass shootings in San Bernadino, California. It was the deadliest terrorist attack to occur in the United States since 9/11. A married couple, described by the FBI as "homegrown violent extremists," carried out the attacks, which killed 14 people and seriously injured 22 others at the Inland Regional Center in San Bernardino. *December 3, 2015*

13

HARD THINGS ARE HARD

DREAM BIG DREAMS

THE GIRLS DRESS UP FOR A STATE DINNER

A HISTORIC TRIP TO CUBA

YOSEMITE IN PERSON AND IN VIRTUAL REALITY

SUPERMAN FLEXES HIS MUSCLES

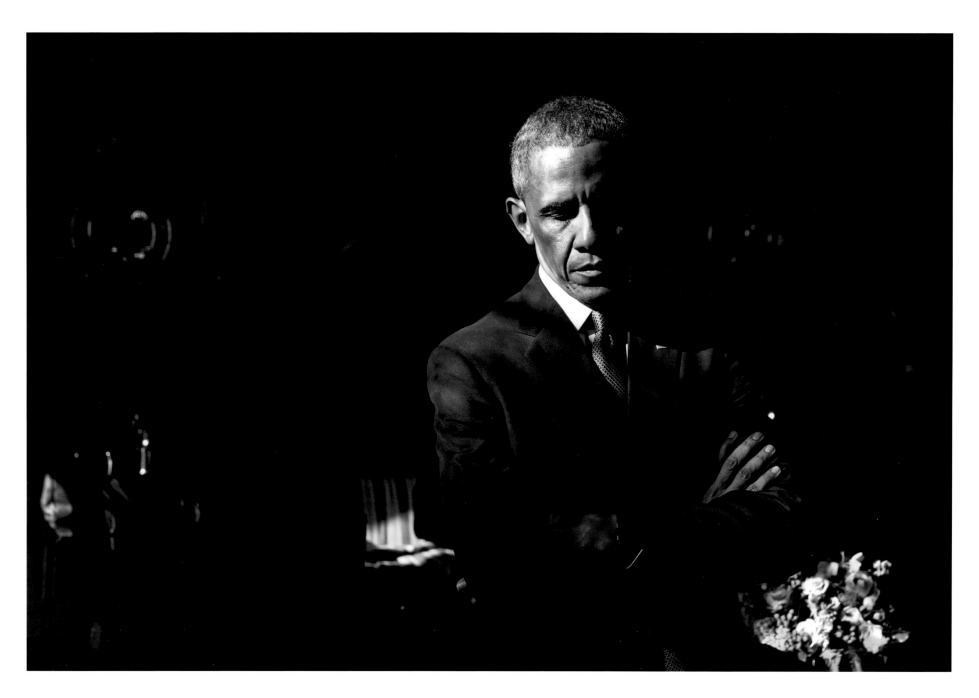

At the White House, waiting to announce steps he was taking to reduce gun violence. The President was introduced by Mark Barden, whose youngest son, Daniel, was shot and killed at Sandy Hook Elementary School in 2012. Later, while delivering his remarks, the President began to cry as he recalled the day of the Newtown, Connecticut, shootings. *January 5, 2016*

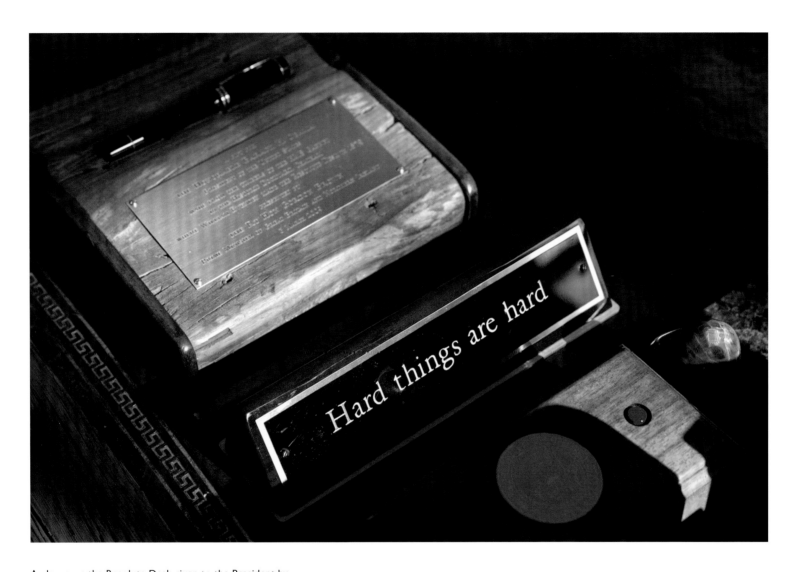

A plaque on the Resolute Desk given to the President by
David Axelrod, who made the phrase a refrain during the efforts
to pass health care reform. *January 29, 2016*

OPPOSITE: Reciting the essence of his upcoming State of the Union
address to chief speechwriter Cody Keenan (with laptop) and Deputy
National Security Advisor Ben Rhodes. *January 7, 2016*

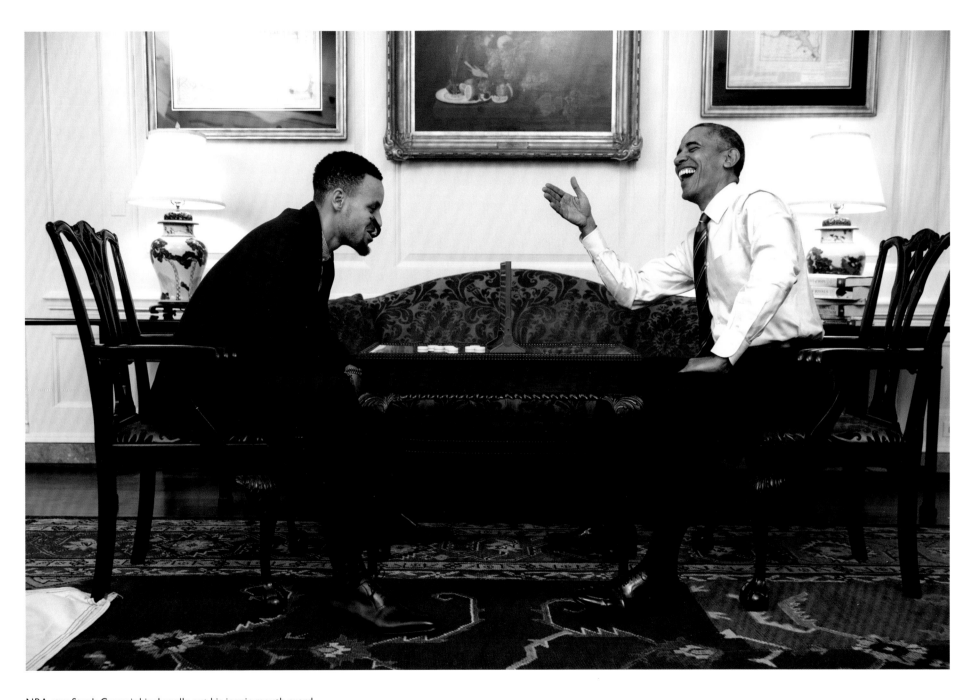

NBA star Steph Curry jokingly pulls out his iconic mouth guard during a White House taping to promote the My Brother's Keeper program. *February 4, 2016*

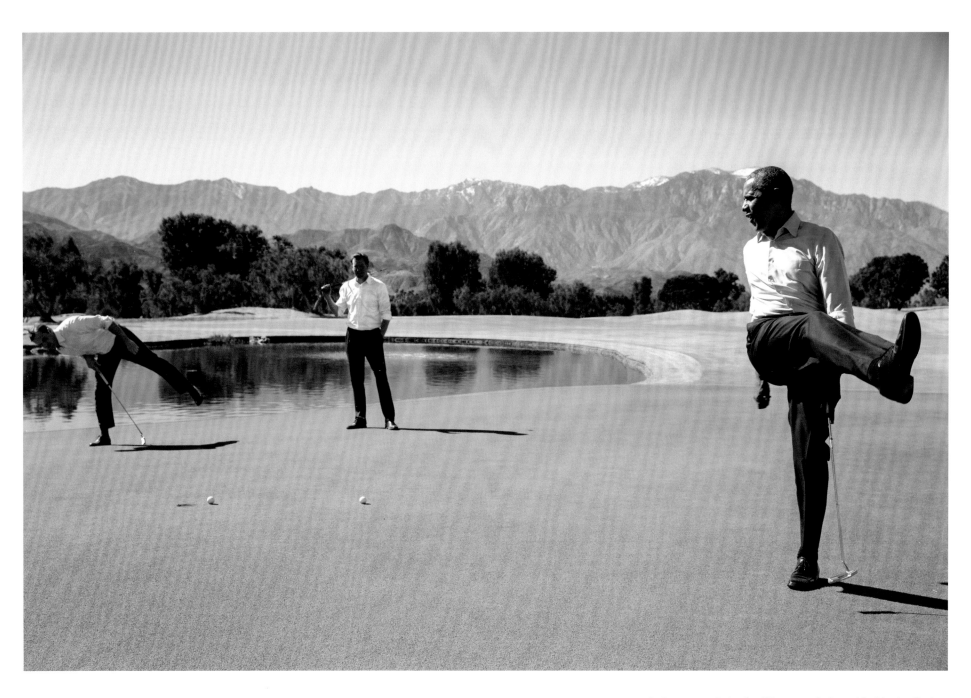

An impromptu hole of golf in street clothes with aides Joe Paulsen and Marvin Nicholson after the U.S.–ASEAN summit at Sunnylands, in Rancho Mirage, California. *February 16, 2016*

DREAM BIG DREAMS

It was a routine reception, celebrating African American History Month. The President had done dozens of receptions like this in the East Room throughout his Presidency, and they seldom yielded a good photograph. But anticipating that the President would stop to greet Clark Reynolds of Washington, age three, I knelt near him in the hope I'd capture their interaction. I ended up making one of my favorite photographs of the Presidency—and it barely includes the President.

Just after this picture was taken, the President leaned down low to talk with the young boy. Like the photograph of Jacob Philadelphia touching the President's head (see page 39), this one provoked a huge emotional reaction when we posted it on the White House website. We later made a large print for Clark, and the President inscribed it: "Dream big dreams, and work hard to achieve them—you will do great things!" *February 18, 2016*

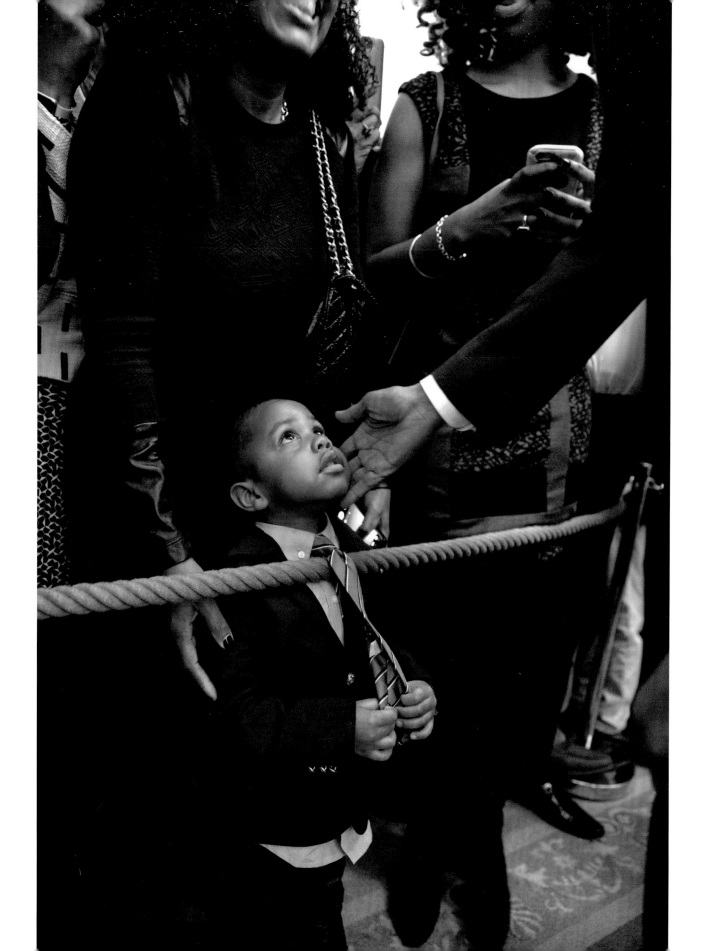

Before a conference call with European leaders, listening to his National Security team. I love this photograph because it is so emblematic of the President's casual, thoughtful approach when talking with staff. *February 23, 2016*

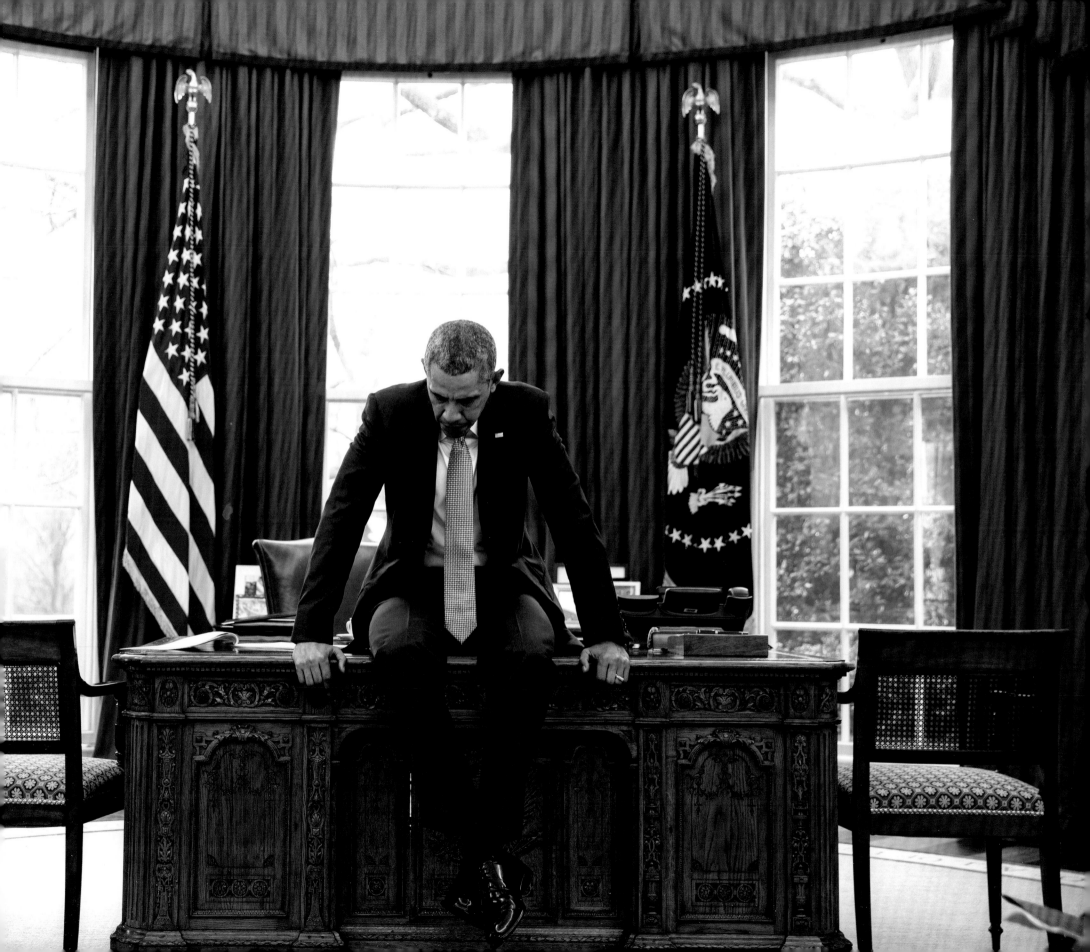

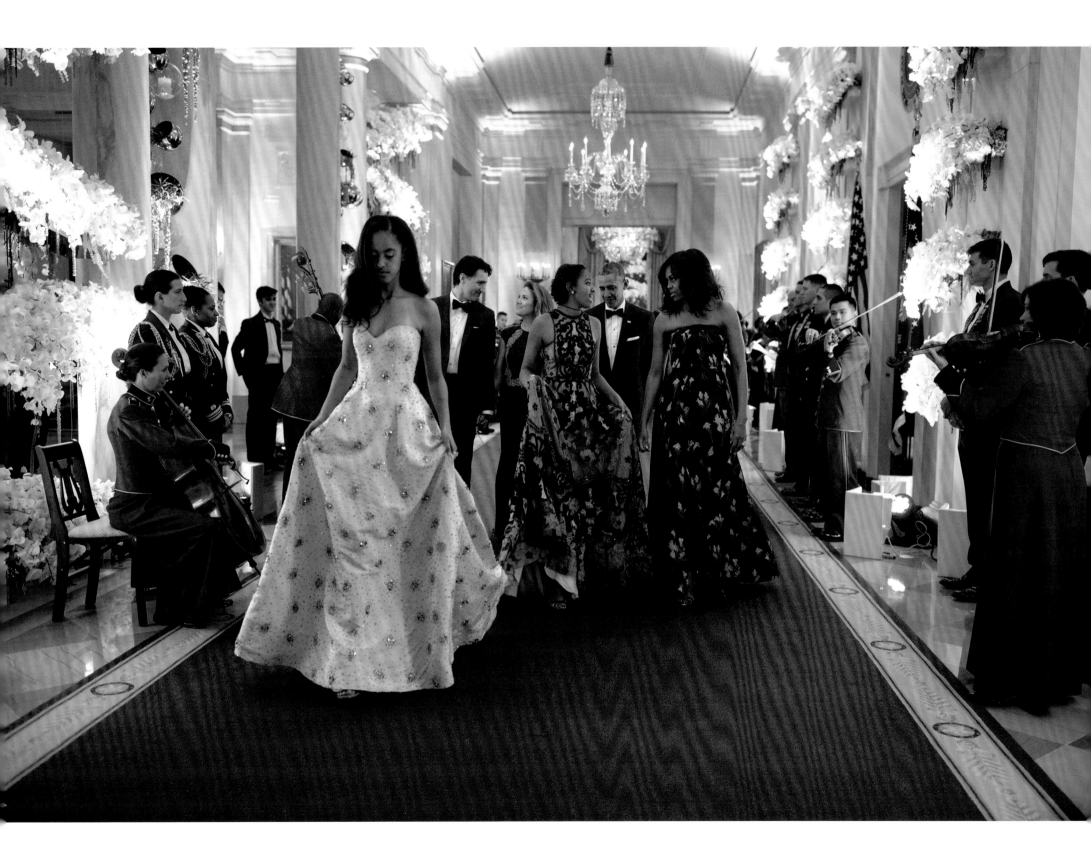

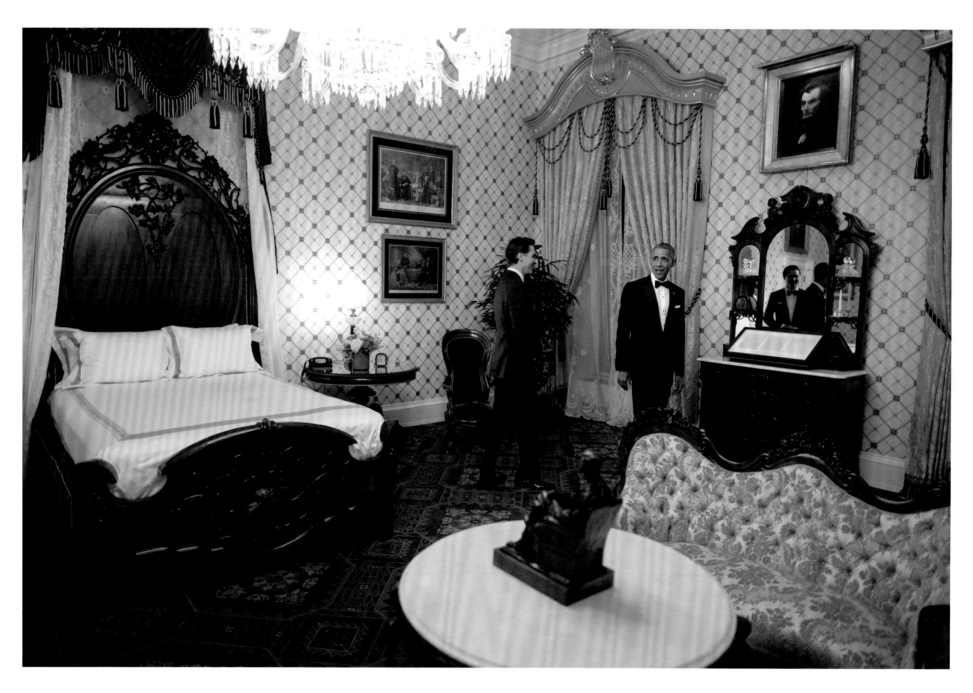

Showing Prime Minister Justin Trudeau of Canada the
Lincoln Bedroom in the private residence. *March 10, 2016*

OPPOSITE: Malia and Sasha walking along the Cross Hall
with their parents, Prime Minister Trudeau, and his
wife, Sophie, during a state dinner. It was the first state
dinner the girls attended as guests. *March 10, 2016*

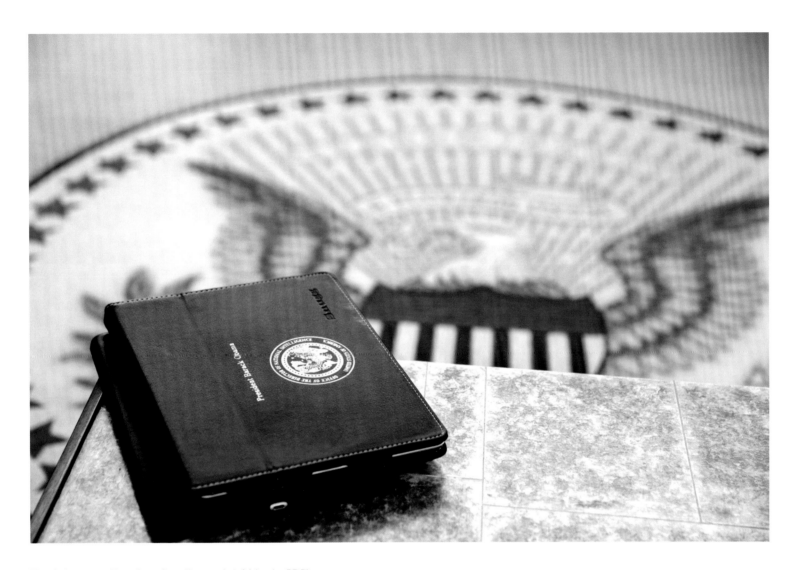

The daily written Presidential intelligence brief (aka the PDB), which had been upgraded from a thick binder to a secure iPad in 2012. The President's first meeting of the day was an intelligence briefing, also called the PDB. *March 16, 2016*

OPPOSITE: Dancing with personal aide Ferial Govashiri to practice for her upcoming wedding. *March 16, 2016*

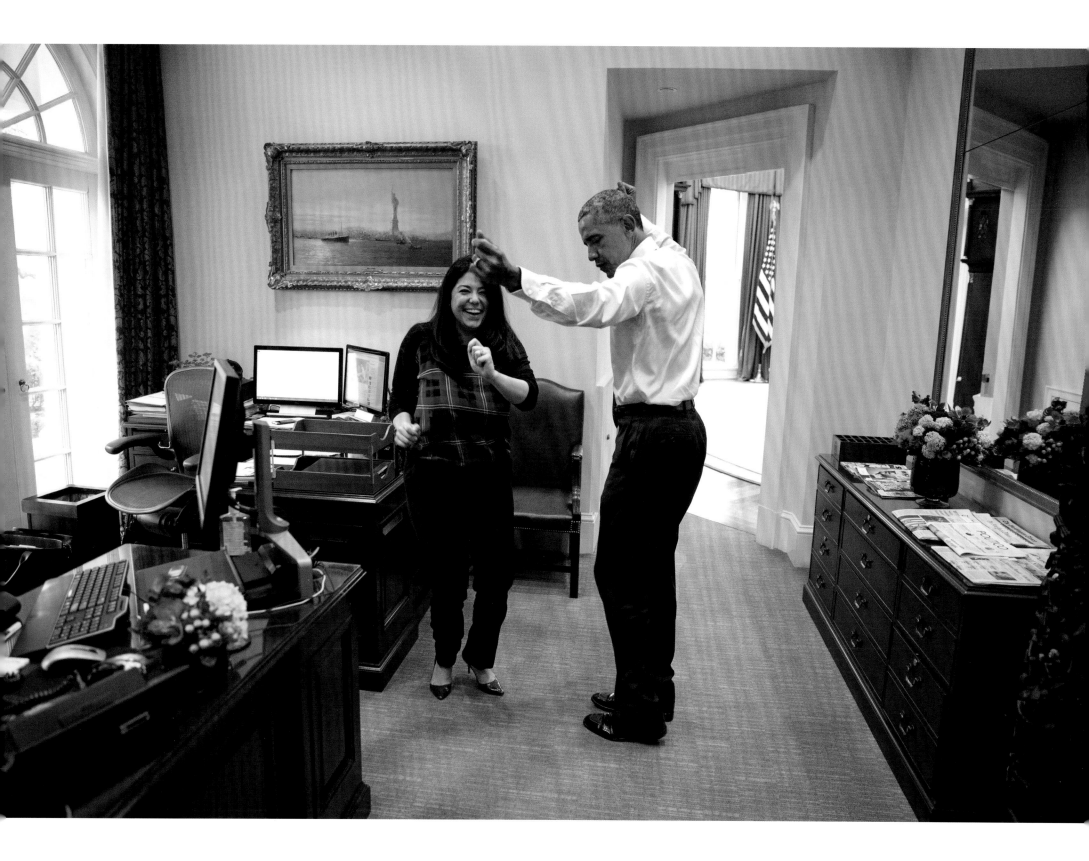

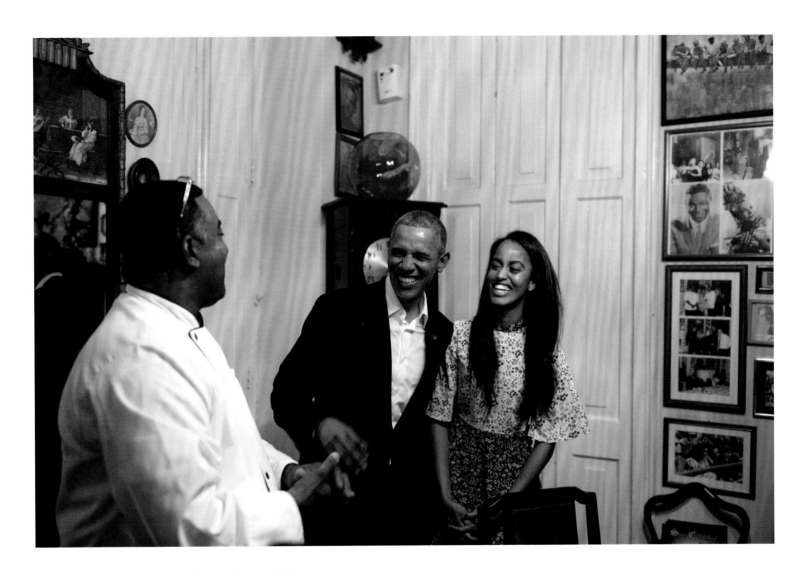

Conversing with a restaurateur in Havana, Cuba, as Malia
translated from Spanish to English. *March 20, 2016*

OPPOSITE: Applauding a run with President Raúl Castro of Cuba
during an exhibition baseball game between the Tampa Bay Rays and
the Cuban national team in Havana. President Obama and
his aides had secretly negotiated with Cuba to normalize relations,
ending a 54-year standoff. *March 22, 2016*

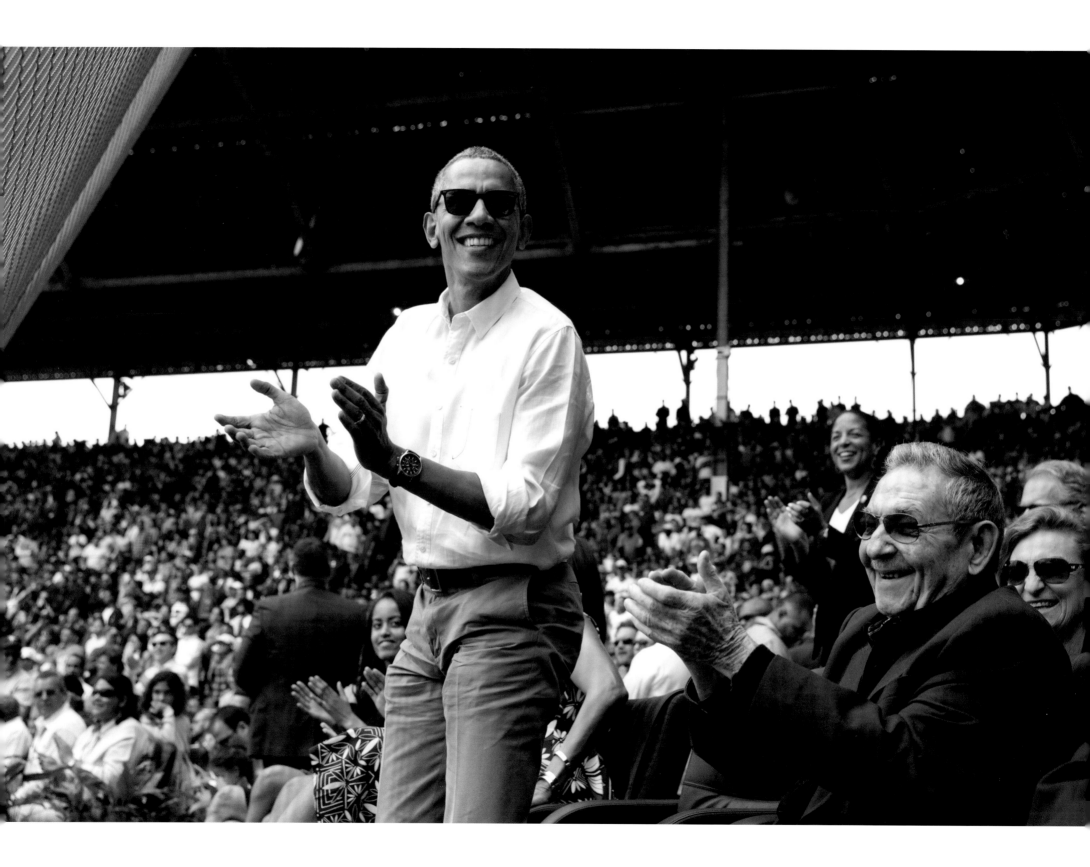

Air Force One at dusk at Los Angeles International
Airport. *April 7, 2016*

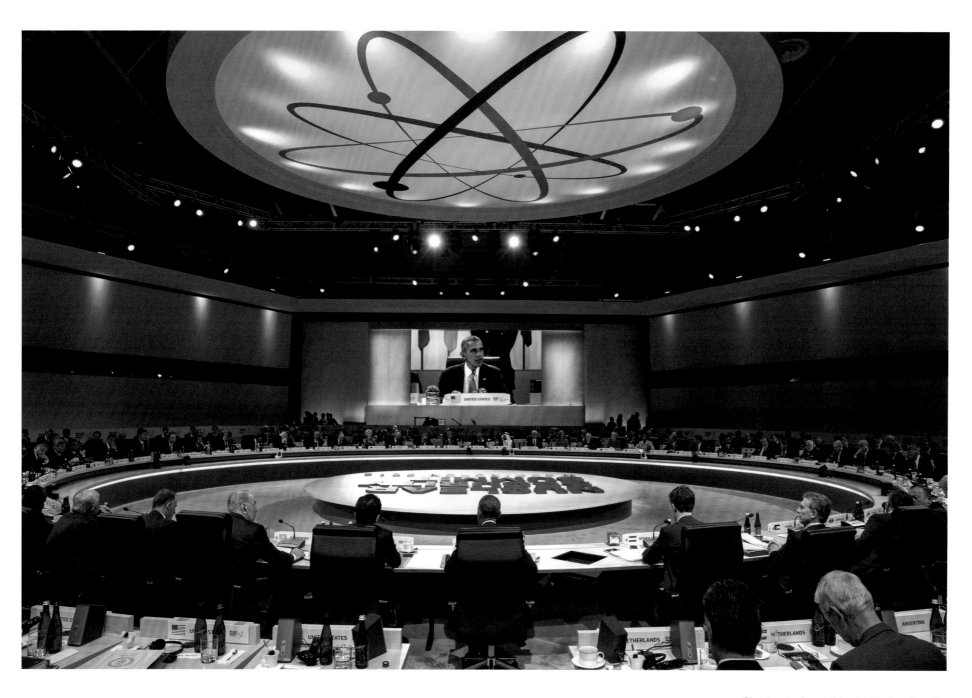

Chairing the fourth biennial Nuclear Security
Summit in Washington. *April 1, 2016*

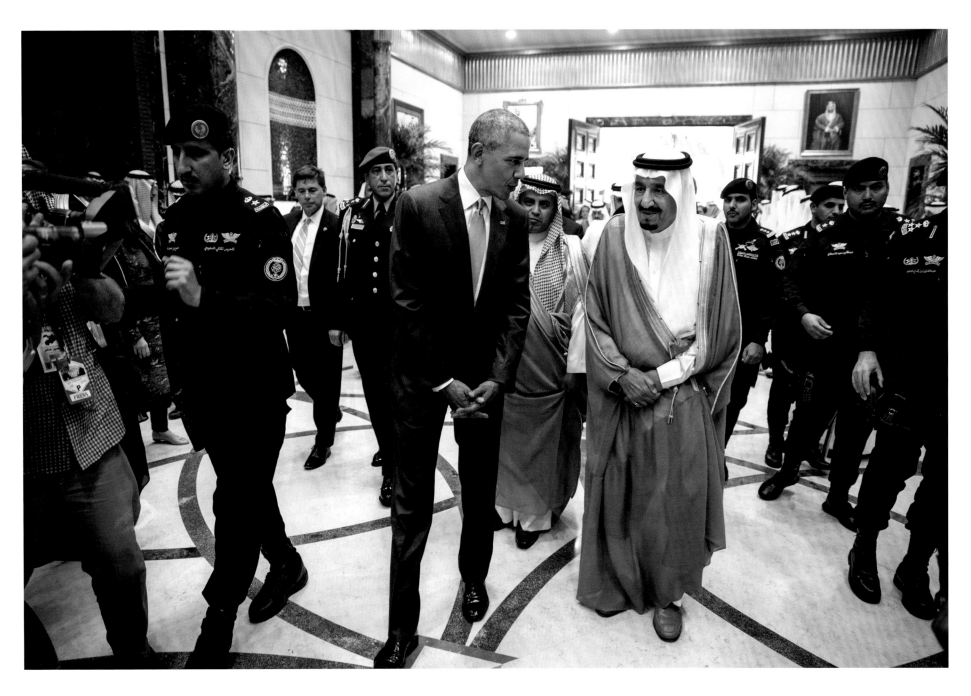

With King Salman of Saudi Arabia at Erga Palace,
in Riyadh. *April 20, 2016*

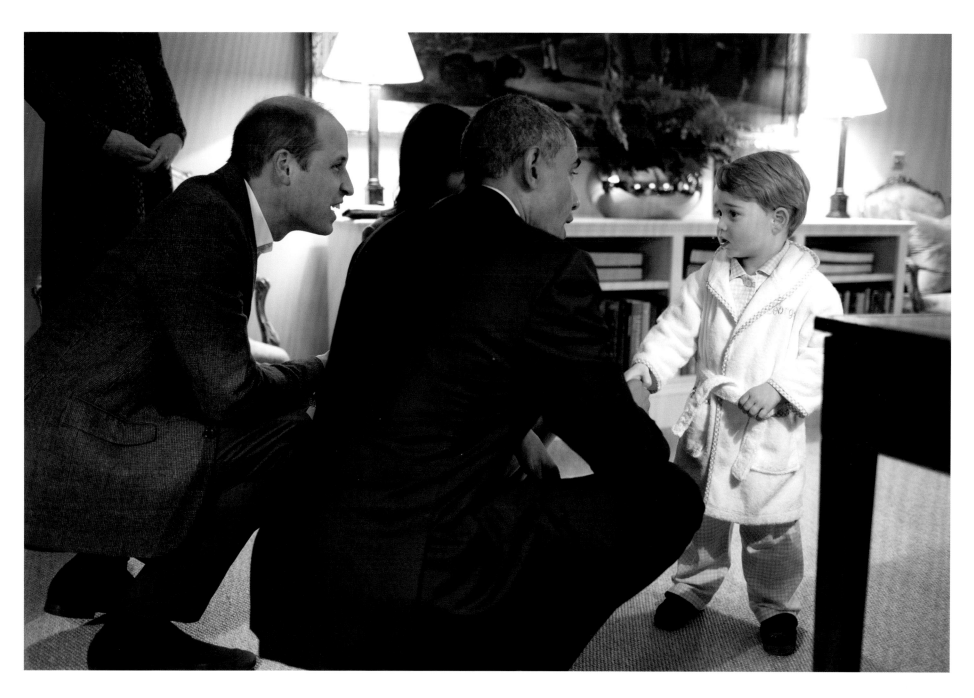

Meeting Prince George at Kensington
Palace, in London. *April 22, 2016*

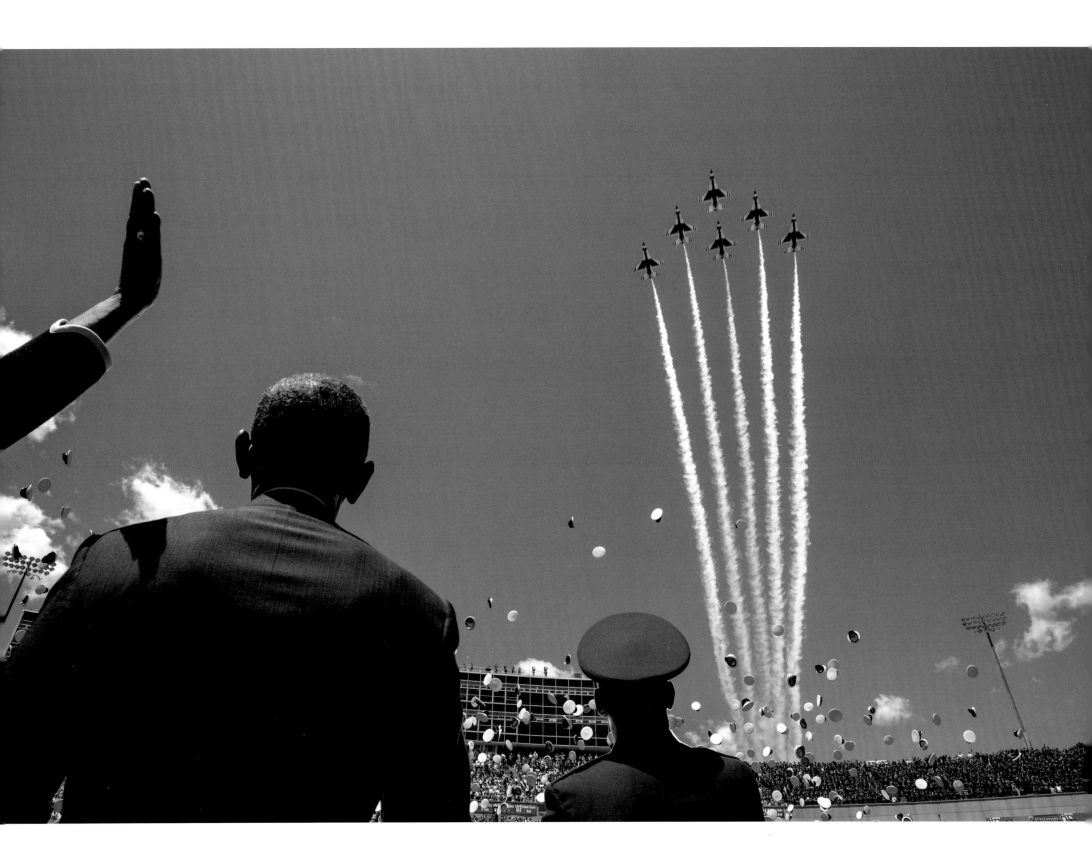

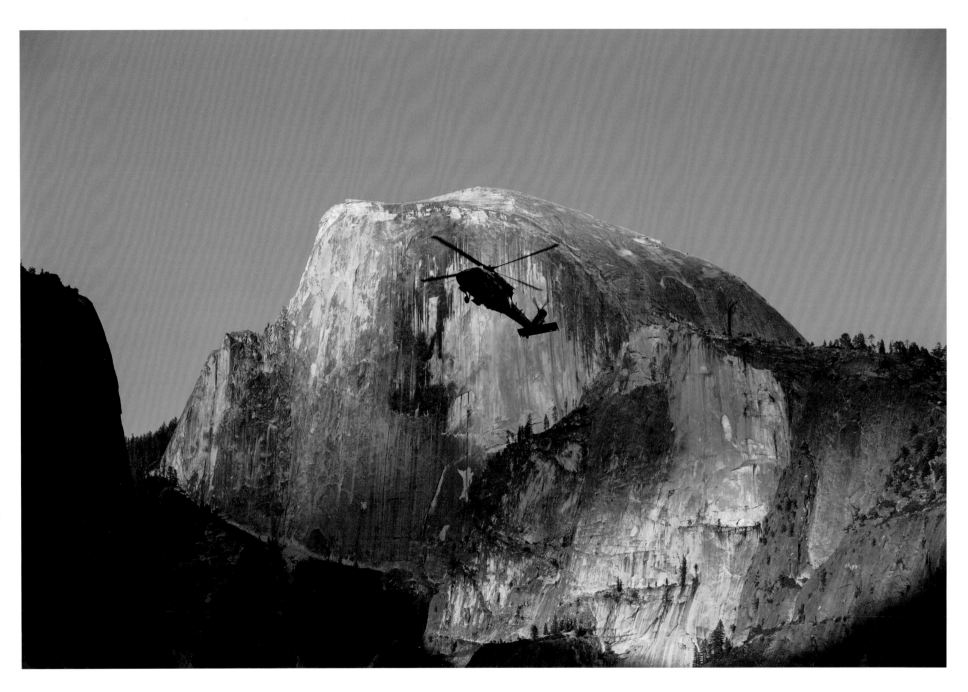

Nighthawk 2 lands in front of Half Dome, at
Yosemite National Park, California. *June 17, 2016*

OPPOSITE: Thunderbirds flying in formation at the
Air Force Academy commencement in Colorado Springs,
Colorado. The President attended a different
service academy's graduation each year. *June 2, 2016*

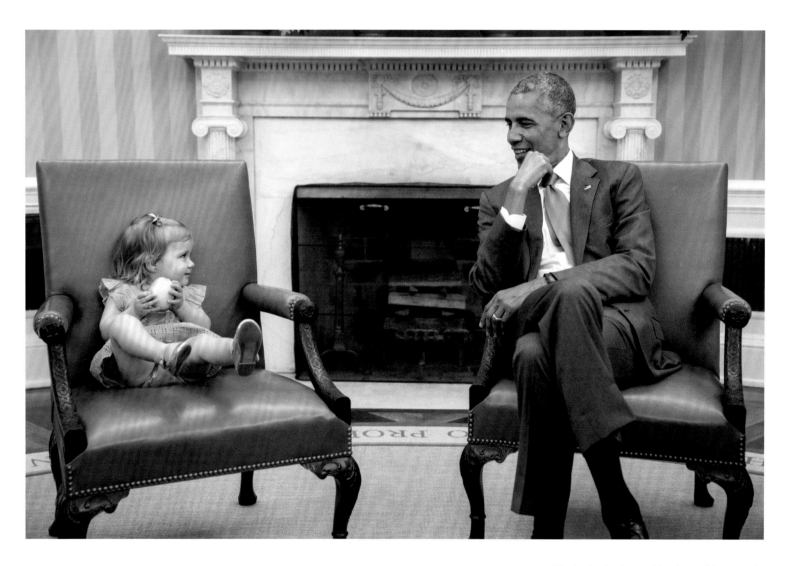

Maelin Axelrod, granddaughter of former aide
David Axelrod, looking at the President after she crawled
up on the Vice President's chair. *June 22, 2016*

OPPOSITE: A state dinner in the East Room in honor of Prime
Minister Lee Hsien Loong of Singapore. *August 2, 2016*

Lost in a virtual-reality film from his trip to Yosemite National Park earlier that summer, as personal aide Ferial Govashiri continues to work. *August 24, 2016*

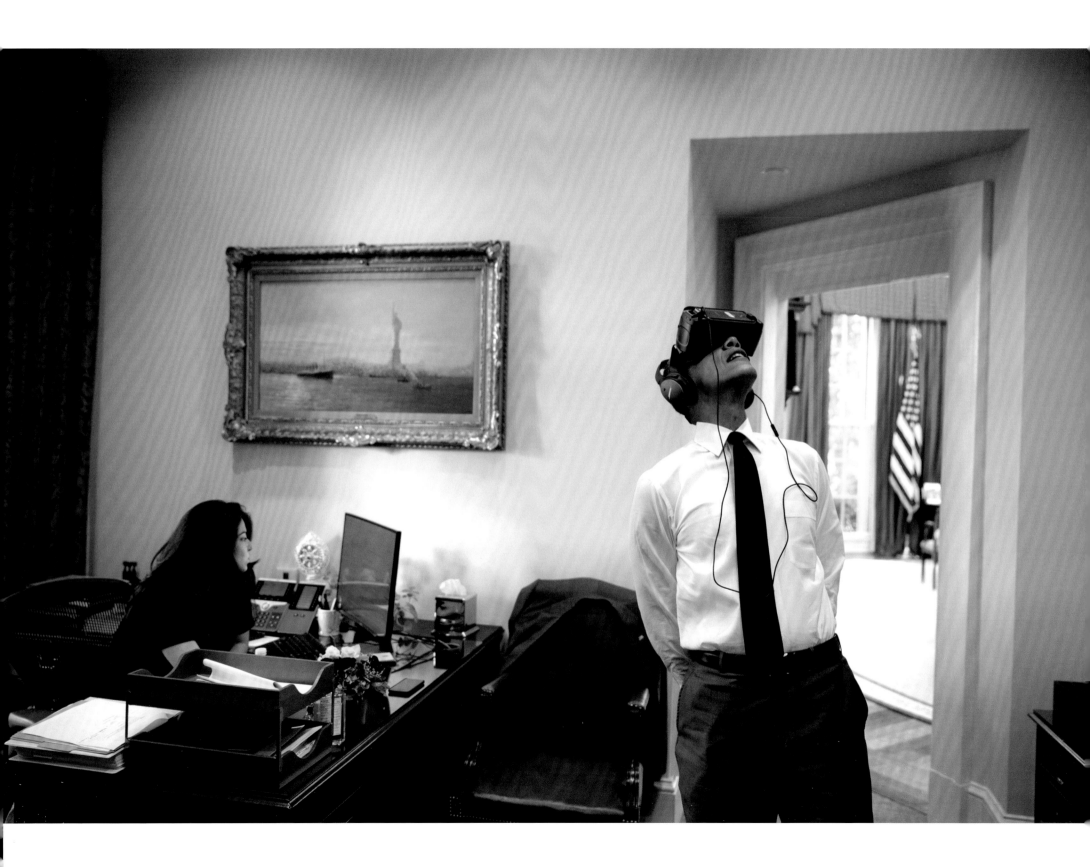

Joking with Prime Minister John Key of New Zealand
and Prime Minister Malcolm Turnbull of Australia at
the ASEAN gala dinner in Vientiane, Laos. *September 7, 2016*

OPPOSITE: Sipping a coconut at a stall alongside the Mekong River
in Luang Prabang, Laos. *September 7, 2016*

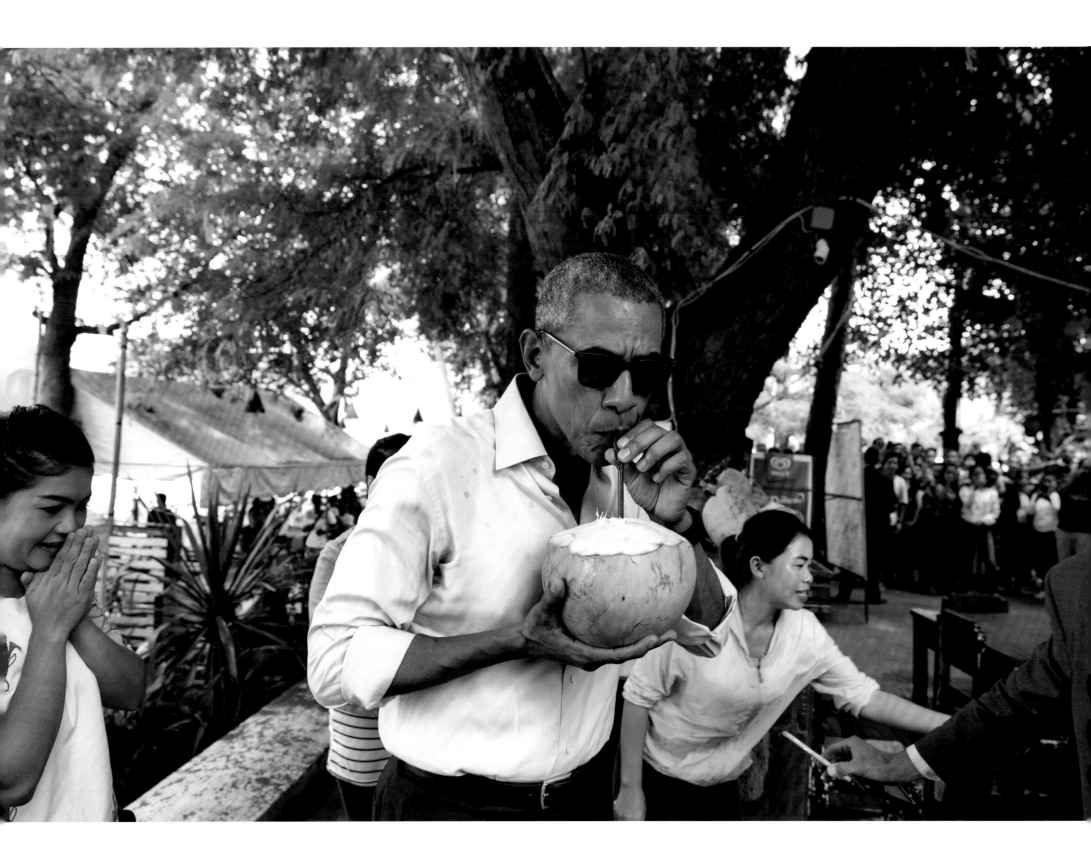

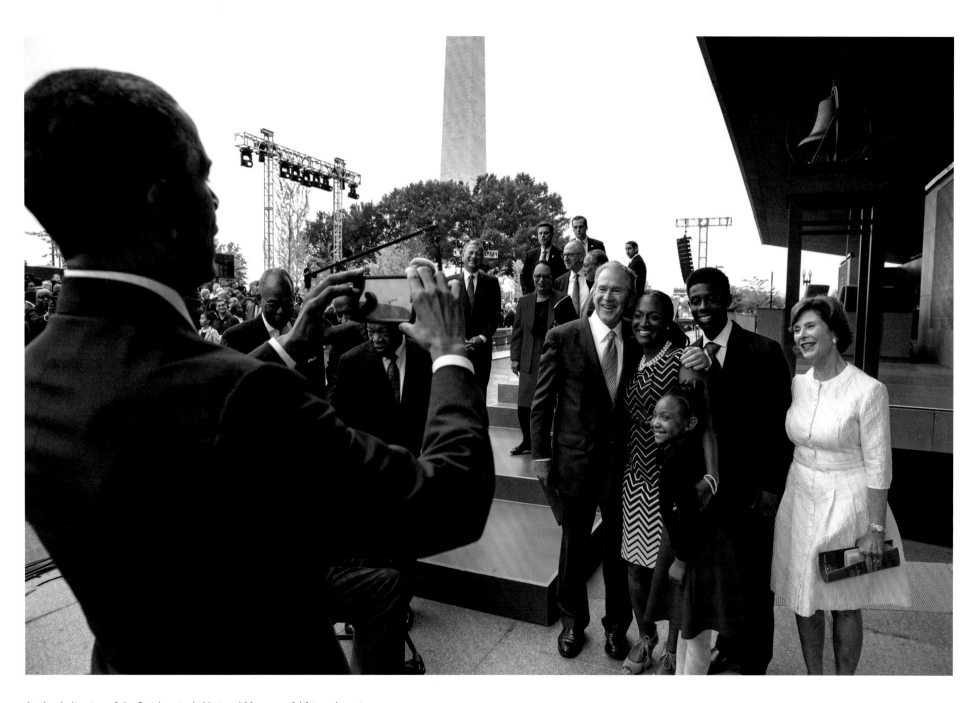

At the dedication of the Smithsonian's National Museum of African American History and Culture, former President George W. Bush asked President Obama to take a photo of him with the Bonner family, whose ancestor Elijah B. Odom escaped from slavery in the South to freedom. *September 24, 2016*

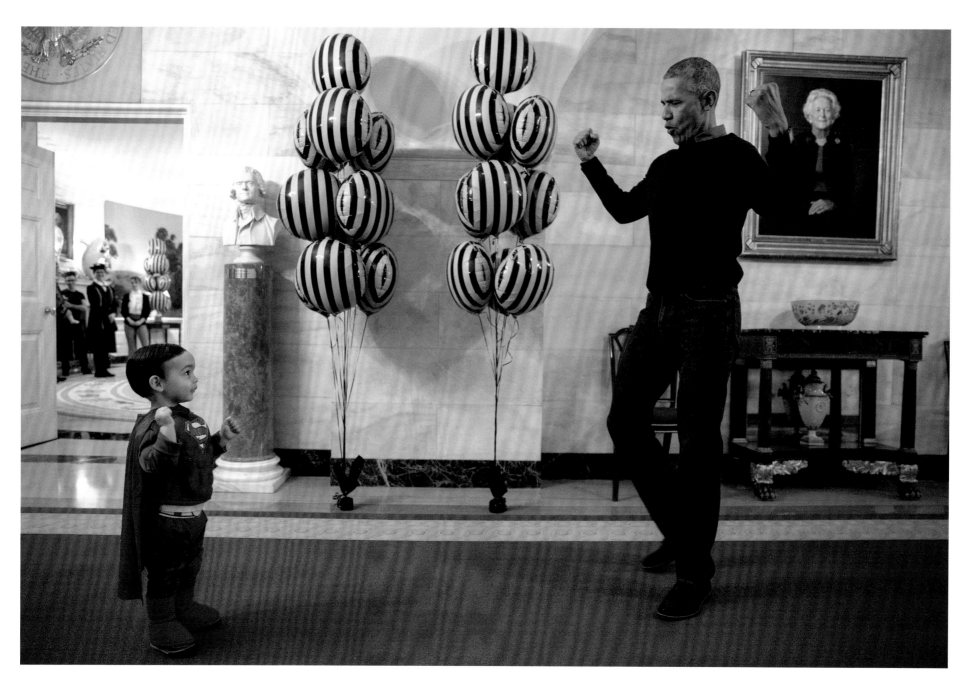

Flexing muscles with Superman, aka Walker Earnest, son of press secretary Josh Earnest, on Halloween. *October 31, 2016*

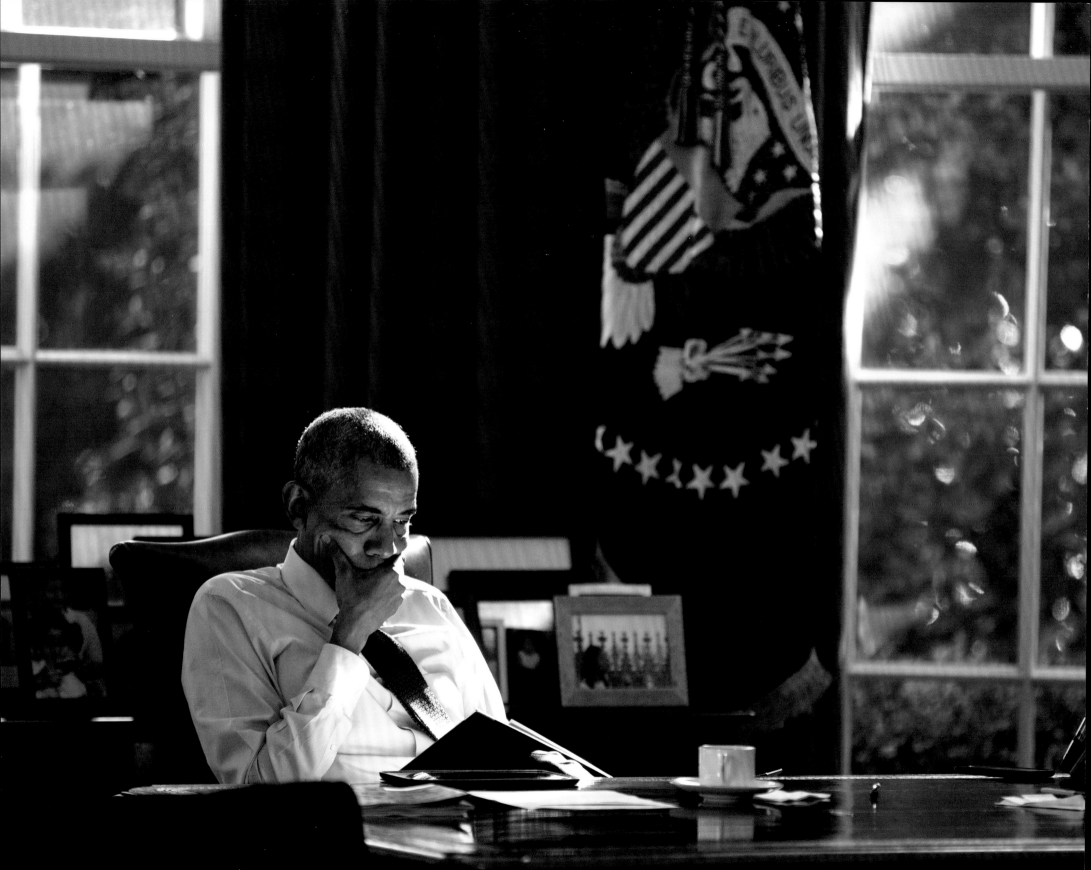

Reading at the Resolute Desk. During autumn and winter afternoons, the President's desk was bathed in dramatic backlight. In the final months of the administration, I tried to capture the President in that special light because I knew I'd never have the chance again. *October 14, 2016*

14

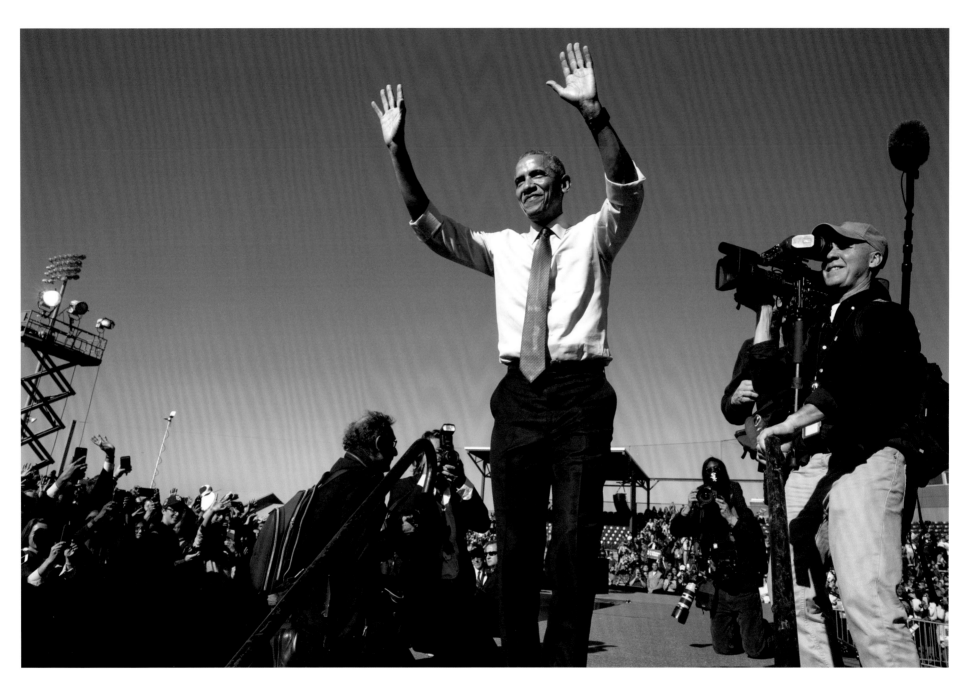

Campaigning on behalf of Hillary Clinton in Ann Arbor, Michigan, the day before the 2016 Presidential election. *November 7, 2016*

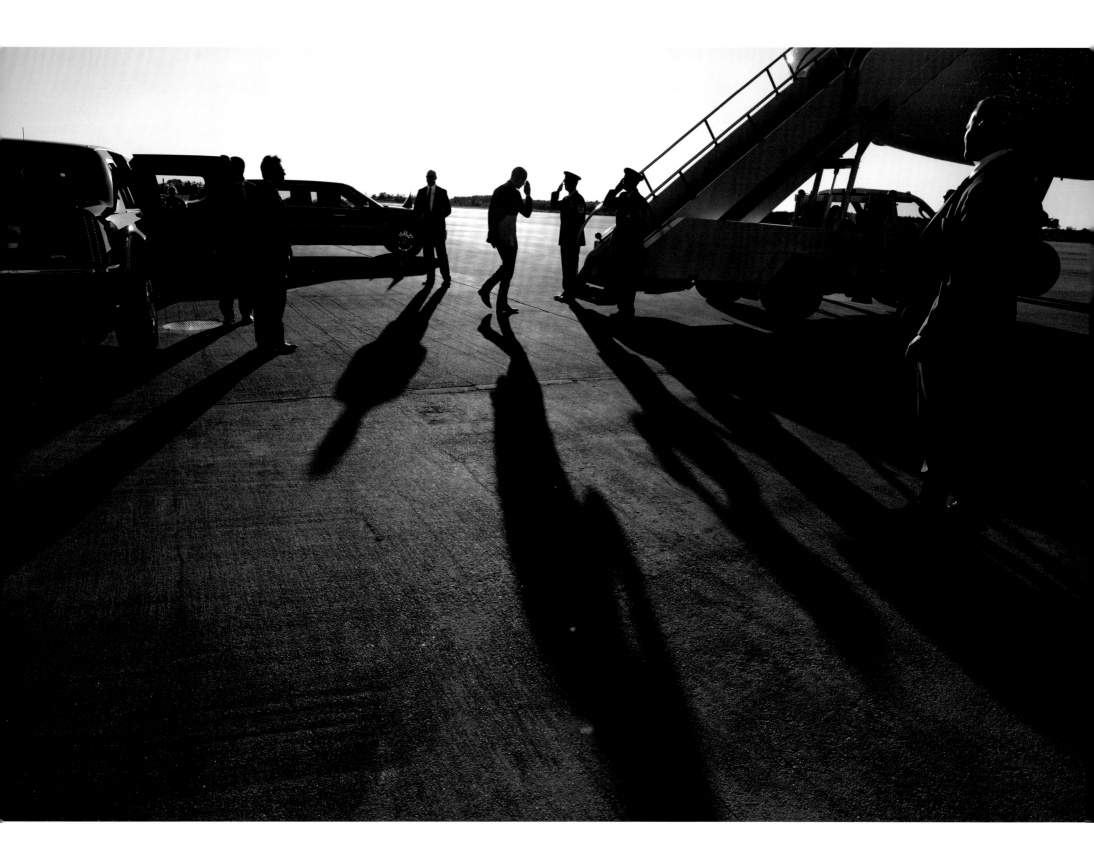

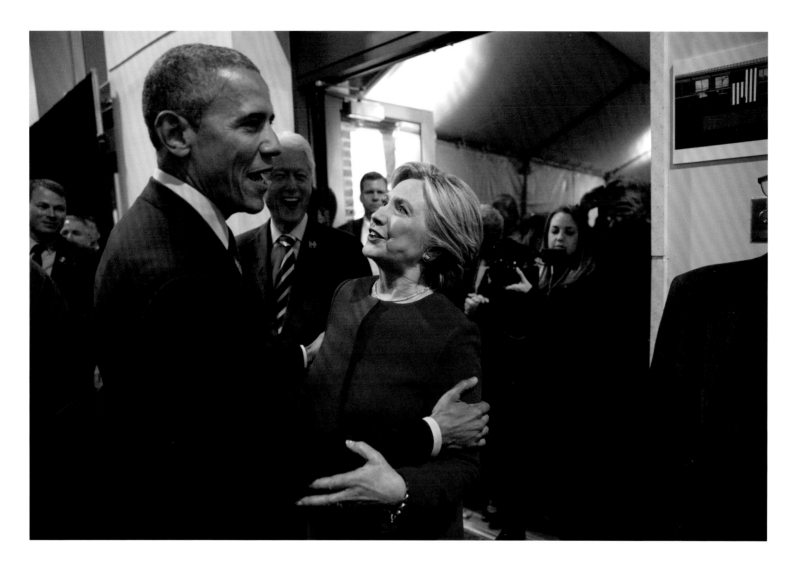

Feeling optimistic with Hillary Clinton and
former President Bill Clinton on Election Eve
in Philadelphia. *November 7, 2016*

OPPOSITE: Boarding *Air Force One*
after campaigning for Hillary in Charlotte,
North Carolina. *November 4, 2016*

Election Day at the White House. Receiving early exit-poll data
from political director David Simas. *November 8, 2016*

OPPOSITE: The morning after the election, the President asked Josh Earnest and his team to
stop by to discuss the afternoon press briefing. He expected just a few people;
Josh arrived with the entire communications, research, and speechwriting staff.
The meeting turned into an impromptu pep talk, with the President picking
up the staff's spirits after the Democrats' loss. *November 9, 2016*

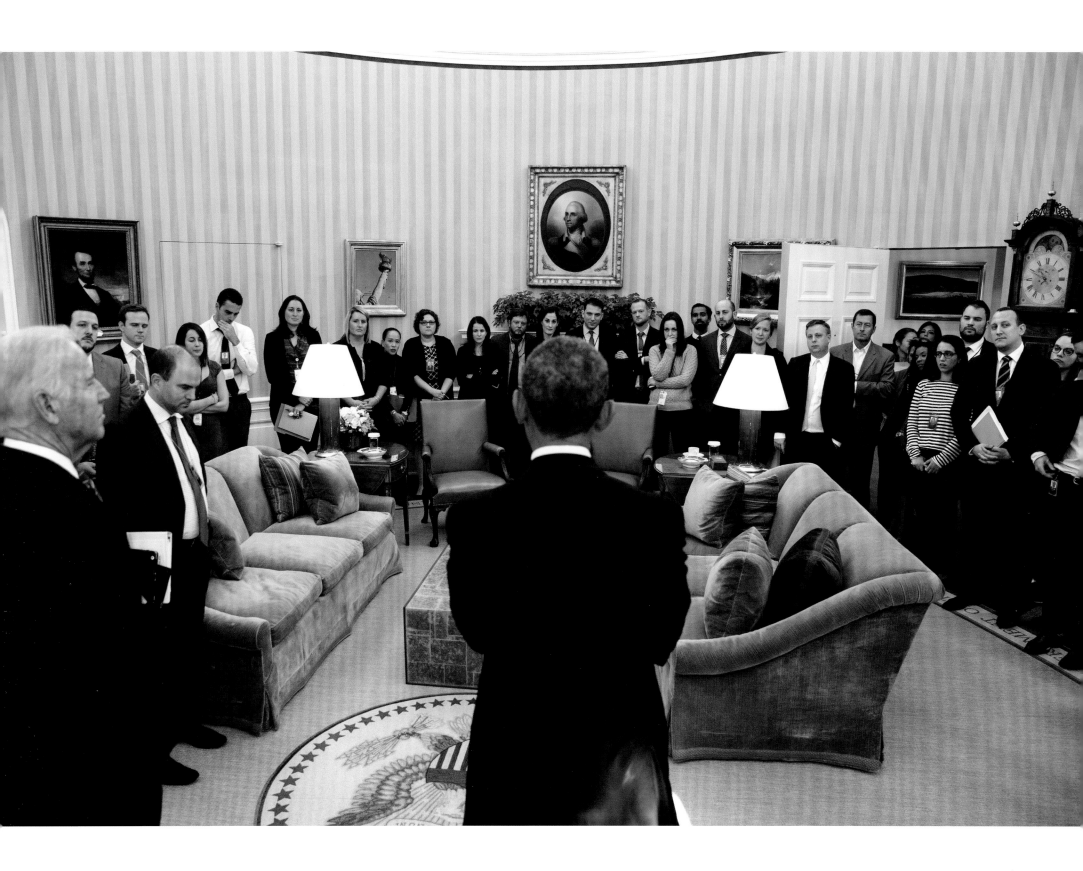

Giving President-elect Donald Trump a tour of the
private study adjacent to the Oval Office. *November 10, 2016*

Visiting with Alex Myteberi, age six, and his family. Alex wrote to the President after seeing a heartbreaking photograph of Syrian boy Omran Daqneesh covered in blood and dust after an air strike: "Can you please go get him and bring him to my home.... We will give him a family and he will be our brother." *November 10, 2016*

Congratulating Bruce Springsteen before awarding
him the Presidential Medal of Freedom. *November 22, 2016*

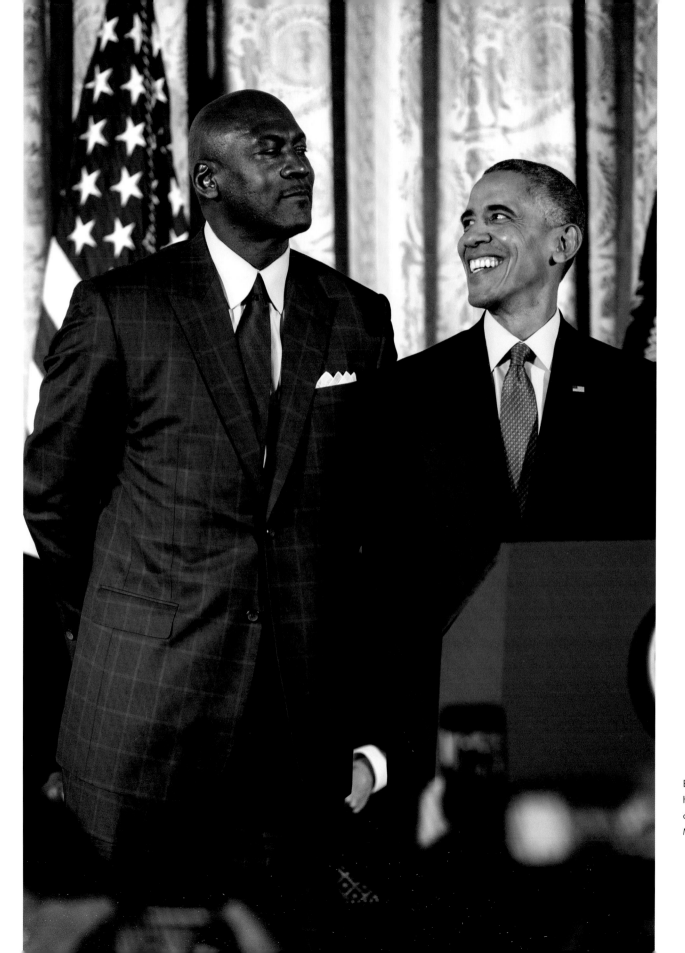

Eyeing Michael Jordan while
his Presidential Medal
of Freedom citation is read.
November 22, 2016

A final toast at the senior staff holiday dinner in the East Room. The
President became emotional while reading a recent letter from
Rebekah Erler (see page 243) thanking him and his administration for all
the work they did for the middle class. *December 5, 2016*

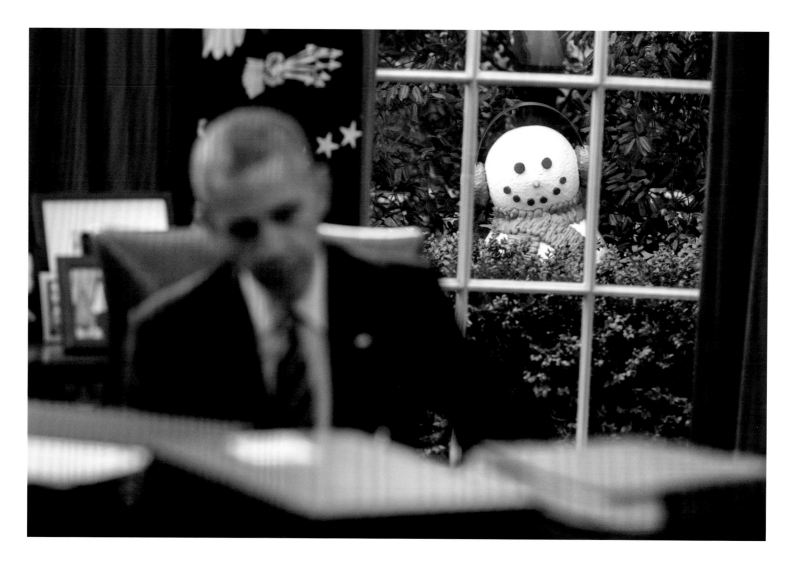

Signing a series of year-end bills under the watchful eye of a snowman. As a holiday prank, staff had moved four snowmen from the Rose Garden to peek inside the Oval Office. *December 16, 2016*

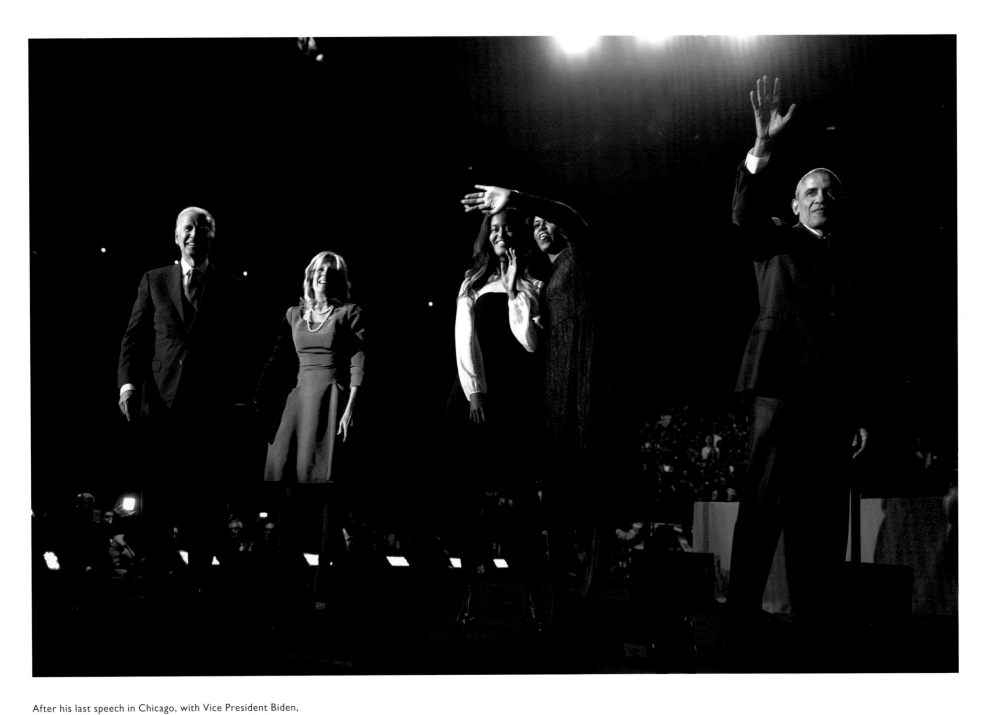

After his last speech in Chicago, with Vice President Biden,
Dr. Jill Biden, Malia, and the First Lady. Sasha had to stay in
Washington to study for a school exam. *January 10, 2017*

OPPOSITE: Teary-eyed during a farewell military ceremony
at Fort Myer, Virginia. *January 4, 2017*

FINAL DAYS

Once the initial shock of the election wore off, the last two weeks of the President's tenure were a whirlwind of packing up and saying good-bye. There was a farewell speech in Chicago, a send-off from the military at nearby Fort Myer, and a visit from the World Series champion Chicago Cubs.

The President managed to surprise Vice President Joe Biden with the Presidential Medal of Freedom in what the VP thought was going to be just a family reception. That same night, Bruce Springsteen performed a solo concert in the East Room for those of us who had been there all eight years.

Then came the final day of the administration, all too soon. Knowing the logistical difficulty in driving to the White House on Inauguration Day, I slept in Josh Earnest's office (he had a comfortable sofa) the night before. I was sound asleep when I heard loud clanging sounds and awakened at 3:00 a.m. to find three workers cleaning out his fireplace for the next administration.

To make a symbolic photograph of the President leaving the Oval Office for the last time, on the morning of January 20, I commandeered a ten-foot ladder and used a super-wide-angle lens as he walked out to the Colonnade. He and the First Lady then welcomed the President-elect and his wife during a reception on the State Floor, and before too long, we were headed to the Capitol for the swearing-in.

In advance, I made sure I had a seat on the helicopter when we left the inauguration so I could make a picture of the President looking at the Capitol as we flew away. That didn't really work out, but I managed to snap a shot as we flew over his former residence—the White House—one last time. *(Photographs continue through page 347.)*

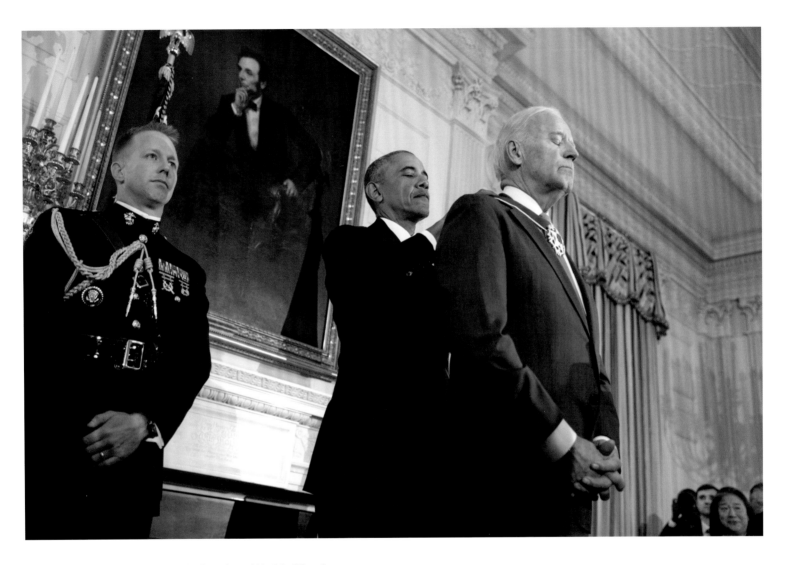

Surprising the Vice President with the Presidential Medal of Freedom, awarded with distinction. "To know Joe Biden is to know love without pretense, service without self-regard, and to live life fully," the President said. *January 12, 2017*

With the World Series champion Chicago Cubs. The First Lady
spoke emotionally to the players about what the team meant to Chicago
and to her family. As a little girl, she had bonded with her father
by sitting on his lap as they watched the Cubs on TV. *January 16, 2017*

Most of the Obama staff had been off-boarded earlier in the week. On his final night in the White House, POTUS invited the remaining staff up to the private residence. For most of them, it was the first time they had ever been on the Truman Balcony. *January 19, 2017*

OPPOSITE: Earlier that afternoon, shooting hoops with chief of staff Denis McDonough during their last end-of-the-day walk together on the South Grounds. *January 19, 2017*

Leaving the Oval Office for the last time as President of
the United States. *9:14 a.m., January 20, 2017*

THE ARC OF THE MORAL UNIVERSE IS LONG, BUT IT BENDS TOWARD JUSTICE

HUMAN DESTINY IS BEYOND HUMAN BEINGS ★ THE WELFARE OF EACH OF US IS DEPENDENT FUNDAMENTALLY UPON THE WELFARE OF ALL OF US ★ THE ONLY THING WE HAVE TO FEAR IS FEAR

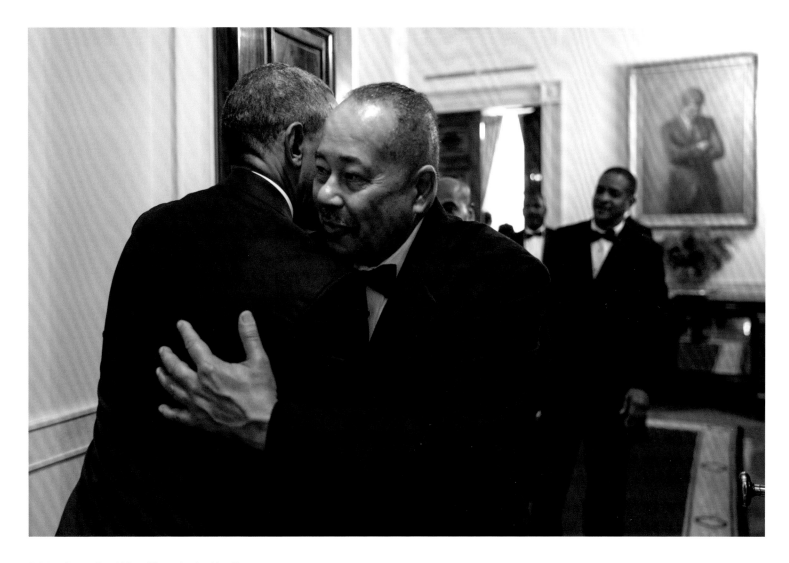

Bidding farewell to White House butler Von Everett.

10:15 a.m., January 20, 2017

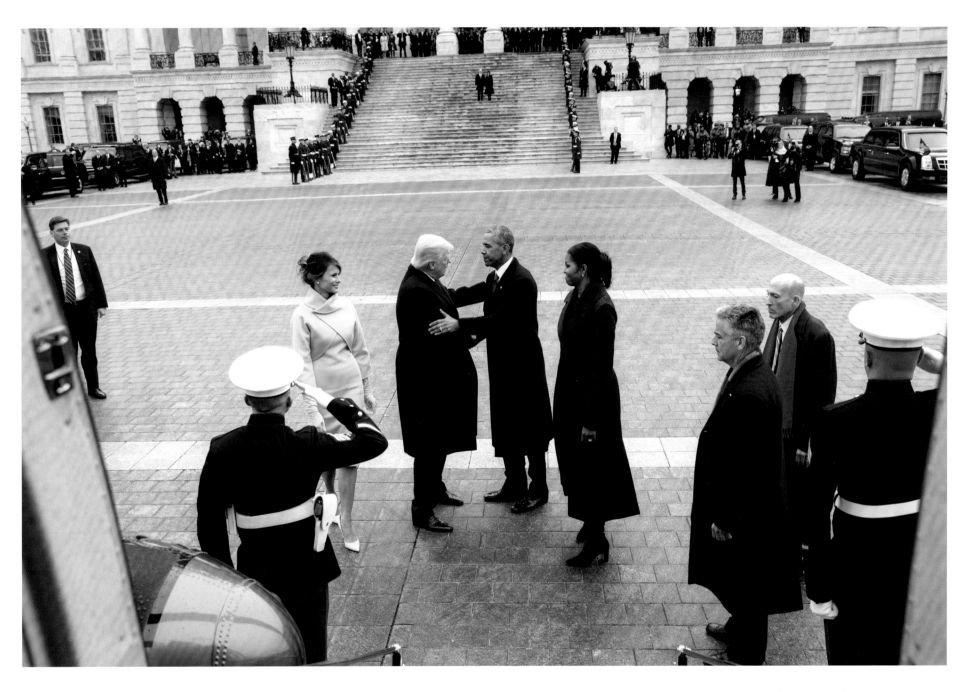

Saying good-bye to President Donald Trump and
First Lady Melania Trump after the inauguration ceremony
at the U.S. Capitol. *12:40 p.m., January 20, 2017*

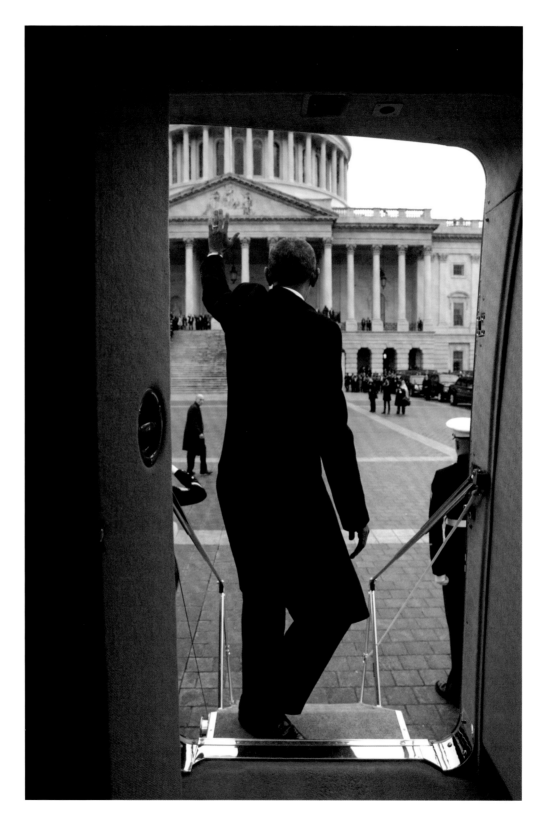

Boarding the helicopter, now called *Executive One*, at the U.S. Capitol. *12:41 p.m., January 20, 2017*

OPPOSITE: Flying over the White House. "We used to live there," he said. *12:46 p.m., January 20, 2017*

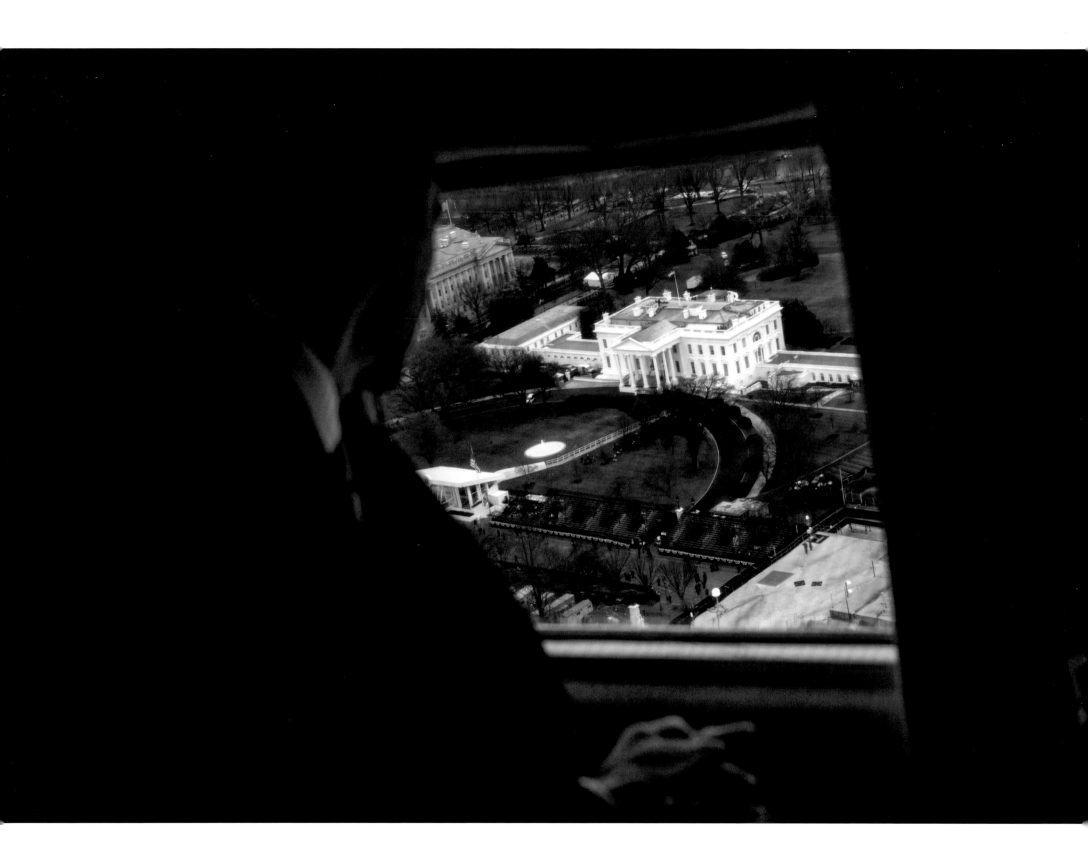

FOR PATTI

ACKNOWLEDGMENTS

First and foremost I thank Barack Obama for the trust and access he gave me to visually document his administration for history. Along the way, President Obama and I also developed a lasting friendship. Thanks, POTUS. I'm still gunning for your top word score in Scrabble.

Thanks to Michelle Obama for her support along the way and for being an incredible First Lady in both substance and style. Thanks to Malia and Sasha: I am so proud of how you always conducted yourself in the public eye.

I worked alongside hundreds of people at the White House and on the road. All of you made sacrifices to serve your country with dedication and professionalism. Many of you were also extremely gracious and personally helpful to me. This includes the permanent employees of the White House, members of the military who support the White House, the protocol office at the State Department, and the Secret Service. Thank you.

In the Outer Oval Office, thank you to my work family through the years: Brian Mosteller, Anita Decker Breckenridge, Ferial Govashiri, Reggie Love, Katie Johnson, Joe Paulsen, Marvin Nicholson (my partner for thousands of games of Spades), and Bobby Schmuck (an honorary member of the Outer Oval).

Many stellar professionals gave their all in the Photo Office, some for many years: Janet Philips, Chuck Kennedy, Lawrence Jackson, Rick McKay, Jenn Poggi, Alice Gabriner, Katie Bradley Waldo, Al Anderson, Tim Harville, Amanda Lucidon, Samantha Appleton, Sonya Hebert, Anna Ruch, Shelby Leeman, Jared Ragland, Amy Rossetti, Jim Preston, Kim Hubbard, Phaedra Singelis, Keegan Barber, and Nora Becker. Those from the Bush administration who stayed on for a few months in 2009: Joyce Boghosian, Sandra Eisert, Dan Hansen, and Nikki Brooks.

Thanks to Vice President Joe Biden and his photographer, David Lienemann, who technically worked for me but really was out there on his own every day. David also had support from Chris Mackler and Jordan Brooks.

Melissa Winter of the First Lady's office was a great friend for eight years and, most important, a fellow fan of Bruce Springsteen.

The President's chiefs of staff and national security advisors all understood the historical importance of my work. Special thanks to Denis McDonough for too many things to mention.

Robert Gibbs trusted me enough to give me access back in the Senate days and was my biggest advocate as the Presidency began.

I had great support from the President's friends, especially Marty Nesbitt, Valerie Jarrett, Sam Kass, and the Campathalon gang. (Plus, of course, our mutual friend Julia Roberts.)

Thanks to Brandi Carlile for her friendship, support, activism, and especially the inspiring music she creates with the twins.

I thank my agent, David Black, for his support and wisdom. He was, and is, the best advocate in making sure that I produced the quality photography book that I wished for. Thanks also to his entire team at the David Black Agency, especially Jenny Herrera and Susan Raihofer.

At Little, Brown and Company, I lucked out in having Mike Szczerban as my editor. I don't know much about publishing, but I could tell he did a lot to produce the book we both wanted. Thanks to publisher Reagan Arthur and the entire LB team, all of whom supported this project and wrote personal notes on why they hoped to publish my book. Special thanks to Nicky Guerreiro, Lisa Ferris, and Ben Allen.

Yo Cuomo at Yolanda Cuomo Design was a delight to work with, helping me transfer the book that was in my head onto actual pages. I'm going to miss spending time in her studio. Thanks also to her team of Bonnie Briant and Bobbie Richardson and for some expert insights from Jonno Rattman.

At Verona Libri, thanks to Nancy Freeman and Zeno Ferrandini.

Thanks again to Jenn Poggi and Alice Gabriner, who gave me wise advice on structuring this book and choosing which photographs to include. Thanks to Shelby Leeman, who expertly prepared the photographic files for publication.

Thanks to my mom and my late dad for instilling their work ethic in me. Thanks to my sisters, Jane and Amy, for their support, and for watching over Mom the past eight years.

Finally, to my family: thank you, Xan and Callie, for your support and encouragement in what I do. I am so proud of you. You have both grown up to be standout adults with good hearts and souls.

To my wife, Patti: you have been so supportive of me and my work, even when it meant missing weekends, vacations, birthdays, and holidays. I can never thank you enough. I promise that I will be with you on Christmas Day this year and look forward to lazy days at the lake for many summers to come.

Photograph by Barack Obama

PETE SOUZA was the Chief Official White House Photographer for President Barack Obama, and the Director of the White House Photo Office. Previously Souza was an assistant professor of photojournalism at Ohio University, the national photographer for the *Chicago Tribune*, a freelancer for *National Geographic*, and an Official White House Photographer for President Ronald Reagan. His books include the *New York Times* bestseller *The Rise of Barack Obama*, which documents the President's meteoric ascent from his first day in the United States Senate through the 2008 Pennsylvania Presidential primary. Souza is currently a freelance photographer based in Washington, D.C.

Little, Brown and Company
Hachette Book Group
1290 Avenue of the Americas, New York, NY 10104
littlebrown.com

First Edition: November 2017

Little, Brown and Company is a division of Hachette Book Group, Inc.
The Little, Brown name and logo are trademarks of Hachette Book Group, Inc.

The publisher is not responsible for websites (or their content) that are not owned by the publisher.

The Hachette Speakers Bureau provides a wide range of authors for speaking events.
To find out more, go to hachettespeakersbureau.com or call (866) 376-6591.

ISBN 978-0-316-51258-9
LCCN 2017941348

10 9 8 7 6 5 4 3 2

Printed in Italy by VERONA LIBRI

BOOK DESIGN BY YOLANDA CUOMO, NYC

Associate Designer: Bonnie Briant

Assistant Designer: Bobbie Richardson